Jakob Tuggener

Martin Gasser

Jakob Tuggener

Photographs

With a preface by Guido Magnaguagno

Jakob Tuggener-Foundation

Scalo Zurich—Berlin—New York

Acknowledgements

I am deeply grateful to Maria E. Tuggener for granting me access to her late husband's estate, for her generosity in sharing her invaluable personal possessions and affectionate memories, and for her unwavering faith in both the book and the exhibition project. The many talks and discussions with her will remain unforgettable experiences.

Both this book and the exhibition would not have been possible without the help of a great number of people. In this place I can only mention a few personally: Guido Magnaguagno who was the first person with whom I discussed Jakob Tuggener's work and who contributed the very personal introduction to this book; Peter C. Bunnell, Professor in the History of Photography and Modern Art at Princeton University, whose enthusiastic support and constructive criticism guided me through the many years of research and writing; Walter Keller who always believed in the visual power of Tuggener's photographs and who did not hesitate to dig up this treasure; Alexis Schwarzenbach who with his critical questions and meticulous attention to detail helped shape my original manuscript into the final text; Jean Robert and Käti Durrer who created the graphic design of this book which is both originally theirs and distinctively reminiscent of Tuggener's own book maquettes; and my wife Noryah who patiently read drafts of the text as it developed and who provided the sometimes much needed moral support. All these people—and the many more who contributed to the completion of both book and exhibition and are not mentioned here personally—deserve my appreciation and gratitude.

This book was written on the basis of my dissertation *Jakob Tuggener: Photographs 1926–1956* (Princeton 1996) which was supported by the Fowler McCormick Fund and the Spears Fund at Princeton University, USA, and by a grant from the Erna and Victor Hasselblad foundation in Göteborg, Sweden. The basic archival work was made possible by the Jakob Tuggener-Foundation, Uster, Switzerland.

The Jakob Tuggener-Foundation expresses its sincere gratitude to the Baugarten Stiftung, Zurich, the Department of Finance of the canton of Zurich, and the Swiss Federal Office of Culture, Bern, for their most generous help in the acquisition of the Jakob Tuggener estate. The Foundation also thanks the Kunsthaus Zürich for serving as a repository of the Tuggener estate, especially Cécile Brunner for acting as its devoted guardian.

The Kunsthaus Zürich is pleased to join the Jakob Tuggener-Foundation and the Swiss Foundation of Photography in thanking the Zurich for the generous support of the first museum retrospective of Jakob Tuggener's oeuvre at the Kunsthaus.

Martin Gasser

Contents

Preface: Tuggener—The Illustrious 6

Introduction 11

Plates 15

Zurich to Berlin 35
Early Albums 40
Berlin and the Reimann Schule 54

Making a Living and Art 73
Work for Magazines 78
Photographs Taken in the City 86
Landscape and Countryside 90
Speed and Danger 94
Summer 1936 in Brittany 102
A Film Project 105
Vienna 1938 106

Technology 113
Fabrik 125

Plates 137

The End of the Era of the Machine 169

Plates 173

Countryside 187
In the Army 190
Frühling, Sommer, Herbst, and *Winter* 192
Uf em Land 200
Zürcher Oberland 202

Plates 205

Nights at the Balls 245
Palace Hotel 251
Ballnächte 255
Exhibiting *Ballnächte* 258

Plates 264

The Late Years 313
The Photographer as an Expressionist 316

Plates 321

Appendix 328

Tuggener—The Illustrious

At the first colloquium on Latin American photography, held in Havana in 1983, the American photo historian Naomi Rosenblum handed me a little note during a lecture, on which she had jotted the question, "What about Tuggener?" At the back of the auditorium the venerable Manuel Alvarez Bravo was shooting pictures, wearing a white glove on the hand he was using to press the release, while on the stage up front Alberto Korda was involved in a heated debate with Fidel Castro. Even so, Naomi Rosenblum evidently thought it worth making a digression.

The question has remained unforgettable, its echo enduring. It was more than justified because at the time Tuggener had not made much of a ripple either in the States or in Zurich. He had retreated into his own kingdom, a cellar between Titlisstrasse and Bergstrasse in Zurich, and his publications were already history. The question had deeper implications: Why didn't you or friends or the Swiss Foundation for Photography, or the Kunsthaus Zürich, or patrons of the arts, why didn't any of you do anything for him? Naomi Rosenblum was working on her *A World History of Photography,* published in 1984, and there was a big black hole around Tuggener's name and oeuvre, which she had probably encountered in Edward Steichen's landmark exhibition "The Family of Man" (1955) or in Otto Steinert's publications on "subjektive fotografie." She probably did not know about what had followed: the occasional small exhibitions at the Neue Sammlung in Munich (1969), at the Helmhaus Zürich (1974), at the Museum der Stadt Solothurn (1978) or finally in 1981, after a prolonged tug-of-war, a show at the Kunsthaus Zürich, "Tuggeners Bücher" (Tuggener's Books). In other words, her query dated three decades into the past, into photohistory, so to speak, and to a biography that then already encompassed fifty years. An increasingly quixotic legend had become entwined with this photographer's name, and has since acquired mythological proportions. From Zurich to New York to Havana.

Though much belated, this book hopefully answers Rosenblum's question. The legend now has—one is almost tempted to say, unfortunately—been unmasked; the mystery disclosed; one of the last photographic treasure chests unlocked; the myth subjected to examination. Can this fiercely independent oeuvre of a photographer-cum-author, who always thought of himself as an artist, be included in the history of the medium,

and even more, enjoy the recognition and appreciation of a contemporary public with a critical eye? As a rule, absence is penalized, especially since photography, too, is now subject to the dictates of the art market. Tuggener himself was optimistic, though late in his life he began to wonder whether the changing times even deserved his pictures, which he himself pored over daily. Even when he was no longer actively at work— except for re-pasting his unpublished book maquettes and keeping a record of his life in astonishing diaries filled with bits of photographs and drawings—he continued to act as the guardian and historian of his own work, his own commentator, defender, and his own premier viewer. Very rarely did he grant anyone an audience in his studio—as he did Walter Binder, then director of the Swiss Foundation for Photography, and me—and visitors had to be on their best behavior to be granted the privilege of looking at the one existing copy of an exquisitely bound book of original prints.

He was an aristocrat. An odd creature, a recluse, an alluring eccentric. Every act was as unusual as the atmosphere that made him happy. He defined the rules that governed his life as an artist. He laid down the laws both in his photography and his private life; he called himself *Photographischer Dichter I* (Photographic Poet I) and his wives figured chronologically from I–III. He stored a selection of his best works in folders labeled "Louvre."

He was inimitable, imperious, and unsettling. Decked out in a straw hat, well-cut suit, beautifully groomed beard, he came straight out of one of those French films of poetic realism, which apart from Expressionism and "Neue Sachlichkeit" inform the aesthetic of his work. He radiated the aura of a poet much more than that of the photographer keeping an eye out for commissions. The grandeur with which he rose above all material worries and contingencies, though they must have been frighteningly grave at times, was magnificent. Art was daily nourishment enough; and the beauty and poetry, the charm and sweetness of women and the visible world, substance enough for survival. His retreat, in which darkroom and kitchen were identical, in which an immense four-poster bed decorated with an ancestor's portrait took pride of place, where the cupboards bulged with photographs and oil paintings fraternized with film equipment and steam engines, this retreat

was alight with the magic radiance of his being. The moment visitors crossed the threshold they were caught and captivated; the rarity of the atmosphere was almost physically tangible. Invited to sit down for dinner where a bottle of wine already stood open on the table, one first had to submit to a manner of interrogation. The conversation during the previous visit had been meticulously noted in his diary, and when the typically Tuggener-like proposal to stage a photographic competition with Swiss photographer René Burri on a car or bicycle race fell through, for example, the reproaches were vehement. These notes, in which he recorded the day's weather along with his love life, in a sense provided the moral standards of his conduct and are perhaps the core of the *Gesamtkunstwerk* named Jakob Tuggener. This *Gesamtkunstwerk* unites the various media, drawing and photography, film and watercolors; an interest in folk culture and technical achievements, in rural life, factory workers, and the upper crust; the stylistic symphony of an oeuvre spanning fifty years with the inimitable timbre of each single photograph; allure and ambitions, eccentricity and triumphs.

His cheerful hauteur was never affected. It was credible because it was authentic, but amusing as well, being so contrary to convention. These visits may well have been the first time that I really sensed what it is to be an artist. He had an unfailing nose for atmosphere, for the perfect ambiance, for the inner truth of the moment, and the authenticity of things. He was a pictorial being, with an eye for inconspicuous, seemingly insignificant things, with a gently caressing gaze of unassuming curiosity. He had a flair for eroticism; his photographs often look as if he had fondled their patina. His sensitivity to surfaces was enticing. He never did manage to escape the appeal of furs and glittering champagne glasses, of jewel-studded décolletés and silken skin. At the same time he was fascinated with the working man's sweat and sooty factory bays. Tuggener "the Illustrious," according to his own assessment. And thus in his photographic empire the world is always a still life but never a *nature morte,* for it is quickened with the emotionality of a sensitive author.

Should he be re-inserted in the history of Swiss photography, where he has in fact always ranked among the best, and must now—after sifting through work that has been inaccessible for decades—be situated there again, his oeuvre stands apart in many respects from that of his peers, the three great "S's": Gotthard Schuh,

Paul Senn, and Hans Staub. These photographers devoted themselves primarily to documentary photography: Senn cultivated a dramatic, monumental pictorial idiom; Staub was an epic verist; and Schuh alone acknowledged that photography has artistic qualities.

It was not until a generation later that two Swiss photographers, Werner Bischof and Robert Frank, entered the stage and were to make photographic history. While Bischof engaged in Hans Finsler's "neue fotografie" before moving to the frontlines of reportage by joining Arnold Kübler's *Du* and becoming a co-founder of *Magnum*, Robert Frank's work, with its long-time concentration on the artistic exploration of his own existence, throws illuminating light on Tuggener. They are the only *authors* who in their day acted first and foremost as their own clients. Who relied on their own lives and their own creative potential. With no schools and no followers. Who were stylistic pathfinders. Whose imagery is stirring and unique. And whose oeuvre therefore belongs not only to the art of photography, but to the art of our century.

Had he not been so ornery, Tuggener would long since have been named in concert with Brassaï or Bill Brandt. And Naomi Rosenblum's question would have been unnecessary.

"What about Tuggener?" The entire oeuvre has survived and been archived, the first monograph published. Exhibitions and a new film thoughtfully present a long hidden treasure to the public. Along with Tuggener, one asks: does the public deserve it? Were he still alive and could appraise what his third wife and president of the Jakob Tuggener-Foundation, Maria E. Tuggener—who as "sole heiress" looks after his legacy with his blessing—and the art historian Martin Gasser have presented as his lifework without his imprimatur, he would probably be filled with the uninhibited pride—which struck his visitors—in never having done anything superfluous and never having wasted his time. His oeuvre is indeed timeless.

Guido Magnaguagno

Translation Catherine Schelbert

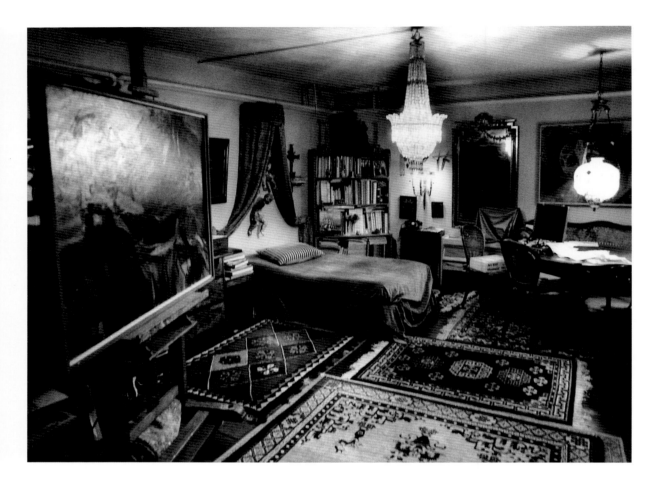

Untitled, Jakob Tuggener's basement apartment at Titlisstrasse, Zurich, 1970

Introduction

A picture can only be explained by a text but it cannot be experienced by it. Because the soul lies deeper down, there, where no words can penetrate.

Jakob Tuggener

While studying in the United States in 1988 I came across a short notice in the international edition of the Swiss newspaper *Tages-Anzeiger:* the photographer, painter and filmmaker Jakob Tuggener had died at the age of eighty-four. Of course, I was familiar with the work of this important Swiss photographer—at least I thought I was—and I had been interested in meeting him and perhaps writing about his work for quite some time. However, what inspired me to write immediately to his widow was not only that I wanted to offer my condolences, but also the fact that Tuggener was to be buried in Matt, a small village in a remote valley in the canton of Glarus. This was where my mother was born and grew up, and where I had spent many vacations at my grandmother's house when I was a child. I wrote to Mrs. Tuggener about my relationship with this village and asked whether she would be interested in meeting me to discuss the possibility of my writing an academic thesis about her late husband's photographic oeuvre. As it turned out, Maria E. Tuggener was a native of the neighboring village in the same valley and, intrigued by this coincidence, she agreed to a meeting on one of my next visits to Switzerland.

Soon after this first exchange of letters I began doing research on Jakob Tuggener in the art library of Princeton University. Apparently not much of Tuggener's work had been published in the United States or England. But he was mentioned frequently with Werner Bischof, Gotthard Schuh, Paul Senn, and Robert Frank as one of the founders of modern Swiss photography. I went to see Robert Frank in New York and he vividly remembered Tuggener as an outstanding figure whom he first became aware of during his time as an apprentice and assistant at Michael Wolgensinger's

studio in Zurich in the early 1940s. In later years he got to know him as a cultured and modest man. He was impressed by the fact that Tuggener had no money—and did not seem to need any—but still managed to express in his photographs and films a most intense passion for life. Because of this passion and his uncompromising commitment to personal expression Frank felt that among the many photographers in Switzerland Tuggener was the only true artist of his generation.[1]

After Robert Frank had settled in the United States in the early 1950s, he brought Edward Steichen, the director of the Department of Photography at The Museum of Modern Art in New York, in touch with Jakob Tuggener. Steichen was preparing two major exhibitions: one was to present contemporary European work, the other was to concentrate on photographs dealing with "the basic universal elements in human relations."[2] Frank accompanied him to Switzerland in the fall of 1952. They met with Tuggener on 2 October to look at his work: his most famous book *Fabrik,* published in 1943, and several later book maquettes with photographs taken in factories and in ballrooms of luxury hotels, from which Steichen made a selection. Steichen was very impressed and after his return to New York wrote to Tuggener: "Your work will be an outstanding contribution to the exhibition, and I hope you will send the prints we decided upon together."[3]

Despite Steichen's favorable response to his work and the prospect of it being exhibited at the prestigious museum in New York Tuggener apparently had to be reminded to send the pictures. Apologizing to Steichen he wrote: "If I am delayed it is because I am not a rich man. I cannot send you all the photographs you selected, only nine pictures from the maquette *Schwarzes Eisen* (Black Iron) and another nine of the pictures taken in ballrooms. I know it will be worth doing this work for you and that the pictures will be returned again."[4] Sending the photographs was indeed worthwhile and ten of them were shown in the exhibition "Post-War European Photography" that opened at The Museum of Modern Art on 26 May 1953. Tuggener's work was received with enthusiasm and a critic wrote that the picture of a factory errand-girl rushing to work was "one of the very few typically 'European' photographs in the entire exhibition of European work."[5] In the seminal exhibition "The Family of Man" that opened at the same museum in 1955 Steichen included two photographs by Tuggener. One was a picture of a dancing lady in a long dress seen from the back, and the other was a forceful close-up of muscular men's arms. In the exhibition that became one of the most popular photography exhibitions ever, *Arme der Arbeit* (Arms of Work) was shown as a gigantic enlarge-

ment and was reproduced, together with Tuggener's dancing lady, in the exhibition catalogue that sold millions all over the world.

After my initial research into Jakob Tuggener's work and its critical reception, I had to agree with what the Paris correspondent of *Creative Camera* magazine had written in 1977: "Two photographs in Steichen's 'Family of Man' is all many people have ever seen of [Tuggener's] photographs. But his work—that of a humanitarian, with a sympathetic and ironic concern for his fellow men—is one of the best examples of poetic realism. ... His many faceted work, with its wonderful love of detail and contrast, for harshness and glamour, is really worth discovering."[6]

During the summer break of 1989 I had the privilege of discovering the real scope and depth of Tuggener's oeuvre. Mrs. Tuggener invited me to the small basement apartment in Titlisstrasse in Zurich where her husband had lived and worked from 1960 until his death in 1988. Nothing had changed since then and it felt as if Tuggener had only just stepped out to fetch the newspaper. Divided by a temporary wall, the space consisted of a living-room/bedroom that also served as a studio and a kitchen/darkroom with an adjacent tiny toilet. The rather gloomy space was only illuminated by two small windows and a chandelier. A king-size bed with wooden angels and a crown-like baldachin mounted to a water-pipe running all across the room above it dominated the living-room. The rest of the furniture consisted of a round wooden table, a sofa and a couple of chairs, a large mirror with a gold frame, a bookshelf, an antique bureau, a chest of drawers, a large two-door cupboard, and some oriental rugs: stylish period furniture in an otherwise shabby basement. There were paintings and drawings on the walls, one or two on an easel by the side of the bed, and large mounted photographs stacked on a shelf against the makeshift dividing wall. On one side of the kitchen there was a simple cooking facility, a table with two stools, a cupboard for dishes, a trash can, and on the other side chests with drawers, a Leitz Focomat enlarger with some other outdated darkroom equipment and a round print-washing basin that also served as a kitchen sink. All this evoked the life of the artist Jakob Tuggener as he was described shortly after he moved into this apartment: "Thin, with a short beard like an Austrian, soft but impulsive, and a pure idealist whose independence and creative freedom are much more important than material security and success, who consciously takes the sacrifice of bourgeois welfare as the price to be paid for inner and outer freedom."[7]

After some tea and a pleasant conversation Mrs. Tuggener opened the two doors of the large cupboard and I saw hundreds of orange Agfa photopaper boxes stacked on

several shelves with large folders underneath. All the boxes were labeled and full of hundreds of prints, some of them just workprints, others beautiful vintage exhibition prints from the 1930s and 1940s. Among these thematically ordered photographs there were dozens of documents, small drawings, newspaper clippings, and personal notes revealing the context in which the photographs had been made. The folders, a few of them bearing the promising label "Louvre," contained dozens of drawings and watercolors. Smiling proudly Mrs. Tuggener pulled out one of the drawers of the bureau which contained all of Tuggener's silent films, rolls and rolls of material most of which had never been seen in public. In another drawer in the kitchen there were all of Tuggener's negatives, neatly collected in the original negative pockets and ordered in thematic groups tied together by rubber bands that were already disintegrating. I was completely overwhelmed by the sheer volume of what Tuggener had left behind and the immediately apparent richness and depth of his legacy. Through innumerable further visits and long conversations with Mrs. Tuggener, interviews with Tuggener's contemporaries and extensive research in libraries and archives as well as second-hand bookshops and flea markets, the full scope and meaning of Tuggener's oeuvre gradually unraveled in front of my eyes during the following ten years. Working like an archaeologist I was unearthing layer after layer and putting the pieces together in an attempt to understand the whole: Tuggener's early albums, his drawings of film scenes, the films themselves, his photographs and watercolors, the documents, his personal texts, his business records, and his personal correspondence from "tempi passati" (past times) as Tuggener had labeled one envelope containing love letters. But, above all, there were almost seventy carefully bound and titled book maquettes which constitute the core of Tuggener's work. Originally intended for publication, these photographic books were his own very personal form of art. Tuggener never liked to part with his books and looked after them as if they were his children. Only reluctantly did he show them—one book at the time—to a few chosen admirers whom he received as visitors in his apartment. So it is not surprising that so little has been known, up until now, about this wonderfully creative artist.

Notes

1 Interview with Robert Frank, 15 December 1989.
2 Undated press release, The Museum of Modern Art, New York, (ca. 1952).
3 Letter from Edward Steichen, 16 December 1952, Edward Steichen Archive, The Museum of Modern Art, New York.
4 Tuggener in letter to Edward Steichen, 18 February 1953, Edward Steichen Archive, The Museum of Modern Art, New York.
5 Anon., "The Museum of Modern Art Shows over 30 Important Works," *U.S. Camera,* September 1953, p. 38.
6 D. Seylan, "Contributors," *Creative Camera,* December 1977, p. 400.
7 Heinrich Stöckler, "Jakob Tuggener," *Leica-Fotografie,* November/December 1961, p. 230.

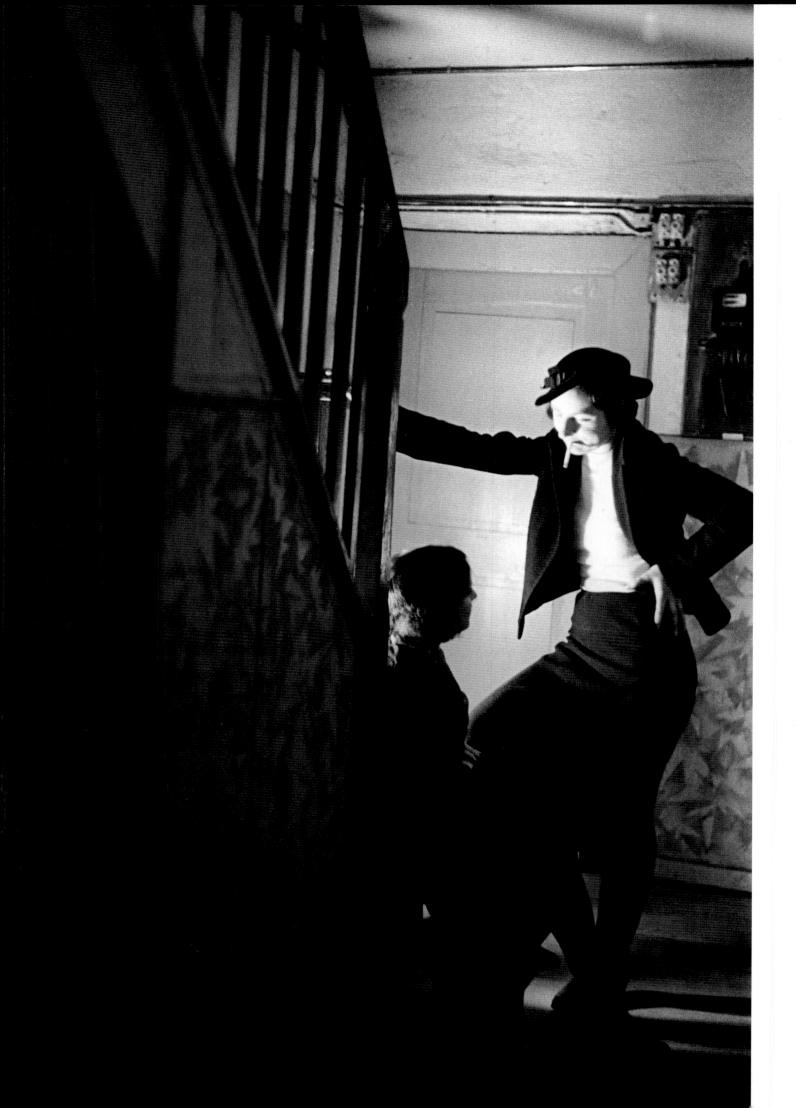

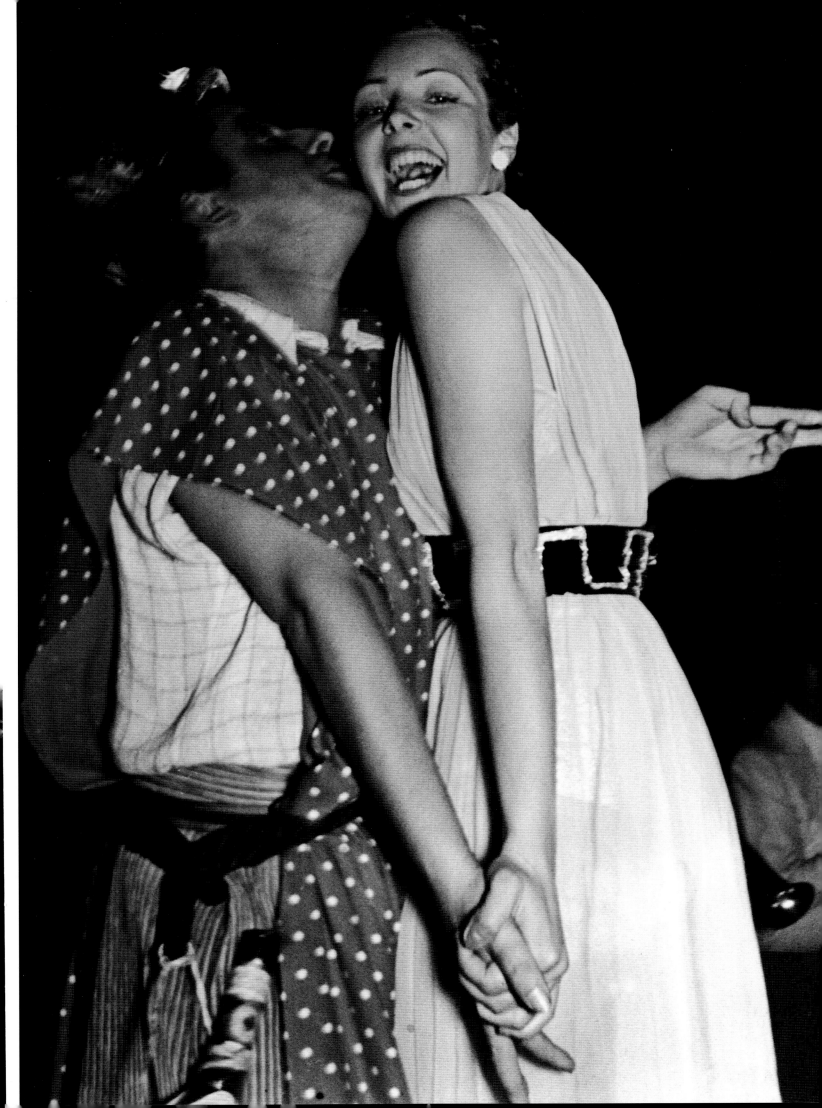

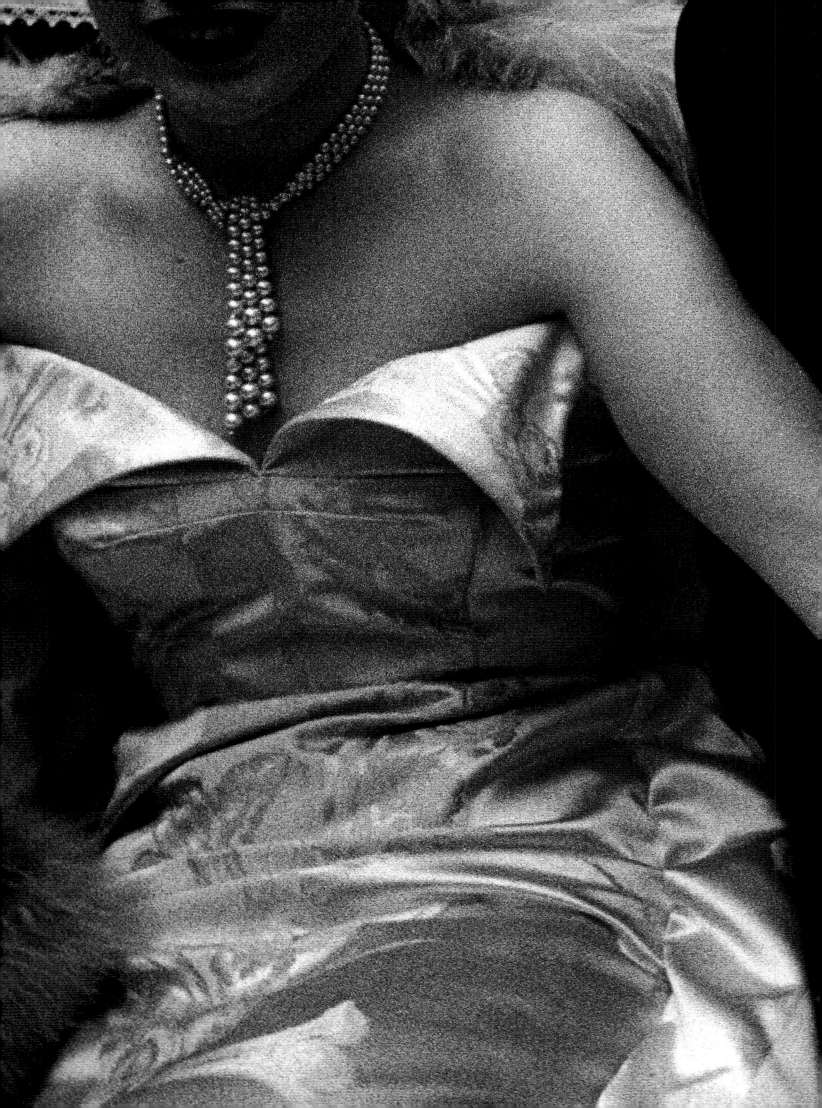

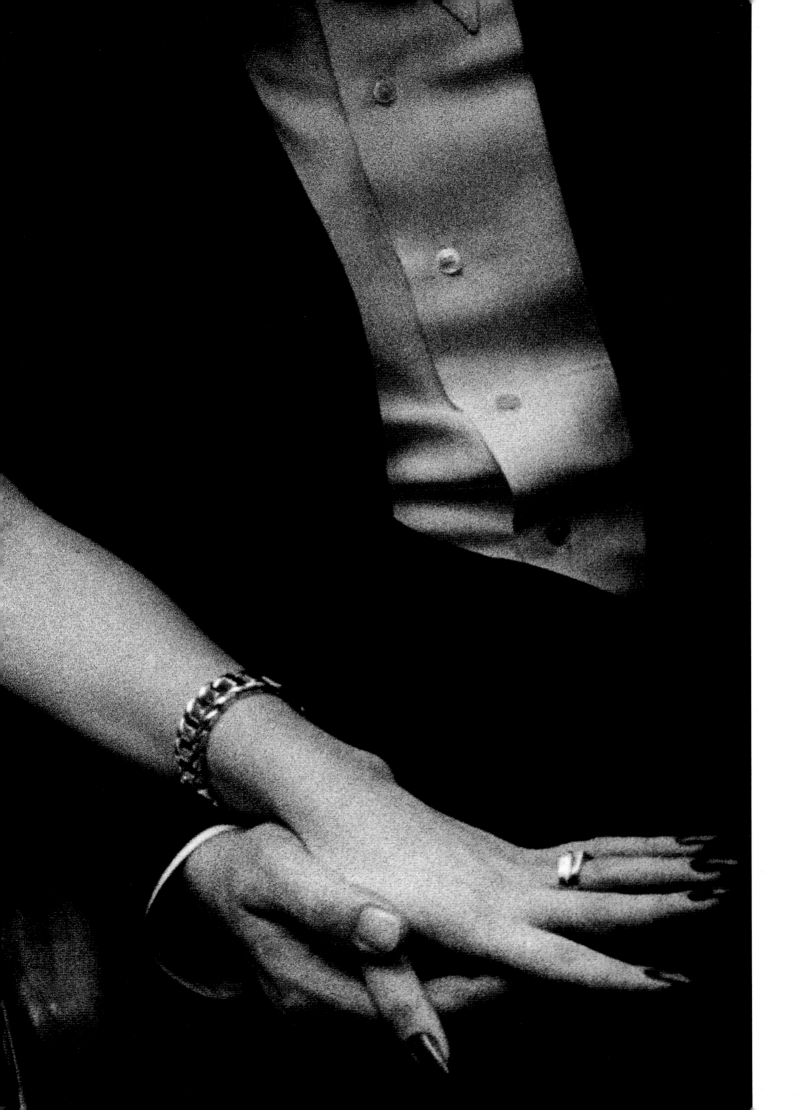

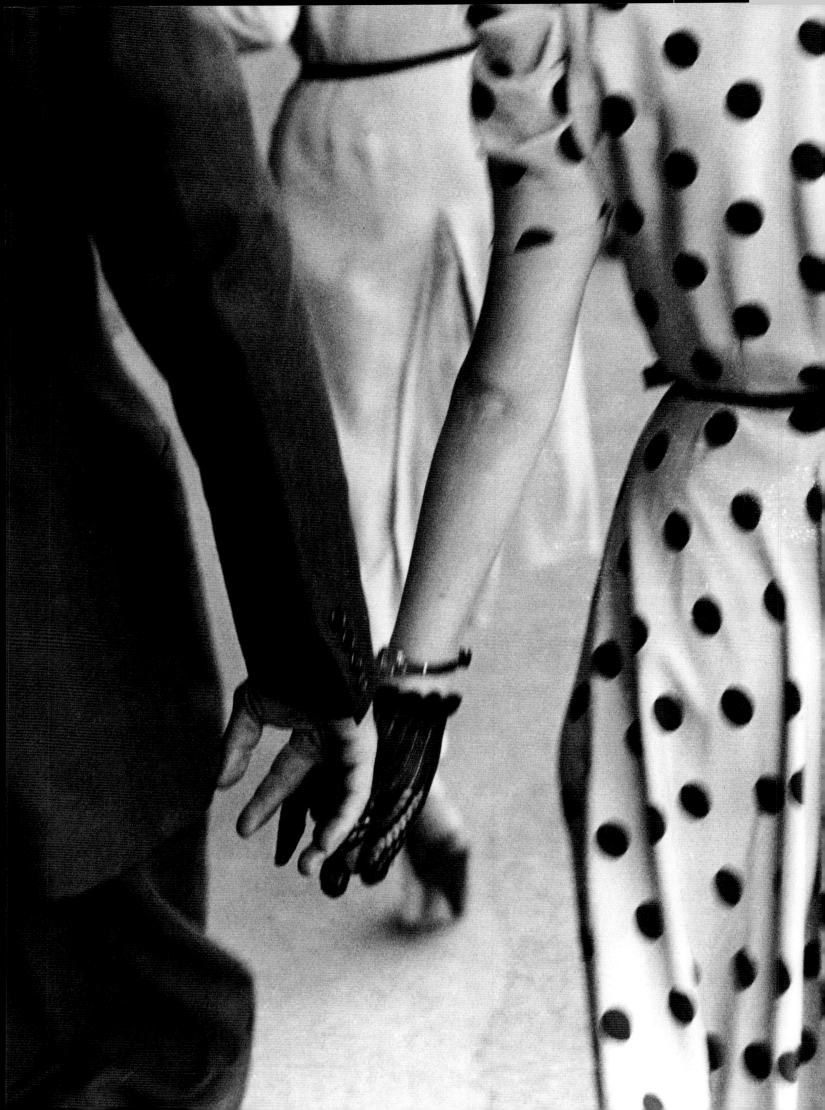

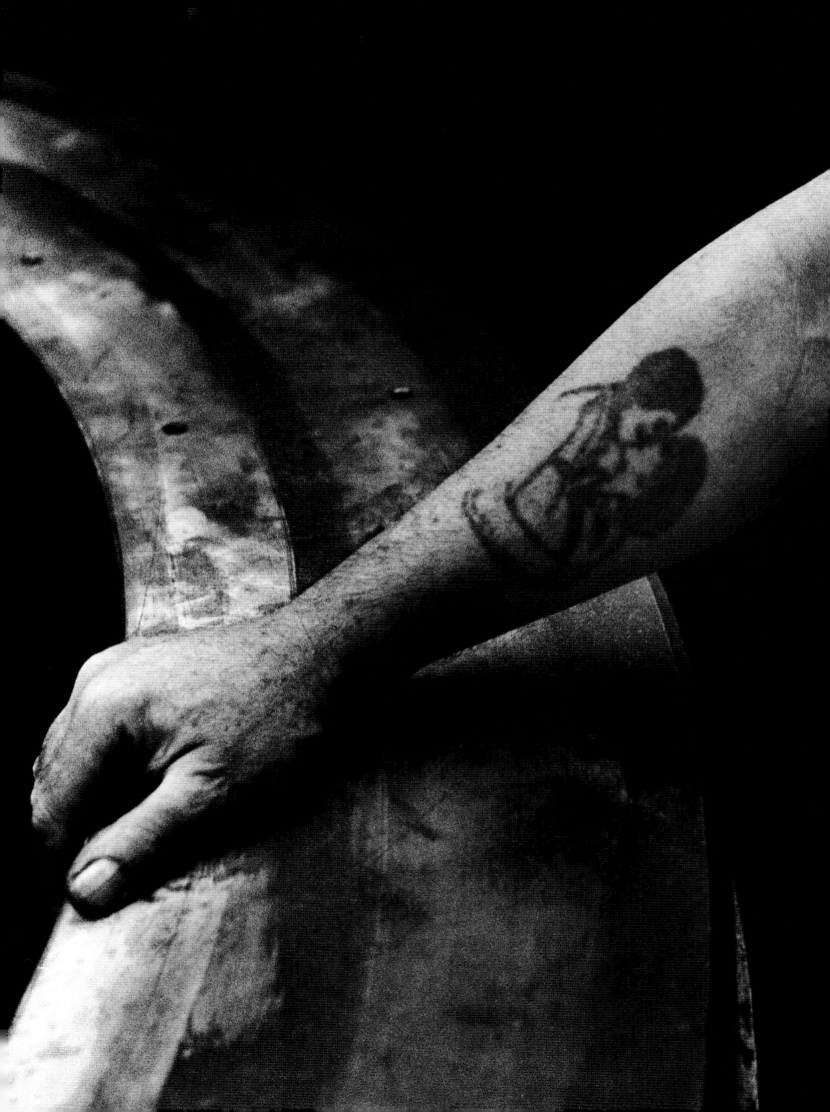

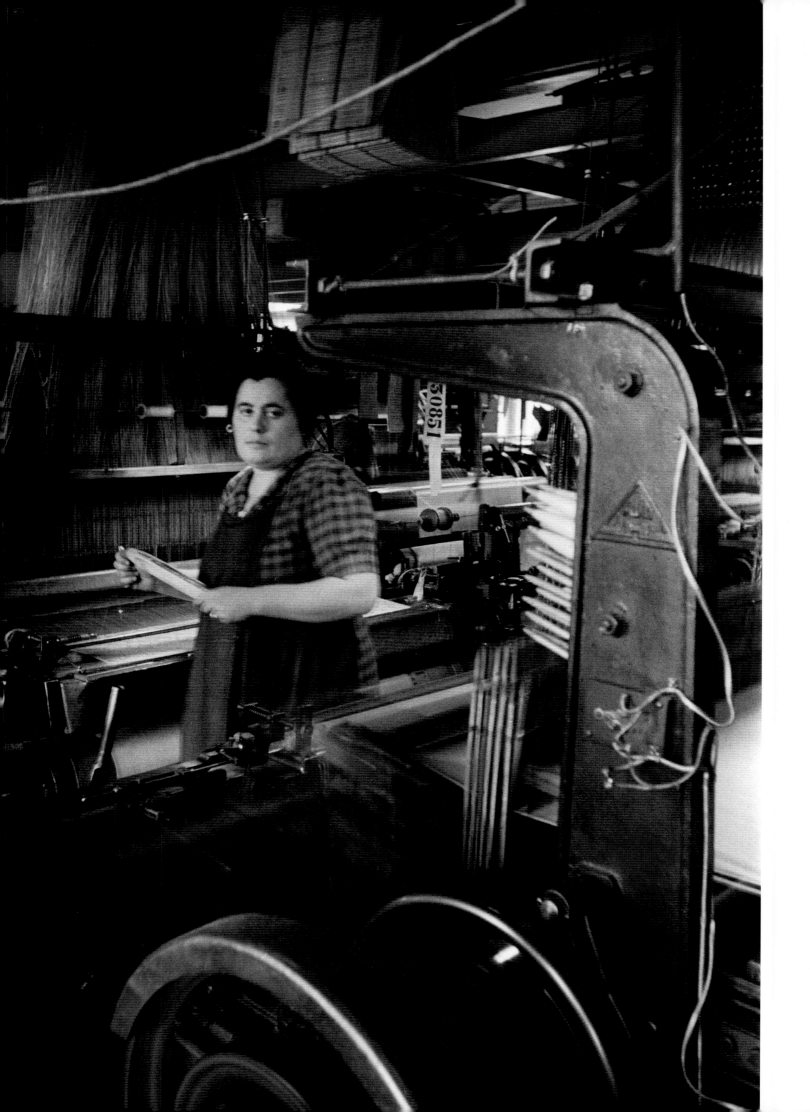

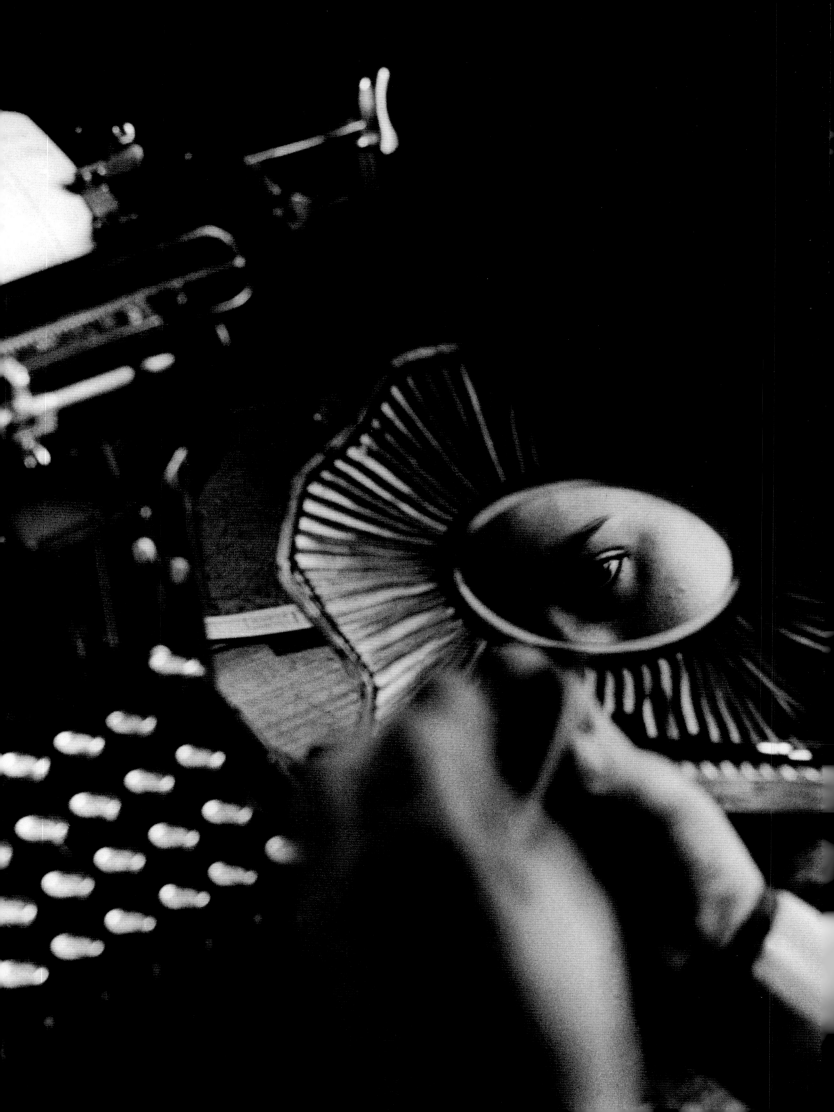

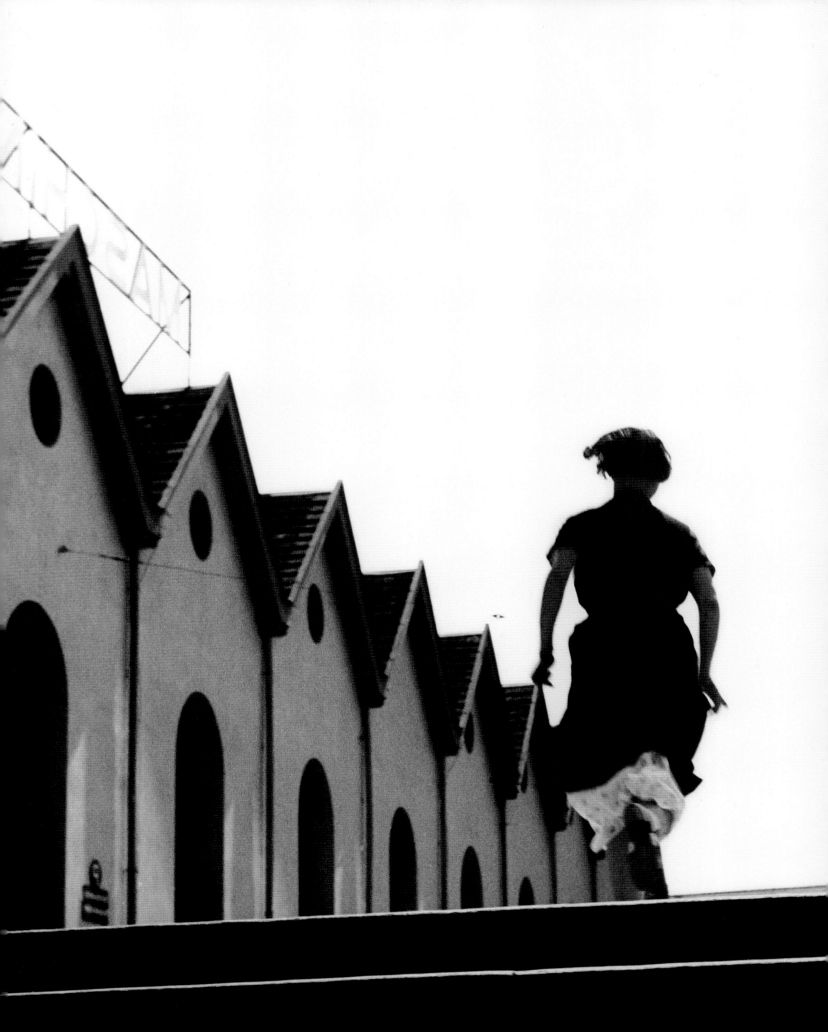

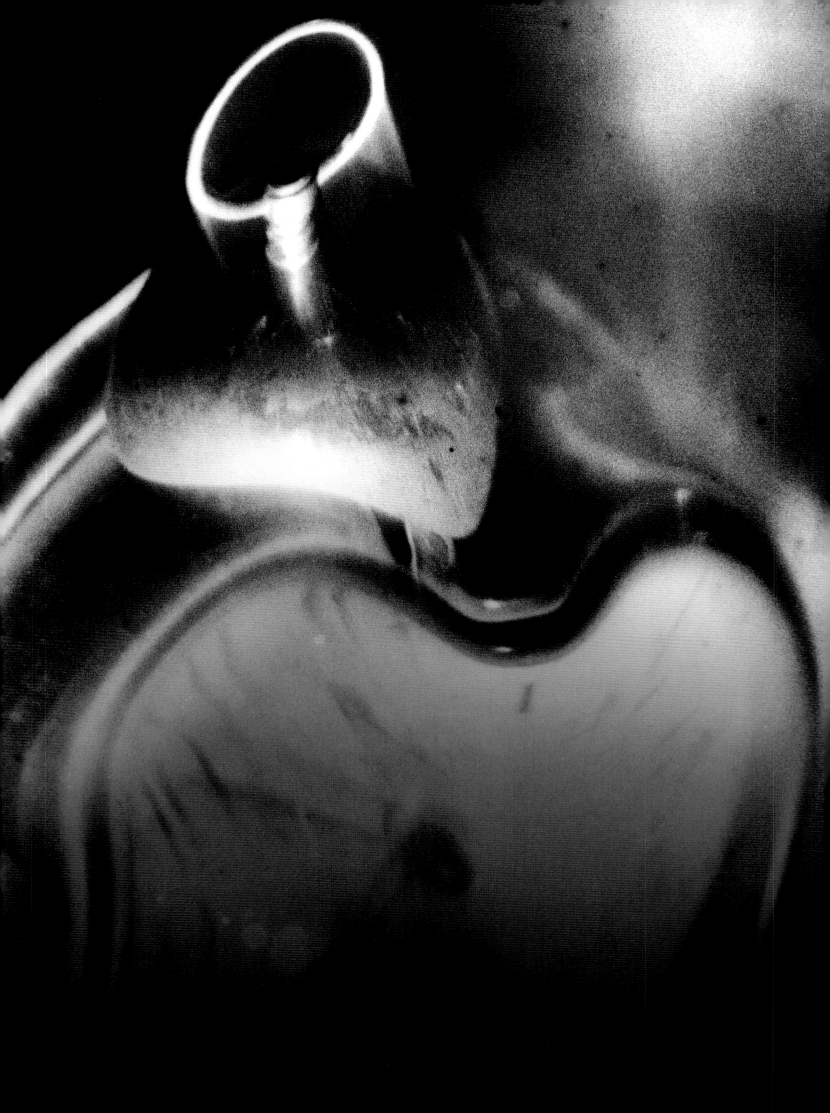

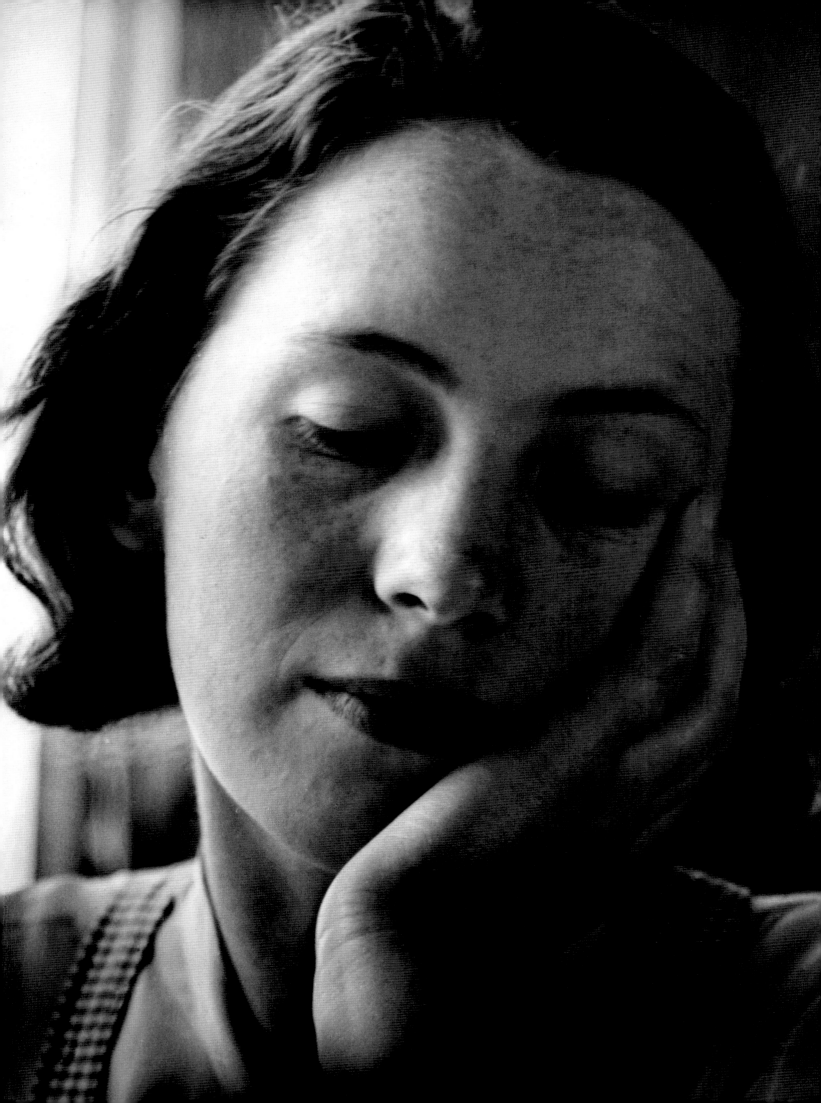

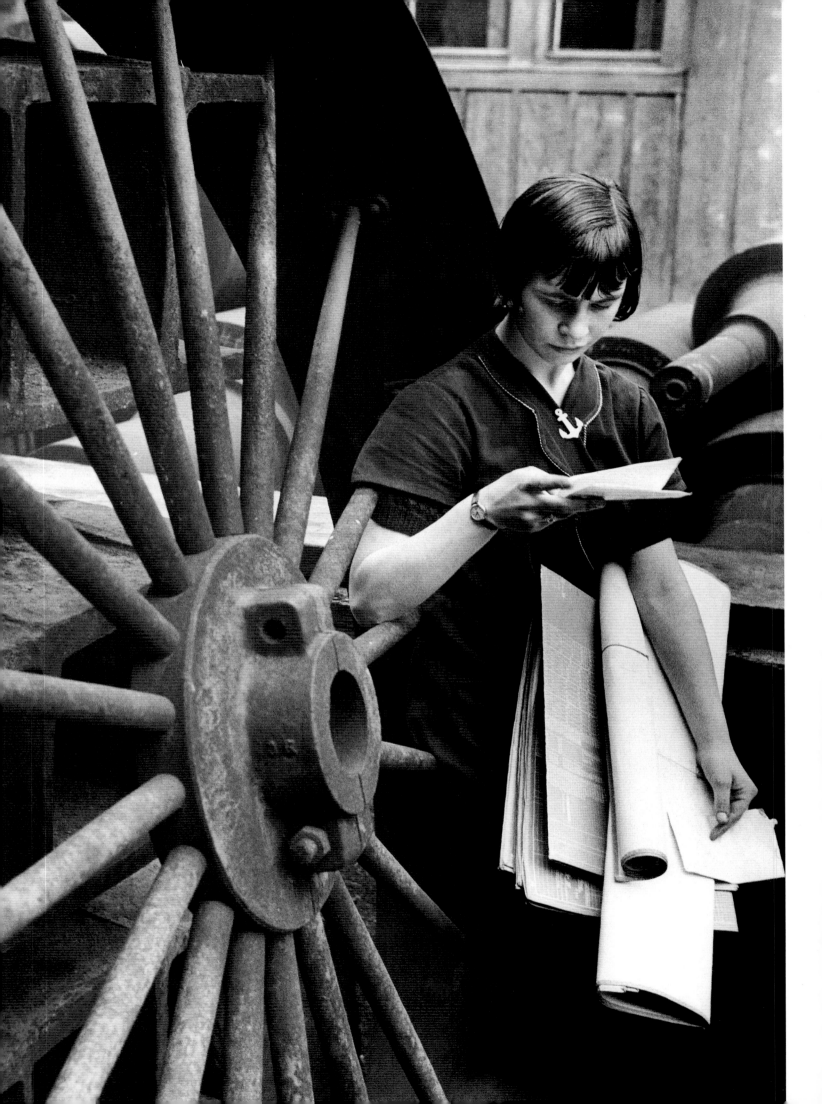

Plates pp. 15–30

p. 15 **Berti,** Oerlikon Machine Factory, 1936

p. 16 **Untitled,** outside Tuggener's attic room, c. 1935

p. 17 **Auf dem Maskenball** (At the Masked Ball), c. 1948

pp. 18/19 **Untitled,** Ticinesi ball, Grand Hotel Dolder, Zurich, 1949

p. 20 **Heimkehr nach dem Rennen** (Returning Home After the Race), Bern, 1949

p. 21 **Amore** (Love), Oerlikon Machine Factory, 1940s

pp. 22/23 **Realität und Vorstellung** (Reality and Imagination), no date

p. 24 **Im Büro der Giesserei** (In the Foundry Office), 1937

p. 25 **Am Morgen** (In the Morning), 1936

p. 26 **Vor dem Erwachen** (Before Waking Up), Berlin, 1930/31

p. 27 **Tuggeners erste heisse Liebe** (Tuggener's First Hot Love),
Oerlikon Machine Factory, c. 1935

pp. 28/29 **Das Doktor Buch** (The Medical Book), Oeschgen, 1942

p. 30 **Berti,** Oerlikon Machine Factory, 1936

THE CHURCH

The distress of life engenders in us a yearning for relaxation and peace of the soul. However, relief can only be achieved if we explore the reasons for our restlessness and if a new direction in life is revealed to us. This picture deals with this problem. It shows not just any church, but is a pictorial rendition of the fundamental intellectual contemplation of its essence. Once the factual content is clarified, the disparate parts will come together to form an intellectually assembled construction of thoughts.

The soul toils wearily and restlessly upwards along the red banister. The nearer it comes to the trapeze-shaped opening of the door, the greater the feeling of relief. Relaxing and guiding is the semi-circular shape above the door. The view of the interior reflects the contemplation of life, the sacrifice of intellectual work which brings the healing of the soul. The great dome-shaped cupola covers the assembly room. It is an expression of the unified upward gaze and of the call of thanksgiving. It leads upward to infinity, to the source of life, to the concept of God. In order to show the internal meaning of the construction, the shape of the cupola is painted with the emotional symbols of the struggle for life and redemption. A few windows in the circle of the cupola open to the ether. From the inside they project relaxation and courage on to the road ahead.

The bell tower functions as a magnet. Its roof attracts the feeling under its dome while the objects on the side call the wrestling minds to them through the magnetic pull of their forms. Going back to the church we see in the middle of the cupola a slanted edge leading toward the lower left. This edge separates the whole construction into an active side of life on the right and a passive side on the left. This separation can be seen along the entire length of the picture. A narrow gap leads from the interior room into this little noticed area of death and the next world. Thoughts travel along a musty flow of colors toward the place of physical decomposition, to the grave mounds that symbolize the earth from which our bodies are taken. If we look at the black outlines marking the background to the left of the tower and the bumpy curvature of the cemetery wall, then what lies behind appears as a vacuum and a mysterious world, an instinctive expression of the concept of the next world. The area left of the tower therefore represents the field of occultism, and the side of real life lies on the right.

Jakob Tuggener about his watercolor **Die Kirche** (The Church), 1922

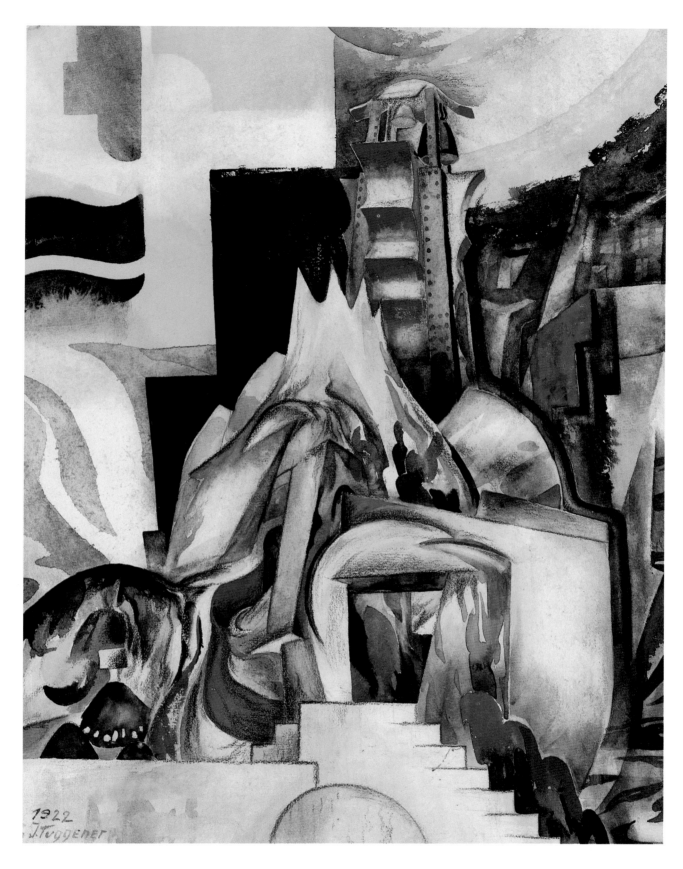

Die Kirche (The Church), watercolor, 1922

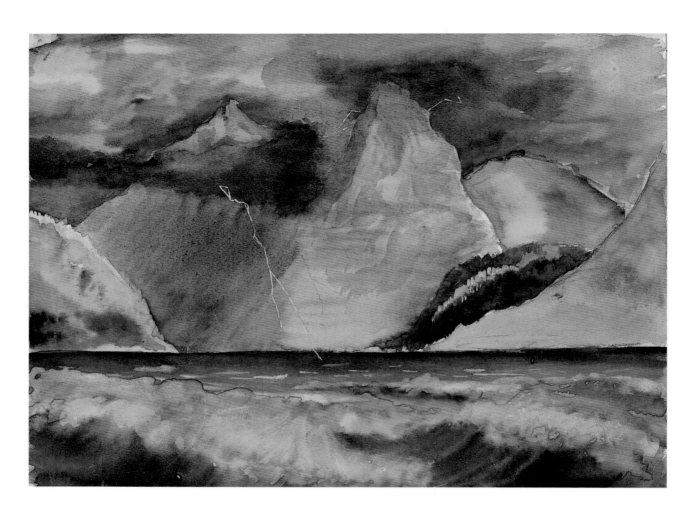

Untitled, backdrop for Tell Theater, watercolor, c. 1918

Zurich to Berlin

Jakob Albert Tuggener was born in Zurich on 7 February 1904 at 9 a.m., fifteen minutes before his twin sister Anita. Jakob and Anita were the only children of Jakob Arnold Tuggener and his wife Anna Barbara (née Sennhauser) who lived in a small house in the Seefeld, a quiet area near the lake at the south-eastern edge of Zurich. Jakob's father, an independent lithographer, was the proud descendant of an old Protestant Zurich family tracing itself back to the sixteenth-century knight Wilhelm Tugginer who played a decisive role as a mercenary warlord under the kings of France. His portrait always hung in the Tuggener home and a street nearby was named after him, so Jakob was well aware of his historic roots. He later explained that from his grandfather, a machine fitter in a coal mine in the nearby Aa valley, he inherited a penchant for the world of the factories and from his godmother and aunt Luise Tuggener, a silk winder in a textile factory, his love for silk and other fine cloths. And to his father who taught him how to draw when he was still a child he owed his "hungry eyes."[1]

The twins had a sheltered upbringing and went to neighborhood schools where Jakob's artistic talent showed very early; his highest grades were always in his drawing classes. He drew and painted after nature, mostly in watercolor, but also produced imaginary landscapes such as a series of backdrops for his own Tell Theater, where for his friends he staged the heroic tale of William Tell and the foundation of Switzerland with paper puppets. Of the three pieces that survive, an expressive rendition of a thunderstorm over an agitated lake surely served as backdrop for Tell's famous leap to freedom out of the boat taking him into captivity.

Towards the end of his time at secondary school Tuggener expressed the wish to become an artist. His father tried to persuade him to train as a graphic artist but Jakob refused, preferring to draw and paint the "life of his soul" as an autodidact.[2] In the spring of 1919 he began an apprenticeship as a technical draftsman at Maag Zahnräder A.G., a metal company producing gearwheels in Zurich. Even though Tuggener later said that he was not unhappy during his four-year apprenticeship[3], there must have been times when he felt otherwise since he called one 1922 drawing *Jeden Tag in das Fabrik-Gefängnis* (Every Day into the Factory-Prison). Even though Tuggener was often late for work and showed signs of a somewhat disorderly life-style by growing his hair and fingernails unusually long, he passed his final examination with excellent grades in March 1923. Without any further formalities he continued to work in the construction department of the company.

A year later Tuggener was called up for military service which was deferred for a year, and he completed his basic training as an infantryman in the fall of 1925. After this, like all other young Swiss men, he was obliged to do so-called repetition courses, regularly occurring military training programs taking place in various parts of the country. He was an enthusiastic soldier but not a very good shot and more than once had to participate in special shooting courses.

Probably due to the fact that Tuggener could not find real satisfaction in his work as a mechanical draftsman, he increasingly felt a need to redirect his life and to explore its spiritual meaning. This uneasiness can already be felt in one of his earliest watercolors entitled *Die Kirche* (The Church) of 1922 about which he wrote: "Due to the distress of life there occurs in us the yearning for relaxation and peace of the soul. However, relief can only be achieved if we explore the reasons of our restlessness and then a new direction of life is revealed to us."[4] Tuggener turned to religion and remembered his confirmation motto, "Teach me, oh Lord, Your Way, that I may walk in Your Truth." This prompted him to seriously study the Bible and think about the meaning of the Gospel—he even took a night course at a Catholic adult education center. At the same time he turned to other, more esoteric sources. Most importantly, around 1924 he took a course in phrenology, the analysis of the contours of the skull to determine a person's character and talents, at the international Mazdaznan-Tempel-Gemeinschaft (Mazdaznan temple community) in Herrliberg near Zurich. It was probably there that he met Johannes Itten, the former Bauhaus master who had developed the preliminary course during the first years of the Bauhaus in Weimar. Itten, a close adherent of Mazdaznan teachings which

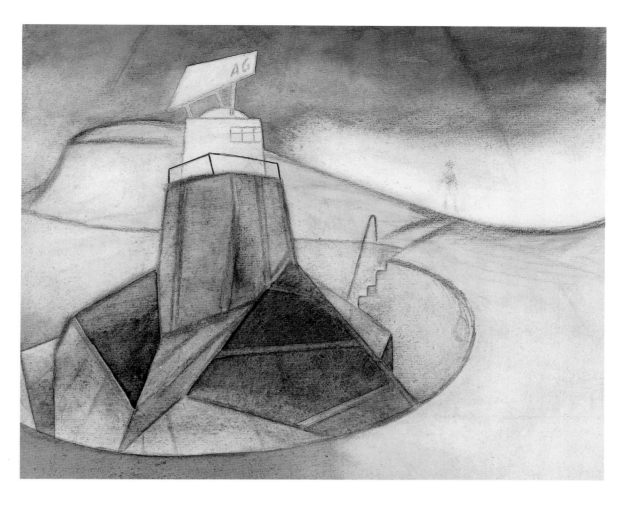

Jeden Tag in das Fabrik-Gefängnis (Every Day into the Factory-Prison), crayon, pencil and watercolor, 1922

originated in Persia, defined their essence as "Knowing God, becoming one with the Divine Spirit within yourself. God within yourself."[5]

Tuggener was searching for an inner, spiritual truth that could not simply be found on the surface of reality but had to be experienced subjectively and which would ultimately lead to one's own self, one's soul. He combined ideas of empathy ("Einfühlung") and experience ("Erlebnis") circulating in expressionist art theory, Mazdaznan and other Eastern conceptions of salvation with his religious fervor and thus formed his own conception of himself as an expressionist artist. He later wrote: "Art is 'the way' towards one's self, which is the 'inside' of all things as opposed to the 'outside' pretense."[6]

Another important area of interest for Tuggener was the cinema. Every Saturday afternoon he went to see a film—sometimes the same film over again—and afterwards he drew the actors' portraits and painted film scenes from memory. As a hand-written list reveals, Tuggener actually saw over two hundred movies between

1921 and 1930 and began to live more and more in this world of film. He illustrated this situation in a painting in 1922 and later explained: "In the upper left corner I depicted my workplace in the tempering workshop, around it scenes of silent films of the period. The spiral shows my diving from the workplace into my world of dreams."[7] In the upper quarter of the picture Tuggener showed the Orient Cinema in front of which people can be seen studying the film stills on display. Tuggener explained that he "never missed making the pilgrimage to the Orient Cinema to admire the photographs and to draw after them later at home," and that the cinema meant both "church and shrine" for him.[8]

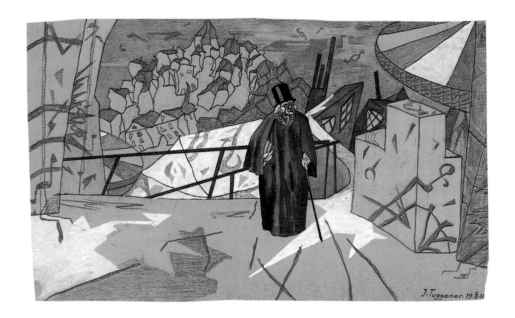

Das Kabinett des Dr. Caligari, sein erstes Auftreten
(The Cabinett of Dr. Caligari, His First Appearance), watercolor, 1921

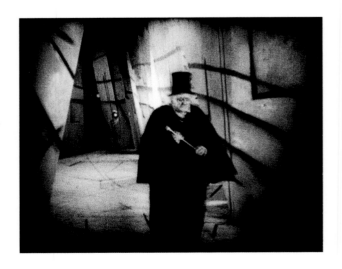

Untitled, photograph of a film projection of Dr. Caligari, no date

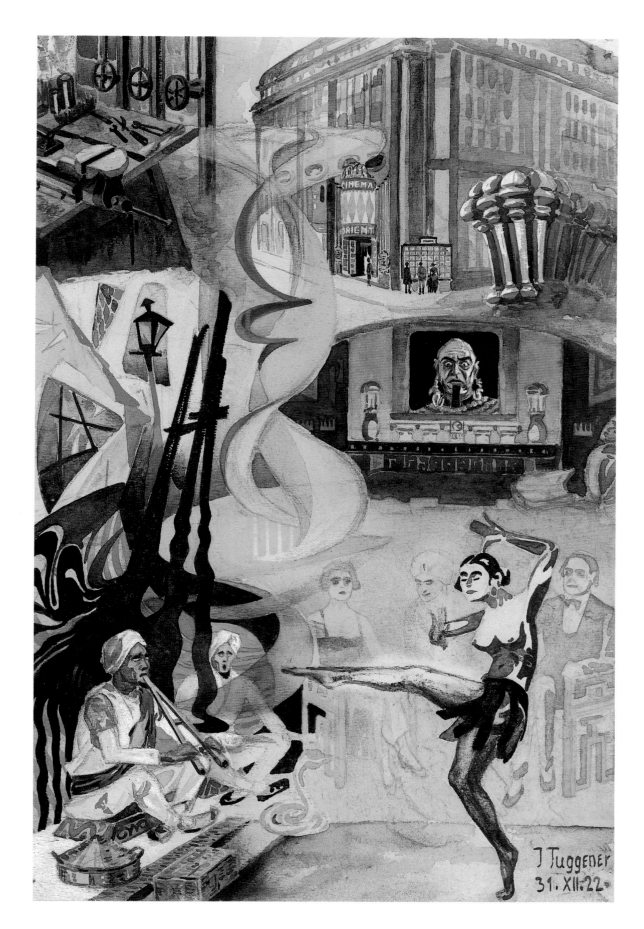

Untitled, Cinema Orient, watercolor, 31 December 1922

Early Albums

Tuggener never revealed when exactly or how he began to take photographs. He was certainly aware of photography at an early age since his father took family pictures and reproduced lithographs with a camera. Yet it is very likely that he was introduced to the practical use of a camera and the work in the darkroom around 1926 by Gustav Maag, the factory photographer at Maag Zahnräder A.G. At the beginning of one of his early albums of photographs taken in the Maag factory he juxtaposed two pictures on a spread, one showing Gustav Maag working in his photographic laboratory, the other a self-portrait of Tuggener with a folding camera taken in a mirror. The similarity in pose and the formal parallels suggest a homage to Gustav Maag as his teacher.

The self-portrait displayed in this album is the first of a great number Tuggener took throughout his career. As in this picture he always used a tripod and a cable release or a delayed-action shutter release. The camera he used for most of the pictures he took until the early 1930s was a simple folding camera for 6x9 cm glass plates and sheet film.

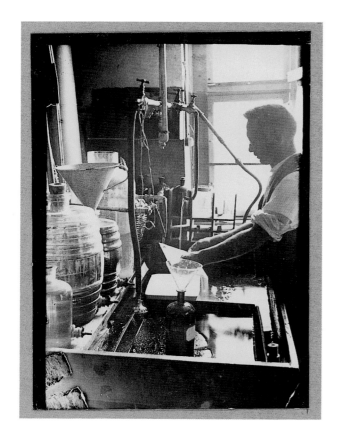 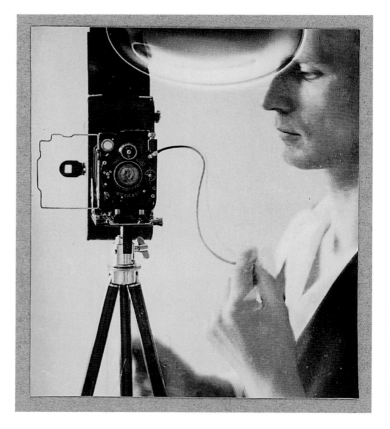

Untitled, Gustav Maag, factory photographer, c. 1926/27 Bei Maag Zahnräder (At Maag Zahnräder), self-portrait, 1927

Tuggener's very first surviving photographs stem from his first trip abroad in 1926. His sister Anita was then living in Milan and he may have seen this as a good opportunity to travel to Italy and especially to the city of Venice. An album simply entitled *1926* and containing twenty-three photographs is the only evidence of this first "photo-trip." It is a kind of beginner's scrapbook of photographs in different sizes and processed in a variety of techniques, most likely in the darkroom at Maag Zahnräder. Most of the pictures show picturesque scenes at the port of Venice and along the canals. They are very reminiscent of the countless pictorialist views of the same places taken since the 1890s that the Swiss illustrated magazine *Camera* was still publishing in the 1920s.

Tuggener produced twenty-five albums in the ten years between 1926 and 1936. Initially they were photographic scrapbooks like the one from Venice that can be seen as a parallel or continuation of Tuggener's sketchbooks with drawings and watercolors. But very quickly they became more intricate and later developed into Tuggener's favorite and most important means of artistic expression, his elaborate book maquettes, the first of which he produced in 1935. It was not a single image on the wall that was his goal but a picture among many, a group of images, a series, and eventually, the book: Tuggener's private way of directing a kind of theater or a film of his own.

Most of Tuggener's albums made before 1930 deal with landscape, put together after vacations, hikes or other trips in Switzerland. As with going to the movies, hiking in the mountains provided an escape from his work at Maag Zahnräder and from his parents' home that may have become too confining after his sister Anita had returned from Italy in 1928. During long hikes through remote valleys and across solitary passes, photographing extensively, Tuggener got to know the Swiss mountains, especially the central Gotthard massif, the heart of Switzerland which plays a significant role in the national mythology of this small Alpine country.

Switzerland, like many other countries, considered itself God's country and the grandeur of the Swiss Alpine landscape symbolized this, especially in the context of the formation or strengthening of national identity. Such sentiments were not only expressed in literature and art but also in a great number of films, many of which Tuggener was absorbing during the 1920s. Among them were patriotic films such as Friedrich Genhardt's *Wilhelm Tell* (1921), nationalistic "Heimatfilme" (homeland films) such as Walther Zürn's *O Schweizerland mein Heimatland! Heil Dir Helvetia* (O Switzerland my Home! Heil Helvetia) (1924), and several "Bergfilme"

(mountain dramas), such as Arnold Fanck's *Der heilige Berg* (The Holy Mountain) (1926) and *Die weisse Hölle vom Piz Palü* (The White Inferno of Piz Palü) (1929), both with Leni Riefenstahl as the leading actress.

The most interesting of Tuggener's landscape albums is *Lukmanier 1928.* It was made after a solitary ten-day hike through the central Swiss Alps that Tuggener undertook in August 1928. The album takes the process of hiking, or more specifically, Tuggener hiking across the Lukmanier pass as its narrative. The first picture shows Tuggener with a walking stick and his camera over his shoulder walking up-hill towards a small church. The next series of pictures is a reportage of a religious procession in the village of Brigels followed by the portrait of a monk in the monastery of Disentis. Juxtaposed with the monk is a self-portrait of Tuggener wearing his hat and crouching in the dark opening of a wall. This "religious" sequence ends with a photograph of a church taken through a window and a picture of Tuggener sitting on a bench contemplating the landscape in front of him. A series of photographs follows of landscapes, streams, houses and trees that are in most cases united by the presence of some part of the road or path on which Tuggener is hiking. One of them is reduced to the empty road itself lying in front of the solitary hiker. The climax of the narrative is a series of pictures taken on top of Piz Scopi, the last one showing Tuggener sitting on the ground next to a young woman contemplating the mountain peaks in the far distance. Clouds are hanging just above the mountains and Tuggener has taken off his hat.

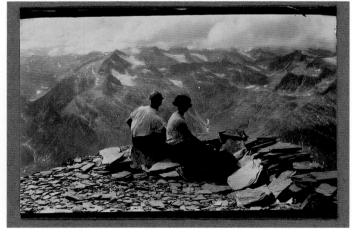

Untitled, Lukmanier, 1928 Untitled, on Piz Scopi, 1928

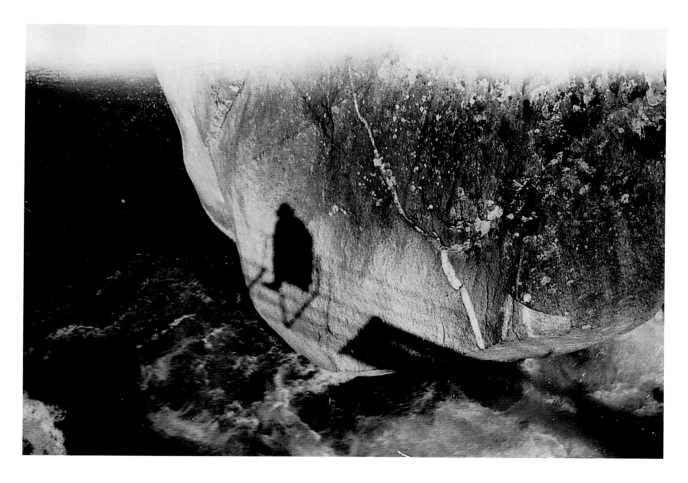

Untitled, Bavona valley, self-portrait, 1928

Lukmanier 1928 demonstrates that Tuggener was not only interested in recording views of unreachable mountain scenery which were tremendously popular at the time but that he tried to see the people and their cultural and religious activities as part of the landscape he was passing through. The album also shows that Tuggener consciously used sequencing and juxtapositions in order to construct meanings and narratives. The procession sequence, for example, seems to be a story that sets the stage for Tuggener's walk, his own procession or "pilgrimage" through the landscape. The album shows his own experience of the landscape as a spiritual landscape. The mountains become a church and he is both a common man in search of his self and a monk in search of the divine spirit. The narrative form is complex and not simply chronological and as a whole this album is a dynamic self-portrait, a kind of film in which Tuggener himself is the actor.

The album that is most directly influenced by Tuggener's interest in film, however, is his 1929 *MZAG* (*M*aag *Z*ahnräder *A.G.*), subtitled *Roman v. J. Tuggener* (Novel by J. Tuggener). The photographs in this album are arranged as a kind of tour through the Maag factory beginning with the receptionist, passing through the assembly rooms, ascending the staircase, and ending in the drawing rooms and administrative offices of the company. The layout of the pictures clearly refers to Tuggener's favorite film *Das Cabinet des Dr. Caligari* (The Cabinet of Dr. Caligari) (1920), the famous expressionist silent film by Robert Wiene. Tuggener placed some of the photographs on the pages in a slanted, not horizontal way and used pieces of black paper to crop images irregularly in order to imitate and underscore the shape and dynamics of, for example, the staircase. While black frames had existed in earlier albums as simple border strips, in *MZAG* they became an independent, expressionist tool which not only allude to the painted set of the original film but also seem to be directly inspired by the design of *Der Illustrierte Film-Kurier* promoting *Dr. Caligari.*

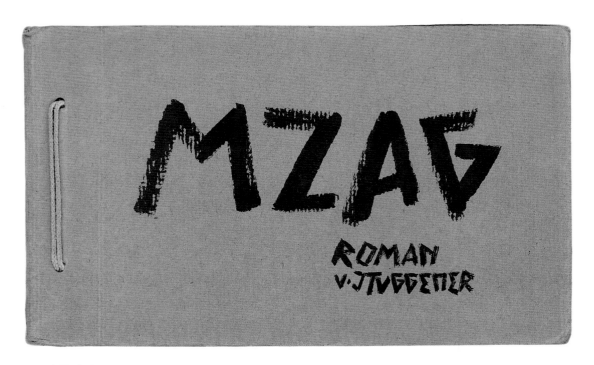

MZAG, Roman v. J. Tuggener (MZAG, Novel by J. Tuggener), album cover and photographs, 1926–29

X

189

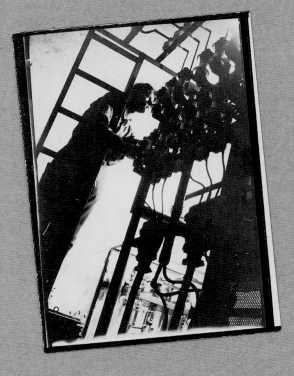
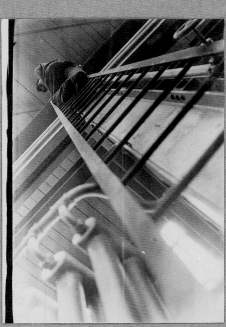

193

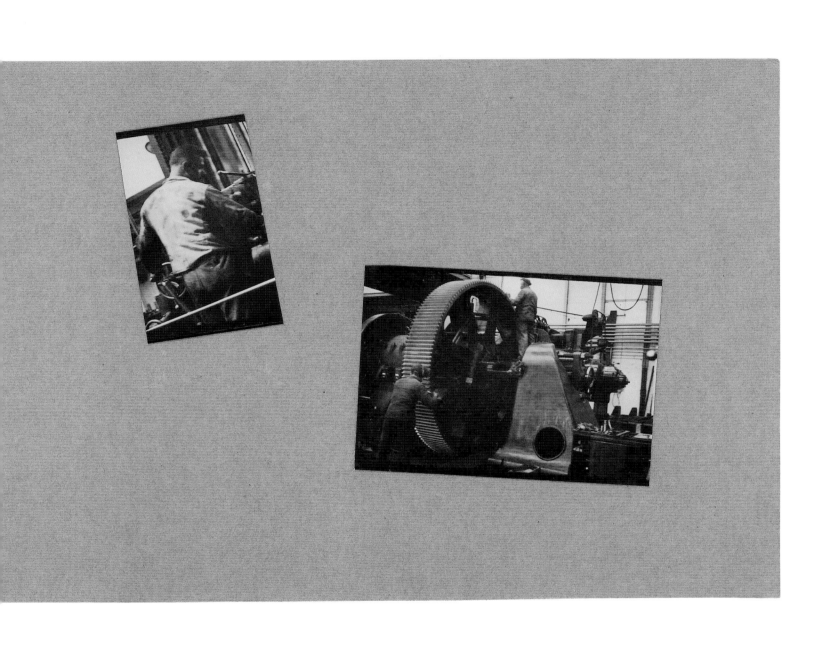

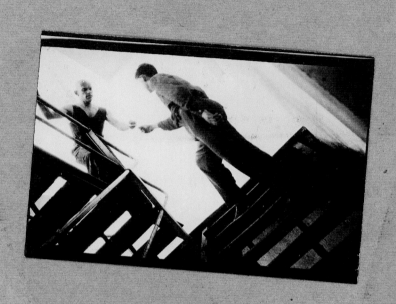

194

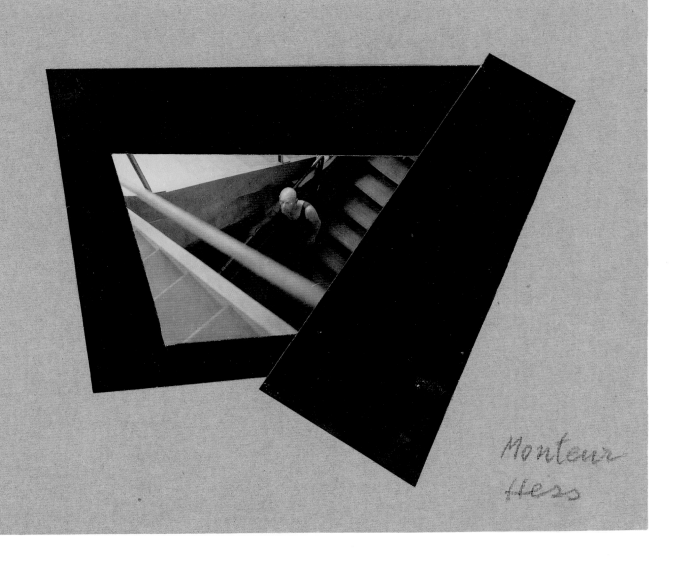

Monteur
Hess

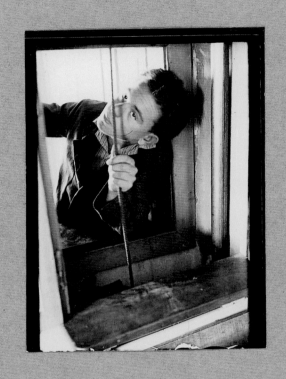

204

The album *MZAG,* which also includes Tuggener's self-portrait juxtaposed to the factory photographer, represents Tuggener's place of work. The viewer experiences it as a tour through the factory—not unlike the hike through the mountains in *Lukmanier 1928.* It is an "inner" view of Tuggener's "factory-prison" as well as a view of himself caught in it. According to Siegfried Kracauer the expressionist style in *Dr. Caligari* signified that the film was a projection of inner emotional states rather than a documentation of outer reality. He argued that the film was one of many signs of a general rejection of real life in favor of a retreat into an interior world that characterized Weimar society.[9] The expressionist design of Tuggener's *MZAG* allows for a similar reading and the subtitle "novel" further points to a fictional aspect in Tuggener's experience: his place of work had become less real than his world of film to which he tried to escape. Thus with *Lukmanier 1928* and *MZAG* Tuggener seems to project two contradictory inner landscapes: the mountains, as the spiritual and nationalistic landscape; and Maag Zahnräder, as the materialistic and technological one. In these early albums Tuggener already addressed two apparently opposed topics which were to become central to his work: life in the country and the world of the factory. In many of the photographs in the *MZAG* album one can also see a new type of composition: the pictures are taken from unusual, slanted angles, mostly from below or from above. This, too, can be related to the visual language of *Dr. Caligari.* But together with the close-up photographs of objects such as a faucet or the metal bars of a crane they also reflect the aesthetics of the photographers of the New Vision such as the Russian Alexander Rodchenko, the Hungarian László Moholy-Nagy or the German Albert Renger-Patzsch.

Certainly, by 1929, the ideas of the New Vision were being aired in Switzerland. Apart from becoming aware of examples of this new photographic style appearing sporadically in advertising and in the picture press, Tuggener saw one or perhaps several important photography exhibitions at the Kunstgewerbemuseum in Zurich in 1928 and 1929: "Photographien Albert Renger-Patzsch" with photographs from Renger-Patzsch's 1928 book *Die Welt ist schön* (The World is Beautiful), the "Russische Ausstellung" (Russian Exhibition) that included a separate section on new Russian photography, and "Film und Foto" (Film and Photo), the traveling version of the seminal Deutsche Werkbund exhibition. This important exhibition included a large group of photographs and photograms by László Moholy-Nagy as well as work by other modernist American, Russian, and European photographers, among them Hans Finsler, the most important Swiss exponent of the New Vision.

It is the clarity of the New Vision, the "straight" use of the medium, sharp focus and truthfulness to the form and the material qualities of the objects in front of the camera that must have appealed to Tuggener. These new aesthetic qualities inspired him to make his own experiments and collect them in a separate album, later simply titled *1929*. The pictures in this album clearly show that he was trying to work out problems of abstraction, of the dynamics of diagonal lines, of the effects of light, of the rendition of surface texture of different materials, of close-up views, and of the worm's- and bird's-eye-view. Several of these photographs can be compared to similar ones taken by Renger-Patzsch and Finsler.

However, Tuggener's layout in *1929* has a very didactic quality pointing to an additional source: Werner Gräff's book *Es kommt der neue Fotograf!* (Here Comes the New Photographer!), which accompanied the "Film und Foto" exhibition. Gräff celebrated the new mobility of both photographer and camera and boldly argued for a break with all photographic rules and conventions by means of the so-called "entfesselte Kamera" (unleashed camera). Tuggener, who by 1929 was getting more and more interested in photography, was obviously inspired by the fresh

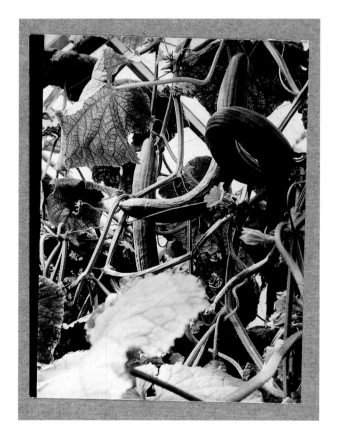

Untitled, streetcar rails, 1929

Untitled, cucumbers, 1929

approach in this textbook aimed at professionals and amateurs alike. The photographs in *1929* are loosely arranged in thematic pairs or juxtapositions like the ones in Gräff's textbook and in all the photographs Tuggener seems to have consciously explored aspects of the aesthetics of the New Vision. As if under the guidance of Gräff he juxtaposed curvilinear and diagonal or chaotic and ordered images, views from above and views from below or technical constructions and biological forms.

Over the course of the years 1926–1930, one can therefore observe in Tuggener's work a move from conventional landscape photographs to a more personal interpretation of landscape, the influence of expressionist films on sequence and juxtaposition of photographs, and the radical impact of the aesthetics of the photographic avant-garde imported from Germany in 1928–29. Even though this new "realism" was at odds with Tuggener's "expressionism," he was fascinated by its direct way of looking at reality and experimented with it.

During the same time important changes occurred in Tuggener's personal life. In his mid-twenties he was still living at home with his parents and his sister Anita. But in 1929 he had a serious quarrel with Anita after tearing up a photograph of her lover which so enraged their father that he threw his son out of the house. Tuggener immediately moved in with his lover, Senta Heisch, a hat and lampshade maker fifteen years his senior. She was a member of an esoteric circle that included a clairvoyant in neighboring Austria whom she and Tuggener visited in 1929. Despite this Tuggener underwent a personal crisis towards the end of the decade. His spiritual search for the right "way" had apparently been unsuccessful and a former lover described him as a sad and lonely person, a "soul tired of the world."[10]

There was another crisis that had a direct impact on Tuggener's life: the economic crisis set off by the great crash of the stock market in 1929. The management of Maag Zahnräder "encouraged" him to quit his job, in other words he was laid off at the end of May 1930. This must have been the final link in a chain of events that made Tuggener seriously reconsider the course of his life. For a long time he had dreamed of becoming an artist, or perhaps getting into film, and now there was a chance. He started a course in nude drawing at the Kunstgewerbeschule in Zurich but soon decided to go to Berlin, the very center of European avant-garde art, film and photography. Thinking that he could stay for at least one year with the money he had saved from his work at Maag Zahnräder he traveled to Berlin in early August 1930.

Berlin and the Reimann Schule

In his introduction to *100 x Berlin* published in 1929 the writer Karl Vetter enthusiastically stated that Berlin was not only the capital of Germany, but in terms of size (880 square kilometers) the largest city in the world and in terms of population (4.2 million) the largest city on the European continent. The yearly consumption of 500 million kilowatts in electrical energy provided by the most modern power station built in 1927 was for Vetter a sign of its progressive attitudes towards "material and ideal values." He captured the essence of the city's modernity stating: "One of the reasons why many things were and are impossible outside, and possible only inside Berlin, is its much despised lack of tradition. Other cities have restraining forces connected with the history of art and the political forces of civilization; Berlin has none of these. It has made a virtue of its necessity and rushes in breathless haste and American time towards the realization of a modern democracy." Summing up what one could expect from a unique city like this, he quoted the German poet Goethe who once said: "Outside Berlin, success seems impossible to me."[11] Surely, success was on Tuggener's mind as well when he started his artistic training in this modernist metropolis.

Originally Tuggener wanted to study with a well-known portrait painter but then, perhaps following his father's more pragmatic advice, he decided to study at the Itten Schule founded by Johannes Itten in 1926. Tuggener was already familiar with Itten's esoteric ideas from the time of his studies in phrenology and so the course at the Itten Schule, with its close adherence to the Mazdaznan teachings, must have appealed to his "expressionist" sensibilities. Itten's stated goal was "to develop the creative powers" of his students and "to train the artistic intellectual capacities as well as the powers of the soul." The program was directed towards "painters, sculptors, architects, pedagogues, photographers, and draftsmen in advertising, fashion and pattern design," and the students were assigned to classes according to "phrenological points of view."[12] However, after Tuggener had rented a room in the house of a Jewish lady on Bayerische Strasse in the affluent western part of the city only a block away from the Itten Schule, he discovered that the master himself was absent when he went to register. Immediately he changed his mind, looked for another place to study and eventually signed up at the Reimann Schule situated about a mile away.

The Reimann Schule was founded in 1902 as a private art and applied arts school which offered training in the areas of painting, sculpture, interior design, advertis-

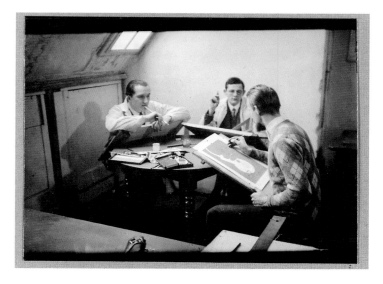 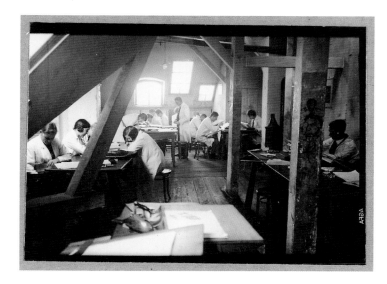

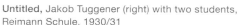

Untitled, Jakob Tuggener (right) with two students,
Reimann Schule, 1930/31

Untitled, class of Carl Gadau, Reimann Schule, 1930/31

ing, textiles, film, fashion, stage design, window-display decoration, and metal-work. In contrast to the esoteric Itten Schule, the training here was more oriented towards practical and useful design, towards the formation of "artistic powers for the professional work in crafts, trade and industry."[13] During the 1920s there were up to one thousand students a year, many of whom were foreigners whose hard currency was needed for the survival of the school. When Tuggener entered the school it was organized in three departments, the Kunst- und Kunstgewerbeschule (Art School and School of Arts and Crafts), the Höhere Fachschule für Theater-dekoration (Advanced College of Theater Decoration), and the Höhere Fachschule für Dekorationskunst (Advanced College of Decorative Arts). Unlike the Bauhaus or the Itten Schule, there was no course in photography. Yet in 1928 it became the first art school to offer a course in film, and Tuggener was interested by this. The Reimann Schule was closely allied to the Werkbund, the association of designers and architects attempting to involve industry in design processes in order to facili-tate production, and the students' work was published and discussed in the Werk-bund's yearbooks and reports. Through a variety of book publications, the school's own magazine entitled *Farbe und Form* (Color and Form), and exhibitions of stu-dent work, the school enjoyed an excellent reputation throughout Europe.

We only know about the first half of Tuggener's stay, until the end of 1930, from a letter he wrote to his father before Christmas. He reported that he was taking a class in typography and the film course which, however, he was about to drop since too much emphasis was put on animation geared towards advertising which

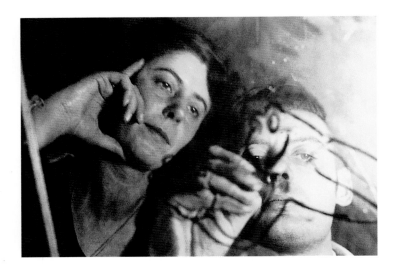

Untitled, film teacher Adolf Rheinboldt and assistant,
Reimann Schule, 1930/31

Tuggener decidedly disliked.[14] His true interest lay in realistic silent film and several of the contemporary city films influenced both his photographs taken in the city and his own perception of Berlin. Even before he left Switzerland he had seen Fritz Lang's *Metropolis* (1925–26) and Walter Ruttmann's *Berlin, Symphonie einer Großstadt* (Berlin, Symphony of a Metropolis) (1927). In Berlin he undoubtedly saw Dziga Vertov's *Der Mann mit der Kamera* (The Man with the Movie Camera) (1929) and Charlie Chaplin's *City Lights* (1931). He was also greatly impressed by the Czech filmmaker Berthold Bartosch whom he met in the Berlin suburbs and who was working on an animated film based on a series of woodcuts entitled *Die Idee* (The Idea) by Frans Masereel. For Tuggener Bartosch was an artist and he considered his Masereel film the "deepest and holiest that I have ever experienced."[15] During the second half of his stay, Tuggener took courses in typography and graphic design with Max Hertwig and Carl Gadau and nude drawing and poster design with Josef Seché. He dropped film and concentrated on poster design which his teachers considered the most suitable and promising area for him. One example of his original designs was executed in brown and yellow watercolor. Its subject is Mahatma Gandhi, then much discussed in the media because of his non-violent resistance to British rule in India. It is very likely that Gandhi's image on the poster was copied from a news photograph, a common practice among the Reimann students which Tuggener called "stealing."[16] Tuggener also designed advertisements for technical equipment, an area that his teacher Gadau had suggested to him probably because of his technical background.

On the back of a photograph showing the large but rather crowded attic studio of Gadau's design class Tuggener noted: "Design class of the teacher Gadau at the Reimann Schule, my place was in the front row to the right, near the window. A Jewish girl who saw my work said: 'Yes, yes, the great talents come from the province!' (Zurich)."

When Tuggener left the Reimann Schule at the end of April 1931, Gadau wrote a very positive and encouraging report on his performance in his class: "In more than ten years as a teacher I have rarely found such a particular talent for large format poster design as Mr. Tuggener. Mr. T. has at his disposal a vivid imagination, he possesses a very well developed feeling for form and design, he has a fine sense for color. Added to this is great diligence and a strong, honest will."[17]

Apart from his course work Tuggener took a great number of photographs which he collected in two albums, one entitled *Berlin Reimannschule 1930/31,* the other an untitled scrap album. In 1964 he reprinted a selection of these pictures and composed a book maquette entitled *Berlin, 4. August 1930–30. April 1931* and subtitled *Meine Zeit an der Reimann Schule* (My Time at the Reimann Schule). The album *Berlin Reimannschule 1930/31* is comprised of photographs showing Tuggener's co-students and their life at the school. Like many of his earlier albums it begins with an introduction, in this case with two pictures of an alarm clock. The first is a distorted view of the clock evoking the dream-like perception of its disturbing ringing and the second a perfectly clear view, as if seen after a first rubbing of the eyes. After this opening sequence alluding to Tuggener's awakening to a day in Berlin, he can be seen sitting at the breakfast table in a self-portrait probably taken with a cable release.

The rest of the photographs in the album were all taken at the school itself. There Tuggener apparently liked observing female students and surreptitiously took several snapshots catching them at work or engaged in other activities like secretly reading the newspaper under the table. The album also contains a double portrait of two painting students, one of whom was the Swiss painter Walter Jonas who studied with Moritz Melzer, an expressionist artist formerly associated with the artists' group *Die Brücke.* Another Swiss painter Tuggener met at the school was Hermann Pieper who appears in a picture of a group of students casually sitting and lying around someone talking into a metal megaphone. A picture, incidentally, which is very similar to the ones taken by students of the Bauhaus in Dessau a few years earlier.

The end of the album is as significant as the beginning: a photomontage showing two quarreling students. The two photographs mounted together effectively combine aspects of both space and time to form one dynamic pictorial event, in the manner of Werner Gräff's models in *Es kommt der neue Fotograf!*

The culmination of the school's yearly activities was the "Gauklerfest" or Reimannball, a costume ball that formed a high point in the Berlin social season each winter. While providing the students with an opportunity to freely create extravagant costumes and carnival decorations without any commercial or professional restraints, it also produced a financial profit which was used to support those students who were without means. Held at the Kroll Opera over two nights, it was the most popular costume ball in Berlin attended even by celebrities like Marlene Dietrich and Leni Riefenstahl. The ball was seen as a welcome opportunity to escape the rough economic reality of the day. *Der Konfektionär* wrote: "Despite the bad times, an indescribably beautiful image, this 'Gauklerfest' at Kroll! The exemplary decoration—full of inexhaustible imagination—was from a technical point of view alone a work of art."[18]

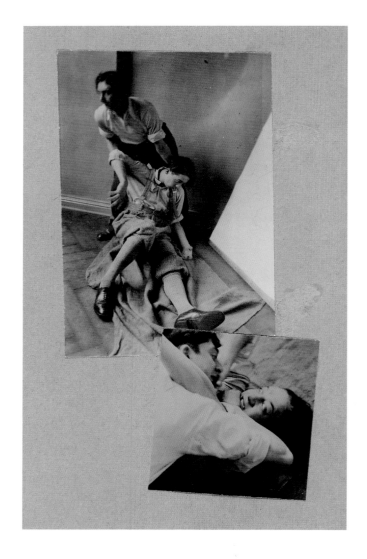

Untitled, quarreling students, Reimann Schule, 1930/31

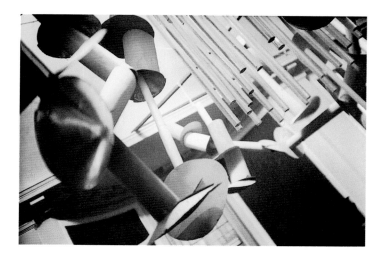

Untitled, decoration at the Reimannball by Else Taterka, 1931

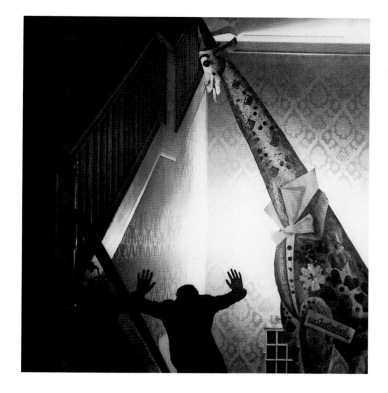

Groteske vom Reimannball (Grotesque from the
Reimannball), 1931

Tuggener did not want to participate in the design and production of the ball deco-
ration because he felt it was an exploitation of the students.[19] However, he pho-
tographed his fellow students and other workers painting and putting up the deco-
rations at the Kroll Opera. Compared to the dynamic photographs which appeared
in *Farbe und Form* and which were taken by photographers working for the picture
agencies Atlantik and Keystone, Tuggener's images seem rather withdrawn and
lifeless. Nevertheless, two of Tuggener's photographs were published in *Farbe und
Form* marking the beginning and the end of the selection of press reports. One
shows the decoration hanging from the ceiling made by the teacher Else Taterka in
a totally oblique and abstract way, the other shows a black figure trying to be scary
in front of a huge giraffe, entitled *Groteske vom Reimannball* (Grotesque from the
Reimann Ball). These two are Tuggener's very first published photographs.

Like all the Reimann students, Tuggener designed his own costume and he photographed himself in it. But even though he attended the "night of grotesque, fantastic and refined eroticism"[20] and even though he was actively involved in photography, it did not occur to him to photograph the activities of this great social event and the people participating in it. There may have been personal as well as technical reasons for that. On the one hand, Tuggener was apparently in the company of a beautiful young woman, Ilse Jaenecke from Stralsund, who might have kept him from taking photographs. A short romance developed but Tuggener never went to see her at home, even though he promised he would. On the other hand, he was still using a 6×9 cm camera that did not lend itself to professional reportage-like snapshots taken under available-light conditions. In that respect the "provincial" Tuggener was certainly not quite up to date, since more handy and mobile small-format cameras had been on the market since the mid-1920s.

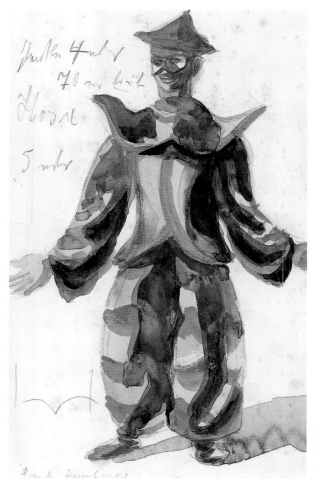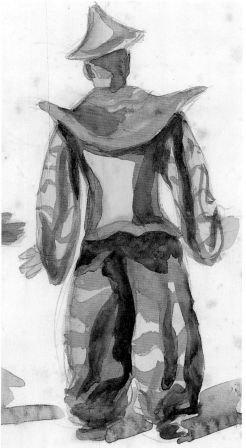

Untitled, costume study, Reimann Schule, watercolor, 1930/31

The handicap of not owning a small-format camera did not prevent Tuggener from taking a large number of dynamic exterior photographs of the city of Berlin. Just as he had slowly hiked through the Swiss mountains on a small road, he now rode at great speed through Berlin on the city train. He wrote to his father that these rides were "breath-taking and imposing" and that the views from the train added up to a "real cross-section" of the city.[21] This experience can be seen in relation to Ruttmann's film *Berlin* of 1927, a typical "cross-section-film" mounting a multitude of short sequences taken with a constantly moving camera. This technique created a continuous flow of images representing, as Siegfried Kracauer put it, a matter-of-fact "cross-section of an arbitrary part of reality" with a strong "that-is-life" atmosphere.[22]

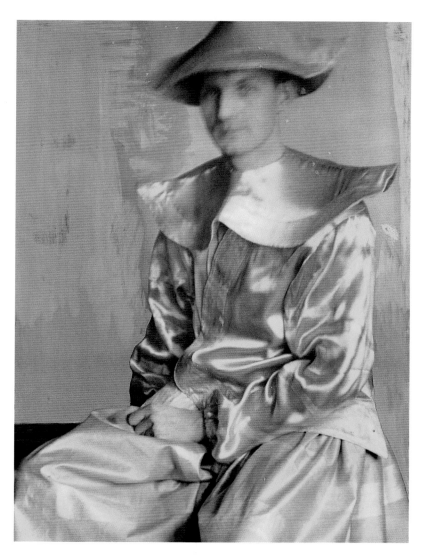

Untitled, Jakob Tuggener in his ball costume, self-portrait, 1931

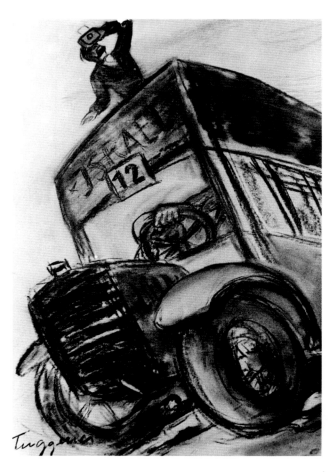

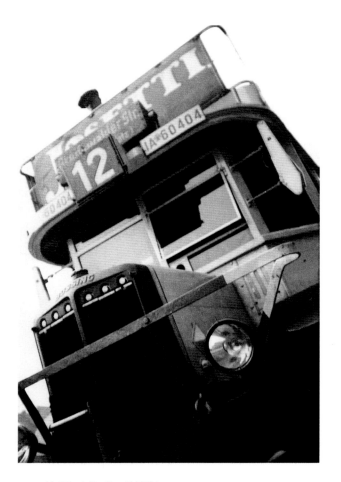

Jakob rast wie Wotan durch Berlin, (Jakob Racing Like Wotan through Berlin), original photograph of a lost drawing, Berlin, 1930/31

Untitled, Berlin, 1930/31

To the best of his abilities Tuggener "unleashed" the camera that accompanied him and turned it into an extension of his constantly moving eyes. He expressed this in a drawing which was clearly inspired by one of his photographs. The photograph shows the front of a city bus with its typical open deck on which a person's head can be made out. Taken from a very low vantage point, it is composed diagonally producing the impression that the bus is taking a curve. This feeling is intensified in Tuggener's drawing because the overall quality of the lines is much less defined than in the photograph—which was probably taken when the bus was not moving—and because the wheels are turned to the side. In addition, the driver can be seen holding the steering wheel and forcefully trying to turn the bus. The diagonal lines are set at an even steeper angle than in the photograph, adding to the dynamic movement of the image. Instead of the small head of the person on the deck seen in the photograph, Tuggener added himself on top of the bus as a standing figure looking through his camera up towards the façades of the city's buildings and monuments. He is like Dziga Vertov in his 1929 film *Der Mann mit der*

Kamera who wrote: "I am the film-eye. I am the human eye. I am the machine which shows you the world in a way that only I am capable of seeing. From today and forever I free myself of the human inability to move. I am in constant motion."[23]

We can see that Tuggener was fascinated by the life of the city as well as by the dynamics of the New Vision, but it is telling that he was still unable to express his new experiences in the appropriate medium, namely photography, and thus had to resort to drawing. So, after all, there was a great difference between the quiet contemplation of Alpine landscape—for Tuggener a very introspective, religious experience—and being carried through the city on a bus or train. In 1964 Tuggener entitled a reproduction of this drawing *Jakob rast wie Wotan durch Berlin* (Jakob Racing Like Wotan through Berlin)[24] which clearly shows that he was not trying to experience the presence of a divine spirit, but that he saw himself as a restless and conquering god. He experienced Berlin as an exciting place to which he responded as an individual with all his senses and an intensified sensibility. He clearly embraced the city as the focal point of modernity and the aesthetics of the New Vision, expressing the belief in technological progress and celebrating the city's spiraling dynamics.

Despite the problems the city may have caused him at times—Tuggener later remembered that he once quickly left the Alexanderplatz because he felt threatened by knife-yielding "gangsters" and provocative prostitutes—he thought Berlin to be the "right" city for him because, as he wrote to his father, "it has no tradition and no style. Everything grows out of the ground individually and with a mind of its own."[25] Tuggener thought the various modernist buildings most interesting and enjoyed Berlin's total absence of tradition—the very lack of tradition that, as Karl Vetter had stated, was despised by many.

Tuggener took many photographs of the modernist structures that fascinated him so greatly: the well-known Karstadt department store and, above all, the Funkturm (wireless tower) which had already appeared in László Moholy-Nagy's 1925 film-script entitled *DYNAMIK DER GROSS-STADT* (Dynamic of the Metropolis) as the hub of the city.[26] Karl Vetter had also focused on the Funkturm, comparing it with the Eiffel Tower as a symbol of modernity. In the plate section of *100x Berlin,* he juxtaposed this new emblem of Berlin with the Siegessäule, the monument to victorious nineteenth-century military campaigns. He wrote: "It is the offspring of technics, imposing and yet nobly modest; a poem of steel and symmetry it hurls itself into the blue beyond. Around its columns breathes the song of the future,

a hymn of victory over the past replete with heavy sorrows, over collapse and despair, over pessimism and death. ... The Funkturm and its marvels are for that reason the signs of the time born with us because they do not tell of the triumph of might but of the triumph of mind."[27]

Among Tuggener's photographs of and from the Funkturm which appear on a page-spread of the Berlin scrap album there are some that concentrate on the iron structure of the tower seen both from below and from above; others offer views downwards onto the square with its arrangements of streets, paths, and chairs and tables of the restaurant. These pictures are remarkably similar to the photographs taken only two years earlier by Moholy-Nagy which later became well-known.

The layout of the photographs on the page-spread has an abstract quality as lines and shapes continue from photographs looking up and placed in the upper half of the page into those looking down in the lower part thus creating an impression of the real space one would perceive while ascending the tower. At the very top of the page, Tuggener included a slanted and cropped view of a classical building and a picture of a windmill taken from below. This juxtaposition alludes both to the "classicism" of the radio tower's iron construction (as a modern Siegessäule or Berlin Eiffel Tower) and to the simple fact that one would feel the wind on top. Seen as a whole this page-spread with its extreme views of such diverse subjects comes as close as anything to the idea of the unleashed camera, and, with its formal arrangement, again proves Tuggener's fine sense of sequence and composition.

While Tuggener took photographs looking down from the new, tall structures of the city, he also took pictures in the streets. They are either views taken from a distance showing unpopulated rows of buildings and shops, or pictures of dense traffic situations with street vendors, cars, buses, and façades. In the few instances where Tuggener tried to take pictures of people in a reportage-like fashion, he was either too shy or his camera was too slow, for most pictures turned out blurred. Tuggener even went below ground, into the subway. But again, most likely for technical reasons, no pictures of the subway itself or the people riding on it exist. However, he took a whole series of photographs of people walking up the stairs toward the street or using the escalator of the subway station. They are reminiscent of stills of another city film, *Berlin von unten* (Berlin from Below) (1929) by Alex Strasser that Tuggener may have seen as well. One of these pictures taken on the stairs looking up he placed at the top left corner of a group of photographs entitled *Berlin 1930. Reportage by Jak Tuggener.* This picture of the entrance to the sub-

Berlin, album page, 1930/31

way—in another version it is entitled *Mit mir durch Berlin* (With me through Berlin)—serves as the opening of a collection of views of the city which includes the Siegessäule, the river Havel, the Reimannball, and a surprising snapshot of a puddle in the middle of a sidewalk with a pair of legs and a dog walking by. Even though this group of pictures is titled "reportage," there is no apparent story or line of thought. Rather, it seems to be a photographic version of a typical cross-section-film.

Tuggener also showed his Berlin photographs to students and teachers and even exhibited them at the school. Referring to two self-portraits that he included in a letter to his father, he boasted: "These two photographs are hanging as huge prints in a frame at the school. Someone said: 'Yes yes, this Swiss fellow will one day become a famous photographer.'" And referring to the planned opening of a photography department at the Reimann Schule he talked about his ambitions of becoming the teacher of photography at the school. He continued with great self-confidence: "Since I am the best photographic talent, they will ask me to come all right" and "when photography will be part of the curriculum next year, they can then call me in as an artistic adviser."[28]

Even though the film teacher Rheinboldt apparently considered him "the best talent that ever got into his hands,"[29] Tuggener was neither hired as a teacher nor as an artistic adviser when it was finally decided to get Werner Gräff to run the school's new photography studio. Tuggener left Berlin at the beginning of May 1931, and he wrote to his friend Ilse Jaenecke in Stralsund that he wanted to study photography at another school, possibly in Switzerland, but he never did.

Nevertheless, Tuggener's photographic interests had changed considerably during his time in Berlin. Landscape had almost totally disappeared from his repertoire. Portraiture was, except for a few studies, still absent from his work, and the photographs of the Reimannball were mostly restricted to pictures of the decorations. The theme of technology that Tuggener dealt with in some of his poster designs began to surface in his photographs, for example in the ones taken in industrial areas along the city train track and the river Havel. Moreover, on his way back to Switzerland he discovered ocean liners, boats, piers, buoys, and other kinds of installations in the ports of Hamburg and Cuxhaven and on the island of Helgoland. This interest in technology certainly had personal origins but the ship as a floating machine was, together with the automobile and the airplane, part of the technical subject matter popular with modern photographers. Above all, however, the modernity of the city became the new theme that Tuggener, inspired by both the bustling

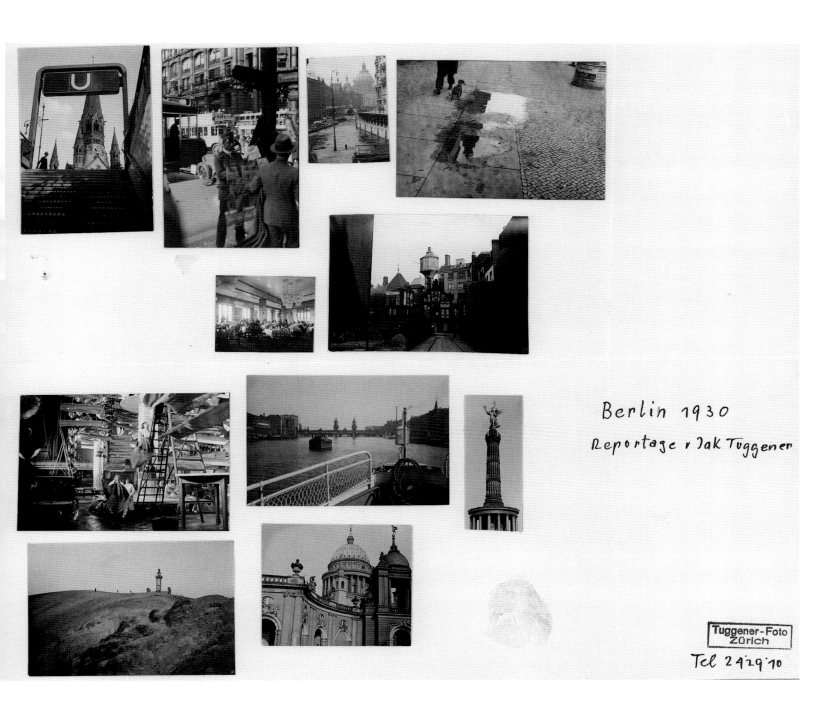

Berlin 1930
Reportage v Jak Tuggener

Berlin 1930, draft for a reportage, 1930/31

life of the city itself and the aesthetics of the New Vision, expressed with his camera. His intentions are apparent, even though he was somewhat limited by his slow and cumbersome equipment.

Tuggener had become a "new photographer" but not a strict advocate of the New Vision. He was still much more interested in personal expression than factual representation. He was fascinated by new technology as a force, as a dynamic expression of modernity which he, as a human being, was able to experience by seeing with his eyes, smelling with his nose, and hearing with his ears. Although he was not a reformer or member of the avant-garde like Hans Finsler, who was at this same time also preparing to return to Zurich following his appointment as a teacher of photography at the Kunstgewerbeschule, "Jak" Tuggener, as he now called himself, went back to Switzerland with new impulses, looking at his home country with fresh eyes.

Notes

1 Jakob Tuggener, "Jakob Tuggener über sich selbst," 15 March 1978. See also Inge Bondi, "Der kürzeste Weg zum Herzen," in *Puls (Weltwoche),* 10 September 1980, p. 7 and Jakob Tuggener in interview with Inge Bondi, April 1980.

2 Tuggener in a hand-written text on the back of an undated drawing, (early 1920s).

3 Tuggener quoted by Kurt Ulrich, "Der Fotograf Jakob Tuggener; Berühmt, doch ohne Erfolg," in *Brückenbauer,* 6 January 1978, p. 15.

4 Tuggener in an undated manuscript, (ca. 1922).

5 Johannes Itten (1926) in Willy Rotzler (ed.), *Johannes Itten. Werke und Schriften* (Zurich: Orell Füssli, 1972), p. 229.

6 Tuggener in an undated manuscript, (1936).

7 Tuggener quoted in *Maag Panorama,* June 1975, p. 7.

8 Tuggener, "Aus der Stummfilmzeit," undated manuscript, (ca. mid-1950s).

9 See Siegfried Kracauer, *Von Caligari zu Hitler. Eine psychologische Geschichte des deutschen Films* (Frankfurt a/M.: Suhrkamp, 1984), pp. 67–83.

10 Letter from an unidentified woman, 1928.

11 Karl Vetter in introduction to L. Willinger, *100 x Berlin* (Berlin: Justh, n.d. [1929]), pp. XXIV–XXVII.

12 "Lehrplan der Itten Schule in Berlin" in Rotzler, *op. cit.,* pp. 229–230.

13 Advertisement in *Farbe und Form,* April 1931, p. 77.

14 Tuggener in letter to his father, (1930).

15 Tuggener, "Aus der Stummfilmzeit," (ca. mid-1950s).

16 Tuggener in letter to his father, (1930).

17 Report by Carl Gadau, 28 May 1931.

18 *Der Konfektionär,* 27 January 1931, quoted in *Farbe und Form,* February 1931, p. 28.

19 See Tuggener in interview with Simone Kappeler, September 1978.

20 *Rostocker Anzeiger,* 8 February 1931, quoted in *Farbe und Form,* February 1931, p. 32.

21 Tuggener in letter to his father, (1930).

22 See Kracauer, *op. cit.,* pp. 191–195, and 581.

23 Dziga Vertov in *LEF* (1923) quoted in Ulrich Gregor and Enno Patalas, *Geschichte des Films,* vol. 1 (Reinbeck: Rowohlt, 1976), p. 99.

24 Tuggener in "Berlin Buch Code" (1964), list sent to Edith Wildhagen.

25 Tuggener in letter to his father (1930).

26 See László Moholy-Nagy, *Malerei Photographie Film* (Munich: Albert Langen, 1925), p. 120.

27 Vetter, *op. cit.,* p. XXVI.

28 Tuggener in letter to his father, (1930).

29 Tuggener in letter to his father, (1930).

GRAND PRIX IN BERN

Well, the car race was something for me. ... I am satisfied because I gave my best. I call one of my pictures *Reiter der Apokalypse* (Rider of the Apocalypse). This idea occurred to me suddenly and I liked it very much. I went to the priest; unfortunately there is no text in the Bible which could serve as the basis for my photographic visions, but I will find another title which expresses the greatness of our century. I have changed in a strange way. All of a sudden I perceive sport as the upholder of our time. The dynamism, the speed are the essence of the present time. How I enjoy being and becoming its messenger! You should have experienced the monsters racing by, like arrows singing and thundering. Oh, it was overwhelming; cold trickled over my heart. Technology is the most grandiose poetry. Such sport is heroic, fantastic, and near death. This was a day whose impressions I shall never forget. I also saw the tragedy of the heart. I wanted to take pictures of a woman who said goodbye to her husband, the race car driver. It was so moving, a great film scene, but I felt inhibited to take a picture of it. Afterwards I saw this woman again. She had covered her face with her hands. Her husband was dead — five laps before the finish he lost a wheel, the car crashed into a pine tree which was cleanly shaved off; it turned over, felled another tree and ended up as a heap of rubble. The pine tree killed a bystander and injured another one. All these impressions were deep, technology is wonderful, and grief is shattering.

Jakob Tuggener, 29 August 1934

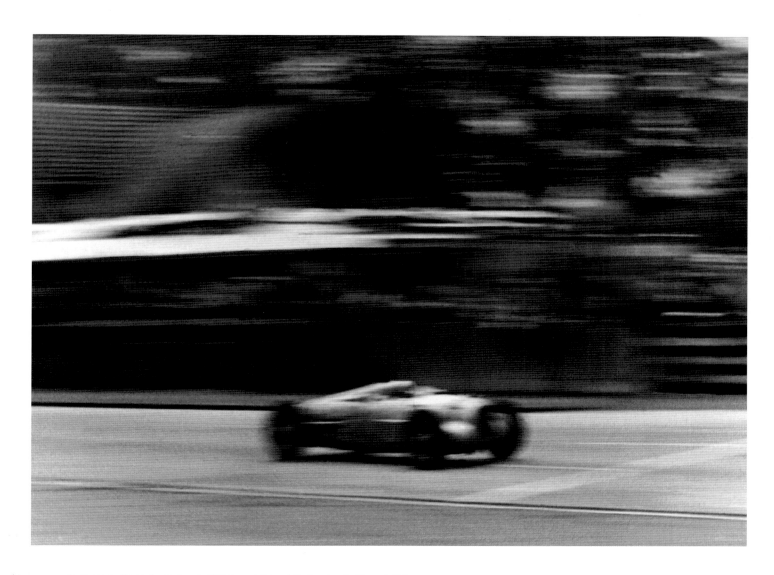

II. Grosser Preis der Schweiz (2nd Grand Prix of Switzerland), Bern, 1935

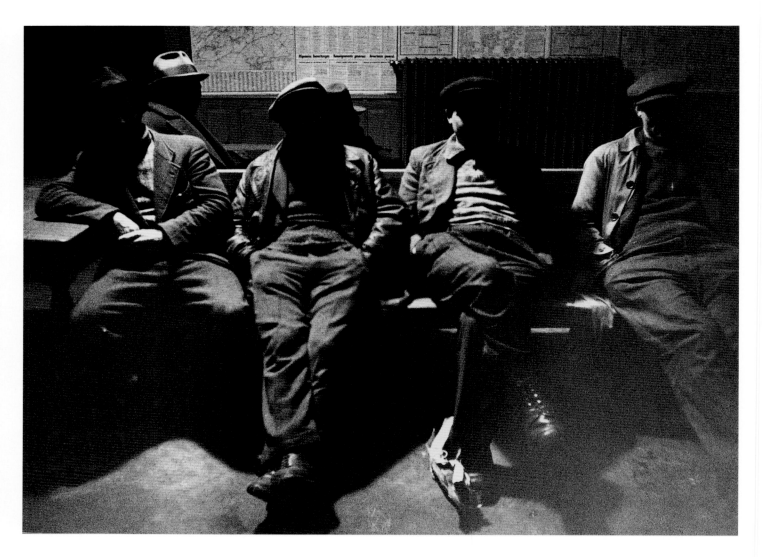

Wartsaal (Waiting Room), 1930s

Making a Living and Art

When Tuggener returned from Berlin Switzerland's economic situation had gotten worse. Unemployment was widespread in 1932 and in 1936, although the economy showed first signs of picking up, it reached its climax with about 93,000 people out of work—five per cent of the working population. Since 1928 Zurich had been governed by a city council dominated by Social Democrats who turned the provincial town into a thriving, socially conscious city before conservative parties took over again in 1938. Even though "red" Zurich suffered from the economic crisis like every other city in Europe, the city government entertained modernist utopias such as demolishing the entire old center and building a futurist train station combined with airport and highway. Although this project never got beyond the drawing board, several modern co-operative housing complexes, a new sports stadium, a congress building, and several schools—among them the modern Kunstgewerbeschule— were actually built. However Zurich was also, at least until about 1935, the center of Swiss extremist right-wing political groups and even home to an active group of German Nazis.

Tuggener went to live with his parents again—Senta Heisch would not admit him into her house because he had found a new girlfriend on the train back from Berlin. The times were very difficult, especially for his father who was working freelance. Tuggener had to do all kinds of small jobs and errands such as selling his father's lithographed pictures of saints, a job he found embarrassing and degrading. Even though he was desperate to make enough money to be independent there is no indication that Tuggener ever wanted to return to his old profession or earn some

money as a technical draftsman. On the contrary, everything points to his insistence on trying to survive on what he had learned at the Reimann Schule and to establish himself as a graphic designer and photographer. Only very few examples of this work survive. One is Tuggener's very first publication in Switzerland, the cover of a 1932 issue of the *SBB Revue,* the official magazine of the Swiss railways. As Tuggener later remarked, nobody was interested in his "poster-creations" and it was practically impossible to make any money.[1]

SBB Revue, cover, March 1932

Given his economic situation Tuggener was probably not too unhappy when he was called up to resume his training in the Swiss army. He took the first repetition course in October 1931 and the second one in April of the following year. In both he served in an infantry unit under the leadership of Captain Hans Schindler. Whereas no photographs from the first course exist, Tuggener photographed extensively during the 1932 course and a small fold-up album, a *leporello,* entitled *WK 32* (*W*iederholungs*k*urs, repetition course 1932) with a total of fifty-three photographs survives. Like many earlier albums this series of photographs starts with introductory pictures, in this case with the arrival of the soldiers at the train station, the entry inspection, and the first marches. The photographs represent in large part candid glimpses of the life of the common soldiers—not of the officers—taken during the long marches, the breaks, the mealtimes, during work and even at night while sleeping. Tuggener's comrades are always seen through the eyes of one of them, and not from the outside.

Tuggener emphasized his role as "the man with the camera" among equal men whom he was observing. On the back of one of the pictures, which Tuggener later included in a book maquette, he noted: "I gave my rifle to a comrade and took pictures backwards without leaving the marching rows." He was now using a small and mobile 3 x 4 cm roll film camera which he might have borrowed from a fellow soldier. The many photographs of marching soldiers interspersed with pictures of farmers working on the side of the road, the cooks operating their steaming mobile cookers, or views of the Rhine Fall that they passed are themselves arranged like marching soldiers. They are all the same size, 3 x 4 cm, one to a page, thirty on the front and twenty-three on the back of the long and narrow *leporello.* As a series, these small photographs mounted on a strip of paper function like a film producing a steady beat of marching, a continuous flow of soldiers, of military life. The viewer becomes part of what the photographer was experiencing and recording. Tuggener's *leporello* takes up elements from both his earlier albums, such as *Lukmanier 1928,* where he saw himself as a lonely hiker, and his experience of Berlin where he attempted to show a cross-section of a city in motion. At the same time, this *leporello* indicates that Tuggener was, after a shorter than expected "escape" from the Swiss realities, back in line.

WK 32
18–30 APRIL
IN SIBLINGEN
BAT 68/I/1.
48 FOTOS VON
JAKTUGGENER

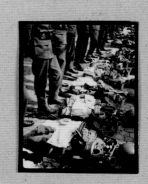

48 Photos VON JAK.TUGGENER
ZÜRICH 8, LUREIWEG 13

1

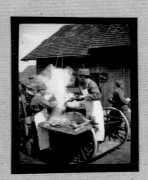

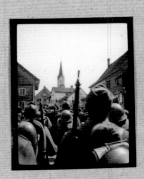

2

23

24

25

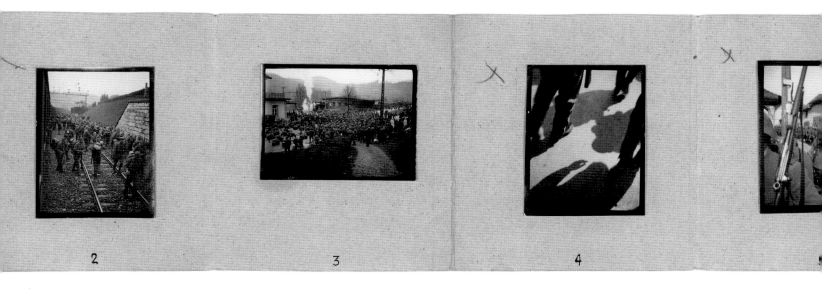

2 3 4

26 27 28 29

WK 32, title page and two sections of the *leporello*, 1932

Work for Magazines

Tuggener gave the *WK 32 leporello* to his captain Hans Schindler who had allowed him to photograph during the repetition course. Schindler was an adjunct to the technical administration of the Maschinenfabrik Oerlikon (Oerlikon Machine Factory, MFO) and later he became its director. In 1930 he had founded an illustrated company magazine entitled *Der Gleichrichter* (The Equalizer). Impressed with Tuggener's work Schindler hired him on a freelance basis. The work Tuggener produced for *Der Gleichrichter* and other non-commercial industrial publications provided him with a more or less regular income on which to survive until the end of the 1940s. While working for the MFO and later for several other companies in the machine and textile industry Tuggener began to make himself known as a reportage photographer. He offered pictures to the rapidly growing illustrated press that had an increasing need for news photographs and pictures of everyday life. By the early 1930s there were several publications on the Swiss market that published such photographs on a regular basis. The most important was the *Zürcher Illustrierte* which enjoyed an international reputation as a modern illustrated magazine. Its editor, Arnold Kübler, used photographs that at once communicated information and possessed strong aesthetic qualities. He presented them in a totally different way to other Swiss magazines such as the *Schweizer Illustrierte* which he considered "incapable of presenting a photograph that could live" and that "had no feeling for photography whatsoever."[2] Kübler, who had lived in Germany from 1919 to 1926, was certainly aware of the innovative use and presentation of reportage photographs by the *Arbeiter-Illustrierte-Zeitung,* the *Berliner Illustrierte Zeitung,* and the *Münchner Illustrierte Presse,* whose modern layout, created by Stefan Lorant, became very influential. Lorant had abandoned the petty-minded "artistic" layout of many small and often irregularly shaped or round images for a more generous arrangement of graphically tight pictures often loosely grouped around a large key image.

Following the German models Kübler wanted "to make a picture magazine for the eye to show the truth of everyday life."[3] However, since only very few Swiss photographers followed his aesthetic precepts, he had to educate and cultivate his own team of photographers. When Tuggener returned from Berlin Hans Staub had already established himself as the "official" photographer of the *Zürcher Illustrierte,* and it proved difficult for Tuggener to place photographs there. In fact, it was not until 1935 that a few of his pictures of a fashion show were published together with some taken by Staub. Until it ceased publication in 1941, the *Zürcher*

Illustrierte only published a handful of Tuggener's photographs, one as a cover picture, but never a complete reportage. Consequently Tuggener had no alternative but to offer his photographs to the less prestigious but nevertheless very popular magazines like *In freien Stunden, Das gelbe Heft, Föhn, Schweizer Spiegel,* and others. Tuggener boasted to a friend that the editor of the *Schweizer Illustrierte* thought that all his photographs were potential cover pictures, that his name was well known at the *Tages-Anzeiger* and that he was "recognized and appreciated everywhere."[4] In many instances Tuggener may have been successful, but there is ample evidence that this was not always the case and that unsolicited photographs were sent back more than once.

Even though it was extremely difficult to make a living as a freelance photographer —the magazines paid about ten francs a picture—Tuggener increasingly considered himself a professional industrial and press photographer, produced a business card and became a member of the Schweizerischer Photographenverband (Association of Swiss Photographers). Yet he earned most of his money during the 1930s from the work he did for industrial companies. The small cash he made from magazine work and from the sale of some of his paintings in the second half of the decade might have been a welcome addition but alone would never have sustained his livelihood.

In fact, without the income from the Maschinenfabrik Oerlikon Tuggener would certainly not have been able to acquire a modern Leica camera which was essential for his future work. When he was commissioned to produce a company brochure in 1934, he borrowed from an engineer a Leica camera equipped with a 9 cm lens to take portraits of workers. Shortly afterwards he bought his own model and began to photograph stories in and around Zurich.

The first reportage Tuggener sold to a magazine was still taken with the old 6 x 9 cm folding camera. Entitled "Vom Sand und Ledischiffen" (On Sand and *Ledi*-Ships) it was a picture story about the people working on the so-called *Ledi*-ships on Lake Zurich. These ships dug up gravel and sand from the bottom of the lake and transported it to a special port at the small village of Schmerikon. Together with a text written by Tuggener the photographs were published in *In freien Stunden* in the fall of 1932. This illustrated family magazine was founded in 1908 and published by Conzett und Huber—who also published the *Zürcher Illustrierte*—for the subscribers of the Vita life insurance company. It was the most widely circulated Swiss insurance magazine reaching over 140,000 subscribers every week.

Vom Sand

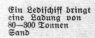

Ein Ledischiff bringt
eine Ladung von
80—300 Tonnen
Sand

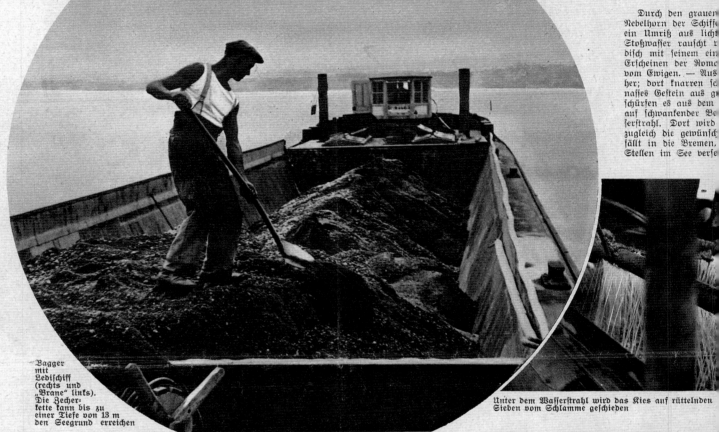

Durch den grauen
Nebelhorn der Schiffe
ein Umriß aus licht
Stoßwasser rauscht
disch mit seinem ein
Erscheinen der Romo
vom Ewigen. — Aus
her; dort knarren sc
nasses Gestein aus g
schürfen es aus dem
auf schwankender Be
serstrahl. Dort wird
zugleich die gewünsch
fällt in die Bremen.
Stellen im See verse

Bagger
mit
Ledischiff
(rechts und
„Brane" links).
Die Becher-
kette kann bis zu
einer Tiefe von 13 m
den Seegrund erreichen

Unter dem Wasserstrahl wird das Kies auf rüttelnden
Sieben vom Schlamme geschieden

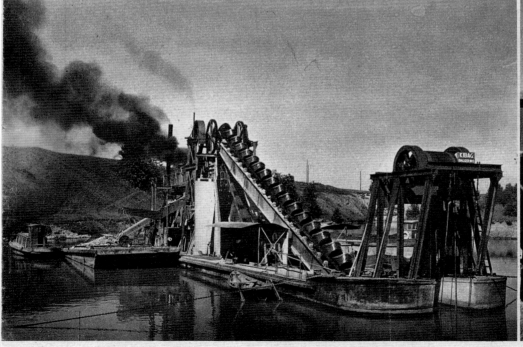

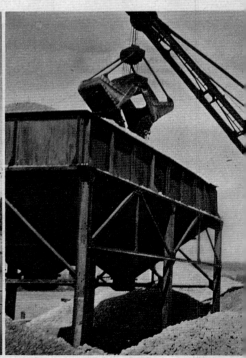

nd Ledischiffen

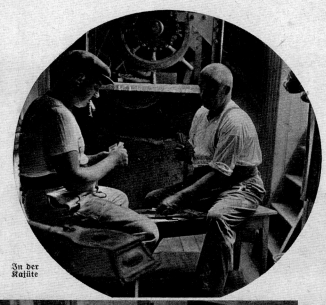

In der Kajüte

es Herbstes dringt das
nstergleich taucht alsbald
n Gewölk. — Weiße
v, vermengt sich melo=
ggen. Gleich wie sein
, so kommt seine Lade
er. Träumend taucht
Wasser. Mächtige Kübel
lummer und tragen es
n Siebwerk und Was=
hlamme geschieben und
e ausgesiebt. Der Rest
aterial an bestimmten
wo es später als schon

ausgeschiedene Sorte neu gebaggert wird. — Aus dem
Zürichsee werden täglich 1000 Kubikmeter Sand gebag=
gert, das ergibt einen Würfel von 10 Mtr. Seitenlänge.
80—300 Tonnen fahren mit jeder Ladung zur Stadt.
Leise rauscht der breite „Schnabel" des Schiffes über
das helle Grün des Wassers. — Behütet vor aller Hast
der Menschen, träumt es dahin zwischen sonnigen
Ufern. Tiefer Friede ringsum. — Zwei bis drei Mann
sind seine Besatzung, einer steuert, einer kocht, der
dritte schläft oder schaut zu den Wolken. Im Kieswerk
warten hungrige Krane. Weitgeöffnet ist ihr Riesen=
maul, so stürzen sie sich in den Bauch des Schiffes, tür=
men Sand zu ganzen Bergen. — Sand, — Atom aus
dem die Städte werden.

Photos und Text von J. Tuggener, jun.

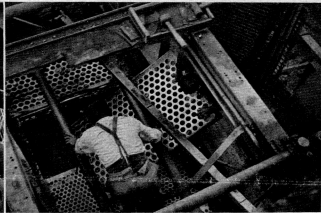 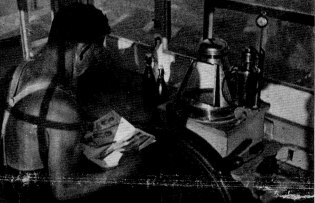

Dampf= und elektrische Krane heben
nd aus dem Ledischiff in die Silos, von
s direkt in die Lastwagen abgezapft wird

Einlegen neuer Siebe für gröbere Kiessorten

Am Steuer

Unten: Im Ledischiffhafen von Schmerikon

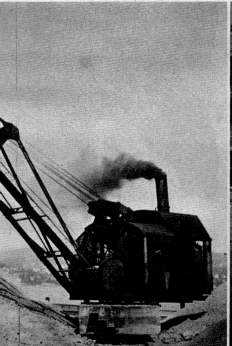 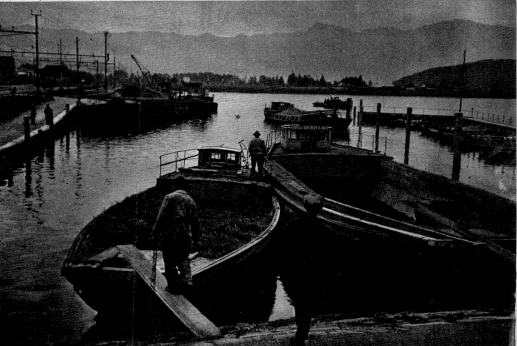

17

The eight photographs were arranged on a double-page spread to show both life and work on the ship, the process of getting gravel and sand out of the lake, the machinery on the boat and in the port, and the unloading of the gravel: an extended portrait of men at their workplace both in terms of time—documenting a whole day's work, including the spare time spent playing cards—and in terms of space—covering the lake and its surrounding landscape. Tuggener's original text was written in a very expressionist and poetic style rich in imagery with an emphasis on the different sounds he experienced while accompanying the ship on its tour. He juxtaposed the romanticism of life on the boat and the stillness of the lake with the "sawing noise of the sieves" and the "stamping machines" and wrote: "the noise of falling stones in the tin channels is giving way to the romantic stillness of the *ledi*-shipping. the broad beak is quietly sweeping over the green of the water. sunny shores, rush and reeds turn by. no hurry, no sound of people disturb the course of the boat."[5]

Tuggener's original layout and text for the reportage were considerably edited by the magazine. The opening phrase of Tuggener's original text "from children's hands trickles the sand, atoms of the cities..." as well as the key photograph it referred to were not included. Moreover, the modern look of the original text— Tuggener followed Jan Tschichold's "elementare typographie" (elementary typography) developed in 1925 and only used lower-case letters—was not incorporated and the standard old gothic typeface was used instead. In the same vein, Tuggener's original spelling of the term photography as "fotografie" was changed to the traditional "Photographie," his description of his work as a "reportage" to "photos and text," and the short version of his name "Jak" that he had adopted in Berlin was changed to "J. Tuggener jun." apparently in an attempt to avoid confusion with his father. Thus, despite his intention to present a modern reportage, Tuggener apparently had to adjust—mainly for economic reasons—to the more conventional taste of a popular magazine.

Despite such experiences Tuggener never went as far as to associate with the truly conservative practitioners of late pictorialism: the circle around Adolf Herz, the editor of *Camera* magazine. Conversely, he never became a member of the Swiss Werkbund either (even though he was invited to join), which included many of the Swiss advocates of the New Vision in photography such as Hans Finsler, Robert Spreng and Gotthard Schuh. Tuggener chose to remain outside both traditional and avant-garde photography groups in Switzerland until the early 1950s. How-

ever, in 1933 he joined the Künstler-Vereinigung Zürich (Zurich Artists Association), founded in 1897, and showed his paintings and watercolors at its exhibitions until the 1950s.

If one looks for obvious elements of New Vision aesthetics in Tuggener's work of the early 1930s, one finds only very few. He did produce a few photographs combined with typography or drawing, multiple exposures, views from extreme angles, and photomontages, but these images only rarely appeared in print. In one of these unpublished montages, entitled *Sand,* made at the same time as the reportage on the *Ledi*-ships, he condensed three elements of the reportage: the digging up of the sand, a child's hands, and the building of the modern city. The montage perfectly illustrates Tuggener's original first sentence—that was omitted in print—talking about the sand as "atoms of the cities." That Tuggener meant *modern* cities can be seen in the fact that he represented it by the architect Otto R. Salvisberg's concrete smokestack of the Fernheizwerk (remote heating station) that was considered, after its completion in 1932, the "crown of the city" and became the prime modernist emblem of Zurich.

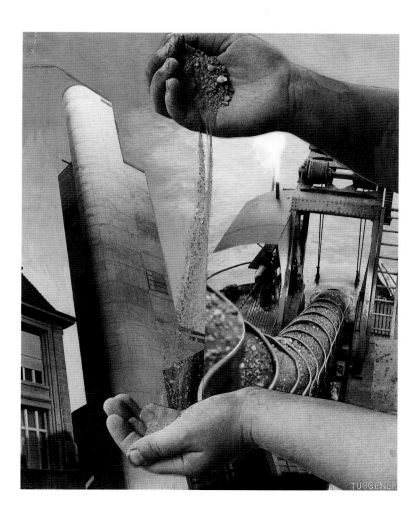

Sand, photomontage, 1932

Another montage, originally entitled *Maschinist* (Engineer) did appear in print. It is the cover picture of a 1933 issue of *In freien Stunden* and consists of photographs of electric power meters and generators and a hand pulling a lever taken at the Maschinenfabrik Oerlikon superimposed over a man's face and an aerial view of a city. Reminiscent of Karl Vetter's measuring of Berlin's modernity with the enormous daily consumption of electric energy the caption reads: "One Single Hand Masters the Power Supply System of a Whole City." A third montage entitled *Ausverkauf* (Sale) of about the same time shows, among the chaos of what appears to be a city-wide clearing sale, two well-dressed men wearing caricature-like carnival masks and leaning casually against a register cashing in on people's frenzy.

There are very few instances where Tuggener photographed from extreme angles. One reason for this might be that Zurich did not have tall buildings like Berlin. Another was perhaps that Tuggener was trying to represent the view of the common man in the street, his view, and was therefore avoiding any extreme perspectives. Some examples of such photographs appear in a series of the Limmatquai seen from above that was probably part of a reportage on traffic policemen Tuggener made for the *Automobil Revue* in 1935. They are very similar to pho-

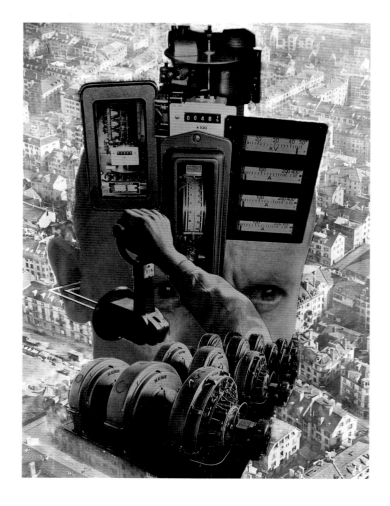

Maschinist (Engineer), original photograph of a lost photomontage, 1932/33

tographs Moholy-Nagy had taken in Berlin around 1930. Although Moholy-Nagy's photographs appear to have been taken from a higher vantage point, the diagonal composition is the same and they also show people early in the morning or in the evening when the sun produces long shadows which become—as in many other photographs of the time—important abstract elements of the composition taking on a life of their own.

These few examples cannot obscure the fact that the joy of experimenting with the new possibilities of camera vision had lost its importance for Tuggener. At first this is surprising since after 1934 he was using a Leica, the truly "unleashed camera." Because of its small size, speed and mobility it certainly opened up new areas for his photography that would have otherwise been inaccessible. However, Tuggener's perspective essentially remained that of a man participating in an event, not that of an outsider who observed what was going on from a distance. This viewpoint corresponded with Tuggener's personal preference to be "within," to experience something of the world "inside," as he said, and capture the essence of his own experience.

It also had to do with the editorial policies of the increasingly conservative magazines that were the potential buyers of Tuggener's photographs. *In freien Stunden* (like many other publications) considered the techniques that Werner Gräff had proposed as elements of a modern photographic vision, simple "photographic tricks" for the short-lived entertainment of a wide and unsophisticated audience. It is possible that Tuggener did not want to be associated with such superficial tricks and therefore refrained from using them. Commercial family magazines like *In freien Stunden* (as well as *Der Gleichrichter* of the MFO) defined the style Tuggener was more or less forced to adopt and the subject matter he had to deal with. Thus, instead of experimenting with modernist, mechanical aspects of photography, he entered new territories of experience that always included people: people at fairs, in the streets, and restaurants of Zurich, people in various rural places in the country, people working in factories, and people enjoying themselves at society events. The aesthetics of the New Vision no longer provided Tuggener with a set of fixed rules, but an opportunity to experience rather than experiment. He moved from the mere "Sehen" to the "Schauen" (to *consciously* see)[6] and his camera changed from a mechanical extension of his eye into an almost organic extension of his whole self.

Photographs Taken in the City

While getting more and more independent artistically—and probably financially as well—Tuggener longed to leave the house of his parents to live in a space of his own. By the end of 1934 he had found an affordable attic room. As he wrote to a friend it was "in the heart of the city, where the lights are and where life is most intense, in the exact mathematical center of the city at night." Inspired by the film set of *Dr. Caligari* Tuggener wanted the attic room to be like an expressionist film

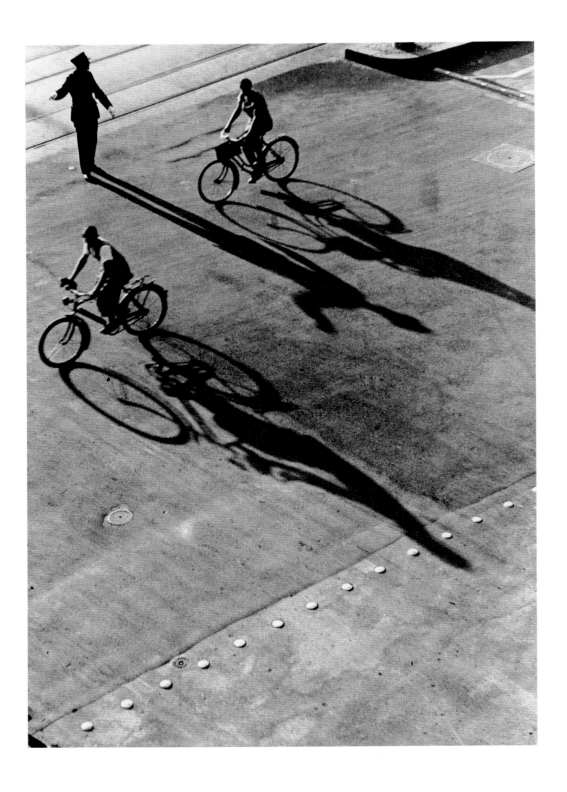

Herbstschatten (Shadows in Fall),
Limmatquai, Zurich, 1935

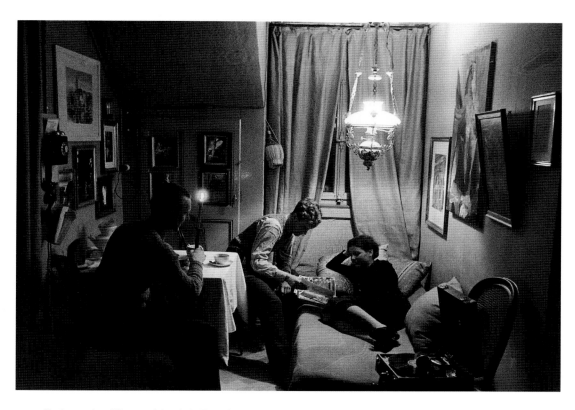

Budenzauber (Charm of the Attic Room), Jakob Tuggener with friends, c. 1935

studio with "its architecture of slanted walls painted over and dissolved into dynamic forms." Tuggener happily exclaimed: "The days have come when I shall be free and live my own life."[7] Finally early in 1935 he moved into Mühlegasse 5 in the Niederdorf, the old center of Zurich. However, as the many photographs he took in his attic room show he did not paint over the slanted walls but decorated them with his own framed photographs and paintings. The pictures also show that he led the active social life of a bohemian, entertained many guests, and dove into the vibrant life of the city at night.

At the same time, work and leisure of the common man in the city became the focus of Tuggener's photographic interests. A typical example for this is the reportage published in November 1934 in *In freien Stunden* entitled "Ein Geschäft wird getätigt" (A Deal is Made). It consists of a series of four photographs showing a newspaper salesman working at a newsstand. As a surviving contact sheet shows, the original inspiration for this reportage was probably the fact that a photograph by Tuggener had appeared on the cover of the *Schweizer Illustrierte,* and he wanted to take pictures of the salesman selling it to people in the street. In the published work, however, his cover does not appear at all, instead the last photograph shows a customer buying an anti-Nazi publication with Hitler's portrait on the cover.

Another reportage had to do with feeding the needy. It was entitled "Ein Mensch der immer gibt" (A Man Who Always Gives) and was published in *Föhn* magazine in 1935. *Föhn,* which took its name from a warm and sometimes very violent and damaging wind coming from the Alps, was a monthly magazine founded in 1935 that disappeared at the beginning of the war. This short-lived magazine on the one hand dealt critically with social and political issues. On the other hand, it was entertaining and humorous, sometimes even frivolous and outright erotic—more than any other "family" magazine at the time (which probably was one of the reasons for its demise). In Tuggener's "Ein Mensch der immer gibt," the owner of a small roadside stall is shown giving away food to small children and unemployed men. The text suggests that this unknown man deserves to be portrayed in a magazine and made famous like a movie star.

Another reportage by Tuggener dealt with night-life, a recurrent topic in *Föhn.* Entitled "Je-Ka-Mi" (*Jeder Kann Mi*tmachen, Everyone Can Participate), its twelve pho-

Untitled, newspaper salesman, 1934

Untitled, street vendor, 1935

tographs depict various amateur performers such as musicians, comedians, story-tellers, acrobats, and singers appearing on the stage of the Schäfli, a hotel and restaurant close to where Tuggener lived. A few of Tuggener's photographs taken at the Albisgüetli, a city fairground and entertainment area with shooting alleys, dance halls, Ferris wheels, freak shows and other attractions, also appeared in *Föhn*.

One reportage which would have fit perfectly into the editorial concept of *Föhn* never found its way into the magazine: "Fantoches Parisiens," a series of pho-tographs showing a man selling "Parisian marionettes" to a crowd of people at the busy Bahnhofstrasse, the main shopping area of Zurich. Tuggener wrote: "Are these not strange things? To see adults with such simple-minded toys? Are these naively painted little figures not grotesque in view of the difficult times we live in? Their behavior is totally uncomplicated. They fight, fall over and stand up again, and all participants have radiant faces. ... The man who sells them knows something about people, he brings them what they need badly—freedom."[8]

Fantoches Parisiens, 1935

Fantoches Parisiens, 1935

Landscape and Countryside

The changing international political climate of the 1930s directly influenced Switzerland, especially since the fascist regimes installed in neighboring Italy and more importantly in Germany increasingly threatened Switzerland's national integrity by means of their nationalist propaganda. This external threat led to a wide range of defensive responses which was commonly referred to as "Geistige Landesverteidigung" (intellectual defense). Far from being a unified doctrine this term is today used to describe the great variety of intellectual responses of all Swiss political and social groups aimed at strengthening Switzerland internally by preserving and fostering typically Swiss thought, ideas and values thus leading to an immunization of the population against fascist propaganda from abroad.

The Geistige Landesverteidigung obviously also influenced the popular press which increasingly emphasized specifically Swiss values such as the traditions of the rural population, the use of local costumes and dialects, and the glorification of the farmer and the land. As in the case of almost all other Swiss artists Tuggener's work too was influenced by the Geistige Landesverteidigung. To a large degree dependent on selling pictures to illustrated magazines, his radius of activity widened and he began to explore the Swiss countryside in reportages that fit into the editorial concepts of the popular press.

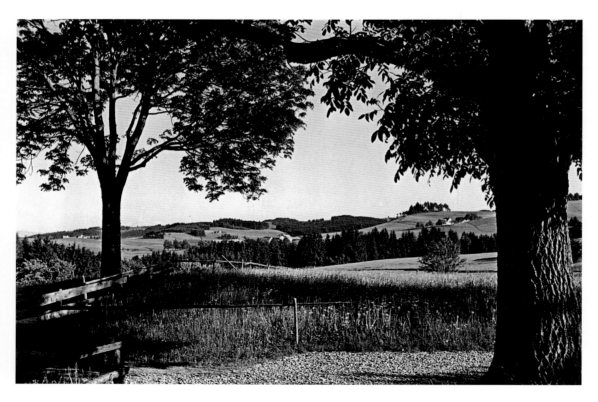

Untitled, Benzenrüti near Heiden, 1934

Working on one of the first of these in the rural canton of Appenzell Tuggener met his future wife, Marie Gassler. The lively exchange of letters that began in May 1934 reflects the ups and downs of their relationship until their marriage in 1940 and represents the most important source of information concerning Tuggener's work and his thinking during the 1930s. In a letter of June 1934, Tuggener referred to a *Staatsalbum* (State's Album) containing portraits of farmers and infantrymen that he wanted to publish if it could somehow be financed.[9] He also told Marie of the time he spent in Braunwald (an Alpine village in the canton of Glarus) from where he had brought back "a few heads." He included a photograph of a "Senne" (Alpine farmer) in his letter with the comment "I believe this is a genuine Glarus face."[10] He even produced a portrait alluding to William Tell that was published in the August 1935 issue of *Föhn* commemorating the Swiss national day.

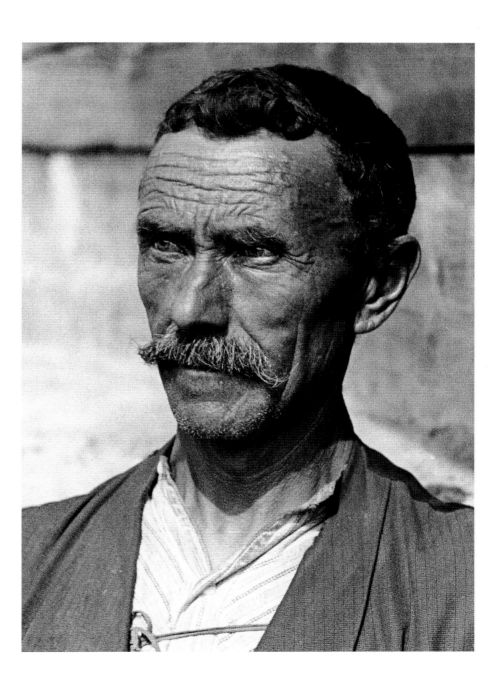

Untitled, man from Glarus, 1934

Nr. 34 / 22. August 1934.
XXIII. Jahrgang.

Preis 35 Cts.
Erscheint Mittwochs

Schweizer
Illustrierte Zeitung

Verlag Ringier ... ngen, Lausanne, Zürich

Einsiedlerin im festlichen Sonntagsstaat an der Jahrtausendfeier

Der berühmte Wallfahrtsort Einsiedeln war am Mariae=Himmelfahrts=Tag (15. Aug.) das Ziel zahlloser Besucher. Die Jahrtausendfeier
des Klosters hatte ihren Höhepunkt erreicht. – Für die Einsiedlerin ein willkommener Anlaß, im schönsten Festschmuck zu erscheinen.

(Tuggener-Photo, Zürich)

Schweizer Illustrierte, 22 August 1934

In the spring of 1934 Tuggener began to take pictures at local and national costume festivals and collected about one hundred carefully numbered portraits—mostly of young women in traditional costumes—in a box labelled "Trachtensammlung" (Collection of Traditional Costumes). With the notable exception of a picture of a girl from Einsiedeln that appeared on the cover of the *Schweizer Illustrierte* in

August 1934 none of these portraits was published. However, some were printed as postcards indicating that he might have intended to sell them to participants of the events.

While the topic of landscape had ceased to interest him in Berlin, back in Switzerland Tuggener's interest in the land was revived but shifted from photography to painting. At first he turned to forests where he spent days indulging in the "miracle of colors" of the fall season. Soon however, his mood changed and he began to paint during weather conditions that usually prevent painters from working outdoors. He concentrated on capturing the feeling of cold with different shades of blue and described how difficult it was to work: "Whenever there is a 'Föhn'-day I am on the Üetliberg or at the lake painting at a wind force of ten until I can hardly hold my brush anymore, today a stormy wind blew over my water pail and the water flooded my palette."[11] At the same time, he indicated that he was taking simple but very expressive photographs under the same inclement weather conditions, such as *Föhnsturm und Zürichsee* (Föhn Storm and Lake Zurich) published in *Föhn* in 1935. While the waves on Lake Zurich are reminiscent of the early Tell Theater backdrop, they also reflect Tuggener's situation, namely that he was still unsettled and trying to understand the meaning of both his art and his life in times of great economic and political turmoil. A friend wrote to him: "Stay in your world! It is beautiful and quiet and far away from all thunderstorms!"[12]

Tuggener did not seem to need such encouragement since he only rarely made obvious reference to social or political "thunderstorms." His photographs only indirectly reflect social conditions and in his numerous texts and letters of the 1930s there is only one direct reference to this outside world. Writing shortly before the devaluation of the Swiss Franc in September 1936 he told a friend in Paris: "Here in Zurich a lot of panic-buying is going on. Everybody still wants to secure the value of his or her money. Even I bought a pair of shoes, although I feel no sympathy towards these machinations."[13] Tuggener would have liked to keep himself away from the fuss people made about the decreasing value of their money. Although he had to struggle hard to earn enough to survive, money itself meant nothing to him. Like other economic, social, and political problems it had the potential to distract him from his work and he therefore repressed or simply ignored it. Still, many of Tuggener's reportages and single pictures reflect the socio-political climate in Zurich in the mid-1930s and the subtle changes that were taking place and Tuggener reveals himself as an acute observer of everyday life in the city.

Speed and Danger

In addition to his interest in tradition, landscape and life in the city, Tuggener began to develop a genuine enthusiasm for the dynamism and speed of machines that he wanted to capture in his photographs. In opposition to the archetypal figure of Tell he considered the "Maschinen-Mensch" (man of the machine age) "the pioneer and man of the century" and was totally captivated by the steam locomotive as the foremost modern machine: "A monster thundering and roaring, fighting its way through gorges, racing across high bridges..."[14]

He began to take innumerable pictures of the local railroads around Zurich as well as the main north–south route of the Swiss Federal Railways through the Alps. After visiting the Paris World Fair in 1937 he wrote that he had definitely taken the machines, especially the railroad, into his "warm, human heart."[15] He had used up almost a whole roll of 35 mm film to photograph from all conceivable angles a huge Soviet train engine, then *the* symbol of socialist progress in the Soviet Union.

In 1934 Tuggener began to go to the aerial shows in Dübendorf near Zurich. He wrote to his girlfriend: "I was there with soul and body, with the eye and even more with my ear." He boasted that he produced photographs that would have even impressed Walter Mittelholzer, the Swiss pioneer aerial photographer.[16] A few were printed as montages in magazines, others appeared in program booklets. At the aerial show of 1937 he did not only take photographs but also executed an oil painting in which he expressed with characteristic futurist-style force lines the dynamism of the figures drawn in the sky and the roaring noise of the airplanes' engines. Tuggener later exclaimed: "At the aerial show you don't really see anything, but the acoustic experience is tremendous, *this* is what I like. In fact, I would love to live in Dübendorf just to be able to listen to this noise every day. For me this is like music played on the organ, real organ music."[17]

At exactly the time when Tuggener went to see the first aerial show, in August 1934, he also went to photograph the first Grand Prix of Switzerland, a car race held on the Bremgartenring near Bern. Not unlike his description of the locomotive, he described the racing car as a "monster," the driver as "rider of the Apocalypse," and the race itself as a sport that was at once "heroic" and "near death." As he wrote in a long letter to his girlfriend, he had actually witnessed the fatal accident of H.C. Hamilton in his Maserati, but even while the "cold trickled over [his] heart" he felt that speed expressed the essence of the present time and that technology was the "most grandiose poetry."[18]

In this letter Tuggener reveals himself not only as a typical man of the machine age but also of the "age of danger" which the German writer Ernst Jünger had described in the early 1930s. In his essay, "Über die Gefahr" (About Danger), Jünger argued that elements of danger related to technological progress and the modern machine penetrated everyday life as never before. He considered the experience of danger one of people's basic needs in modern society, the relief from an over-orderly life and "the antipode of security, boredom, and reason," as Jeffrey Herf stated in the discussion of Jünger in his study of reactionary modernism in Weimar Germany and the Third Reich.[19] This enjoyment of technology as grandiose, mortally dangerous poetry is part of racing drivers' and spectators' life, as well as Tuggener's as a photographer. Jünger wrote: "The wonderful thing in this at once sober and dangerous world is the registration of the moments when danger appears—a registration that is also ... made by machines." The photographic lens "produces images of mathematical demonism," and, by a new technological language, the "sachliche Erlebnisbericht" (matter-of-fact account of personal experience).[20] Both elements are present in Tuggener's letter from the race: the detached "account" of the accident and the description of the pictures of "apocalyptic monsters" recorded by the new machine, his Leica camera.

Tuggener's photographs of the car race were exceptional, certainly a lot more dynamic and expressive of the spectators' feelings than the ones by Max Seidel published in the *Zürcher Illustrierte,* or those in the *Schweizer Illustrierte* that had to be supplemented with drawings to convey at least something of the action at the race. While no pictures by Tuggener appeared in any of the major magazines, a year later a photograph entitled *In rasendem Tempo* (In Racing Speed) was published on the cover of *In freien Stunden* and a reportage included in the magazine. Although he did not go to any more car races before the war (and during the war they did not take place), he remained fascinated by them. From 1947 to 1950 Tuggener returned to photograph the yearly races near Bern but concentrated more and more on the spectators, their gestures, and details found at the side of the racetrack.

The same fascination for both dynamic action and static "stills" can also be seen in the first short film that Tuggener produced with his friend Max Wydler at the 1937 aerial show in Dübendorf. He had met Wydler in the army in the 1920s and they shared an interest in art, photography and, above all, in film. The son of a well-to-do family, Wydler worked as a bank clerk and later became a successful antiquar-

ian and art dealer. Together they conceived of the idea of shooting short films for Swiss industrial companies. Tuggener asked Hans Schindler for support and joined the Vereinigung Zürcher Film-Amateure (Association of Zurich Amateur Filmmakers) in the summer of 1936.[21] He convinced Wydler to buy a 16 mm film camera, an expensive Kodak Ciné Spécial, and sometime in 1937 they began producing films for the Maschinenfabrik Oerlikon and other companies.

With the money they made from these commissioned films they were also able to shoot their own independent films like the one on the aerial show and, in 1938, a documentary on the demolition of the Tonhalle, the main concert hall in Zurich. This film shows in captivating images walls being crushed and a steam hammer pounding in a regular rhythm giving the film its title: *Der Puls der neuen Zeit* (The Pulse of Modern Time). Whereas the destruction was a dynamic scene that Tuggener and Wydler indulged in with apparent pleasure, the actual message of the film was its emphasis on the construction of the new building as "a work of modern technology."[22] In another film about a power station in Wettingen they superimposed the image of a church on the view of the machine hall housing the power generators thus expressing the spiritual dimension modern technology had achieved by this time and an almost religious "belief" in the benefits of technological progress.

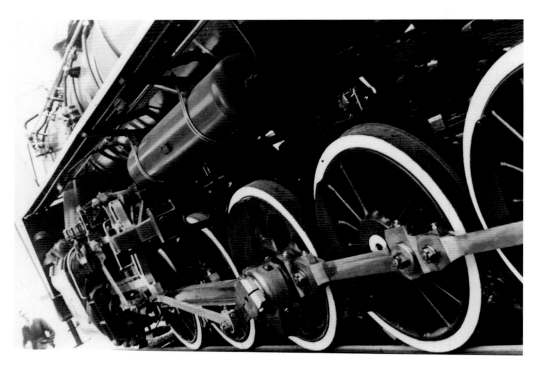

Untitled, Soviet train engine, Paris World Fair, 1937

Untitled, moving wheels of a locomotive, enlarged 16-mm film frames, 1938

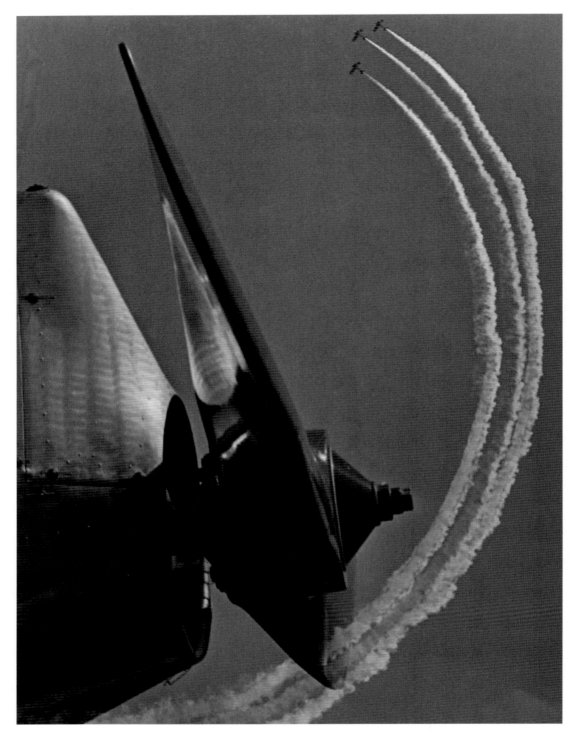

Untitled, aerial show in Dübendorf, photomontage, 1934

This spiritual dimension of technology had developed since the beginning of the century and was, after the experience of World War I, taken up by reactionary modernists such as Ernst Jünger. Photographs of constructions that alluded to religious feelings for technological power, for example *Organ Pipes of Industry* in M.P. Block's *Gigant an der Ruhr* (1928) and Renger-Patzsch's *Die Welt ist schön,* began to appear frequently. But Tuggener and Wydler were not just expressing a

feeling in line with contemporary taste; Tuggener in fact saw himself as a modern artist playing the organ of technology. Responding to the question of why he was painting machines in the workshops of the MFO Tuggener said: "It is the adventurous attraction of the forces in the machines; they want to be formed and resolved. I have to find a word or an image for them, an imagination that resembles the experience. When the great roaring starts and the number of revolutions increases, then it is the same for the man of our time, as when Bach played the organ. The engineer is standing between greater powers than Siegfried in the fight with the dragon. At 4000 revolutions our heart is torn apart, at 5000 the ear, and this we should not paint? Here lies the expression of our time."[23]

Tuggener's allusions to religion and heroic myths are apparent and so are the references, again, to Jünger's conception of the age of danger that Tuggener embraced and spelled out very clearly here: the adventurous attraction to the machine tearing apart hearts and ears as the ultimate expression of his time. Tuggener was captivated by the speed, the power, and the sound of machines whose production and testing he witnessed at the MFO and he continued to express his experiences in painting—and photography—throughout the 1930s.

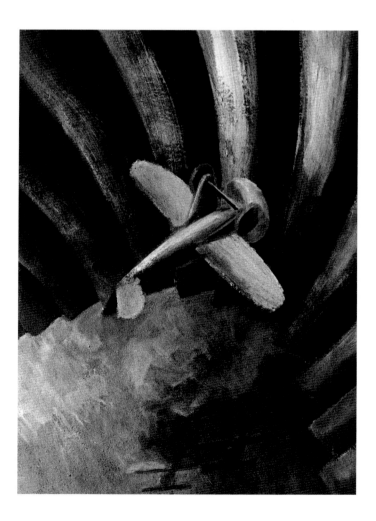

Flugmeeting (Aerial Show),
original photograph of a painting, 1937

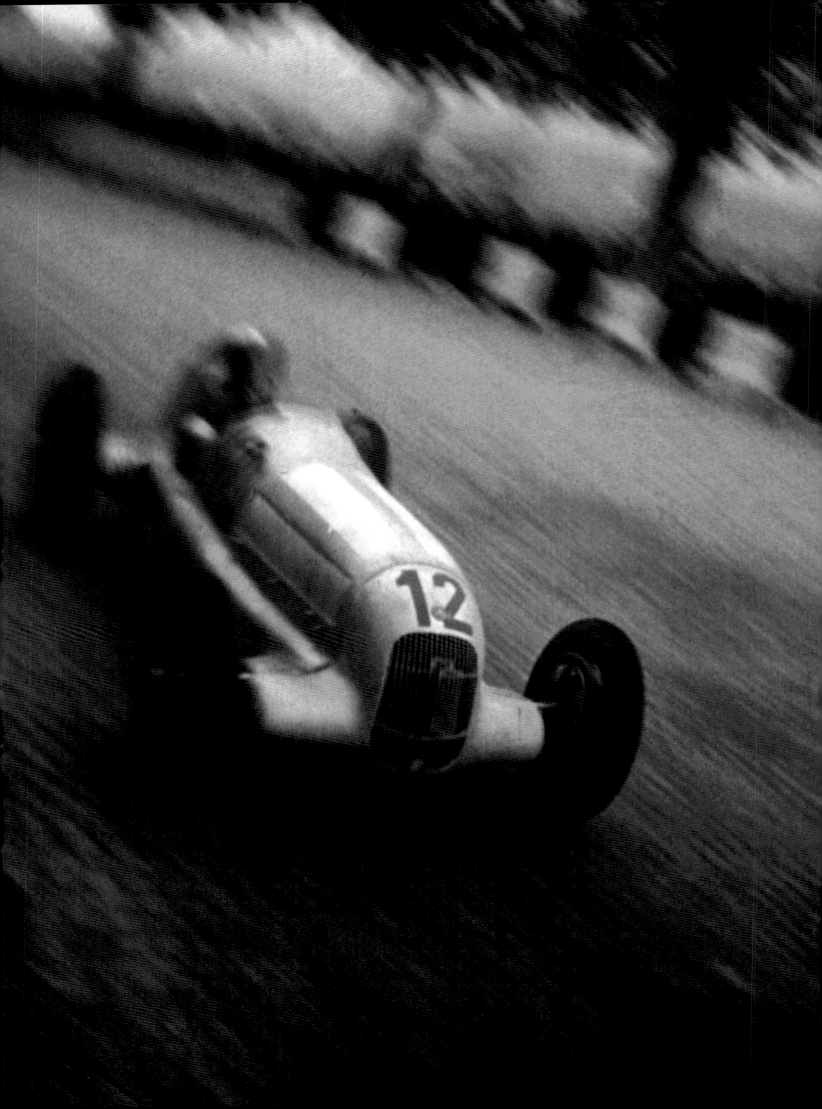

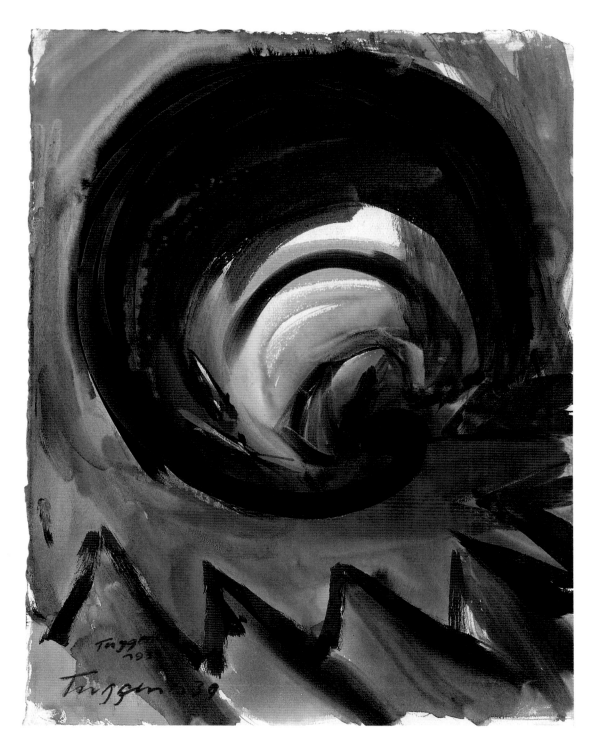

Autorennen (Car Race), original photograph of a watercolor, 1939

In Rasendem Tempo (In Racing Speed), Bern, 1935

Summer 1936 in Brittany

While it seems that Tuggener was totally absorbed with his fascination for car races, aerial shows, steam engines, work in the factory as well as life in rural Switzerland and his home town of Zurich, he was still dreaming of seeing more of the world and, apparently, intended to go to Africa with friends in 1935. When this proved financially impossible, he changed his mind and focused on Iceland. Imagining the volcanic landscape and longing to see the sea, he planned to photograph and make a film of the waves.[24] However, he could not find the money for this trip either. In fact, as Tuggener wrote to Wydler in the summer of 1936, he was not even able to accompany his friend, the painter Walter Jonas, to a small island in the Mediterranean.[25]

Wydler, himself a victim of the economic crisis, had lost his job as a bank clerk and had gone to Paris to improve his French and to learn the basics of art dealing. While he was in France the two men occasionally corresponded, Tuggener usually writing on the backs of reject photographs. Thus Wydler, knowing of Tuggener's wish, sent him an enticing description of the ocean with a small amount of money and an invitation to join him in Brittany. Tuggener was persuaded and the two men spent a few weeks in August 1936 walking the northern seashore between Plouha and the Ile de Bréhat, climbing among the rocks, painting and photographing outdoors, catching fish and shrimp, collecting shells and other treasures they found in the sand.

Tuggener was finally able to experience the sea more intensively than on his short visits to Venice in 1926 and to the island of Helgoland on his way back from Berlin. He observed the immense water surface in the rapidly changing light and tried to capture these fleeting impressions in his photographs. On one of them he wrote: "In the face of the sea our personal thoughts stop, we encounter a dimension of nature in front of whose power our own life appears modest" and "The Spirit of God hovered above the water." On another one he juxtaposed a description of the stillness of the water with the ever-present danger of being surprised by tidal waves. Tuggener closely watched these waves roll onto the shore or crash against the rocks; sometimes, standing in the water, he photographed the different phases of this impressive spectacle.

The grandeur of the ocean, the power of the waves pounding against the deeply fissured rocks, washing ashore tiny creatures like shellfish and shrimps, was the main theme of the photographic report entitled "Am Meer" (At the Sea) that was published on a double-page spread in *In freien Stunden* after Tuggener's return to

Switzerland. At the center is the picture of a huge shipwreck and a small human figure balancing among the wooden remains. The original caption that Tuggener wrote for this picture was: "The most unforgettable impression of a trip to Brittany were the wrecks of old sailboats lying on the shore. It was as if they spoke a language which deeply moved us. They are the story of the sea and testify to the transience of human endeavors."

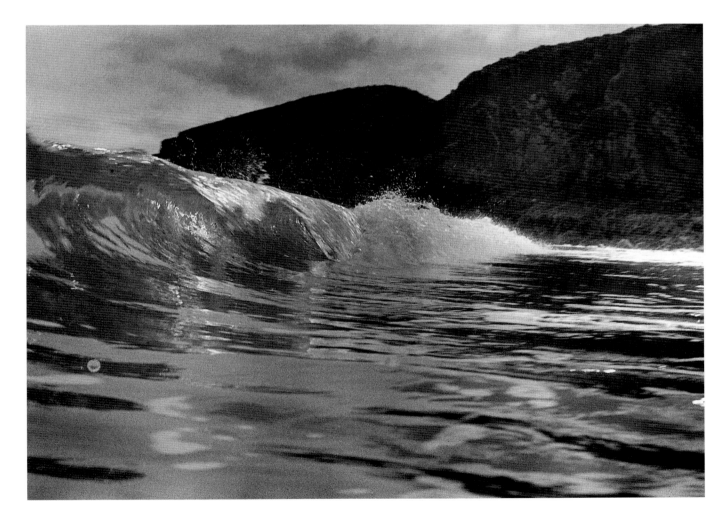

Untitled, Brittany, 1936

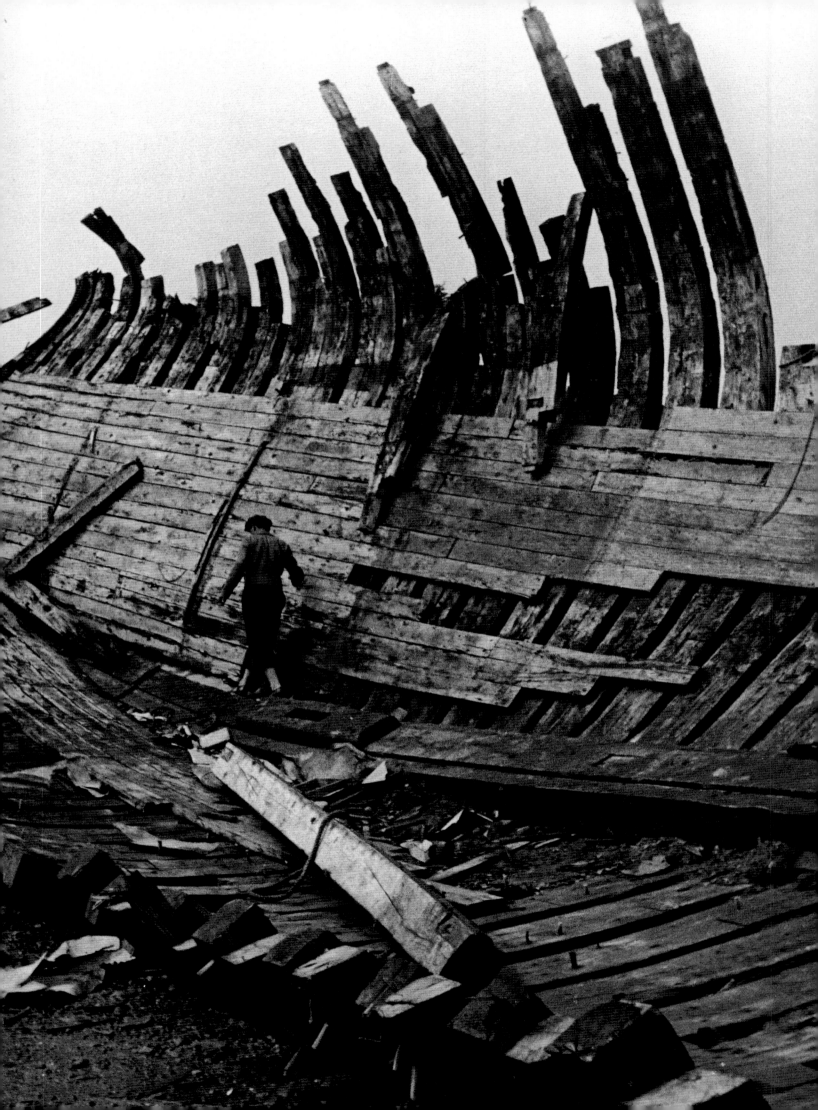

A Film Project

Tuggener and Wydler felt strongly the overwhelming presence of the archaic ship-wrecks while walking along the shore. This had a lasting impact on their long talks about art and the ultimate meaning of life, talks that resulted in a visionary film project. Despite their financial difficulties they seriously thought about producing a film of pioneering importance. They intended to found a production company with an English name spelt in Swiss German, the Först Film Tröst Cömpany Prödöction Tuggener-Wydler. They hoped that their very first film would become a show piece for a new and independent Swiss film industry that was being discussed at the time, both as a means of government propaganda and as a means to reduce unemployment.[26]

When Tuggener found himself alone again in his attic room in Zurich he concentrated on developing the film ideas about which he wrote to Wydler in two long letters. The film was to be about Tuggener's life as someone who was transformed into the higher state of being an artist. It would on the one hand show physical life as "perpetually fading away" and on the other propose "the idea of spiritual life that we want to find as redemption." Related to his earlier thoughts about expressionist art Tuggener developed the Christian ideas of pure spiritual life and redemption and transposed them into the film concept which consequently became a part of his understanding of himself as an artist. He considered the film idea a "visionary" project that would explore "the inner as well as the outer nature of reality" and hoped it would become a commercial "surprise success." In 1936 however, still at the height of the economic crisis, the time was not right for Tuggener's "uncompromising idealism," as he called it, and the film was never produced.[27]

Tuggener's thoughts that went into the film script also influenced an illustrated reportage entitled "Ist Kunst ein Beruf?" (Is Art a Profession?). In it Tuggener described the role of the artist not as a "Handwerker" (craftsman) but as a "Heiliger" (holy man, a saint) and wrote: "An artist does not speak of nature because we cannot understand a tree. The trees, the houses, the people, all these are 'outside of us.' Therefore I do not want to be a chatterer of a world of things that I cannot understand. ... The only thing we can understand is our own self. Only this we are allowed to talk about because only this is our own. *This self-reflection is at once art and religion.*"[28] Tuggener told his friend Wydler that he worked day and night on this reportage and took photographs "from the most realistic life" to illustrate it. He unsuccessfully offered it to the *Zürcher Illustrierte* and read it to a number of people with the result that a young man gave him a copy of Hermann Hesse's book

Untitled, Brittany, 1936

Siddhartha describing the Buddhist way toward the inner self, toward enlightenment. Although Tuggener must have noticed the parallels between Siddhartha's and his own search for the right "way," his only comment on the gift was that now, finally, he was able to fully understand the meaning of the Gospel.[29]

Vienna 1938

The second trip abroad before the outbreak of World War II brought Tuggener to Vienna, as a member of a Swiss delegation to the IV. Internationaler Amateur-filmkongress (4th International Amateur Film Congress) held on 16 June 1938, three months after Austria had been annexed and incorporated into the Third Reich. However, in the reportage entitled "Wien von heute" (Vienna of Today) that Tuggener was able to publish in *In freien Stunden* in August only very few references were made to the changes that had occurred since March 1938: the "Kraft durch Freude" boat, the presence of German soldiers among the visitors of the Prater amusement park, a few banners with swastikas in the background.

Politically more revealing photographs such as the pictures Tuggener had taken of Nazis guarding the parliament or the photographs addressing the discrimination of Austrian Jews did not appear in the reportage. One of these pictures shows two store fronts which were smeared over with paint and marked as Jewish stores, another shows a close-up of advertisements in the street. A poster of a medical doctor attached to a column in the center of the picture is pasted over with a sign reading "Jude," whereas an advertisement for children's soap showing a nurse with a baby on the right carries a sticker "Arisches Geschäft" (Aryan store).

The most striking photograph related to the political situation that was included in the magazine shows a railway freight car on which the name "Österreich" was canceled out by a thick white line. The photograph was accompanied by the caption: "Much has changed, the Austrian Railway has become the German State Railway." This statement is factual and completely "neutral" since its uncommitted wording conceals the fact that Austria, one of Switzerland's neighbors, had ceased to exist as an independent country. In comparison to an article published in *Schweizer Spiegel* at exactly the same time which openly criticized the situation in Austria as a threat to Swiss democracy, Tuggener's contribution in *In freien Stunden* seems to ignore—or repress—all political implications.

Of approximately three hundred photographs Tuggener took during his seven days in Austria, sixty-two survive as an unbound book maquette. It includes numerous

pictures taken from the moving train and the Danube boat he was traveling on, pictures of his travel companions, and photographs taken in the city of Vienna. Whereas the Nazi presence can be detected in the book maquette, it is obvious that the political situation in Vienna was not a topic Tuggener wanted to explore. He probably made it as a keepsake for himself and his fellow members in the film club, preferring, as always, to stay out of the "thunderstorms" of real life.

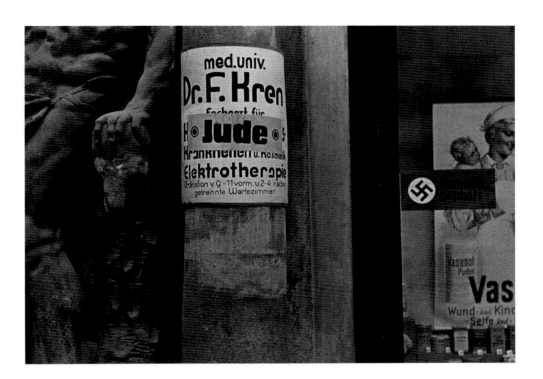

Untitled, Vienna, 1938

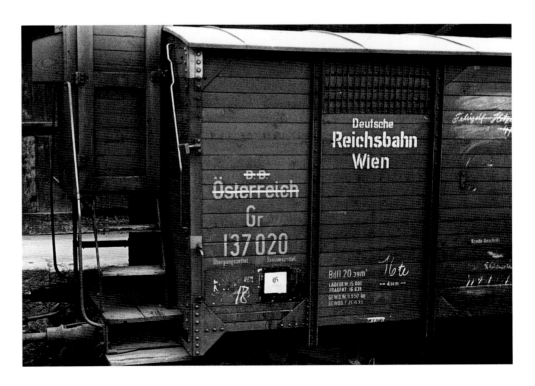

Untitled, Salzburg, 1938

Untitled, Vienna, 1938

Notes

1 See anon., "Besuch in Zürcher Künstlerateliers: Jakob Tuggener," in *Zürcher Woche,* 25 May 1956; and
 Paul Münch, "Besuch bei einem Bilderdichter," in *Die Linth (Rapperswiler Nachrichten),* 15 November 1968.
2 Kübler quoted in Guido Magnaguagno, "Der Photojournalismus," in Schweizerische Stiftung für die Photographie
 (ed.), *Photographie in der Schweiz von 1840 bis heute* (Bern: Benteli, 1992), p. 185.
3 Ibid., p. 186.
4 Tuggener in letters to Marie Gassler, 15 July, 5 August, 20 and 25 September 1934.
5 Tuggener, "Vom Sand und Ledischiffen," undated original manuscript, (1932).
6 Tuggener in letter to Marie Gassler, 2 February 1935.
7 Tuggener in letter to Marie Gassler, 17 November 1934.
8 Tuggener, "Fantoches Parisiens," undated manuscript, (ca. 1935–37).
9 Tuggener in letter to Marie Gassler, 14 June 1934.
10 Ibid.
11 Tuggener in letter to Marie Gassler, 2 February 1935.
12 Letter from an unidentified woman, 7 September 1936.
13 Tuggener in undated letter to Max Wydler, (ca. September 1936).
14 Tuggener in letter to Marie Gassler, 5 August 1934.
15 Tuggener, "Pariser Weltausstellung 1937," in *Der Gleichrichter,* 20 December 1937, pp. 6–7.
16 Tuggener in letter to Marie Gassler, 5 August 1934.
17 Tuggener in interview with Inge Bondi, April 1980.
18 Tuggener in letter to Marie Gassler, 29 August 1934.
19 Ernst Jünger, "Über die Gefahr," in Ferdinand Bucholtz (ed.), *Der gefährliche Augenblick. Eine Sammlung von
 Berichten und Bildern* (Berlin: Junker und Dünnhaupt, 1931), pp. 11–16. Also see Jeffrey Herf, *Reactionary
 Modernism. Technology, Culture and Politics in Weimar and the Third Reich* (Cambridge: Cambridge University
 Press, 1984), pp. 70–108.
20 Jünger, *op. cit.,* p. 16.
21 Tuggener in undated letter to Max Wydler, (before 7 July 1936).
22 anon., "Nachträge zum Klubwettbewerb," in *Film-Ciné-Amateur,* January 1945, unpaginated.
23 Tuggener, "Gespräch über Kunst," undated manuscript, (ca. 1937–39).
24 Tuggener in letter to Marie Gassler, 2 February 1935.
25 Tuggener in letter to Max Wydler, 7 July 1936.
26 See Manuel Gasser, *Die Gefahren einer Schweizerischen Filmindustrie* (Zurich/Rorschach: Löpfe-Benz, 1936).
27 Tuggener in undated letter to Max Wydler, (ca. September/October 1936).
28 Tuggener, "Ist Kunst ein Beruf?" original italics, undated manuscript, (ca. October/November 1936).
29 Tuggener in letter to Max Wydler, 8 November 1936.

EVA IN THE MACHINE FACTORY

Metallic noise, dust, and the smell of oil are the first impressions in the machine factory. Then there are workers, master craftsmen, and bosses, and emotions in about the same order. Everything is work, movement toward one goal, directed and organized, in competition.

See, there she comes—Eva.

What are machines? Who is a piece-worker? Where are the brick walls?

A tidal wave has filled me up; another world like heaven is inside me. Does it exist at all? But Eva is its living proof amidst this desert. At her work place, rubber stamps, eraser and rulers are hanging in rows. She transports letters and drawings from the office to the workshop and vice versa. She, too, is tied into the machinery of the company. But Eva is not a crankshaft; she is the carrier of life, hope, and bloom.

Jakob Tuggener, early 1940s

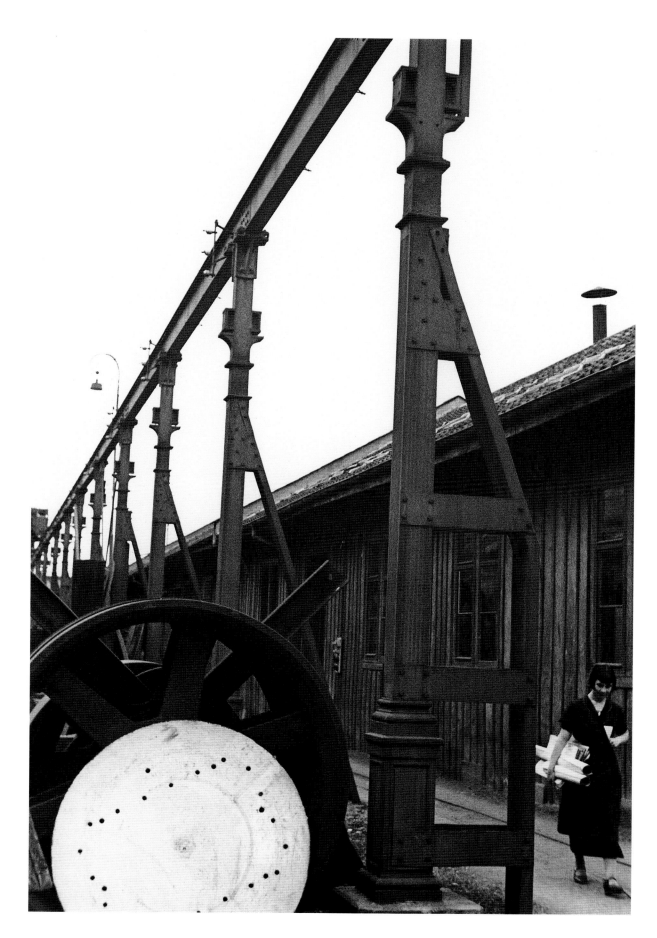

Berti, factory errand-girl, 1936

Der Gleichrichter, magazine title design, 1932

Technology

The most important magazine Tuggener worked for during the 1930s, even more important than *In freien Stunden* or *Föhn,* was the in-house magazine of the Maschinenfabrik Oerlikon (MFO) *Der Gleichrichter.* Hans Schindler, Tuggener's captain in the army, founded it in 1930 just a few months after the stock market crash. Its name, meaning "rectifier" or "equalizer," referred to an electrical apparatus—made at the MFO—which changed alternating current into direct current. This device served as a metaphor for the main program of the magazine, namely to give the same direction (*gleichrichten*) to all the workers and employees, to "make equal" worker and boss, or the poor and the rich, and to bind them more closely to the "mother"-company in order to improve its productivity.[1] This aspect was also underlined by the magazine's subtitle, *Nachrichtenblatt der M.F.O.-Familie* (Newspaper of the MFO-Family).

Numerous articles discussed the economic crisis and the viewpoints of the MFO's administration. Since the majority of the company's business was abroad, its main problem was the drastically reduced export volume due to the continuous high value of the Swiss franc, the deterioration of trade relationships between foreign countries, and the increasing competition of the world market. While shedding light on the economic problems and their complex backgrounds so that the poorer educated workers could understand the current situation, the administration did not hesitate to present its views of how the problems could be solved, or at least eased, and propagated a profitable liberal economy totally free of any kind of government intervention. Apart from this main focus on the company and its interests

Der Gleichrichter was very similar to other family magazines and included accounts from people traveling abroad, an entertainment section with crossword puzzles, lists of the people celebrating their anniversaries, reports of annual festivities, and obituaries.

Although photographic contributions by workers and employees had been solicited since the first issue of *Der Gleichrichter* appeared in 1930, only a few poor quality pictures showing workers in their daily factory surroundings had actually been published. One might think that the job of illustrating the magazine with photographs taken within the company should have been given to the factory photographer which had been a full-time post in the MFO since 1892. However, trained and equipped to produce perfect likenesses of small parts, large machines, or whole interiors of power stations for advertising purposes, a factory photographer would not have been capable of representing a life-like view of the workers and their work environment. On the other hand, Tuggener's photographs of the 1932 military repetition course had impressed Hans Schindler by their lively, communicative portrayal of people within a group. Consequently he hired Tuggener on a freelance basis to photograph for *Der Gleichrichter*.

In the December 1932 issue, a first installment of the "illustrated reportage" entitled "Was Arbeiter über ihre Arbeit sagen" (What Workers Say About Their Work) was published in *Der Gleichrichter*. It included six photographs of metal casters and their assistants accompanied by short texts written by the workers themselves. The series was introduced with some general remarks about how the workers perceived their work. The author stated that he was surprised to find the workers taking great pride in their machines which they called their "helpers made of steel" and that they felt compassion for their co-workers. At the same time he found that all the workers were proud of being part of "great things" such as a giant generator being built for export to Canada. He also noted with admiration that they all proudly stated that their work was hard due to the heat, noise, dust or gas, the machine movements, or the straining positions they had to endure but that they did not complain about this. He quoted many exclaiming: "Hard work is still better than no work at all!"

The complete series of forty-three photographs was published in eleven installments during two years of very serious economic problems and covered the production process from the rough and dirty work in the foundry to complex montages of electric locomotives and power generators. It ended in May 1934 with a photo-

graph of workers leaving the factory grounds after work and one of the gatemen closing the factory gate behind them. It is as if Tuggener had just documented "A Day in the Life of a Worker," a day inside the factory filled with hard work leaving no room for worrying about outside problems.

Hans Schindler was satisfied with Tuggener's work and commissioned him to design the first MFO brochure in 1934. It includes many photographs Tuggener made in the context of the first MFO series and a few technical photographs by the factory photographer. Tuggener was also responsible for the layout and overall design. The text, set in a modern type-face, is very widely spaced and printed in gray, making a contrast to the pictures printed in black and creating the impression that the text is floating behind the picture plane. Its margins are often set at an angle to either contrast with the rigid vertical lines or to echo oblique lines in the pictures on the same page-spread, as in the case of a picture dealing with the short-circuit testing station.

MFO brochure, cover, 1934

Although none of the photographs of large generators is by Tuggener, he combined two of them on the last page-spread with his own pictures in a very effective way. Directly above two typically static images of power generators taken by the company photographer, he placed a photograph of a mountain stream making its way through the rocks and one of clouds in the sky behind the dark outline of a mountain ridge. Tuggener attempted to infuse the otherwise totally lifeless photographs of these powerful machines with energy. As a result, he showed not only the power that the machines were able to produce, but also the power that was ultimately driving them: water falling from the sky and down into the valley.

The MFO brochure starts with the worker and the basic work and ends with the largest and most powerful machines the company was producing. It therefore closely follows the philosophy of *Der Gleichrichter* in stressing that the individual workers are at the center of the company and that their often simple but hard work, undertaken in cooperation with their "steel helpers," provides an indispensable contribution to the company's success. The brochure clearly reflects the MFO's intention to portray itself as a forward-looking, research-oriented company and, in comparison with similar publications of the time, it was both modern and innovative.

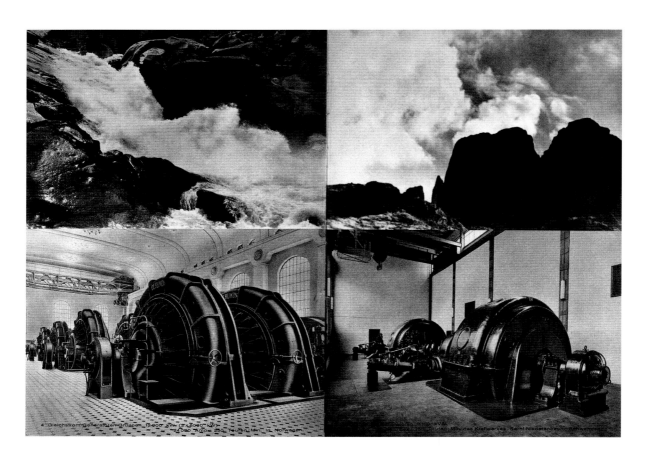

Double-page spreads from the MFO brochure, 1934

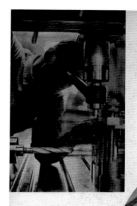

Präzisionsarbeit.

Die einzelnen Teile von Ma-
schinen und Apparaten
sollen so hergestellt wer-
den, daß bei der Montage
keine oder nur wenig Nach-
arbeit notwendig wird und daß
im Betrieb jeder Teil seine ihm
zugedachte Aufgabe erfüllt. Ferner
sollen jederzeit auswechselbare Ersatz-
teile nachgeliefert werden können. Außerdem
müssen bei der Herstellung der Einzelteile auch die im Betrieb auftretenden mechani-
schen Beanspruchungen und Temperaturschwankungen, oder die dadurch hervorgerufenen,
meist außerordentlich kleinen Formänderungen berücksichtigt werden. Das sind die For-
derungen, die an die moderne Fabrikation von Maschinen und Apparaten höchster
Qualität gestellt werden. Es müssen Vorrichtungen und Werkzeuge geschaffen werden, die es

ermöglichen, mit normalen Werk-
zeugmaschinen, Maschinenteile
herzustellen, die den genannten
Bedingungen entsprechen. Unsere
Vorrichtungen und Werkzeuge
werden auf besonders genauen
Werkzeugmaschinen gebaut, die
mit Maßabweichungen von nur
wenigen Tausendstel-Millimetern
arbeiten. Das ist eine Genauigkeit,
wie sie von Hand oder mit ge-
wöhnlichen Maschinen niemals er-
reicht werden kann. Eine ständige
Kontrolle und periodische Eichung
sorgen dafür, daß die erzielbare
Genauigkeit dieser Präzisionsma-
schinen auch dauernd erhalten
bleibt.

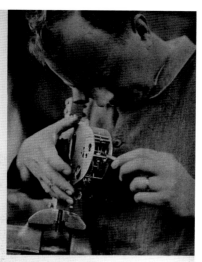

Kleinapparatebau.

Wir bauen Relais für Schutz
und Ueberwachung von Ma-
schinen und Netzen. Uhrma-
cher besorgen mit sicherer
Hand und geübtem Auge die
Zusammensetzung und Prü-
fung der kleinen Werke.

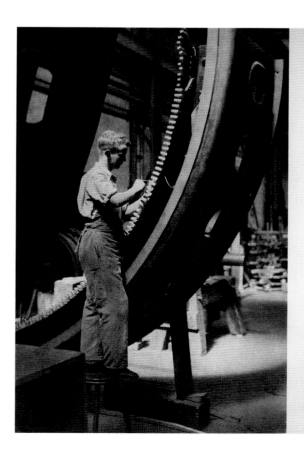

Wicklerei

Die Wicklung ist die Seele der elektrischen
Maschine. In ihr fließt der Strom, der im
Motor in mechanische Energie umgewan-
delt, im Generator aus mechanischer
Energie erzeugt und im Transformator nach
Intensität und Spannung verändert wird.
Frauen und Mädchen legen die feinen
isolierten Drähte in die Nuten der kleinen
Motoren und löten die Endstücke zusam-
men. Männer arbeiten mit den gröberen
Kupferdrähten oder Stäben, die in mittleren
und großen Maschinen verwendet werden.
Die Aufbereitung der Isolation für die Wick-
lung betriebssicherer Generatoren setzt
einen modernen Maschinenpark, geschulte
Arbeiter und eine strenge Fabrikations-
kontrolle voraus.

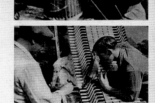

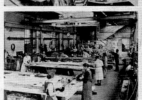

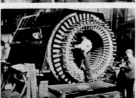

In the September 1934 issue of *Der Gleichrichter* a new reportage with photographs by Tuggener began. It was entitled "Köpfe aus Bureau und Werkstatt" (Heads from Offices and Workshops). The series was announced as another tour of the factory. While the first series had only shown pictures taken in the workshops, the new reportage was also to include photographs of "office people." Significantly, however, it was decided not to let the people speak for themselves anymore and instead to show only portraits without even mentioning any names. The introduction stated: "The individual types are not chosen because of rank or years of service, instead we are guided only by the good pictorial effect and the characteristic expression. Names play no role at all. Therefore we do not mention them anywhere. Only the heads matter to us."[2]

It is uncertain whose idea it was to concentrate exclusively on the faces or "heads" in this new series. It is possible, however, that it was Tuggener's. In June 1934 he had enthusiastically told of his successes in bringing home "a few heads" of rural Swiss types that he would like to publish.[3] And a month later he sent the picture of a worker to his new girlfriend and wrote: "Well, what are my types doing? They are sleeping. A book is out of the question, but I will be able to place them individually. But in the meantime I made new ones. Handymen, directors, and office girls; the people in the factory. Oh, it is beautiful to find *the* face among the hundreds of faces. I can make these illustrations for Oerlikon. In the enclosed picture I see the man of the machine, the man of the century. Next to it, I have a man from the smithy, a face of the time of the Greeks and Romans, a young man 1000 years ago, beautiful and noble. His face is peace and earth. But I also have the office boss, awkward, fat, broad face with a crew cut, his eyes behind glasses, and the pale face of an office girl who would like to escape from the walls of the factory."[4] The photograph Tuggener included in this letter is lost, but two of the ones he mentions, the girl and the office boss, are juxtaposed on the first page of the reportage in *Der Gleichrichter.*

Tuggener's reference to the classical models for his "noble" and "earthy" types are at first reminiscent of Nazi visual ideology, for instance the film and book by Leni Riefenstahl of the 1936 Olympic Games, or the numerous *Das deutsche Volksgesicht* (The German People's Face) books by Erna Lendvai-Dircksen. However, none of Tuggener's pictures contains any of the transfigured heroism so prevalent in both Riefenstahl's pictures of athletes or Lendvai-Dircksen's portraits of workers and farmers. On the contrary, they are factual records of physiognomies of workers

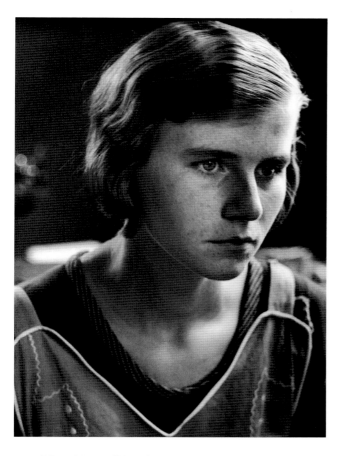

Büromädchen (Office Girl), 1934

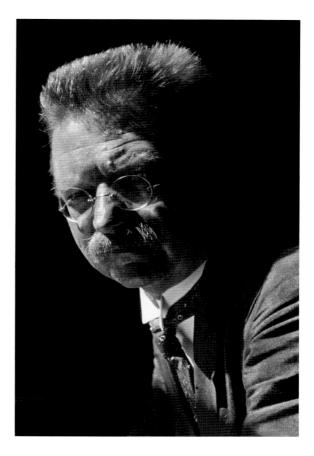

Bürochef (Office Boss), 1934

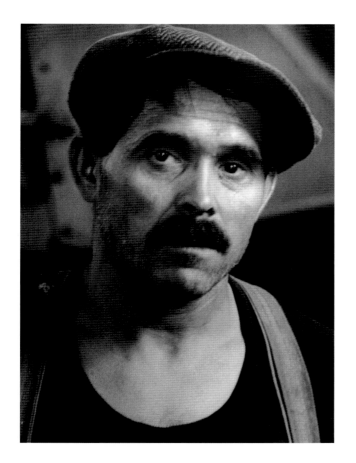

Untitled, worker, 1935

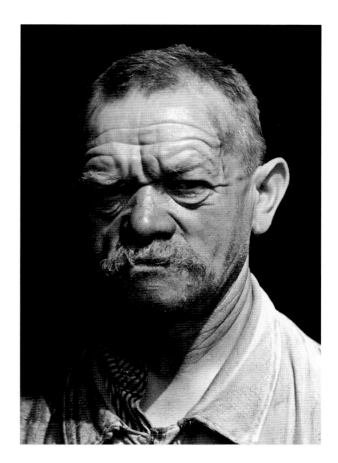

Untitled, worker, 1935

and employees that Tuggener clearly saw related to their professions, i.e. as "Berufstypen" (professional types). They are direct, close-up portraits which, thanks to the use of the Leica camera fitted with a 9 cm lens Tuggener borrowed from an engineer, bridge the distance between the photographer and the sitters.

Even though Tuggener portrayed the workers and the employees as individuals on a par with each other and even though the two different social groups appeared at the same time in *Der Gleichrichter,* the "equalizing" magazine, in the reportage they were essentially kept separate. In other words, the two series were part of a fiction constructed by the magazine about the equality of the members of the "MFO-family." Its program of appeasement was intended to make the workers feel important, equal, and at home, and thus prevent them from considering strike as a means of improving their conditions. The MFO was, of course, not the only company following these policies. In 1937 the metal industry and its unions agreed on social work contracts including an agreement to keep social peace.

Tuggener also produced several entirely different, more personal reportages not spread over several issues of the magazine, but presented on one double-page spread without text. The first was published in August 1936 and was entitled "'s Berti isch z'schbaat cho..." (Berti came too late...). It consists of eight photographs loosely arranged in two rows of three and one of two to form a cluster. Tuggener's layout was new and unique and the fact that the photographs were published as a picture story without text was unprecedented in Swiss magazines. There is no definite direction as to the sequence, although reading it from the top left-hand corner to the bottom right appears logical: Berti, the errand-girl, rushes into the factory under the watchful eye of the gateman who takes notice of her being late. The last picture showing her carrying a couple of rolls of plans is superimposed with the picture of two spheres which seem like bubbles enclosing her. In this picture Berti seems to be imprisoned in an oppressive world from which she would like to escape. As in many of Tuggener's earlier albums, the beginning and the end are significant. Here, they juxtapose the world the girl is coming from with the factory where she is locked in for the day. It alludes to the move from the outside to the inside, the "factory-prison."

In many of his texts of the 1930s Tuggener explained that he was trying to find images for his own experiences, images that reflected his own state of mind. In the case of the reportage on Berti, he wanted to express her fear when she arrived late, a feeling that he himself had experienced many times while working at Maag

Der Gleichrichter, 15 August 1936

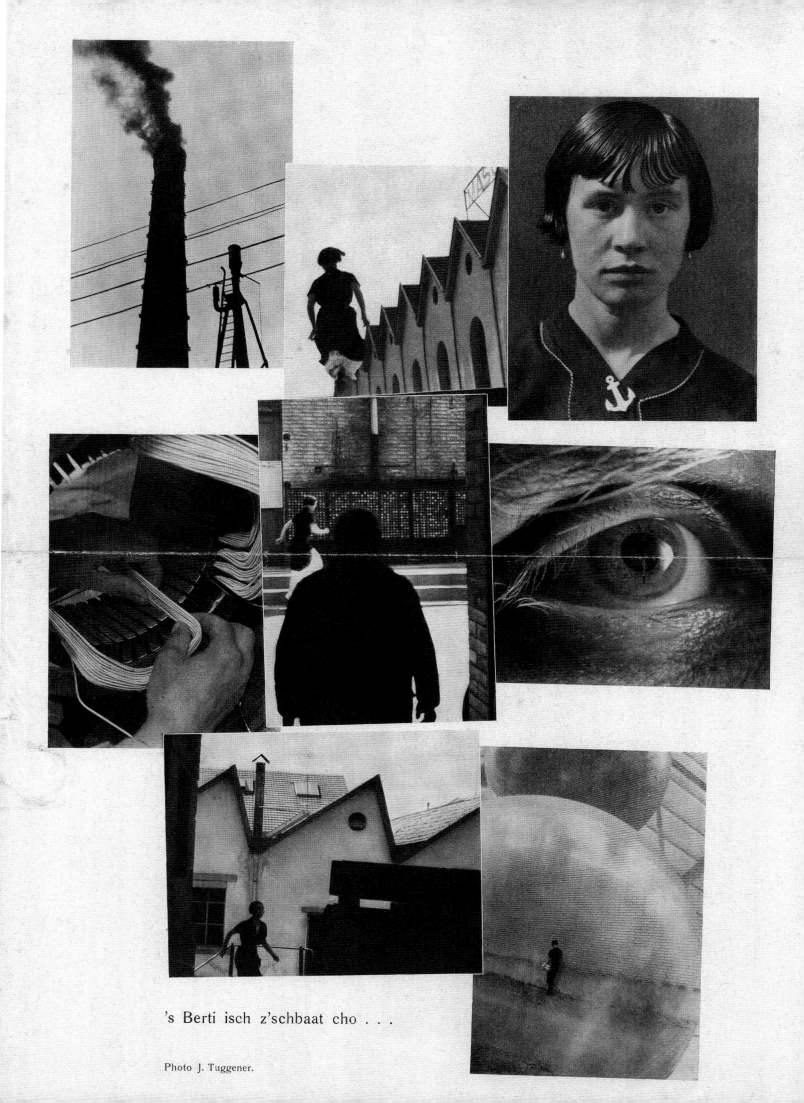

's Berti isch z'schbaat cho . . .

Photo J. Tuggener.

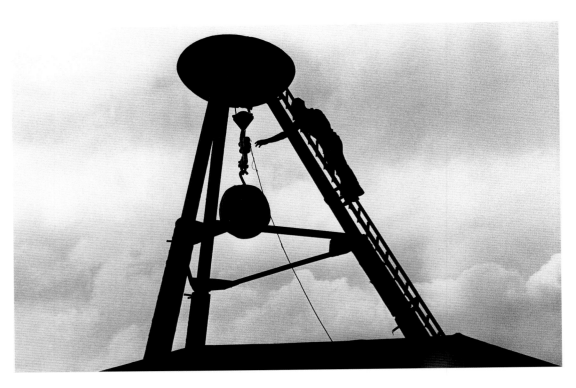

Guillotine, 1936

Zahnräder.[5] At the same time, the errand-girl carrying letters and drawings through the factory represented for Tuggener a divine element of life, a ray of light among the dark machinery of the factory. In a text for another unpublished reportage about the errand-girl he called her "Eva, the carrier of life, hope, and bloom."[6] Perhaps the name of the girl Tuggener had in mind was not even Eva or Berti, but Margrit Kunz. As he later remembered in a short text on the back of portrait of a dreamy young woman, Margrit was his "first hot love at the MFO" who "combined gentleness and sweetest love."[7]

If Tuggener described with the Berti reportage life in the factory, then his second reportage without words for *Der Gleichrichter,* entitled "Der Scharfrichter" (The Executioner), dealt with an aspect of death. With seven photographs again loosely arranged in a cluster around a portrait of a worker and a close-up view of a heap of broken cast metal parts Tuggener shows aspects of the crushing of metal pieces by a large iron ball. The focus of the layout is on the "executioner" who is seen holding the handle which sets off the iron ball. Tuggener sent a copy of this picture to his friend Wydler and described the "uncanny picture series of the guillotine": "The third photograph is the hangman in Oerlikon. He has the handle in his hand, then an iron ball weighing 10 tons falls from a height of 15 meters onto the cast pieces and crushes them into 'Bircher'-muesli."[8] Tuggener later chose this powerful portrait as the cover photograph for his first book *Fabrik.*

After the war broke out the "MFO-family" was torn apart as large numbers of male workers, as well as some directors were called up for active military service. Tuggener, too, was drafted on 2 September 1939 and had to serve almost uninterruptedly until July 1940, and then another two hundred and eighty days until 1944. During that time his photographs only sporadically appeared in *Der Gleichrichter* which became the vehicle for an "increasing spiritual closeness in the service of preserving the fatherland."[9] On the occasion of the tenth anniversary of the magazine in December 1939, Hans Schindler called for an active defense of the country because he was convinced that Switzerland would be attacked in the near future. In his article written in Swiss German he wanted to inspire the readers to fight for the independence of their company just as they would for the freedom of their fatherland, thus directing the strength of the ideology of the Geistige Landesverteidigung towards the fight for survival of the MFO.[10]

Tuggener was not interested in this openly political program of *Der Gleichrichter,* and his general conception of the factory as a human place of work and of modern technology as a thrilling experience had given way to a more critical view by the time he was drafted. While he had earlier seen speed as the essence of the modern age and technology as grandiose poetry, he now felt threatened by the results of rapid technological progress. Tuggener turned again to the Bible and looked for a text to express his new, more negative view. He found it in the story of Cain and Abel. In a letter written to a friend at Easter 1939 he described himself as Abel (the artist) who was killed by his brother Cain ("the 'worker' in the machine factory") and wrote: "The vision of our time races over Abel's corpse. The restlessness, the traffic, the rationalization, the mechanization emptied and killed the soul."[11]

This vision of life being drained from what Tuggener considered the essence of his own self, the soul, was so strong that he wanted to make it into a film with real people as actors: the director of a factory as Cain, and himself as Abel. It was to express the "two principles and ways of the world," namely the artist (Abel) striving towards the "inside," to personal fulfillment and redemption, and the worker (Cain) being trapped on the surface of the "outside" doomed to unhappiness and destruction.[12] Unlike Tuggener's and Wydler's earlier film project that was to be realized near the open sea in Brittany, this film was to be shot in the Swiss mountains, in a place that Tuggener had discovered as a personal retreat in the late 1920s. However, it was not until after the war that the two filmmakers

found the means to start shooting in the Alps and Tuggener completed the film alone in 1952 under the title *Der Weg aus Eden* (The Way out of Eden).

Even though Tuggener had in mind Hans Schindler, the director of the Maschinen-fabrik Oerlikon, to play Cain, the murderous "worker," it was in fact Schindler who in 1941 again came to Tuggener's financial rescue by commissioning him to produce and design a new MFO brochure. Perhaps intended to commemorate the sixty-fifth anniversary of the company, it was not published until the spring of 1943. In the introduction Hans Schindler stressed both the "fertile" functions of the MFO for the whole population as a tax-paying research and production company, and its human qualities in terms of being a consistent employer of a large number of workers.

All forty-nine photographs that were included in this brochure were numbered and given short but detailed descriptive titles listed on a separate page at the end. There is no text with the pictures, all but one are printed one to a page or as double-page pictures and all except two bleed to the edges of the page. The layout is therefore much simpler and bolder than in the first brochure and relies exclusively on the expressive power of large, uncropped photographs, their juxtapositions and sequence.

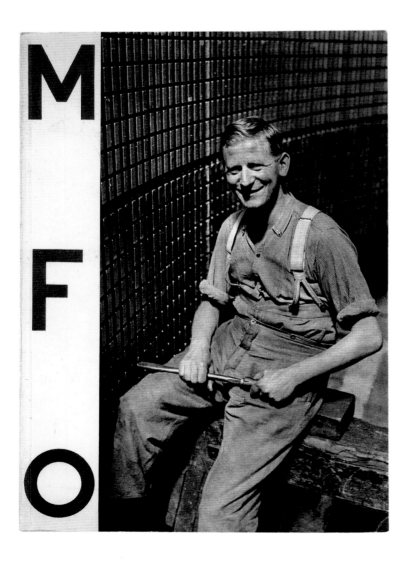

MFO brochure, cover, 1943

Fabrik

At exactly the time when the MFO brochure was published, in April 1943, Tuggener signed a contract for a book with the Rotapfel-Verlag in Erlenbach near Zurich. The Rotapfel-Verlag (originally Eugen Rentsch Verlag, named after the administrator of the company) was founded after the First World War by Emil Roniger, a wealthy entrepreneur acquainted with a number of modern artists and writers. He was very close to the French Nobel Prize winner and active pacifist Romain Rolland who had lived in Switzerland since the beginning of the war, and he published a large part of Rolland's literary work. Roniger and Rentsch also supported and published contemporary art (most importantly *Die Kunstismen, Les ismes de l'art, The Isms of Art* of 1925 by El Lissitzky and Hans Arp) and they were interested in the modern medium of photography. They regularly published photography books containing, for example, Walter Mittelholzer's aerial views or Albert Steiner's landscapes. By the early war years, the publisher's program included not only literature with a strong emphasis on biographical novels and photographically illustrated "gift books for nature-loving people," but also publications dealing with "essential questions of life," Christian thought and, in the spirit of the all-pervading Geistige Landesverteidigung, books and booklets intended to support the morale of the soldiers on active duty at the Swiss border.

According to the contract Tuggener was to deliver a finished book maquette entitled *Fabrik* (Factory) comprising eighty photographs. He was to receive 3,000 francs (which he received three days after signing the contract), fifteen free copies of the book, plus ten per cent of each softbound copy sold. We do not know why and how Tuggener was able to make such a favorable contract paying him an advance which was a third higher than what he had received for the 1943 MFO brochure, a high sum also in view of the fact that some photographs had been made on commission and were therefore paid for already. Perhaps it was a contact made in the army who did him a good turn: we know from an inscription on a group photograph taken on the 1938 repetition course that he served under a certain Captain Rentsch. But it could also have been Hans Schindler again who might have been interested in seeing photographs taken at the MFO published by a respected commercial publisher. It is certain, however, that Tuggener must have worked on *Schwarze Fabrik* (Black Factory), as he called the maquette in an earlier state, and the MFO brochure at the same time, perhaps beginning as early as 1941. A further indication for the possible involvement on Schindler's part might be the

fact that both the MFO brochure and *Fabrik* were printed by the same company, Gebrüder Fretz in Zurich.

Comparing the MFO brochure and *Fabrik* one notices certain similarities: same printing technique (gravure—although *Fabrik* is printed darker and appears almost sooty) and almost identical size, selection, juxtaposition and sequencing of some of the images. However, there are significant differences as well, the most obvious being the different covers. Whereas a friendly worker smiles brightly from the cover of the MFO brochure, it is the *Scharfrichter* (The Executioner) who confronts the viewer on the dark cover of *Fabrik* designed by the well-known Swiss graphic artist Pierre Gauchat. Unlike in the MFO brochure Tuggener was able to include in *Fabrik* a large number of photographs he had taken in the factories of other major Swiss companies, such as Escher-Wyss and Oerlikon Bührle, and a few unrelated pictures taken in entirely different contexts. Even though they were created at the same time, during the first years of the war, a careful analysis reveals that the two publications express totally different views. Whereas the MFO brochure is carried along by the optimistic and unwavering modernist belief in technology and progress, the (black) *Fabrik* expresses, as we shall see, a deep skepticism towards precisely that belief.

The seventy-two photographs in *Fabrik* are either printed one to a page or spread over two pages. They usually bleed to the edge of the page and in only a few instances there are borders on one side of a photograph. There are no page numbers and no captions with the pictures. However, all photographs are listed and titled—but not dated—in a general way on a list of plates printed on a separate bluish sheet of paper inserted in the back of the book. The entire picture sequence is structured in nine thematic sections by white pages separating one from the next. As Tuggener explained on the list of plates, he wanted these white pages to function as "empty" spaces or "Gedankenstriche" (hyphens) creating room for the viewer to generate his or her own thoughts. The varying lengths of these thematic sequences together with the picture formats alternating between the one-page vertical and the double-page horizontal, create a particular rhythm throughout the book.

The nine sections of *Fabrik* can roughly be divided into two parts, a first "historical" one dealing with the traditional textile and metal industries (sections one to four) and a second one dealing with modern technology based on electricity (sections five to nine). The first section, serving as an introduction to the book,

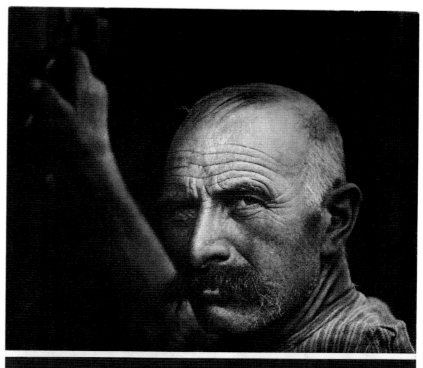

Fabrik. Ein Bildepos der Technik von
Jak Tuggener (Factory. A Pictorial Epic of
Technology by Jak Tuggener),
cover designed by Pierre Gauchat, 1943

begins with a picture of the floodgate of a small factory stream and other exterior

views of small factories and leads into the workshops of various weaving mills.

Towards the end of the section the photograph of *Der Scharfrichter,* the same as

on the book cover, is juxtaposed with a dark picture of a steam whistle. A similar

juxtaposition is repeated in the following spread: the close-up of a worker's profile

next to a smoking smokestack. The last image of this introductory section is the

central picture of the earlier reportage on Berti, the errand-girl, showing her rush-

ing by the gateman.

The photographs of the second section deal with the foundry and the smithy, and

the third section has to do with steam power: a picture of a steam locomotive and

two photographs taken from a moving train are followed by a photograph of a rac-

ing car driver behind the steering-wheel and the image of racing cars reduced to

mere streaks on the page by their speed. The final image of this section is a close-

up of the cylinders of a high-pressure steam turbine on which Tuggener placed a tiny naked doll facing the viewer; the right-hand page is empty.

The fourth short section, consisting of only two almost abstract close-ups of vane wheels and rotors of steam turbines, is followed by the fifth which opens with a picture of a huge brick wall and a door which Berti is about to enter. This picture is followed by a page-spread where two photographs are juxtaposed in such a way as to give the impression of only one image showing the welding of the huge casings for electric power generators. The central page-spread of the following section shows the office girl from the reportage "Heads from Offices and Workshops" staring at a disproportionally big counter on the opposite page. The following photographs show increasingly specialized and sophisticated electric machines, some operated by concentrated workers, others totally automatic. This section ends with a photograph of a mountain stream cascading down into the valley.

In the seventh section a photograph of a traditional Lötschental mask is juxtaposed with another image of a mountain stream. Two images of the assembling of large transformers and switches end it and lead to the eighth section dealing with a modern power station. A photograph of the pole wheel of a huge power generator is followed by double-page images of a monumental dam in the mountains and huge black generators inside a power station. This section is brought to a final climax by a photograph of three airplanes rising into the sky in a dynamic curve.

The ninth and final section consists of a juxtaposition of two photographs: the one on the left shows rows of standing grenades in front of which Tuggener again placed the naked little doll, this time facing the shells. The worker in the photograph on the right—with wide open, questioning eyes and a furrowed forehead—seems to be looking over the doll and over the grenades into the distance.

In the short but very perceptive introduction to *Fabrik* Arnold Burgauer, an independent journalist regularly writing for *Die Tat* and the *Neue Zürcher Zeitung,* gave many clues as to how the book can be interpreted. He saw this *Bildepos der Technik* (Pictorial Epic of Technology) as the book was subtitled, as "a piece of the history of time and mankind, as a glowing and sparking documentary report of the world of the machine, of its development, its possibilities, and its limits," as "a mental voyage through time" on which the viewer has "a hundred possibilities to encounter the theme of man and machine in all its dimensions."[13] He described the workers in Tuggener's photographs as "faces scurrying by, masks, as if hammered out of metal, giants standing at their hearths, ghostly, fearful, serving, withered, believing, in spite

of force and hardness. ... What wealth of intuition and association!"[14] And about Tuggener he said that he possessed the "tense gaze of the hunter and the dreamy eye of the artist." Burgauer hit upon a central point in Tuggener's background that informs the structure of the book: "Chains and wreaths of images are woven, questions rise, thesis and antithesis. Each has its own character, its mold, its special climate, its sadness. ... Without wanting it, Tuggener has applied the laws of silent film to the sequence of still images and, in so doing, has discovered anew the primordial cell of art, the rhythm."[15] Tuggener consciously excluded all text from the series—in fact, as Burgauer remembered later, Tuggener was even against a written introduction.[16] Burgauer understood Tuggener's intention of creating an inner landscape by way of associations provoked by the outer, the material world represented in the photographs. He attested to the book's calm grandeur and noble quietness showing all signs of perfection and bringing it close to the masterworks of Jean Renoir, Robert Flaherthy, or John Ford. At the same time, he was reminded of Käthe Kollwitz and Frans Masereel because of Tuggener's "honesty of creative skepticism." Surely, it was also the absence of words, the stark contrasts of black and white, and the somber mood that related *Fabrik* to Masereel's series of woodcuts. The most important visual tools employed by Tuggener in *Fabrik* were in fact borrowed from film, namely the concept of montage which the Russian film director and theorist Sergei Eisenstein had developed since the early 1920s. This concept had been discussed in numerous popular publications such as Hans Richter's 1929 *Filmgegner von heute—Filmfreunde von morgen,* and textbooks for amateurs such as Alex Strasser's *Filmentwurf Filmregie Filmschnitt* of 1933 that Tuggener, as a member of an amateur film club, may have been familiar with.

In 1943, the year *Fabrik* was published, Eisenstein described the basic aim and function of montage as "the need for connected and sequential exposition of the theme, the material, the plot, the action, the movement within the film sequence and within the film drama as a whole" in order to produce "a maximum of emotion and stimulating power." In this context, Eisenstein particularly emphasized "the fact that two film pieces of any kind, placed together, inevitably combine into a new concept, a new quality, arising from that juxtaposition" and he quoted the juxtaposition of a picture of a grave and the picture of a weeping woman leading to the inevitable association of a widow.[17] Tuggener's thorough use of montage was noted when one critic remarked: "Tuggener's picture book has the infectious power of a Russian film."[18]

Already in the opening picture of the book there is movement, water slowly flows by a floodgate. Following the water from the left-hand bottom to the upper right, the viewer is drawn into the picture and compelled to turn the page to get into the book. The movement of lines in many of Tuggener's photographs lead from one picture to another, connect them and sometimes even create the impression that two different pictures next to each other are one, thus producing a line of thought, a plot, to use Eisenstein's term. The viewer is moved from one space into another without noticing it, as if following a moving film camera. Water itself represents the continuity of the story on the thematic level, leading through the whole book from the tame factory canal to the wild water in the mountains filling the huge reservoir, a metaphor for the development depicted in the book and the building up of a powerful energy.

Tuggener had experimented with the idea of montage to evoke certain associations in earlier reportages. However, in *Fabrik* there are many juxtapositions creating very different associations that accumulate in the viewer while looking at the book from page-spread to page-spread. They create in the end, as Hans Richter wrote, an impression that transcends the "particular" and becomes "typical."[19] *Der Scharfrichter* (The Executioner) and the steam whistle represent the beginning of work while the next spread, the worker and the smokestack, evoke the hard and dirty factory work itself. One can associate the monotony and stupidity of work with the office girl staring at the counter, and the juxtaposition of the mask and the mountain stream creates the impression of the demonic power of nature that can be associated with both electric generators or the war. The empty pages between the sections serve as surfaces for the projection of our own associations, just as after-images appear on the retinas of our eyes. In the final spread, in Tuggener's "last and most bitter parable," as Burgauer called it[20], all the images the viewer is able to remember and the accumulated associations come together and find a resolution either in the pensive man's face on the right or in the little doll on the left. The whole history of technology and mankind, represented here by a tiny, naked figurine and an old man, passes in front of our eyes and is constantly questioned by the stubborn presence of the grenades.

As a model for filmmakers Eisenstein described how Pushkin created rhythm in his poems by using an intricate montage technique: "Rhythm constructed with successive long phrases and phrases as short as a single word introduces a dynamic characteristic to the image of the montage construction. This rhythm serves to

establish the actual temperament of the character depicted giving us a dynamic characterization of his behavior."[21] Using different lengths of sequences from two images to twenty-one, different formats (horizontals and verticals), different camera positions (close-up, medium shot, long shot), and variations of light and shadow, Tuggener created a particular rhythm that begins with a slow pace, then steadily picks up to reach a first climax in the fourth section (a spread with two almost abstract pictures of machine parts), then slows down again considerably in the sixth section (mostly dealing with precision work), increasing in speed and reaching with one more slight recession the final climax in the last page-spread. The rhythm thus gives a dynamic characterization of the factory's behavior, to use Eisenstein's words, expressing the increasing speed of technological progress which leads—possibly—to the chaotic climax of war.

Additional clues to the meaning of *Fabrik* can be found in images taken from earlier reportages based on Tuggener's own experiences. The cover of the book sets the tone. It is the executioner who opens the curtain to the dark drama in which the errand-girl Berti represents fleeting life. After rushing into the factory (and the book) at the very end of the first section, Berti does not appear again except in the exact center of the book. There a kind of love story seems to develop that finds its resolution in a double portrait of herself and a young worker. As in the earlier reportage on the factory errand-girl the sequence refers to Tuggener's Eva, "the carrier of life, hope, and bloom." Also connected to this idea is the picture of the office girl who would like to escape from the factory which was one of the first images in the series "Heads from Offices and Workshop." If we take Tuggener's earlier interpretation of Eva as "life," then, at least when high precision work measured only in numbers is introduced into the factory (represented by the counter, a forerunner of the modern computer), life is drained.

The images of the racing car driver and the cars in full speed can be related to Tuggener's thrilling experience of the fatal accident of one of the drivers at the car race in Bern in 1934. Burgauer described the face of the driver in *Fabrik* as the "the grotesque face of record that extinguishes itself." The danger of extinction by speed is, of course, also alluded to by the little vulnerable doll which appears for the first time immediately following the racing cars.

The photograph of the airplanes provokes another set of associations. Taken at the 1937 aerial show in Dübendorf the picture shows a demonstration of the use of fog to obscure the view of anti-aircraft forces on the ground. Whereas in 1937 the

movements of the airplanes in the sky were perceived as an aesthetic experience, in 1943 they were certainly associated with enemy bomber planes even in neutral Switzerland. Therefore, the image of the elegant airplanes in relation to the grenades and the little doll could only mean one thing: the dangers of war for a vulnerable people.

In the whole book, however, there is not one photograph of an obviously dangerous situation or of destruction. Yet the order and the sequence of the photographs which all deal with the theme of man and machine, their juxtapositions, and their rhythm create an intense feeling of impending danger that the viewer perceives as directly related to technological progress. It must have been an unsettling feeling in 1943 when danger had become palpable with war raging through Europe. Sirens now also warned of air raids as well as sounding to announce the beginning of work.

Tuggener's juxtaposition of the Lötschental mask—he entitled it *Dämon* (Demon)—with a mountain stream can be associated with the meaning of water as the "national" energy in the spirit of the Geistige Landesverteidigung. Several prints of this picture of the mask exist. Tuggener called one of them *Tell* and on another one he wrote *Urkraft, Schweizergeist* (Elemental Force, Swiss Spirit). Electricity produced by mountain water, "white coal" as it was called at the time, ensured the country's self-sufficiency and independence in terms of energy. The huge water reservoirs were elements in the government's military defense strategy since in case of an attack the dams could be blown up to flood the valleys. However, Tuggener did not just describe an outside danger against which a strong interior would prevail but he evoked a danger that threatened everybody, mankind as a whole, the Swiss included. At the end of his review in the *St. Galler Tagblatt* Burgauer stated that the future of the world depended on "the courage and watchfulness of this living and anonymous worker" shown in the last picture of *Fabrik* "who should not be honored less than the unknown dead soldier."[22]

Fabrik is not propaganda, it is a work of art that forcefully expresses Tuggener's concern, as Burgauer puts it, for the "the responsibility of man for history." He sees him as "the humanist among the photographers." Perhaps Tuggener is also, at least at this point, a moralist. Burgauer though leaves it open when he concludes his introduction: "We cannot say what goes on in the head of that contemporary standing behind the mountain of grenades, whether there are beautiful thoughts topped by high ideals or thoughts clouded by hatred and prejudice."[23]

Tuggener's *Fabrik* expresses, in a way, a pacifist ideology that seems in tune with Romain Rolland's writings that were also published by the Rotapfel-Verlag. During the era of the Geistige Landesverteidigung, pacifism was not a popular movement and fitness for military defence was called for. However, not even a decade later, during the time of the cold war, Tuggener's key image in *Fabrik,* the doll standing in front of the grenades, was interpreted in exactly these pacifist terms. Tuggener kept a newspaper clipping from 1951 with the picture entitled *Ein Zeitbild* (An Image of Our Time) and the following text: "And still an element of peace prevails. What this little creature guards and seemingly directs with its raised hands are not organ pipes. It is like a request, like a deeply felt plea in these roundish little arms: may you not be used to destroy the beautiful great life, spare the people, their homes, and their churches. They have but one life!"[24]

Burgauer had quite naturally discussed *Fabrik* as a work of art, an idea that other critics totally rejected. As the numerous clippings of reviews in Tuggener's estate show, Burgauer's preface was criticized as "hymnal preface bursting with exaltations" or dismissed as "bombast." However, due to the absence of any other accompanying texts or captions, it provided the framework for most of the reviews in which Tuggener was seen as the "Frans Masereel of the camera" who was "artistically in love with effect, association, and symbol." He was perceived as a "director [of a] shattering movie," as an artist (originally a painter) who with photographic means created a "true work of art" that was an "artistically perfect epic of our time."[25]

Many critics regretted the fact that Tuggener did not provide explanatory captions. However, the general tenor was: "The photographer as poet! He has no need for words for the effect of the images alone is strong enough to express what he has to say."[26] Playing with the words "Dichter" (poet) and *"Ver*dichter" ("compressor," meaning someone who compresses, condenses, intensifies, or heightens), the prominent critic of *Die Tat,* Max Eichenberger, described Tuggener as "in the deepest sense of the word a poet, a compressor of reality. He compresses reality until it changes, like air that gets strongly compressed, into another state of matter and becomes super reality."[27] With this assessment, Eichenberger alluded to both Tuggener's intention to reveal a kind of "inner" reality as well as to the means he was using to achieve this which are in part derived from Surrealism.

Generally, *Fabrik* was seen as an important and unique contribution to both contemporary photography and book design that could serve as a model "to teach us

to see again."[28] And Friedrich Dessauer wrote in a magazine devoted to spiritual life and culture: "One can hope for much from this young Swiss artist. He has the gifted eye that not only sees but also knows."[29] Not surprisingly, however, a devastating salvo came from a critic who must have been in a way related to the circle around Adolf Herz, the conservative editor of *Camera* magazine in Lucerne. Right at the beginning of this anonymous review the author made it clear that photography had nothing at all to do with art: "Photographs are documents. ... They are 'transfers of reality,' and with no trick in the world can they deny their origin and meaning." Referring to the "trick" of placing the little doll in front of the grenades, he claimed that it was impossible to attribute an "intellectual quality" to photography that "due to its nature" it could not have, and that, if it *was* art, could only be "kitsch." Also this author would have appreciated captions explaining the photographer's thoughts. However, he concluded "in order to communicate thoughts, one would have to have some. Here, they were obviously missing."[30]

Simultaneous publications competing with Tuggener's book also had an impact on the perception of *Fabrik.* Earlier in 1943, even before *Fabrik* had been published, Arnold Kübler devoted the May issue of *Du* magazine to the Swiss worker including many photographs by Werner Bischof and Paul Senn but only two by Tuggener. Kübler argued that even though the Swiss were spared direct involvement in the war, one had to deal with the reality of the war and learn from the changing situation. One had to accept the fact that technology and industry were also parts of "Heimat," although "the war shows the face of the age of technology naked and in its total violence and cruelty."[31] The industrial workers, too, were part of the Swiss population and only mutual understanding, argued Kübler, would guarantee the survival of the country. Thus Kübler wanted this May Day issue to initiate a dialogue between the bourgeoisie (the people who could afford to buy the magazine) and the industrial worker, the product—and victim—of the age of technology.

This dialogue continued in the same year with Paul Senn's book entitled *Bauer und Arbeiter* (Farmer and Worker), which contained two sections of photographs, one of farmers and one of workers, and an introduction by Kübler. The book portrayed the farmer as the "breadwinner of the people," a hero who had given Switzerland back its self-sufficiency and therefore its independence from the countries at war. At the same time, it deplored the living conditions of the uprooted industrial workers who had lost all contacts with "mother earth." The book argued in favor of improving the social conditions of the workers but, above all, it wanted to "bring

the farmer and the worker closer together, to unite them in common action in the state." Arnold Kübler exclaimed: "If they were one, how strong would they be, how strong would the fatherland be."[32]

This message in the spirit of the Geistige Landesverteidigung was, of course, understood very clearly at the time and many critics commented upon the uplifting spirit of the book. Whereas Senn's "human" photographs in *Bauer und Arbeiter* were perceived as expressing a forward-looking, positive mood in "Dur" (major key), Tuggener's *Fabrik* was criticized by some for lacking a human element and for indulging in the more thought-provoking, introverted "Moll" (minor key).[33] Thus, in direct comparison with Senn's book that was in tune with the spirit of the time, *Fabrik* was always placed second. Except in one instance: Max Eichenberger of *Die Tat* remarked that in *Bauer und Arbeiter* the "und" (and) was only wishful thinking; that Senn's book in fact clearly demonstrated that the farmer and the worker could never be united since no picture showed them together, and the two groups were clearly kept separate. Eichenberger thought the book was somewhat naive, because the economic and political interests of farmers and workers were totally incompatible, and "invisible walls" forever separated their worlds.[34]

For Tuggener, *Fabrik* was a critical success, but a commercial failure: it originally sold for SFr. 14.50 (clothbound) and SFr. 11.50 (paperbound), but was remaindered after the war for SFr. 4, and later given away for practically nothing. Tuggener wrote to Dr. Guggenbühl, the editor of *Schweizer Spiegel:* "At present, my factory book is a failure, but I am proud not to have given in a finger's breadth. The 'faithful to myself' shall prevail, even if it will be on foreign soil or in history."[35] This unrelenting "faithful to myself" may ultimately be one of the most important aspects of *Fabrik.* It is Tuggener's personal and independent expression of his innermost feelings toward a subject he was deeply familiar with. It demonstrates most clearly his successful reaching beyond surfaces to grasp something more universal, something that turned objective observation into subjective experience.

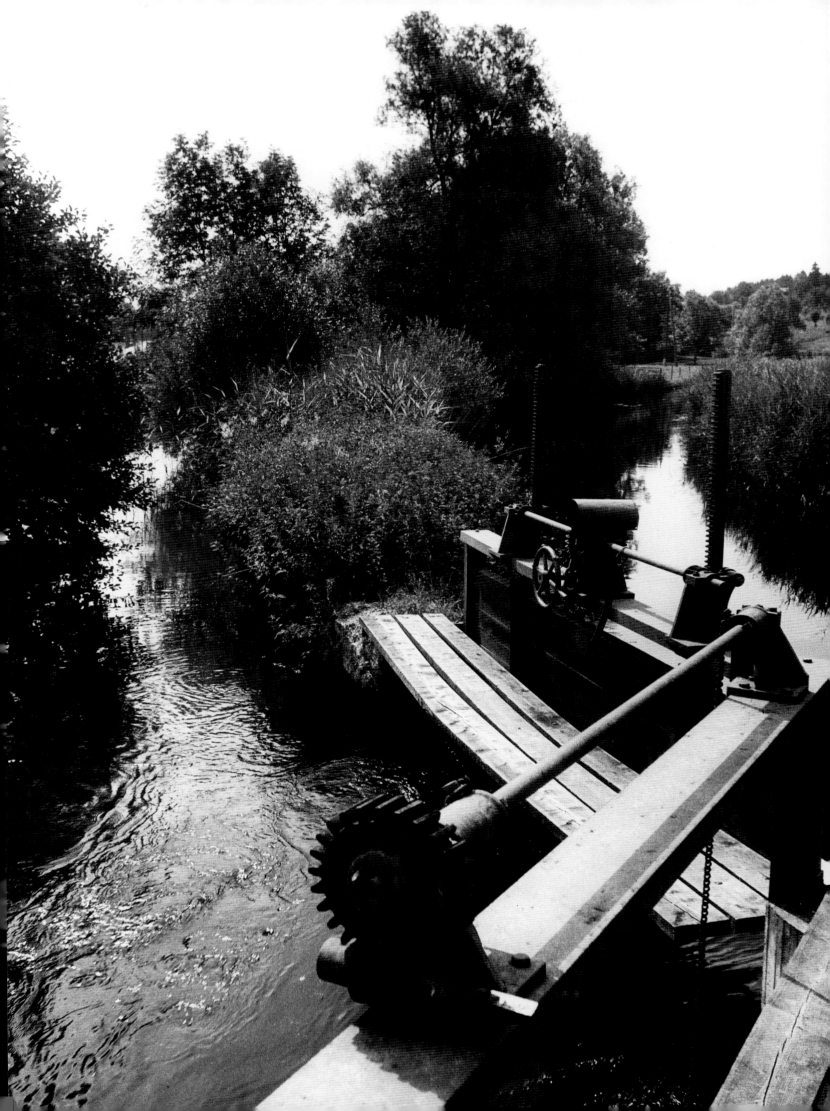

Verbothener Eingang

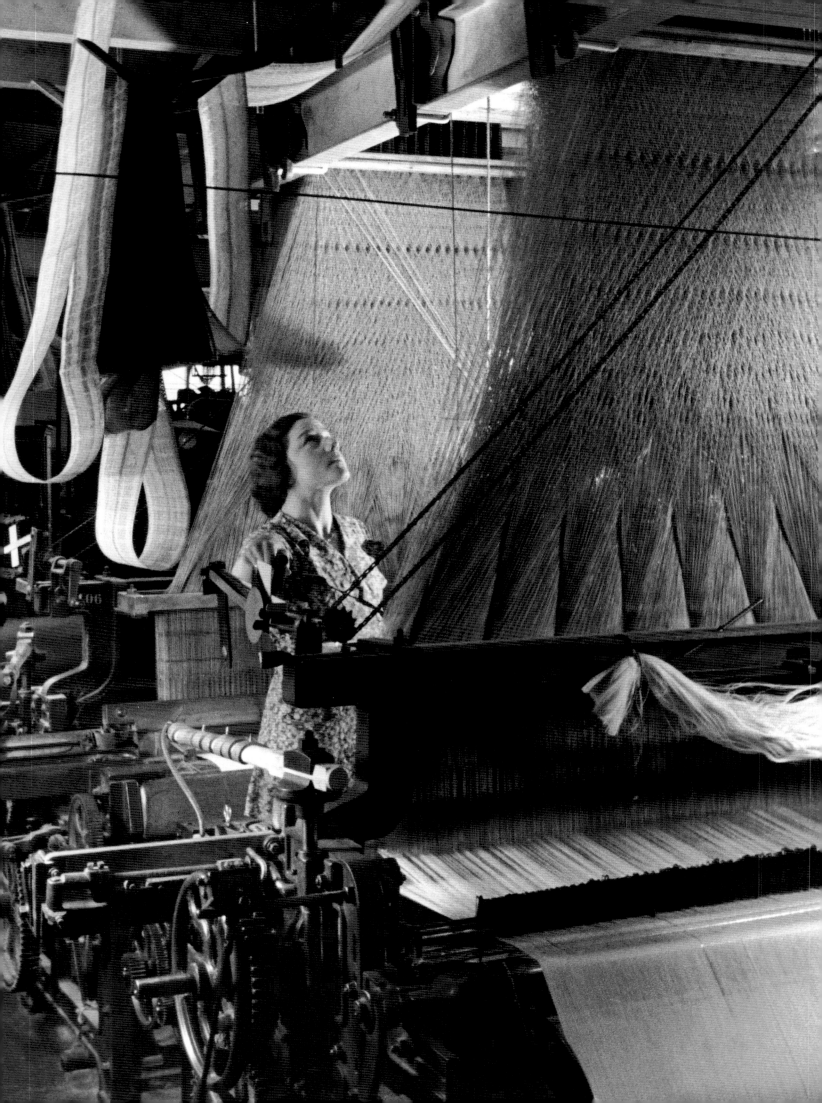

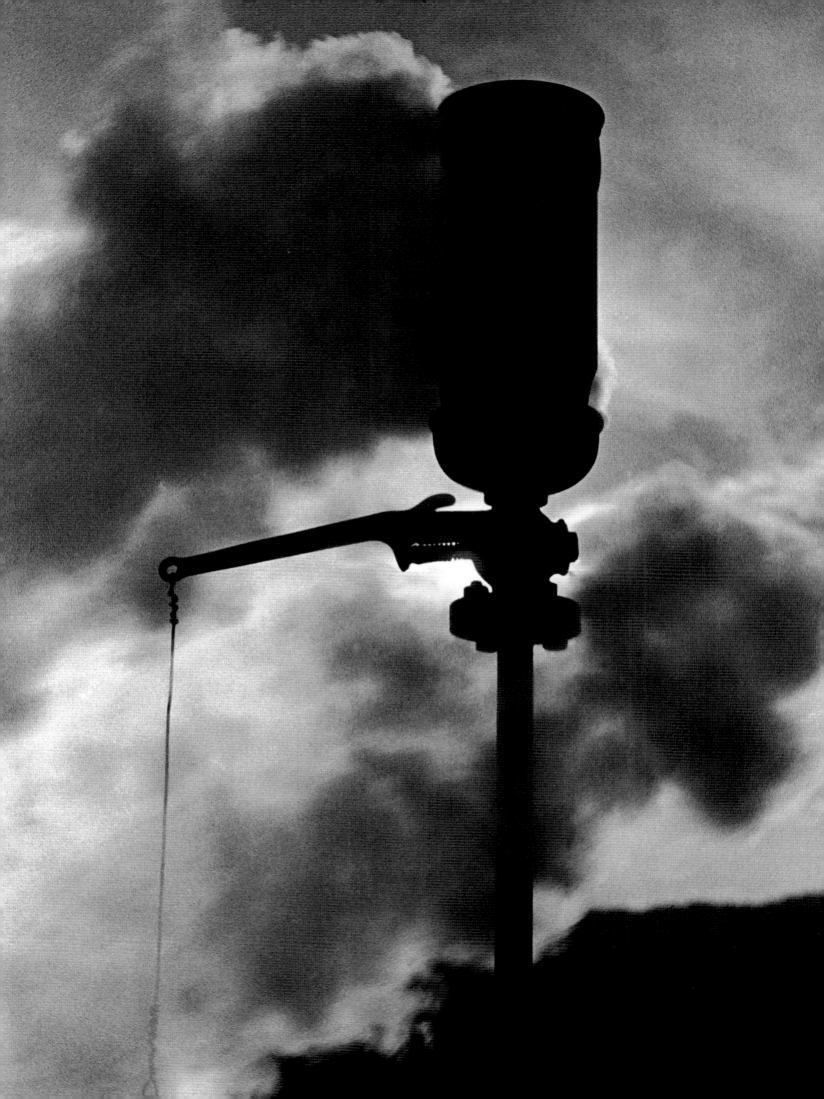

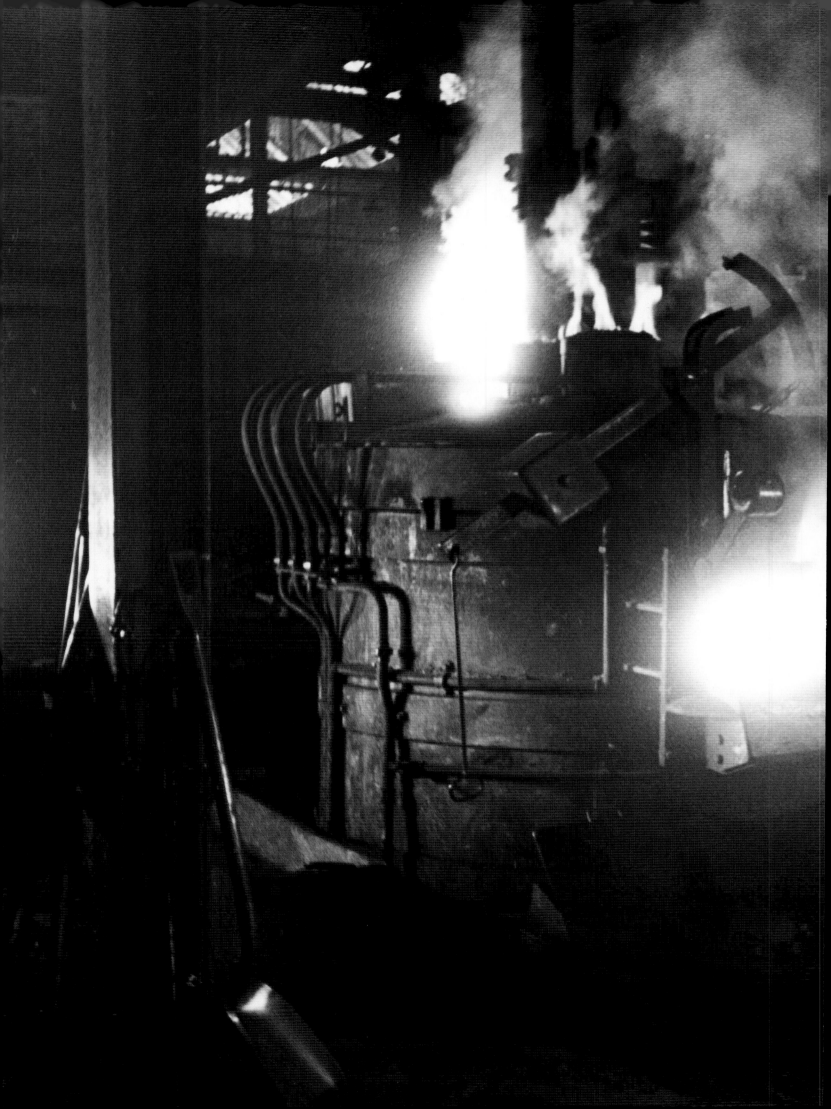

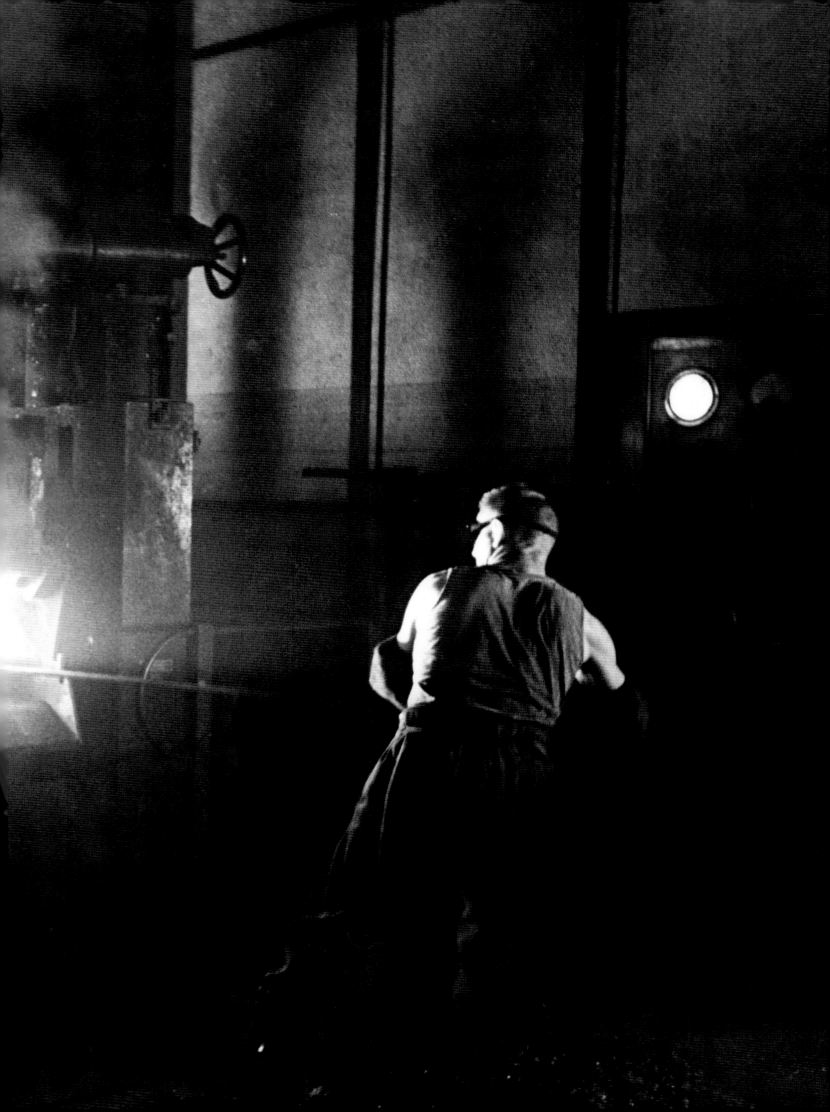

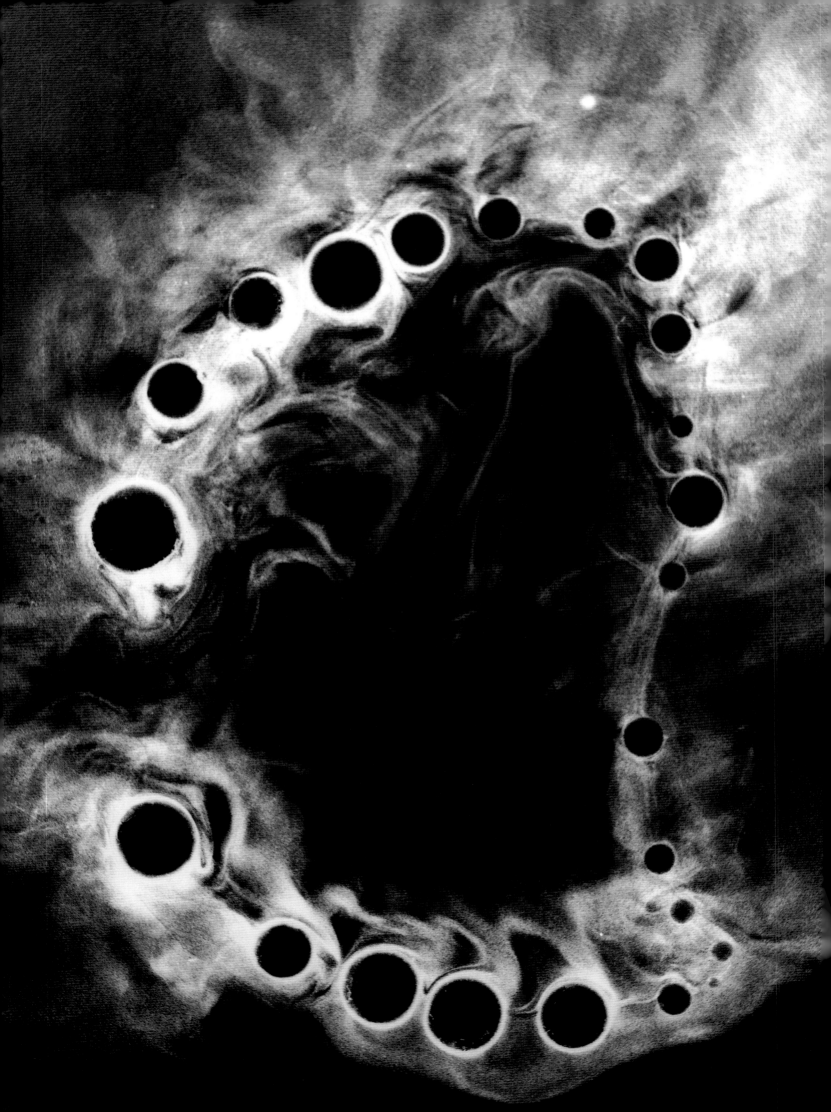

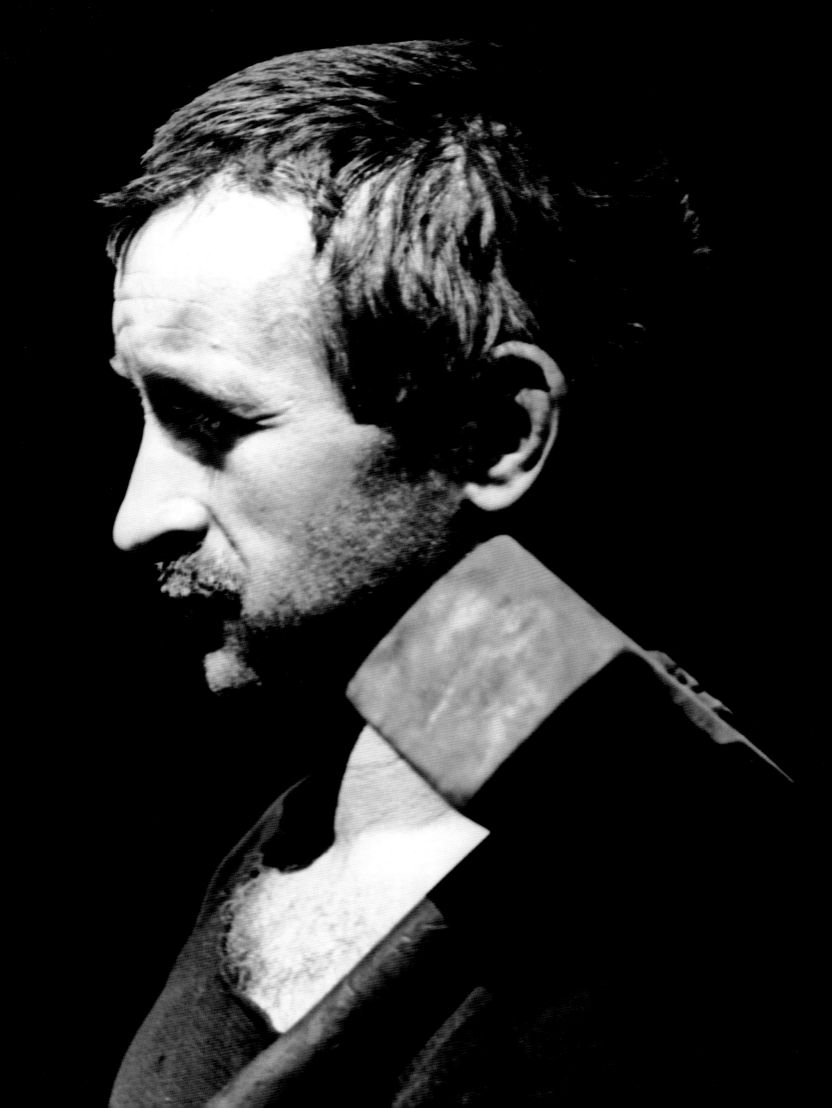

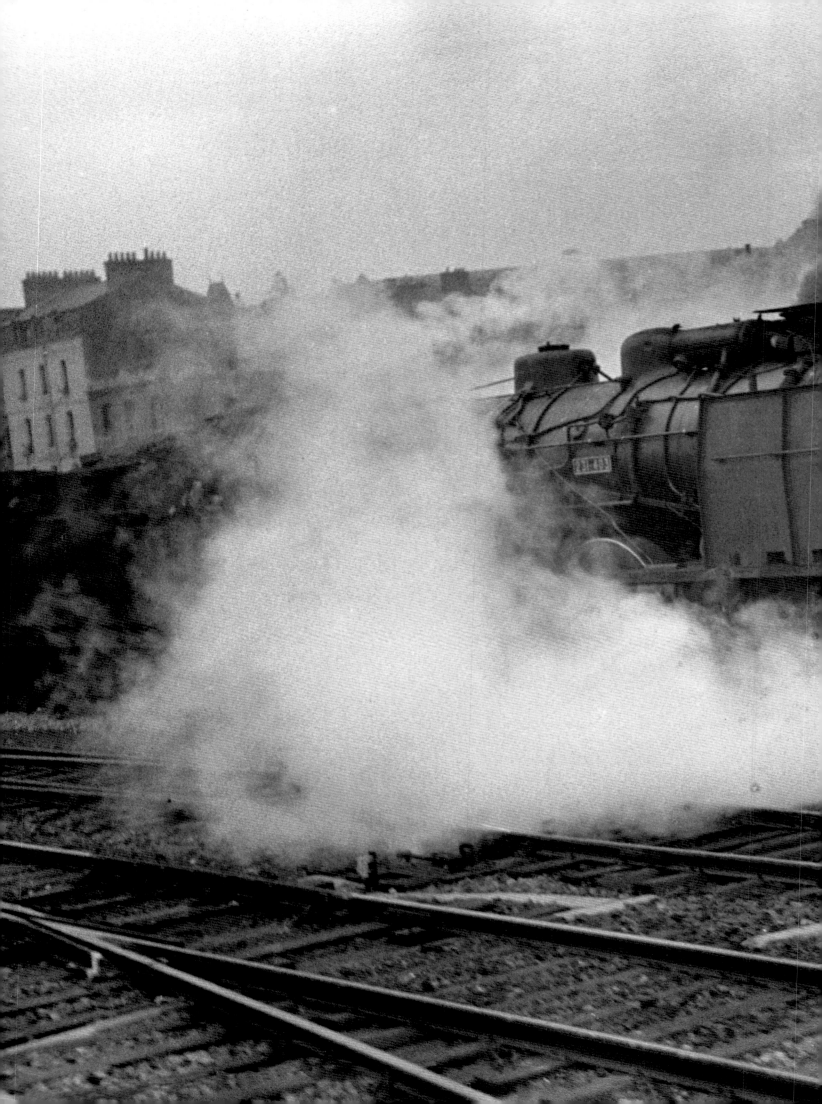

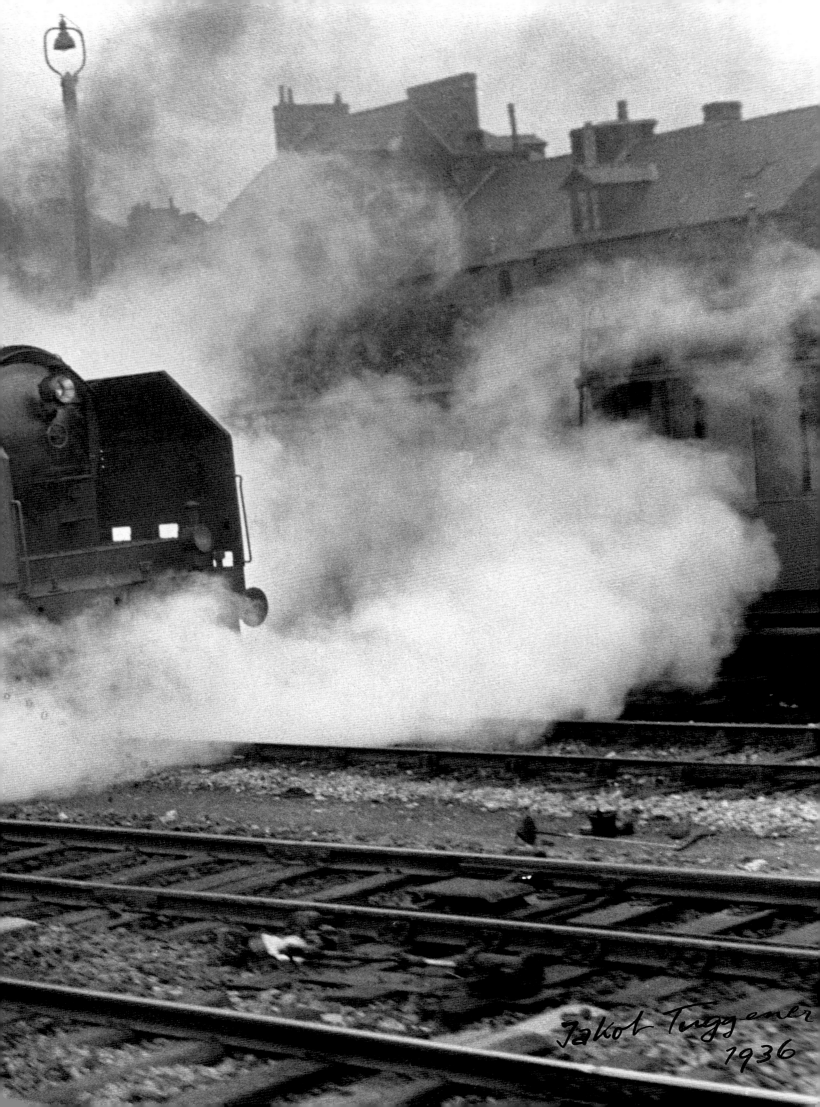

Jakob Tuggener
1936

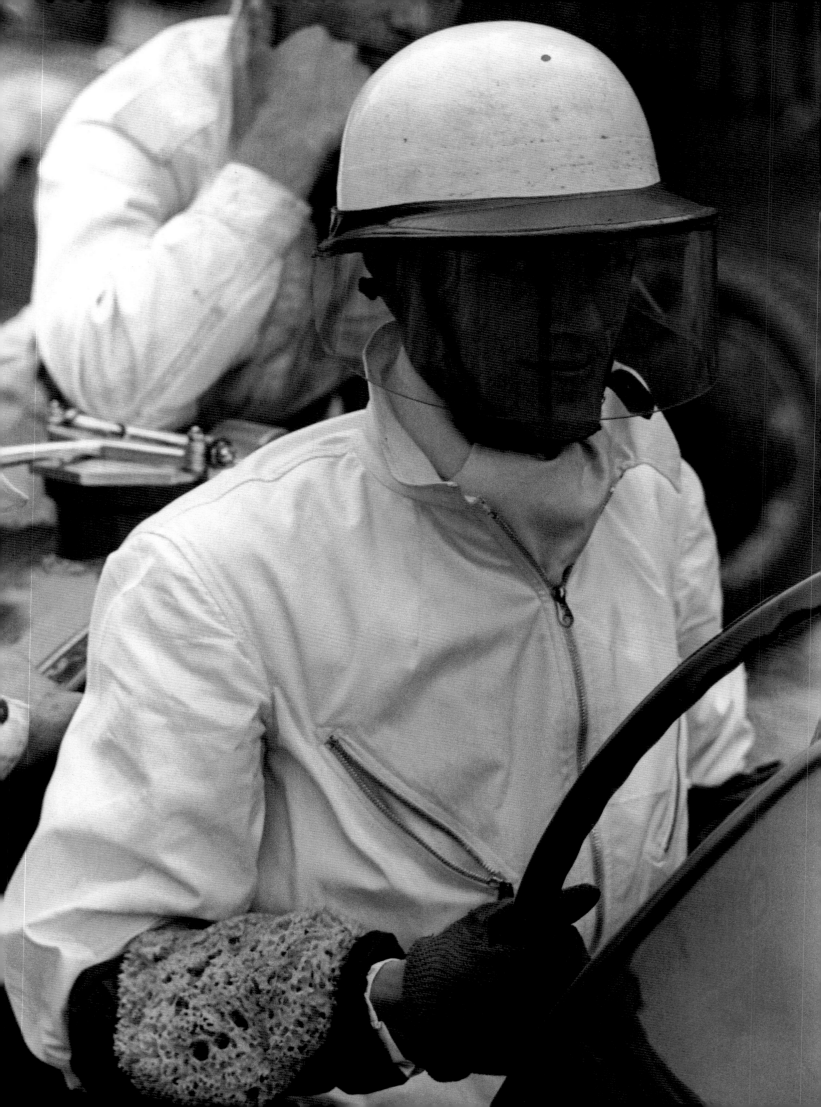

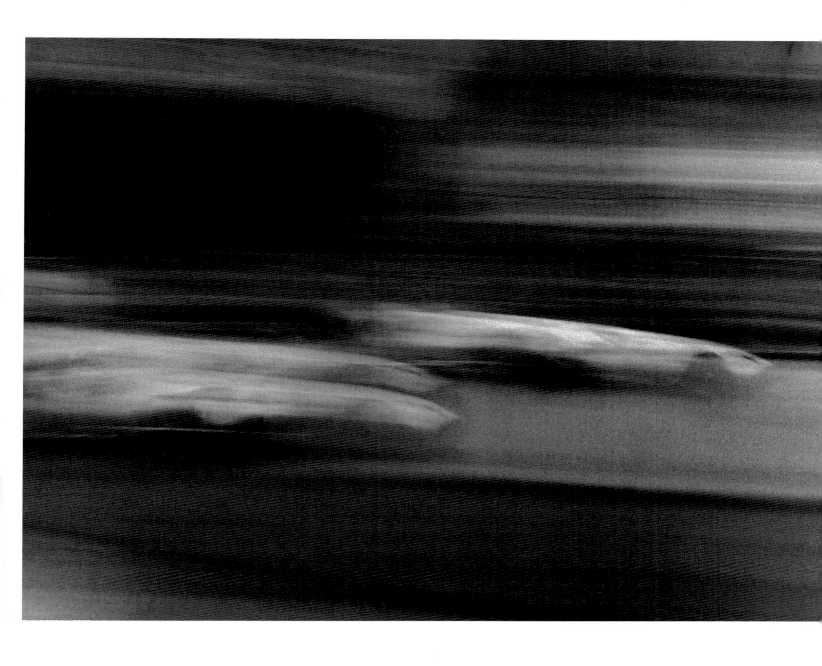

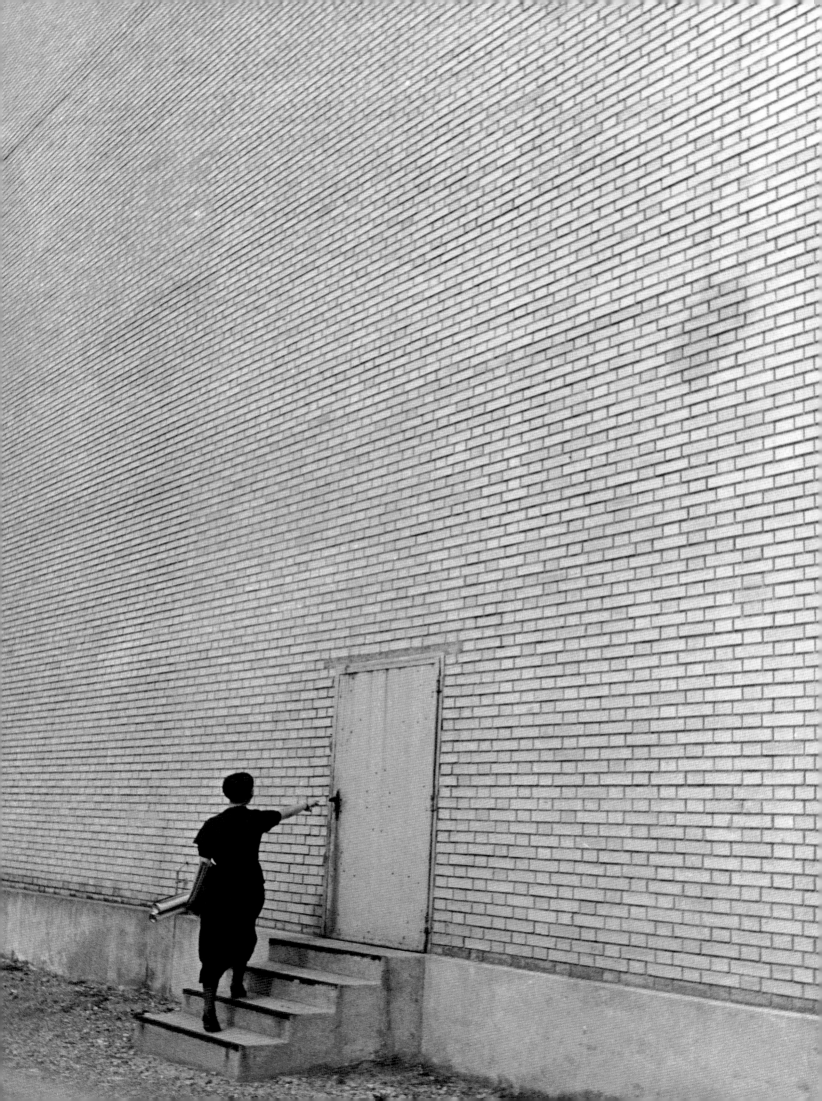

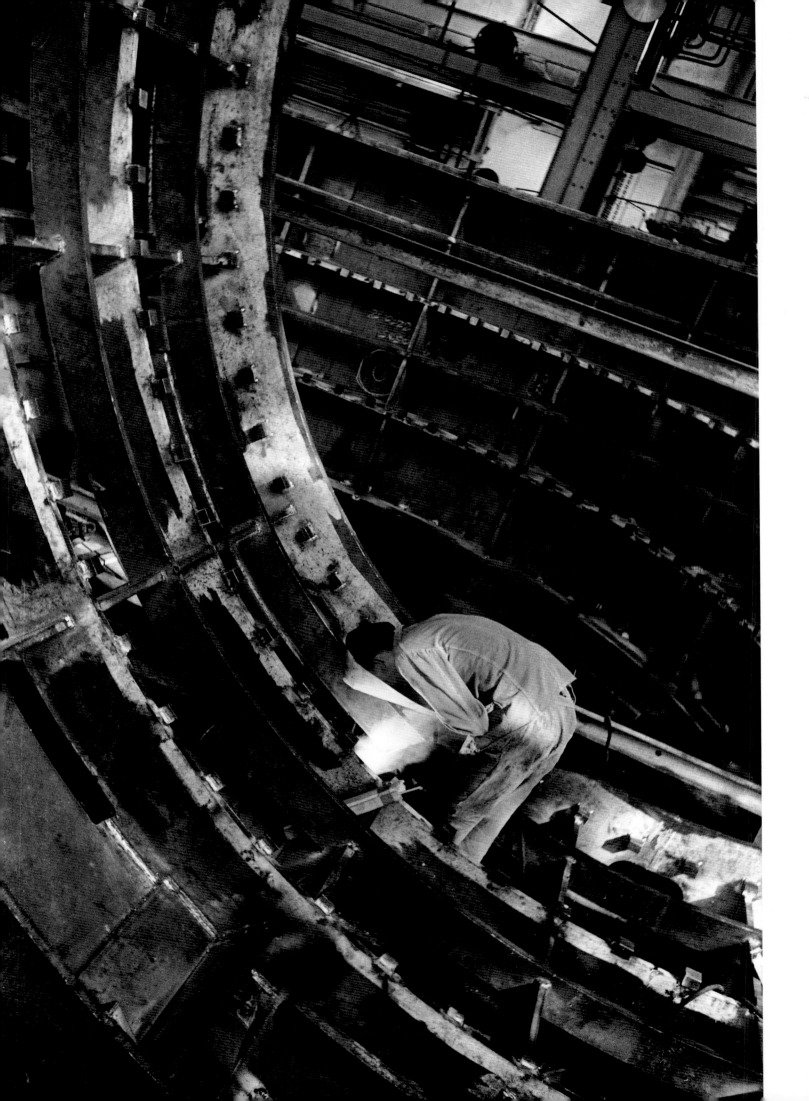

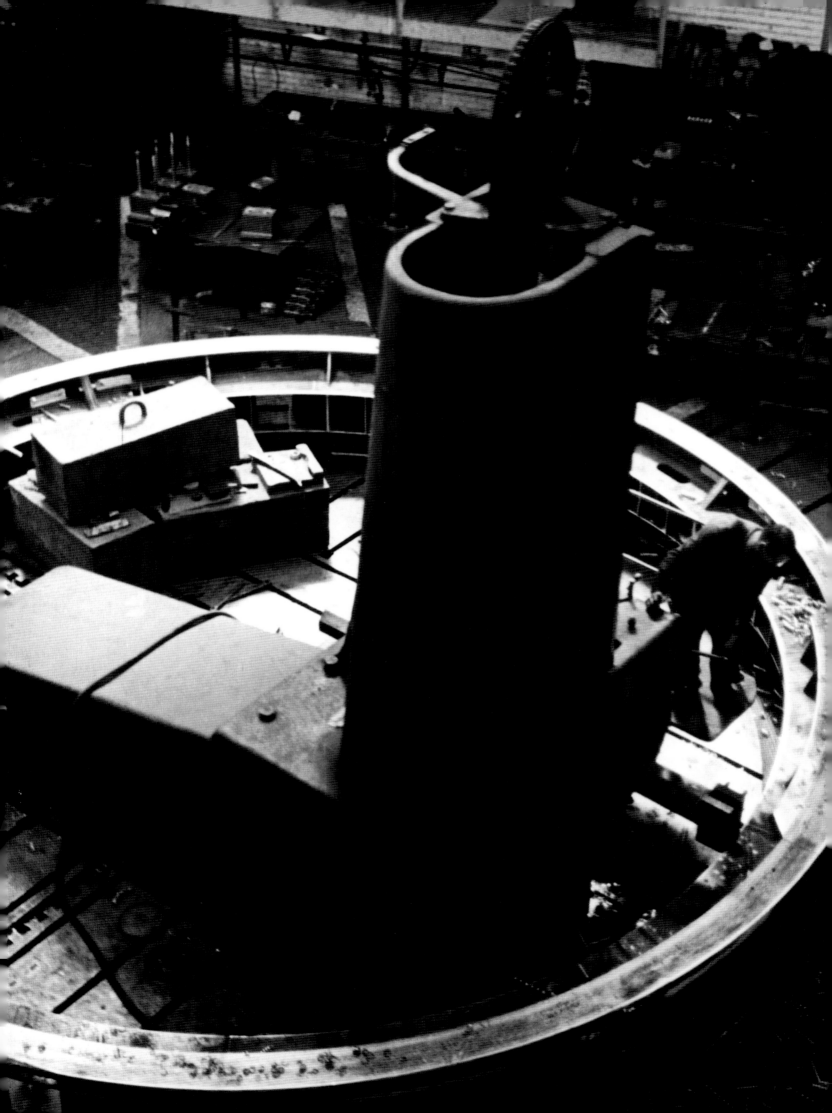

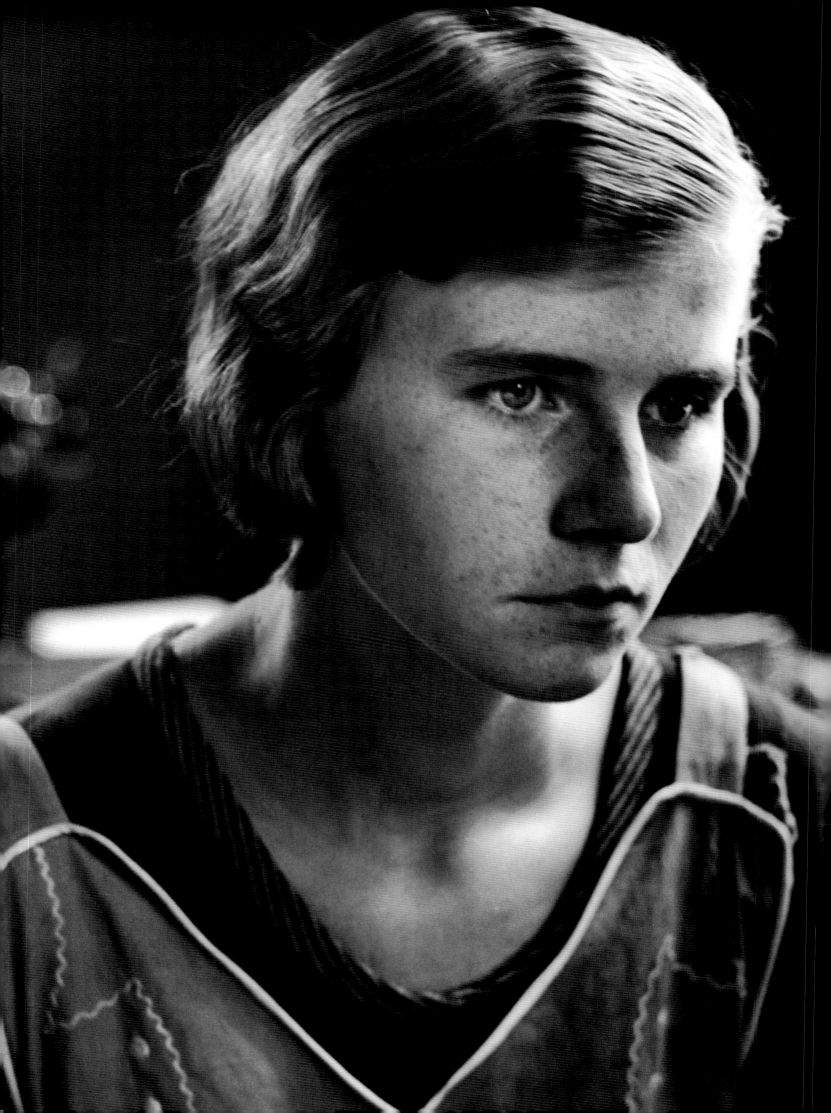

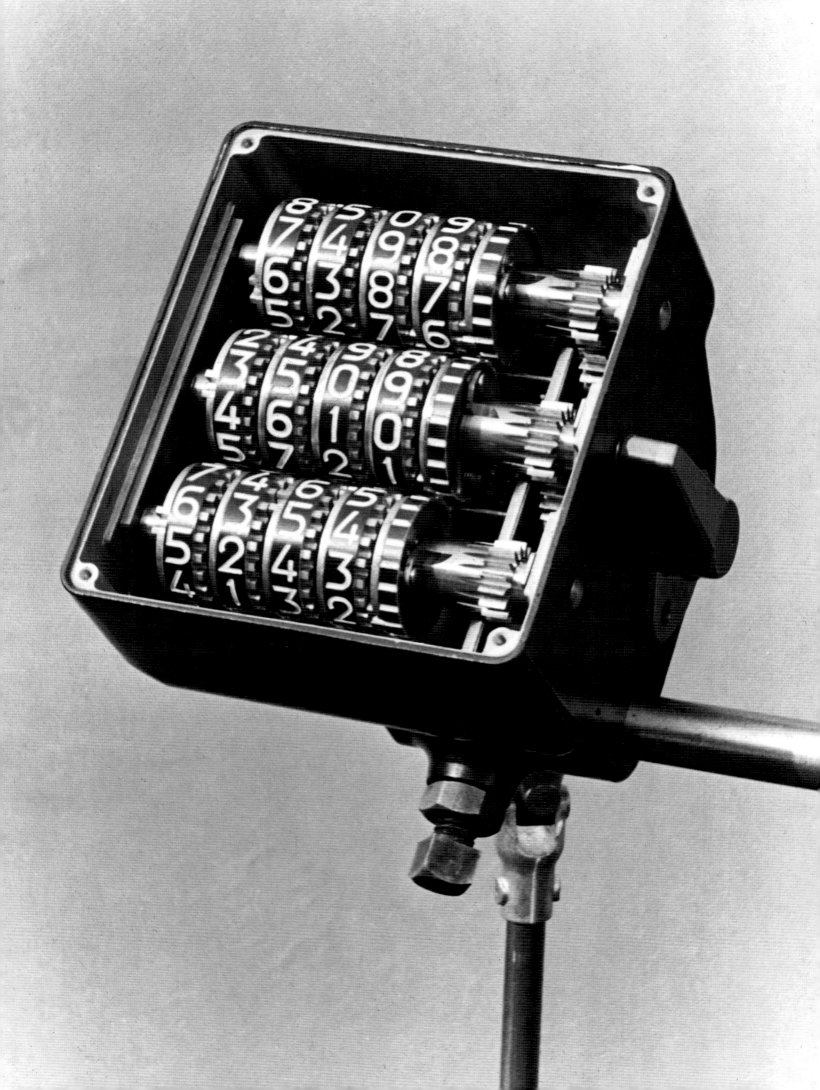

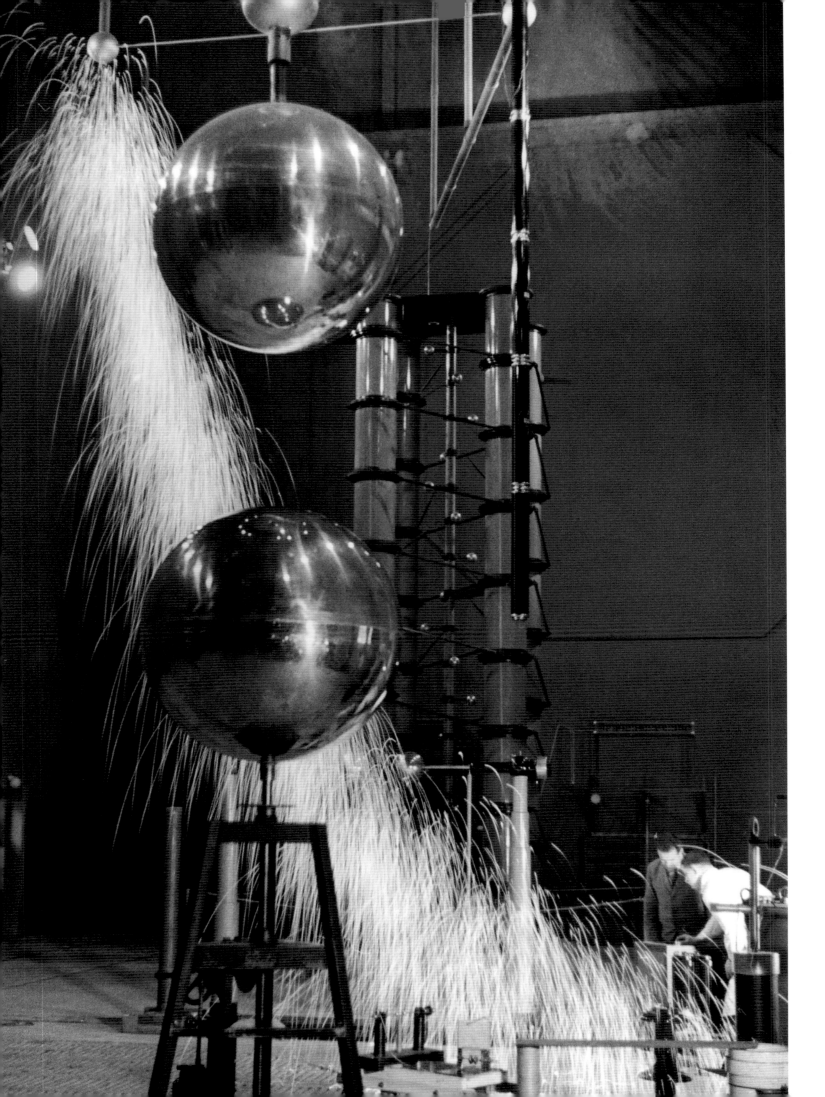

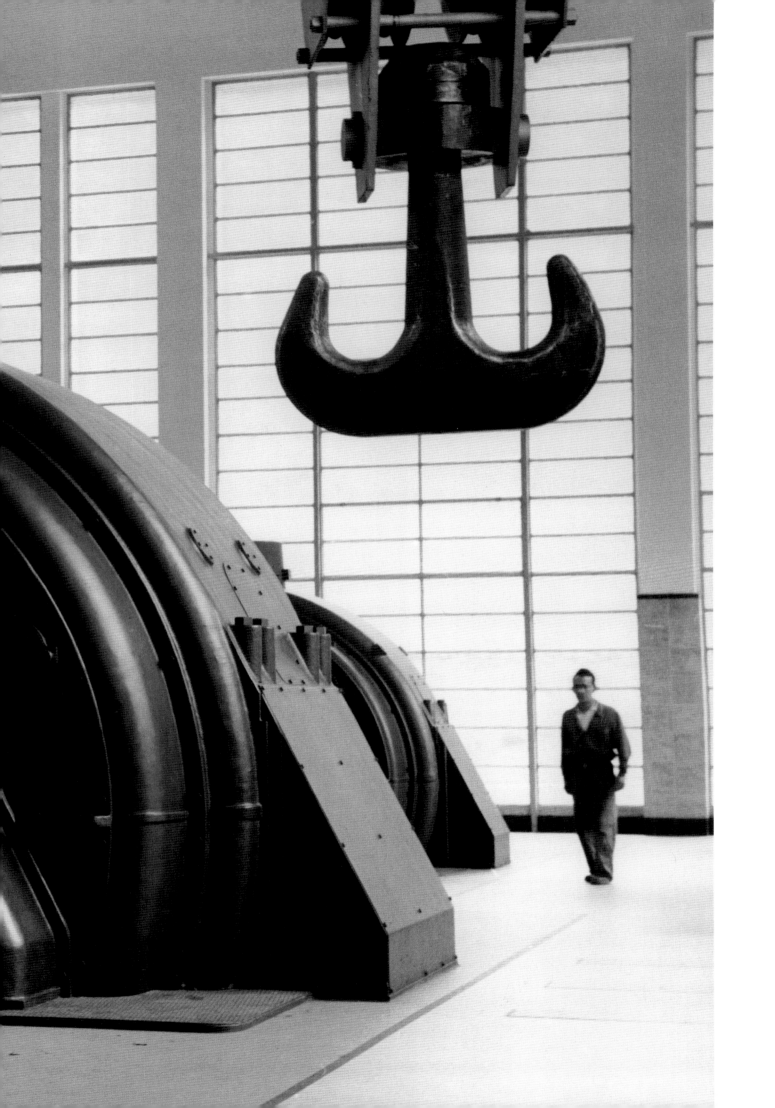

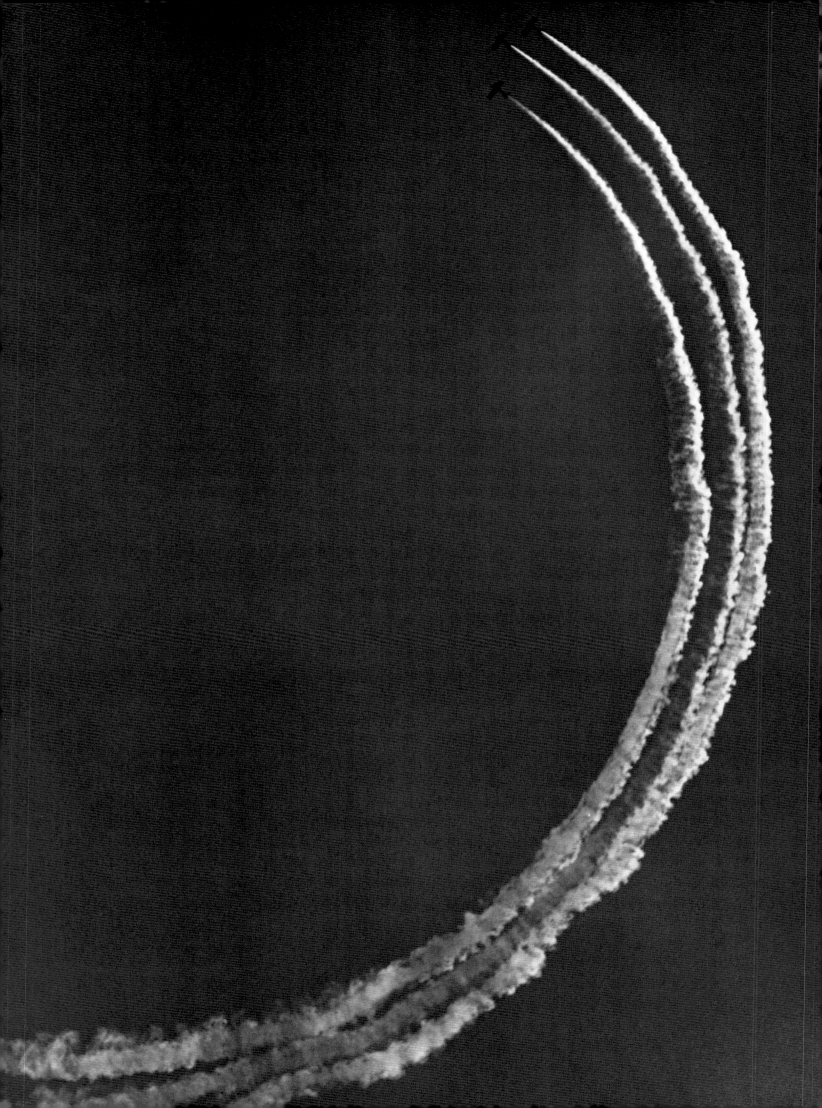

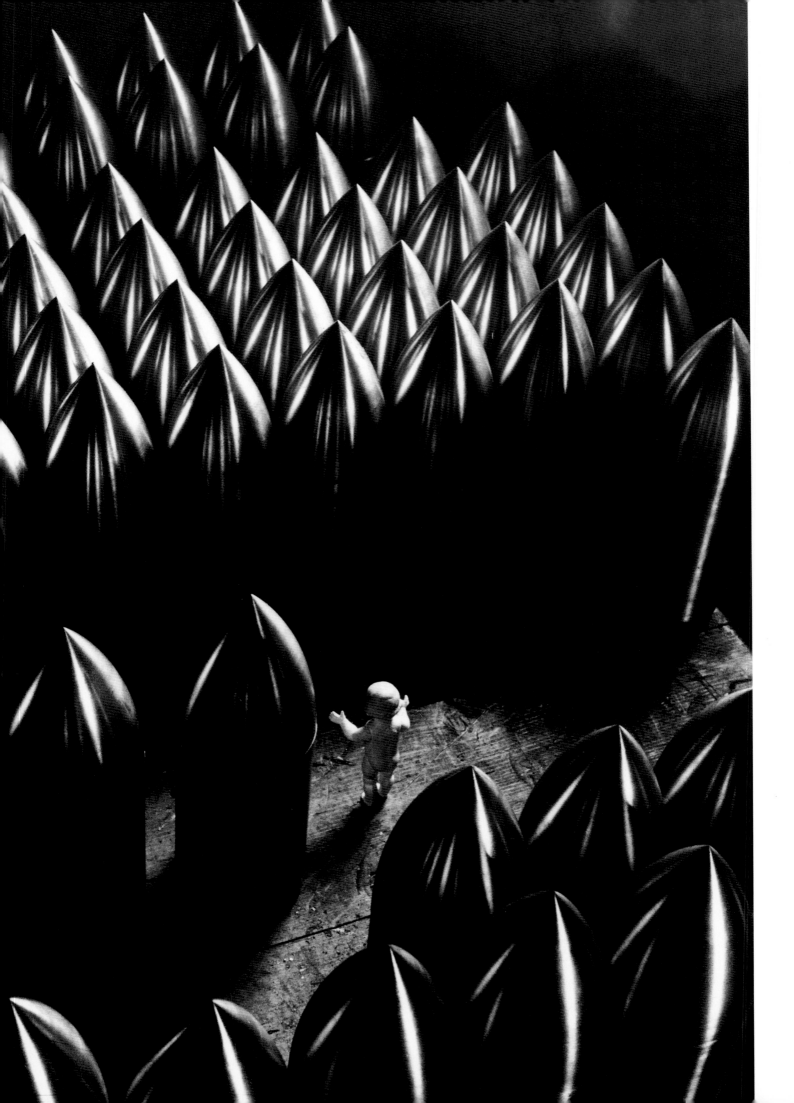

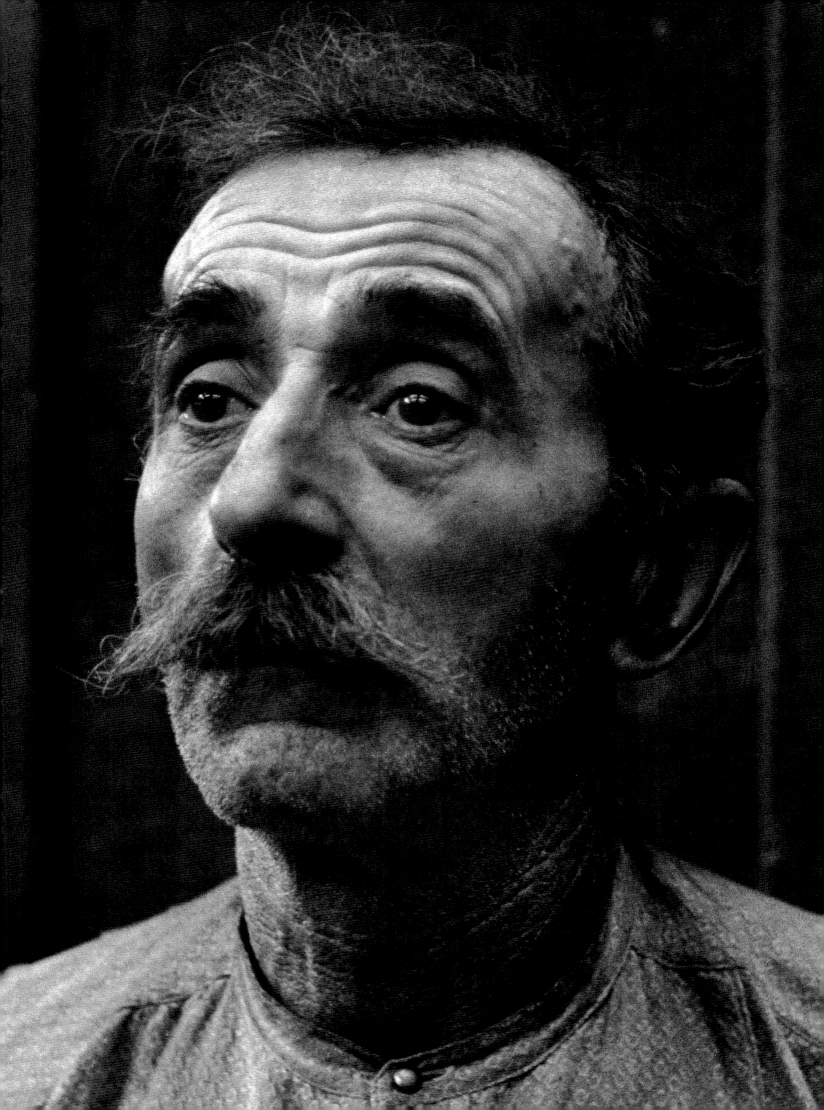

Plates pp. 137–167

Photographs from Fabrik (Factory), 1943

p. 137 **Schleusentor** (Water Gate), Aa valley, 1942

p. 138 **Kamine** (Smokestacks), 1930s

p. 139 **Türe** (Door), 1940

p. 140 **Jacquardwebstul** (Jacquard Loom), Dürsteler Wetzikon, 1942

p. 141 **Ferggerin** (Textile Worker), Dürsteler Wetzikon, 1942

p. 142 **Arbeiter** (Worker), Oerlikon Machine Factory, 1936

p. 143 **Dampfpfeife** (Steam Whistle), Kunstseidenfabrik Steckborn, 1938

pp. 144/145 **Elektro-Ofen** (Electric Furnace), Honegger Rüti, 1942

p. 146 **Feuerrachen** (Abyss of Fire), Berlin, 1930/31

p. 147 **Schmied** (Blacksmith), Oerlikon Machine Factory, 1935

pp. 148/149 **Lokomotive** (Locomotive), Brittany, 1936

p. 150 **Rennfahrer** (Racing Driver), Bern, 1934

p. 151 **Autorennen** (Car Race), Bern, 1934

p. 153 **Fassade** (Façade), Oerlikon Machine Factory, 1936

p. 154 **Schweissen von Generatorengehäusen,** (Welding of Generator Casings),
Oerlikon Machine Factory, c. 1940

p. 155 **Karusselldrehbank** (Lathe), Oerlikon Machine Factory, c. 1937

p. 156 **Fabrikmädchen** (Factory Girl), Oerlikon Machine Factory, 1934

p. 157 **Zählwerk** (Counter), Bühler Uzwil, 1939

p. 158 **Forschungslaboratorium** (Research Laboratory), Oerlikon Machine Factory, 1941

p. 159 **Forschungslaboratorium** (Research Laboratory), Oerlikon Machine Factory, 1941

p. 160 **Dämon** (Demon), Grimentz, 1938

p. 161 **Natur** (Nature), near Disentis, 1930s

pp. 162/163 **Kraftwerk** (Power Station), La Grande Dixence, 1942

p. 164 **Aeroplane** (Airplanes), Dübendorf, 1934

p. 166 **Granaten** (Granades), Oerlikon-Bührle, 1943

p. 167 **Arbeiter** (Worker), Oerlikon Machine Factory, 1934

The End of the Era of the Machine

After the publication of *Fabrik* Tuggener continued to photograph, still on a free-lance basis, for the Maschinenfabrik Oerlikon and an increasing number of other companies until the mid-1950s. He produced a whole series of commemorative books and brochures for the machine, telecommunication, chemical and watch-making industries, which formed the basis for his reputation as a "mentor" of Swiss industrial photography.[36]

However, by the early 1950s, Tuggener realized that the machine age, or at least how he wanted to perceive it, had come to an end. He wrote in one of his last contributions to *Der Gleichrichter* in February 1950: "Whenever I hear of an old machine I do not hesitate to go and see it and spend time to take a picture for future generations. These old machines still look like machines and openly show their mechanic nature. Today, everything is hidden behind casings. Neither does our ear hear the song of the wheels, nor can our eyes see the appeal of their move-ments. They are cans, but no longer machines, at least not the ones that would persist in our imagination."[37] Consequently, Tuggener began to look back at the "history" of the machine age and constructed the "story" of his personal involve-ment in it in two book maquettes. Since the machine as such had lost its attraction for Tuggener, he instead concentrated on the material they were built of: iron. "I do not want to go to the machines, I do not look for them and I do not understand them. I want the iron, the feeling of the iron, its power, and its force. Iron is more than just metal. A dimension of spirit and matter manifests itself in it."[38] The machine age thus became his personal Iron Age and he was later to exclaim many times: "Mein Stoff ist Eisen" (My matter is iron).[39]

In the first of these book maquettes, *Schwarzes Eisen 1935–50* (Black Iron 1935–1950), Tuggener refers back to the form of earlier reportages and loosely portrays a day in the lives of workers involved with iron in a factory. Yet now there is no indication of a "great thing" such as a locomotive or an electric power gener-ator as the final product of their endeavors. No, there is only work from morning to evening, from boyhood to old age. The maquette opens with the photograph of a smokestack that was also at the beginning of *Fabrik,* followed by a dark picture of a mass of workers entering the factory grounds through the gate. It signifies the beginning of work in the morning and finds its correspondence at the end of the maquette with a view of four smokestacks in front of a dark cloudy sky at sunset. Tuggener wrote on the back of a loose print of this picture: "The day with its hard

work is over, the smokestacks are still smoking, the sun bathes the sky with its evening dress in gold as if to bless and praise the work..."

Compared to *Fabrik,* more attention is given to details, which Tuggener treats as poetic "words" to create impressions of both stable moods and fleeting moments. Sometimes Tuggener's images are just single words which evoke complex feelings that resist verbal description by the almost magical presence of certain things such as black iron bolts and white cigarettes and their formal correspondence. In some instances, such single words add up to a sequence, to a "sentence" one might say, or, more appropriately, to a visual poem.

In the same vein juxtapositions of photographs are generally less comprehensible than in *Fabrik.* They seem to rely more on emotional intensity than literal association. Thus, opposing views of inside and outside, up and down, and the strong black and white contrasts throughout the book maquette all evoke the impression of positive and negative at the same time. They ultimately add up to an expression of Tuggener's ambivalent feelings toward the factory and modern technology that were already apparent in *Fabrik.*

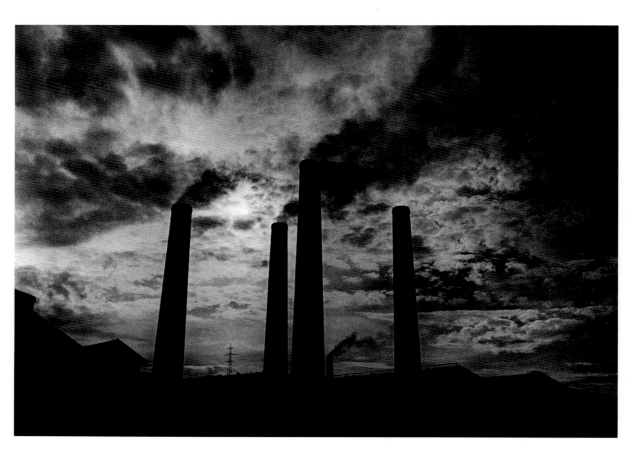

Untitled, Liège, 1949

The second personal maquette Tuggener composed a couple of years later and entitled *Maschinenzeit 1942–1951* (Machine Age 1942–1951) is totally different. It follows exactly the thematic sequence of *Fabrik* but in the end the juxtaposition of a slide-rule and the model for an artificial human heart does not allude to the possibility of war but to the total mechanization of mankind, the final triumph of the machine. Tuggener's dark vision of before the war seems to have come true. As a later caption of the photograph of the artificial heart indicates, mankind was seriously in danger of losing the "miracles of life, the health of the soul and the truthfulness of the spirit."[40]

Notes

1 Anon., "Ich, der Gleichrichter," in *Der Gleichrichter,* 30 January 1930, pp. 1–2.
2 Introduction in *Der Gleichrichter,* 1 September 1934, p. 4.
3 Tuggener in letter to Marie Gassler, 14 June 1934.
4 Tuggener in letter to Marie Gassler, 15 July 1934.
5 Tuggener in interview with Inge Bondi, April 1980.
6 Tuggener, "Eva in der Maschinenfabrik," undated manuscript, (1940s).
7 Tuggener in a text on the back of photograph in *Schwarzes Eisen* (1950), p. 105.
8 Tuggener in letter to Max Wydler, 7 July 1936.
9 R. Huber in *Der Gleichrichter,* 25 September 1939, p. 8.
10 Hans Schindler, "Euseri Ufgab" (Our Task) in *Der Gleichrichter,* 1 December 1939, p. 2.
11 Tuggener in letter to Ernst Zuber, Easter 1939.
12 Tuggener in letter to Marie Gassler, 16 April 1939.
13 Arnold Burgauer in preface to *Fabrik* (Erlenbach-Zürich: Rotapfel-Verlag, 1943), unpaginated.
14 Ibid.
15 Ibid.
16 Interview with Arnold Brugauer, 20 February 1995.
17 Sergei M. Eisenstein, *The Film Sense* (London: Faber and Faber, 1943), pp. 15–16.
18 Anonymous review in *Schweizer Bücher-Zeitung* (1943).
19 Hans Richter, *Filmgegner von heute—Filmfreunde von morgen* (Berlin: Hermann Reckendorf, 1929), p. 79.
20 Arnold Burgauer, "Mensch—Maschine" in *St. Galler Tagblatt,* 5 February 1944.
21 Eisenstein, *op. cit.,* p. 46.
22 Burgauer in *St. Galler Tagblatt,* 5 February 1944.
23 Burgauer in preface to *Fabrik* (1943), unpaginated.
24 *Genossenschaft,* 21 April 1951.
25 *Das Bücherblatt* (1943), *Schweizer Bücher Zeitung* (1943), *Rote Revue* (1944), *Seeländer Volksstimme* (undated), *Neue Berner Zeitung* (undated).
26 *Aargauer Tagblatt,* 11 December 1943.
27 Max Eichenberger, "Drei Schweizer Schaubücher," in *Die Tat,* 11/12 December 1943.
28 Erwin Allemann, "Bilderbücher für Erwachsene," in *Der öffentliche Dienst,* 31 March 1944.
29 Friedrich Dessauer in *Schweizerische Rundschau. Monatsschrift für Geistesleben und Kultur* (undated).
30 Anon., "Zwei Fotobücher aus dem Umkreis des werktätigen Menschen," in *Luzerner Tagblatt* (1943).
31 Kübler in editorial of *Du,* May 1943, p. 2.
32 Kübler in introduction to Paul Senn, *Bauer und Arbeiter* (Zurich: Büchergilde Gutenberg, 1943), pp. 5–16.
33 See anon., "Tuggener und Senn," in *Tages-Anzeiger,* 4 December 1943.
34 Max Eichenberger, "Drei Schweizer Schaubücher," in *Die Tat,* 11/12 December 1943.
35 Tuggener in hand-written note, 3 March 1944.
36 See anon., "Jakob Tuggener—Der Mentor der Schweizer Industriefotografie," in *film + foto,* June 1978, pp. 5–11.
37 Tuggener, "Poesie im Bild," in *Der Gleichrichter,* 1 February 1950, p. 15.
38 Tuggener in *Der Gleichrichter,* 1 November 1949, p. 119.
39 See, for example, interview with Inge Bondi, April 1980.
40 See "Die Maschine und der Mensch," in *Genossenschaft,* 20 February 1954, unpaginated.

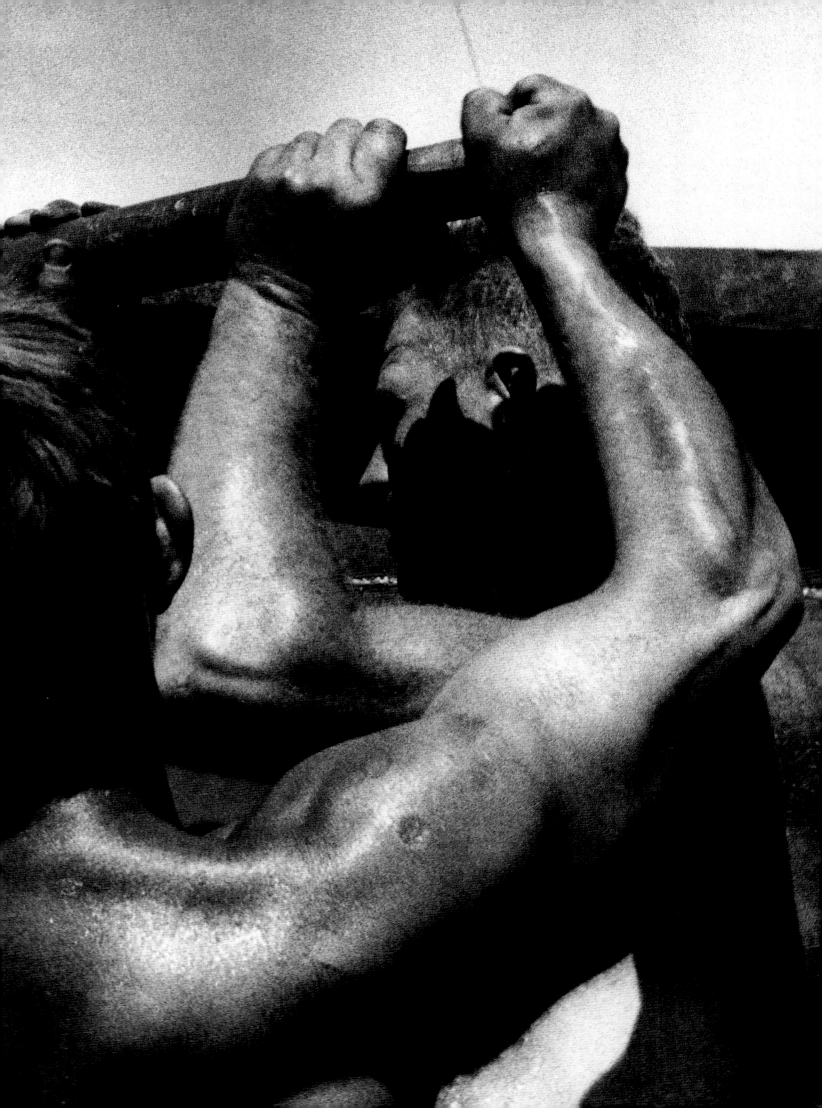

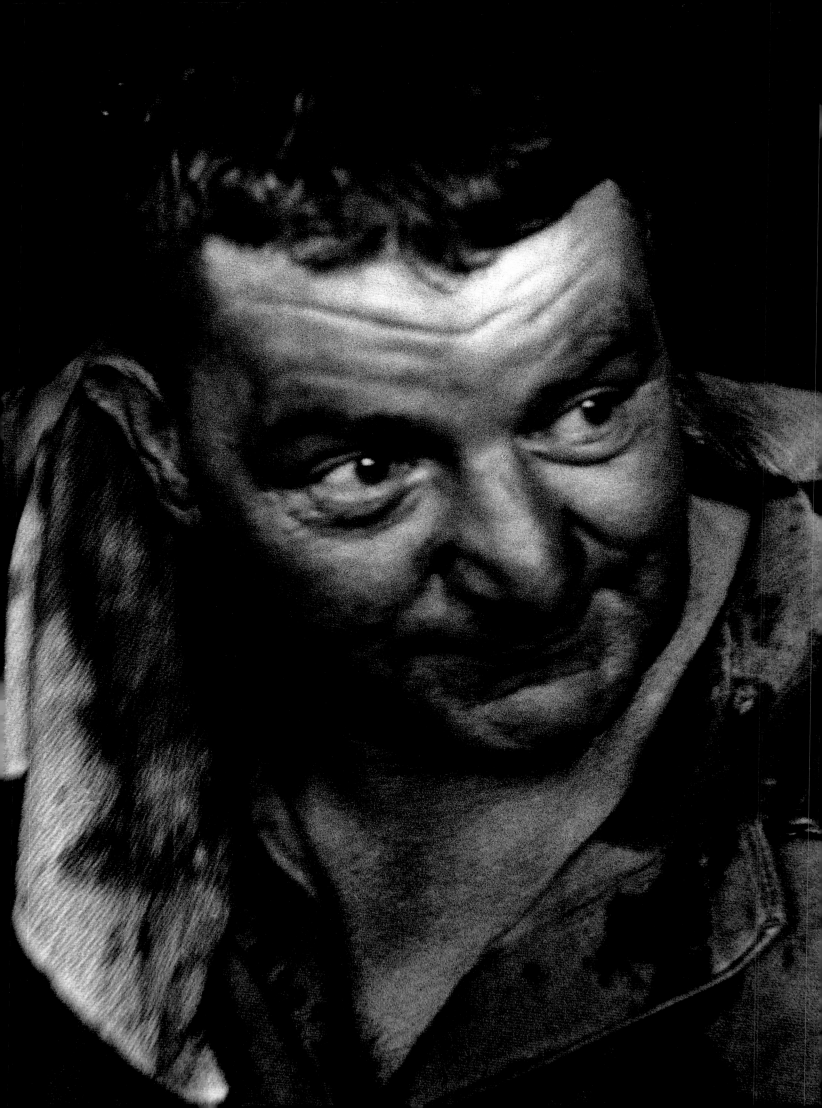

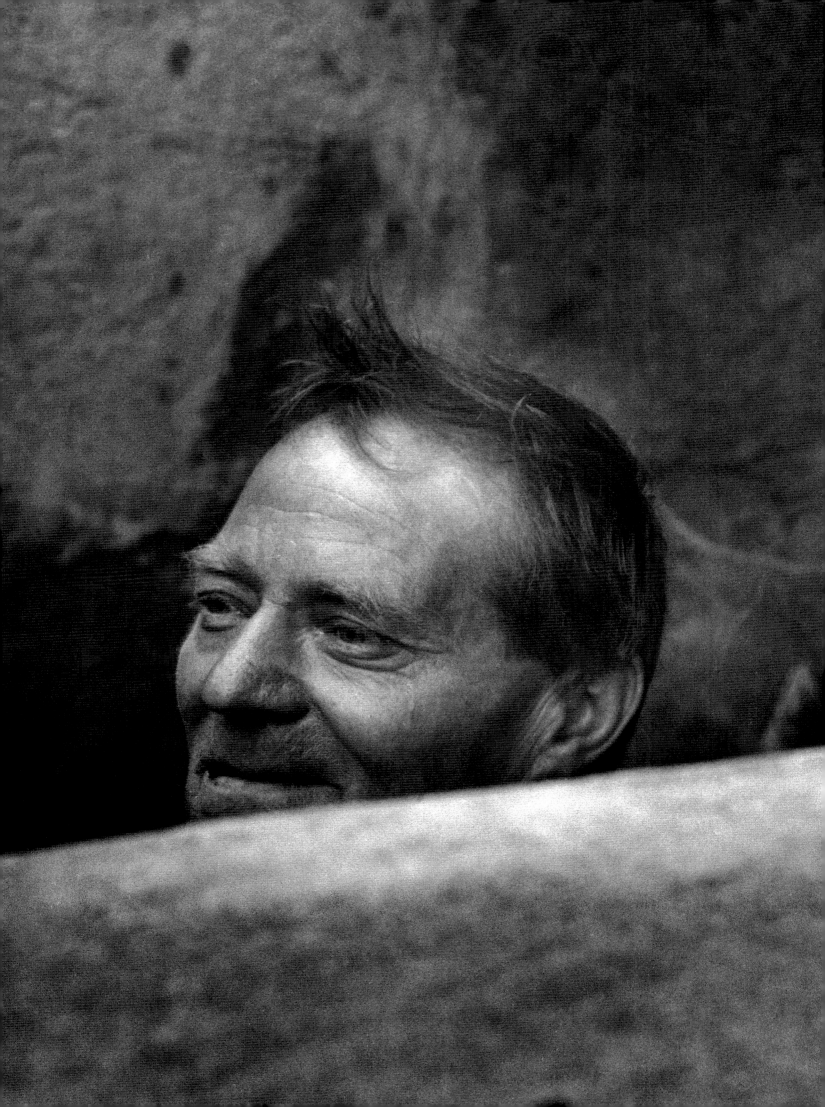

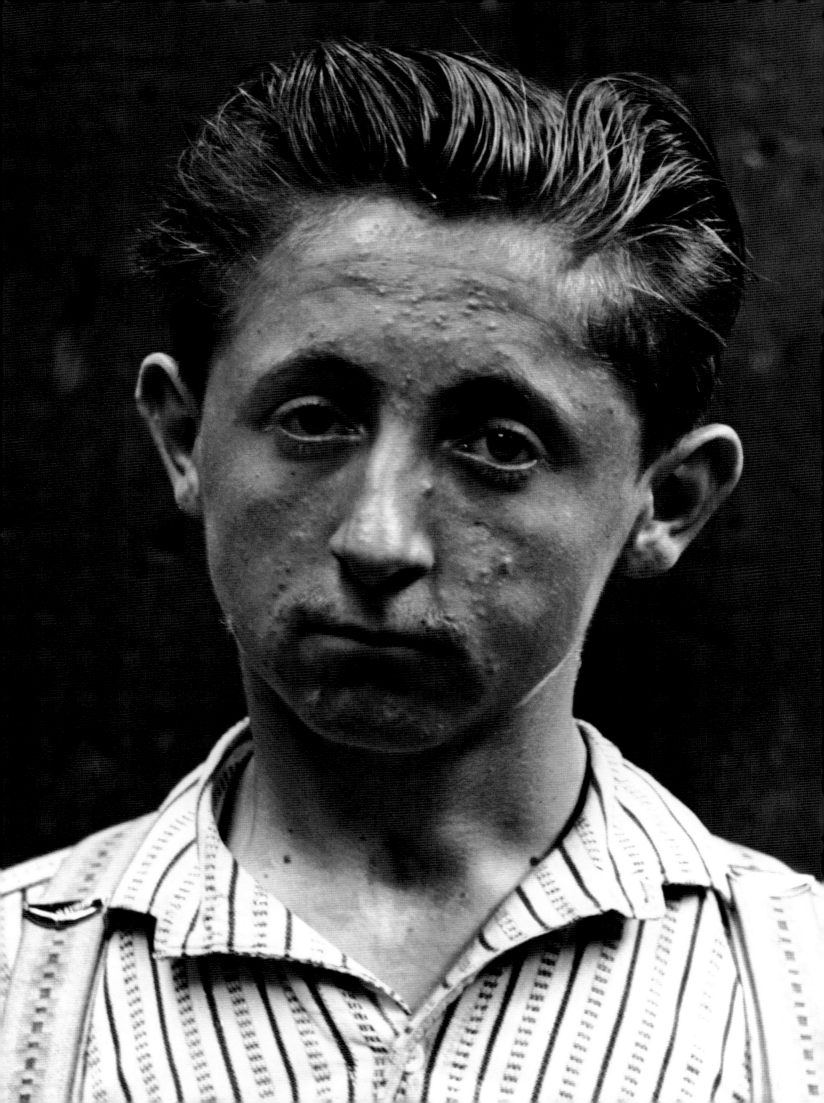

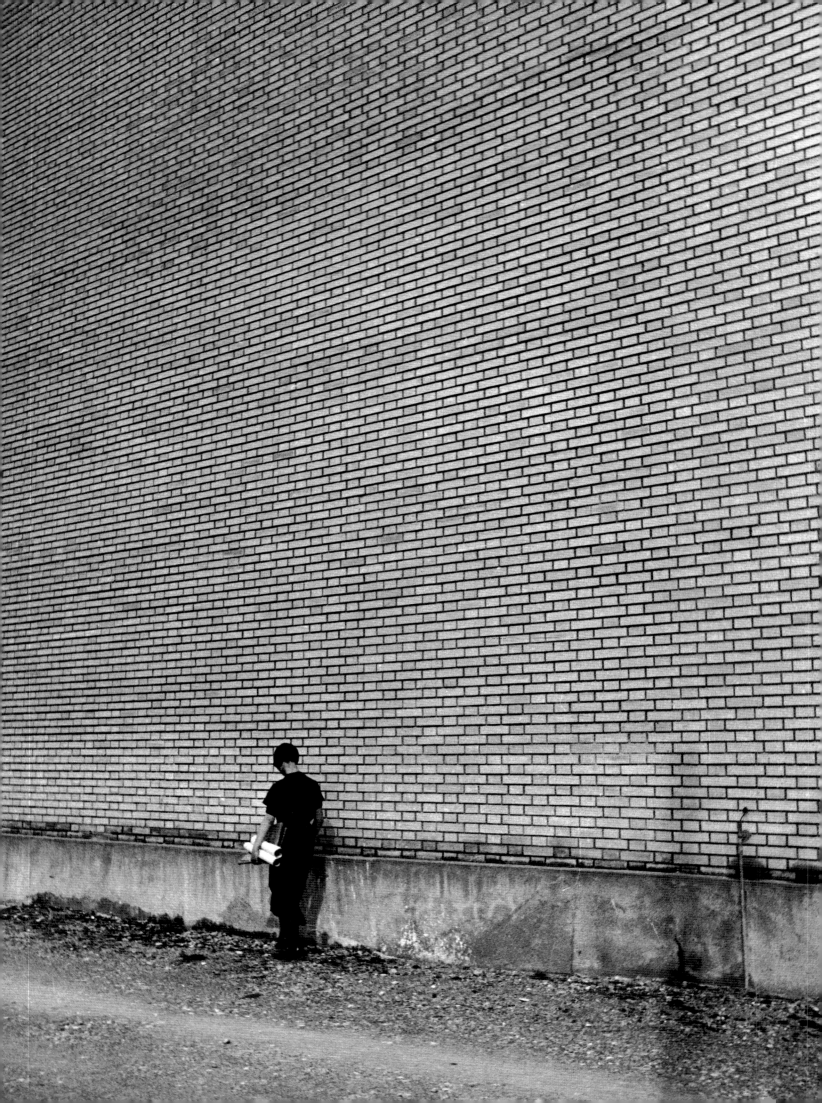

Plates pp. 173–182

Photographs from Schwarzes Eisen 1935–50 (Black Iron 1935–50), 1950 and Maschinenzeit 1942–51 (Machine Age 1942–51), 1952

p. 173 **Arme der Arbeit** (Arms of Work), 1947

p. 174 **Schmied** (Blacksmith), Wagonsfabrik Schlieren, 1949

p. 175 **Untitled,** Unterer Mühlesteg, Zurich, 1944

p. 176 **Untitled,** key hole, 1936

p. 177 **Untitled,** toilet, 1950

p. 178 **Untitled,** graffiti, 1950

p. 179 **Der Indiskrete** (The Indiscreet), 1940s

p. 181 **Stift** (Apprentice), Oerlikon Machine Factory, 1934

p. 182 **Laufmädchen** (Errand-Girl), 1936

LETTER FROM THE ARMY

I am pleased to offer you the picture of the moonlight as a gift. I am so happy that you want it, that you wish to have something of me and my soul. Always look at this picture. It is the way toward me. In its soft outlines is the beginning of over-coming, it represents the transition from the outside to the inside. I would also paint like this in daytime because there is no separation between appearance and feeling in my consciousness. I already painted two more moonlight pictures. They will look more and more like silk. When I am on guard during the night, I look at the whole magnificence of nature. Because in front of us lies a wonderful country and a free and mighty sky.

Jakob Tuggener to Marie Gassler, 1939/40

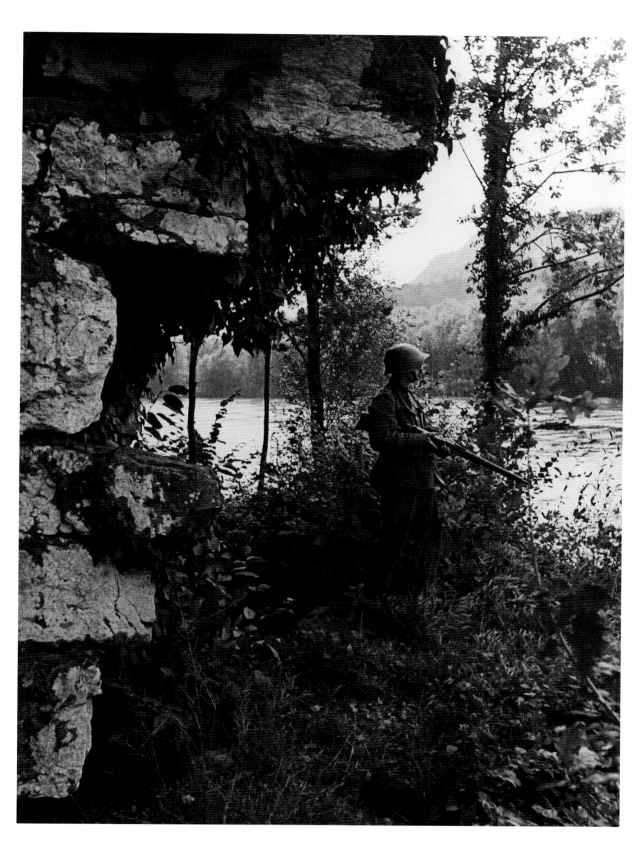

Am Flussufer steht der tapfere Soldat, nach dem Feinde spähend
(On the Riverside Stands the Brave Soldier Looking out for the Enemy), 1939

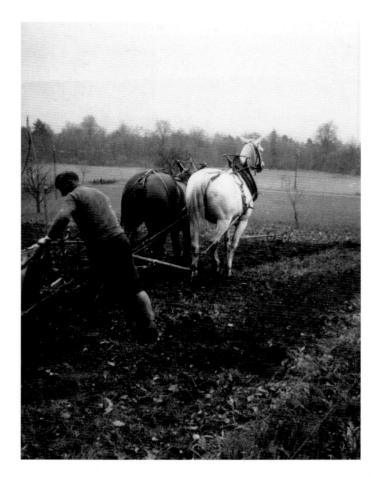

Untitled, plowing farmer, 1932

Countryside

When Jakob Tuggener came back from Berlin in 1931 he was among the first returning Swiss artists, writers, and intellectuals who had left the country during the previous decade. In increasing numbers they decided or were forced to return home when the political and cultural situation in their host countries deteriorated. They became "Heimkehrer" (home-comers) whose viewpoint became a major force in the Swiss arts, especially in literature, of the 1930s. The Swiss writers Franziska and Felix Müller wrote: "The 'Heimkehrer' do not cross the border expecting to enter paradise; a continuation of the discussion leads to the measuring up of the 'deficiencies' and the 'magic' of the little country: its smallness, its narrowness, and an anti-artistic climate stand against the awkward uprightness, the independence, and the beauty of its nature."[1]

Hans Finsler was the most important "Heimkehrer" in Swiss photography. A pioneer of the New Vision in Germany he returned from Halle in 1932 to found the photography program at the Kunstgewerbeschule in Zurich. Another was Herbert Matter who returned from Paris in 1932. During the following years, until he emigrated to the United States in 1936, Matter became one of the leading Swiss artists using a powerful combination of new photography and graphic design in advertising. In England, Bill Brandt too was a "Heimkehrer" from Austria who in his 1936 book entitled *The English at Home* examined the society of his fatherland in a very critical way and served the English version of the Geistige Landesverteidigung with his shelter photographs taken during the Blitz in 1940. Thus the "Heimkehrer" were a phenomenon that could be observed not only in Switzerland but in many other European countries that distanced themselves from Hitler's Germany.

Tuggener had not been away from Switzerland as long as Finsler, or Brandt from England, and he did not engage in direct social criticism—he was too eager to make a living. However, he did look at Switzerland with fresh eyes when he returned and approached new subject matters: on the one hand work in the machine industry, and on the other life in the country. As the contact with Captain Schindler made in the army opened to him the world of the factory, so during the annual repetition courses he got in touch with the rural population which inspired him to start taking photographs of the people living in the Swiss countryside. Already in his 1932 *leporello* album one can find among the many pictures of his fellow soldiers his first photographs of farmers working in the fields. In the following years the growing need of the illustrated press for pictures and reportages about the Swiss rural population opened a potentially lucrative market which Tuggener could not afford to ignore. Thus he began his *Trachtensammlung* (Collection of Traditional Costumes), he photographed in markets and fairs in villages around Zurich, documented traditional rituals and festivals, shot a short film about the mountain village of Grimentz and even produced book maquettes on traditional Bernese houses built of wood and on the different types of villages in eastern Switzerland. Unfortunately a lot of this work is lost which probably accounts for the fact that this facet of Tuggener's oeuvre is today the least known and the least appreciated.

Tuggener's first two published photographs directly portraying farmers and their work appeared in *In freien Stunden* in 1935. They go right to the heart of farm work by showing a farming couple pumping liquid manure from a reservoir under the stable and then bringing it out into the fields in a manure wagon pulled by oxen. The two photographs are placed next to each other as a kind of contrasting "center-fold" in the middle of a love story set in some Austrian noble house. The caption reads: "City people quickly turn up their noses when they encounter a farmer doing this work—but still, what an important role liquid manure plays in agriculture!"[2] Just as when he photographed the car races or the factory, in the countryside Tuggener's interest went beyond visual impressions and included sounds and smells, in this case the stinking manure that is evoked in the caption. Moreover, by placing them adjacent to each other, he produces the impression of one picture. The viewer's eyes are guided into it by the gutter into which the manure is flowing on the left and out again by the oxen pulling toward the right. It is like a cinematic panning movement, a kind of path into and out of a scene that can be found in Tuggener's work over and over again.

Among Tuggener's photographs that were published during the 1930s numerous reportages were on everyday events and places like the annual fun-fair in Bremgarten or Tuggener's visit to a mill in a small valley near St. Gallen which was accompanied by his own text written in Swiss German. Others dealt with religious festivities like the Corpus Christi procession in Appenzell or the "Posaunentag" (Day of the Trombones) in Trub in the Bernese valley of the Emmental. In May 1935 a picture of a group of trombone players was published on the cover of the *Zürcher Illustrierte* and was entitled *Gott grüsse mein Heimatland* (May God Greet My Homeland). This is Tuggener's only picture that ever appeared on the cover of this prestigious magazine.

Very few of Tuggener's published photographs were directly related to the Geistige Landesverteidigung. One was a photograph entitled *Demokratie* (Democracy) and showed the traditional open-air voting in Hundwil, while another was of a Tell-like farmer entitled *Der Schützenkönig* (Champion Rifleman) and appeared in *Föhn.* A third showed a *Senne,* an Alpine farmer who also belonged to the category of "Urschweizer" (archetypal Swiss) and was included in Ernst Laur's monumental book entitled *Der Schweizerbauer. Seine Heimat und sein Werk* (The Swiss Farmer.

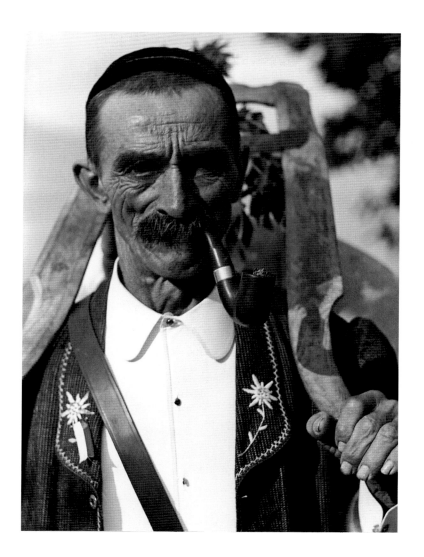

Untitled, Alpine farmer from the canton of Fribourg, 1934

His Homeland and His Work).[3] Published on the eve of World War II, this almost seven hundred-page volume deals with every conceivable aspect of twentieth-century Swiss agriculture and its importance for national economic, political and cultural development. Laur stressed the importance of the farmer both as a "good soldier" and the breadwinner of the nation in case of war and stated: "In the quietness of the village man collects latent powers and people grow to become physically, mentally, morally, and spiritually healthy."[4] By 1939 the farming community was seen as *the* origin of the Swiss people, *the* basis of the Swiss nation both in terms of food production and self-defense, and *the* source of physical reproduction as well as spiritual renewal.

Laur's book was written for (and financially supported by) the Swiss national exhibition of 1939. Popularly called "Landi," it lasted from May until October and attracted over ten million visitors. Initially planned as an industrial and agricultural fair in the mid-1930s, the exhibition gradually developed into an elaborate but also contradictory manifestation of Swiss national identity. While being presented as a modernizing, industrial country, Switzerland's traditional cultural values shaped by the Geistige Landesverteidigung were equally emphasized. Thus, it is not surprising that at the "Landi" the farming community was most prominently represented— including two complete and functioning farms. Rural themes were also amply presented in the three exhibitions in the "Photo-Pavilion" dealing with portraits of the (united) Swiss people, the Swiss landscape "during the seasons," and bread as a daily staple essentially produced by farmers.

In the Army

Like many other photographers—in fact, like every Swiss man fit for military service—Tuggener was drafted for active duty at the beginning of the war in September 1939. During the first three years of the war he intermittently served as an infantryman in the canton of Aargau guarding the northern Swiss border to Germany along the Rhine between Lake Constance and Basel. Later he was stationed in central Switzerland, in the Bernese countryside and at the end of the war in the southern canton of Ticino. During one of his short leaves, in April 1940, he married Marie Gassler who with interruptions had been his girlfriend and lover since 1934. They moved into a house surrounded by a large garden on Gemeindestrasse near the center of Zurich. Their first son Jakob Silver was born in August of the same year, followed by Rainer Severin in 1942.

As soon as Tuggener's unit had settled near the Rhine he began to take photographs, many of which were published, albeit anonymously, like a humorous one of soldiers sleeping crammed like sardines underneath two educational posters of fish in an Aargau country school. But perhaps because of a lack of ideas or the restrictions imposed by censorship Tuggener told his friend Max Wydler that he soon felt "tired of photography" since "topics became increasingly rare and difficult."[5] Many of his photographs never appeared in print because Tuggener never intended them to be seen publicly, like photographs of his comrades playing around in the shower or decorating themselves and their guns with flowers. Yet some were actually prevented from publication by the rigid press censors because they either showed presumably secret weapons and their hiding places or soldiers engaged in inappropriate activities such as off-duty drinking orgies.

For Fusilier Tuggener and his unit the first months of active duty in the war consisted almost exclusively of standing on guard in two-hour shifts along the border looking out for the enemy. An enemy, incidentally, who never came. The writer Max Frisch, who was also drafted and spent the end of 1939 under similar conditions described how his unit built dugouts along the southern Swiss border, how the soldiers sat evening after evening in the kitchens of local families with whom they became more and more friendly, and how even the strongest men were slowly overcome by devastating feelings of boredom and homesickness.[6] Tuggener's experiences were quite different and he wrote to his wife: "We work in the peace of the forest underneath the roof of the beautiful foliage during the day. And in the evening, we go to the Café and consciously enjoy it as something which can't be taken for granted. ... Therefore, we are all calm and not in a silly position like those [people] in the hinterland who are agitated and in a mood of panic. Moreover our food is excellent and, above all, we are always prepared. We know nothing of agitation, rather, we are child-like fatalists."[7]

The agitation Tuggener mentioned referred to the critical time in April 1940 after the defeat of Belgium and The Netherlands when the Swiss people also feared a Nazi invasion of their country. Widespread panic broke out after the fall of France and many people living in areas near Germany moved to the mountains in the hinterland for protection. Tuggener's comment shows that he was happy to be staying away from the commotion—just as in 1936 before the devaluation of the Swiss Franc—and concerned himself with his own personal "experiences and thoughts;" that is, instead of just "sitting under the trees" and getting bored, he used the

ample spare time to "keep himself busy with painting." He wrote to his wife: "When I am on guard during the night, I look at the whole magnificence of nature. Because in front of us lies a wonderful country and a free and mighty sky. I then try to remember the colors and paint the picture in my mind to execute it during the day in my open-air atelier."[8]

Tuggener also painted and took photographs in the kerosene light and sticky air of the dark shelter and in the more cozy atmosphere of the guardroom. While he was serving as a guard at a camp of interned Polish soldiers and officers near Wettingen he took a great number of portraits and offered them for sale.

Frühling, Sommer, Herbst, and *Winter*

Tuggener wanted to paint and photograph the rural people and their environment as he encountered it, in their undisturbed, pure state. Unlike the photographer Hermann Stauder who had "documented" the Bernese farm life earlier, he was not interested in idealized rural genre scenes especially arranged for him. In one letter he wrote: "I made a painting of the kitchen with the fireplace, something the farmer's wife did not understand. She even chased out the chickens, but I have the 'poulets' on the picture anyway, and the cat and the farmer's wife. The next day, the kitchen was painted snow-white and all black romanticism was gone. But I have a good picture…"[9]

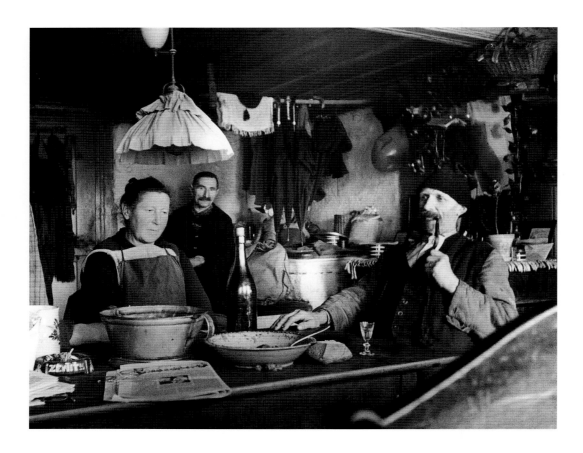

Berner Oberländer Stube
(Living-Room in the Bernese
Oberland), c. 1941

Tuggener not only executed unvarnished watercolors on his numerous excursions into the countryside but he also took photographs of farm interiors, of simple domestic scenes in and around the house including the kitchens, living-rooms, and bedrooms. He also took extended series of pictures of some of the events taking place in the villages, for instance of a "Metzgete," the slaughtering of pigs in a farmyard, and an amateur performance of a play in a village inn. None of these reportages appear to have reached publication, but prints—a few of them are included in book maquettes—and lists of pictures with Tuggener's detailed captions written in Swiss German survive. One of the captions reads: "If one talks about 'Metzgete,' one thinks of eating. As the photographer, I was invited and I almost burst..."[10] If one considers the difficulties of getting enough food during the war years, one can imagine how impressive this experience of eating a pig from head to tail must have been for Tuggener.

Based on photographs of country life taken since 1932, Tuggener put together four individual book maquettes during 1942 and 1943 entitled *Frühling, Sommer, Herbst,* and *Winter* (Spring, Summer, Fall, and Winter). The theme of the four seasons has been, of course, an important one in art, literature, and music since the Renaissance, and Tuggener was certainly aware of this. Close to his interests as a photographer and therefore perhaps serving as an inspiration may have been Albert Steiner's *Die vier Jahreszeiten* published in 1938 by the Rotapfel-Verlag, or one of the photography exhibitions at the "Landi" entitled "Die Schweizer Landschaft in den Jahreszeiten" (The Swiss Landscape During the Seasons).

The layout of the maquettes is not as dense as in *Fabrik.* It feels more spacious, producing an airy atmosphere for the photographs. Unlike *Fabrik,* there are several instances where two half-page pictures are juxtaposed on one spread. There are white pages too, but they do not mark beginnings or ends of sections nor do they function as hyphens allowing space for associations. Rather, together with the many white half-pages, they rhythmically structure the individual scenes depicted sometimes even to the extent of interrupting the dynamic movement or flow of a story. The white pages assume a more physical, not just "empty," quality. A pot-bellied landlord of the village inn, for instance, is looking out of the window and the white page facing him becomes the actual window, rather than the viewer's own space for reflection. So unlike *Fabrik* where the concept of montage was essential for the production of cumulative meaning, in *Frühling, Sommer, Herbst,* and *Winter* this technique was only used occasionally.

The most striking characteristic of Tuggener's *Frühling, Sommer, Herbst,* and *Winter* is that the one hundred and thirty-two photographs are presented in four individual volumes so precluding the perception of a definite sequence with a beginning and an end, as in earlier albums or in *Fabrik.* In other words, the viewer is unsure of whether to begin with spring and end with winter, or begin with winter and end with fall, or any other sequence. In fact, not even the structure according to the seasons is strictly maintained since, for instance, a picture of a mill near Appenzell taken around the end of May 1934, and the photographs from the "Posaunentag" (Day of the Trombones) in Trub that took place in May 1938, appear in the *Herbst* (Fall) volume.

Tuggener did not portray the countryside as fertile land yielding an abundance of foodstuffs the Swiss people needed so badly during the war years. Even though meadows, sports fields, and even parks in cities were converted into potato or wheat fields, and pictures of harvesting amidst the city filled the illustrated press, Tuggener's *Herbst* maquette does not include a single picture of harvesting or of fresh fruit. He only alluded to harvesting with pictures of farmers sitting in the shade of a large tree and enjoying a snack, of a man sharpening his scythe, or of a mill where, presumably, the harvested grains would be milled. Tuggener's *Herbst* leaves the impression that no foodstuffs at all were being produced in the Swiss countryside.

Sommer does not include any picture of haymaking, a very popular farm activity because town people or students would sometimes come and help, and an essential one because its success ensured the survival of the cattle in winter. Yet Tuggener shows a girl lying alone on a haystack reading a book implying that culture was more significant than agriculture, at least to him. In fact, the only seasonal farm activities Tuggener photographed were the preparation of a field in *Frühling,* the clearing of a potato field in *Herbst,* and the (smelly) traces of a liquid manure wagon on the snow-covered ground in an orchard in *Winter.*

What are Tuggener's *Frühling, Sommer, Herbst,* and *Winter* about, if they do not really portray the rural life cycle or the changes of weather, if they do not celebrate the Swiss mountains as symbols of national strength and unity (the Alps only appear in the far background of one picture)? What is their meaning, if they are not promoting the farmer as a national hero (no bearded Tell-like types are present at all), if they do not claim the countryside to be a safe area guarded by the Swiss army where sufficient food stuff for the people was being produced (only a couple

of solitary soldiers can be detected among the farms)? What are the books about if they do not claim the landscape to be a recreational area and if they do not argue for the preservation of rural traditions and customs and show no ethnographic interest whatsoever in the aesthetic qualities of tools or farm implements?

Tuggener's own comments regarding a possible meaning of the photographs taken in the country, especially in comparison to what he expressed in writing concerning technology, are extremely scarce. They are limited to a few about his feelings for the "magnificence of nature," and the "wonderful country" underneath the "mighty and free sky" that he wanted to express in his work. Influenced by circumstances—Tuggener was serving as a guard near the border with Nazi Germany—these remarks reflect, quite understandably, sentiments related to the spiritual (and physical) defense of the country. *Frühling, Sommer, Herbst,* and *Winter* cannot, however, be directly related to this "outside" world which Tuggener experienced. He makes no reference whatsoever to the grand photographic themes of the "Landi": the farmer as a type, the seasonal change of the landscape, and the production of bread. They are totally opposed to Arnold Kübler's and Paul Senn's *Bauer und Arbeiter* that visually presented all ideological aspects of the new "Schweizerbauer" (Swiss farmer) with his new privileges related to increasing production. The wonderful country under the free sky in Tuggener's *Frühling, Sommer, Herbst,* and *Winter* has to be interpreted as his personal, "inner" territory where he could live the freedom of his personal thoughts and express himself artistically.

Yet the question remains what are they about? An important clue is the *Winter* volume since this is the only season described by fitting pictures: several mostly dark snow landscapes, people resting on or near their warm tiled stoves, the liquid manure in the snow. Given that the four volumes do not strictly adhere to the seasonal order and that winter comes across as the only "properly" represented season, one realizes that all the pictures express feelings of coldness and bareness—for instance, almost all trees throughout the four volumes have no leaves. This evokes a general atmosphere of winter that can only stand for the "inner" climate of the countryside or, more to the point, that is essentially a reflection of the spiritual climate of Switzerland itself at the time shortly before and during the war.

This particular climate is nothing less than the spiritual "narrowness" that resulted from Switzerland's cultural and political retreat during the 1930s. In his essays on art in Switzerland entitled *Diskurs in der Enge* (Discourse in Narrowness), the writer Paul Nizon several decades later stressed one aspect of the spiritual "narrowness"

that artists working in "neutral" Switzerland had to contend with all the time: a certain "deficiency" of topics to deal with which he called spiritual "under nourishment" or "malnutrition."[11] The lack of pictures of fruits being harvested or bread being baked, for instance, is the perfect metaphor for exactly this lack of themes Tuggener himself had to deal with. As opposed to the world of the factory, in the country there really was not a lot to talk about if one wanted to avoid the clichés of the Geistige Landesverteidigung. The photograph of a solitary figure surrounded by uncanny snow-covered pine trees walking in the leaden cold most clearly expresses the feelings of "narrowness," of isolation, immobility, threat, and lack of both inspiration and positive outlook. This figure is actually a butcher who walks up to a farm to slaughter some animals—the rural equivalent of the "Executioner" placed at the beginning of the drama in *Fabrik.*

Looking at Tuggener's *Frühling, Sommer, Herbst,* and *Winter* from this point of view, we see they do not depict an outer reality, but an inner state of mind prevalent in Switzerland at a historic point in time: a spiritual winter characterized by reactionary self-definition, cultural mediocrity, preventive blackouts, and rigid censorship. The snow covering the landscape and muffling any (controversial) sound is a metaphor for the government's attempts to keep everything and everybody quiet: "People who don't keep silent harm the homeland!" was a popular government slogan.

In this light, the photograph of the pots with geraniums in a window becomes a metaphor for the country's petty-bourgeois attitudes, its preoccupation with decoration and façades leading to a state where all light is prevented from entering into the narrow living-room and, at the same time, any view of the outside is obstructed as well. The window, although decorative and orderly, in fact goes blind, effectively shutting out reality. The window itself with its compartmentalized panes is the border between the inside and the outside, between pretty but narrow-minded Switzerland and the ugly "Ausland" (foreign countries).

Another example that shows how Swiss petty-bourgeois orderliness becomes almost paranoid to the extent of preventing the possibility of life is a picture of the door to the shop of the Schrämli-Rüegg family in Nieder-Uster, a village near Zurich. In comparison to Dorothea Lange's or Walker Evans' photographs of country stores in rural America taken at about the same time, Tuggener's image shows how perfectly symmetrical the signs are on the door and the two shutters. The picture expresses the proverbial Swiss orderliness and neatness but, at the time of

war, it can also be seen as a metaphor for the Swiss neutrality that treated all other countries as equal business partners, even—or especially—Hitler's Germany. The door with its two "wings" actually resembles an altar (of materialism and commerce) rather than the entrance to an ordinary house where people lived and sold things such as Sunlight soap and Knorr soup. The shutters can be closed and no messy trace of business would be visible, only a perfectly "neutral" façade marked with the inconspicuous sign "Handlung" (Shop). Again, this can be seen as a metaphor for the hypocritical government façade of "neutrality" behind which Swiss businessmen and bankers made profitable deals with Nazi Germany, activities that have only recently attracted large public interest internationally.

Thus Tuggener's *Frühling, Sommer, Herbst,* and *Winter* not only portray the Swiss countryside with "unvarnished," truthful, and unspectacular glimpses of country life, but transcend the outer world and reflect on the inner cultural, spiritual, and political climate during the first years of the war. For Tuggener this climate also had a personal dimension. Soon after his marriage he started feeling confined by his wife's conservative moral attitudes, her expectation of leading a bourgeois life, and the fact that he had to support her and their two small boys. He was afraid of being forced to be a "worker" rather than an artist and "Saint." In the book maquettes, Tuggener sees this confining climate as a "season" emphasizing the aspect of time. In other words, he is expressing the hope for eventual change. His *Frühling, Sommer, Herbst,* and *Winter,* like *Fabrik,* have to be seen as a "Zeitbild" (image of the time), both a reflection—but not a critique—of the cultural climate, and a personal, expressive work of art that transcends the visible world and evokes an inner state of mind longing for spiritual fulfillment.

Tuggener would have liked to publish his *Frühling, Sommer, Herbst,* and *Winter* or *Bauernbücher* (Farmers' Books), as he sometimes called them, in book form like *Fabrik.* However, he was unsuccessful and only small excerpts appeared in print after the war. One reason for this failure might have been that they did not fit into the mainstream ideological sentiments of the Geistige Landesverteidigung. Another might have to do with the fact that Kübler and Senn had already filled the need for an up-lifting book dealing with this subject with their *Bauer und Arbeiter* of 1943. Nevertheless, it was Kübler who published a selection of six photographs from Tuggener's "regrettably hitherto unpublished" book in the February 1946 issue of *Du.*[12] He introduced the photographs by stating that the sequencing and pairing of pictures were important in producing a report not about events but of "conditions"

and concluded that Tuggener "has the ability to see the valid among the confused and arbitrary. He has the courage for leaving out, for darkness which emphasizes the visually essential. ... Tuggener tries in his images to allude and point to the inner life of people and things. ... He does not show farmers' work, but he is concerned with the feeling of the life of the village."[13] Even though Tuggener's pictures were of a somewhat brighter mood than the ones in *Frühling, Sommer, Herbst,* and *Winter* they still were taken to represent winter. "Not just winter here and there," Kübler remarked, but "winter in general, the sinister, strange messenger from outer space, brother of sleep and death."[14] Even after the war, the spiritual state of Swiss society did not change immediately. In fact, feelings of cultural alienation and isolation continued to persist for a long time and they can clearly be sensed in Kübler's selection of Tuggener's photographs for *Du.*

Another group of pictures that was published in a 1945 book entitled *Our Leave in Switzerland* evokes an entirely different climate, at least at first glance. Edited by Arnold Kübler together with the photographer Werner Bischof, the book included two hundred photographs and was intended as "A souvenir of the visit of American soldiers to Switzerland in 1945/46." As in Tuggener's book maquettes, his photographs were published full-page and without any captions. They show a village church, an old lady reading, the interior of a bedroom, the window with geraniums, more geraniums, plants next to the entrance to a house, and four oxen pulling a plow. The most obvious difference to *Frühling, Sommer, Herbst,* and *Winter* is the powerful picture of plowing at the end of the sequence. Underneath this last picture was written: "Generation after generation of Swiss people have lived in neat, modest homes, with windows full of flowers, working industriously in their shops and factories and on their farms and going to church on Sundays. The fact that so many Swiss know the meaning of inner peace is perhaps one of the reasons why Switzerland is intact to-day."[15]

This text, of course, contains all the clichés about Switzerland, such as the neat home, the inconspicuous shop, the industriousness of the factories, and the flowers in the windows, that *Frühling, Sommer, Herbst,* and *Winter* tried to undermine. The irony is, however, that it was exactly these clichés that the American GIs took home with them and that their fellow Americans return to Switzerland with, as tourists, even today.

One single image from a series of photographs of people harvesting potatoes that Tuggener took in 1944 while stationed in the Bernese countryside reached a cer-

Kartoffelernte (Potato Harvest), 1944
(poster designed by Richard P. Lohse, 1947)

tain notoriety in 1947 as a political poster in support of women's right to vote in the canton of Zurich. The picture showing a farmer and his wife filling a sack of potatoes in the field was chosen by Richard P. Lohse, a well-known Swiss graphic designer and abstract artist. He cropped the picture to concentrate on the figures and added in bold type the Swiss German text "zämme schaffe—zämme stimme" (work together—vote together) and a large yellow "Ja" (yes). Even though the typography had a distinctly modern look, the picture clearly tried to evoke sentiments in the spirit of the Geistige Landesverteidigung. Around 2,000 copies of this poster were printed but the campaign, like one a few years earlier, was unsuccessful and it took almost twenty-five years for Swiss women to be given the right to vote on a federal level.

Uf em Land

In 1953, ten years after the creation of the original maquettes, Tuggener revised *Frühling, Sommer, Herbst,* and *Winter* and composed a new one-volume book maquette entitled *Uf em Land 1935–1945* (In the Countryside 1935–1945). The new maquette comprised the same number of pages but nineteen less photographs, of which approximately thirty per cent had been included in *Frühling, Sommer, Herbst,* and *Winter.* The layout is much denser than in the earlier maquettes, more like in *Schwarzes Eisen* (Black Iron) and *Die Maschinenzeit* (The Machine Age) made at about the same time. Most photographs are either full-page verticals or double-page horizontals. There are only six half-page pictures and no white pages at all; indeed, in several instances three or even four photographs are placed on one spread. The layout is dynamic and does not leave much breathing space for the viewer, reflecting the movement and liveliness in many of the photographs.

The sequence, in this case, clearly starts and ends with winter. It is a full continuous cycle whose end ties in to the beginning again. There are typical seasonal pictures such as bright snow landscapes, flowery meadows, fields in broad daylight, and the rain in the fall. Rather than being a sequence of pairs, as in *Frühling, Sommer, Herbst,* and *Winter, Uf em Land* is a sequence of "stories," in at least two instances parts of earlier reportages, that are loosely connected or interlocking. The most prominent ones are: the slaughtering of a pig, theater and dance at the village inn, the carnival, the harvest, the train in the country, the baking of bread, and the visit to a country church on All Souls' Day.

In this lively sequence of pictures there is no more feeling of narrowness from which one would want to escape. Light pervades the countryside and it enters through windows in Tuggener's pictures, flooding people and things as if giving them a spiritual aura. This religious atmosphere is already evoked with the first picture of the maquette showing the village church. The light in *Uf em Land* alludes to purity, to knowledge or wisdom, or to the Holy Spirit itself, as in the photographs of the Christmas tree and the bread placed in a wooden trough next to it. Thus light and space no longer occupy the areas outside the pictures but have moved within. There are all the worldly outer aspects of life, most of them seen in a positive light (the farm work, the meals, the dances etc), but there are allusions to the spiritual inner reality as well.

The maquette ends as it started with a country church, in the graveyard. The last pictures of graves and crosses on All Souls' Day refer to death but also to the eter-

nal life of the soul. Hence in *Uf em Land* Tuggener showed, as in *Frühling, Sommer, Herbst,* and *Winter,* something beyond visible reality, behind the façade. It alludes to a climate that has changed from the inert spiritual narrowness to a light-filled inner space bustling with life, life infused with a spiritual aura that refers back to Tuggener's religious feelings of the early 1920s, of which the church was the symbol. Of course, the changes apparent in *Uf em Land* have to do, on the one hand, with the post-war developments in Swiss politics, economy, and society—the end of the war, increasing industrial production and consumption of goods, and the generally positive outlook in the late 1940s and early 1950s. They also reflect changes in Tuggener's personal life. He had divorced his first wife, who he felt had inhibited his artistic development, and in January 1950 he married Margrit Aschwanden, the daughter of a family of photographers from Altdorf in the canton of Uri in central Switzerland. Herself a trained photograper she took business matters into her own hands and went around trying to sell her husband's photographs to magazines and newspapers. Tuggener did not really like this because he was afraid of her "selling his soul." Margrit Aschwanden later remembered that she used to tell him that one had to eat to keep the soul alive. Mainly thanks to the income from regular work Tuggener undertook for the weekly *Genossenschaft,* the newspaper of the Verband Schweizer Konsumvereine (Association of Swiss Cooperative Societies) they were able to make a living and even to travel—to the south of France and Italy in 1951, and to Venice and Yugoslavia in 1954.[16]

In terms of public recognition, Tuggener was going through one of the most successful periods of his career. His work was included in the influential exhibition "Photographie in der Schweiz—heute" (Photography in Switzerland—Today) held at the Gewerbemuseum in Basel in 1949 and afterwards shown in Copenhagen, Denmark in 1950. In the same year a whole issue of *Camera* magazine was devoted to his photographs and films, and in 1950, together with Werner Bischof, Walter Läubli, Gotthard Schuh, and Paul Senn, he became a founding member of the Kollegium Schweizerischer Photographen (Academy of Swiss Photographers). This group exhibited twice, in 1951 and 1955, at the prestigious Helmhaus in Zurich. Both exhibitions by "five of our best photographers," as they were called in the Swiss press, were received with great acclaim.[17]

Zürcher Oberland

Shortly after the second exhibition of the Kollegium held at the Helmhaus, Tuggener was commissioned to photograph a book on the Zürcher Oberland (upper regions of the canton of Zurich). This project provided at least temporarily comfortable working conditions and Tuggener was busy for over a year. When the book was published in October 1956 it was intended to "present the beauty of the landscape, of the inhabitants in their homes and at their work places."[18] The two hundred and forty photographs show a perfectly idyllic world full of snow-covered Alps in the background and lakes and ponds in the foreground. There is also an abundance of sunny pictures showing the harvest of fruits, grains, and grass as well as photographs documenting the historic past and the cultural heritage of the area. Though more innovative in its layout than many of the preceding book maquettes, it still includes clichés such as the portrait of a young woman in local dress facing a picture of flowers in full bloom, a kind of juxtaposition that can be found in many "Heimatbücher" (Heimat books) produced in the spirit of the Geistige Landes-verteidigung. Thus *Zürcher Oberland* appears to be a perfect "Heimatbuch," or as the critic Urs Stahel disparagingly called it, an "incomprehensible ideal-world-book"[19]—at least at first glance. What Stahel overlooked, however, is the fact that Tuggener's book, unlike any of the other "Heimatbücher," contains a section towards the end that both questions what has been shown in such an ideal state of existence before and foreshadows what was to follow.

Pictures number 219 and 220 show a pensive bearded forestry worker on the left and the black outline of a wooded hill below the dark night sky with the moon faintly shining through the clouds illuminating both the landscape and the furrowed forehead of the man. This typically Tuggener-like spread directly refers to the final spread in *Fabrik* with the difference that the worker has turned into a Tell-like figure and impending doom is not related to war but to more intangible powers from the outside, beyond the reach of the common man. The following and last pictures of the book, most of them taken in winter, clearly refer to this anonymous danger: a stony slope that is abruptly breaking off, a close-up of a thistle, the black outline of a dead tree with its broken branches reaching into an empty sky, a snow storm, the cutting of trees in winter, and a frozen waterfall. The very last picture is familiar from *Frühling, Sommer, Herbst,* and *Winter:* the winter landscape that had inspired Arnold Kübler to comment that Tuggener showed not just winter as it was, but the idea of winter as the sinister brother of sleep and death. Thus not even the com-

missioned *Zürcher Oberland* can be considered a true "Heimatbuch," instead it is a personal vision of a world which was far from ideal.

The dark clouds and the cold that entered *Zürcher Oberland* towards the end of the book also seem to be a reflection of Tuggener's professional and personal life during the second half of the 1950s. No major commissions were coming his way and it became more and more difficult for him to survive as a photographer in the rapidly changing world of advertising which was becoming controlled by a new breed of professionals—the advertising consultants and art directors with whom Tuggener had nothing in common. He also lost his group of colleagues, the Kollegium. After the deaths of Paul Senn in 1953 and Werner Bischof the following year, the group had tried to rejuvenate itself by accepting Kurt Blum, René Groebli, Christian Staub, and Robert Frank into its ranks. They exhibited together once, in 1955, but only a year later Tuggener resigned and the group dissolved. At the same time his marriage approached a crisis, brought about by both Tuggener's repeated affairs with other women and the fact that Margrit felt she did not have the freedom to pursue her own career as an artist; they divorced at the end of 1958. A year later Tuggener moved into the small one-room basement apartment on Titlisstrasse in Zurich where he continued to live and work for the rest of his life.

Waldarbeiter (Forestry Worker), Strahlegg, 1954/55

Mondnacht (Moonlit Night), 1954/55

Notes

1 Franziska and Felix Müller, "'Heroismus der Mitte.' Zur deutschsprachigen Literaur der dreissiger Jahre," in Kunsthaus Zürich (ed.), *Dreissiger Jahre Schweiz. Ein Jahrzehnt im Widerspruch* (Zurich: Kunsthaus Zürich, 1981), p. 440.

2 See *In freien Stunden,* 17 August 1935, pp. 4–5.

3 Ernst Laur, *Der Schweizerbauer. Seine Heimat und sein Werk* (Brugg: Schweizerischer Bauernverband, 1939), p 88.

4 Ibid., p. 651.

5 Tuggener in undated letters to Max Wydler, (1939–40).

6 See Max Frisch, *Blätter aus dem Brotsack* (Zurich: Atlantis, 1940).

7 Tuggener in letter to Marie Gassler, 15 May 1940.

8 Tuggener in undated letter to Marie Gassler, (1939–40).

9 Ibid.

10 Tuggener, "Säulimetzgete," undated manuscript, (ca. 1939–42).

11 Paul Nizon, *Diskurs in der Enge* (Bern: Kandelaber, 1970), p. 46.

12 Kübler, "Zum Februarheft" in *Du,* February 1946, p. 5.

13 Ibid.

14 Ibid.

15 Werner Bischof, Gottlieb Duttweiler, Arnold Kübler (eds.), *Our Leave in Switzerland* (Zürich: "Zur Limmat," 1945), pp. 150–151.

16 Interview with Margrit Aschwanden, 26 May 1990.

17 See for example anon., "Fünf Schweizer Photographen stellen aus," in *Genossenschaft,* 10 February 1951.

18 Paul Weber in preface to Jakob Tuggener, *Zürcher Oberland* (Wetzikon: Verlag AG Buch-druckerei Wetzikon und Rüti, 1956), p. 5.

19 Urs Stahel, "Fotografie in der Schweiz," in Urs Stahel and Martin Heller, *Wichtige Bilder* (Zurich: Der Alltag/Museum für Gestaltung, 1990), p. 154.

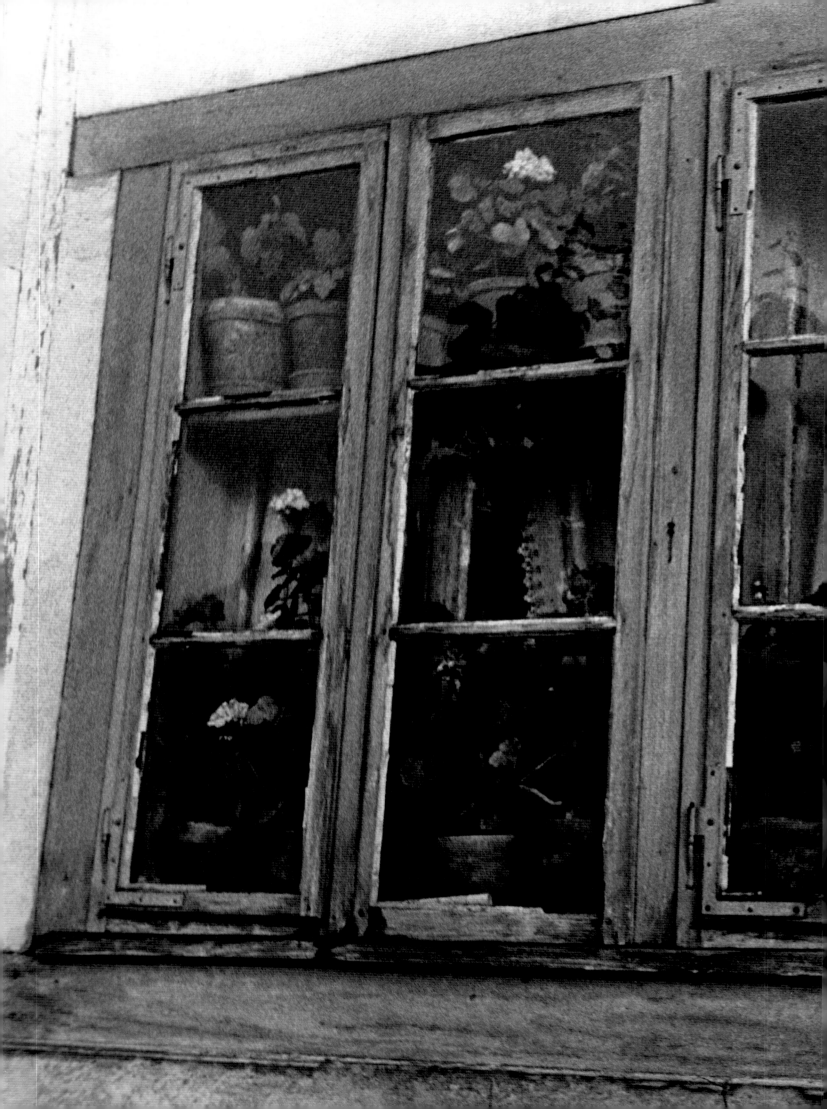

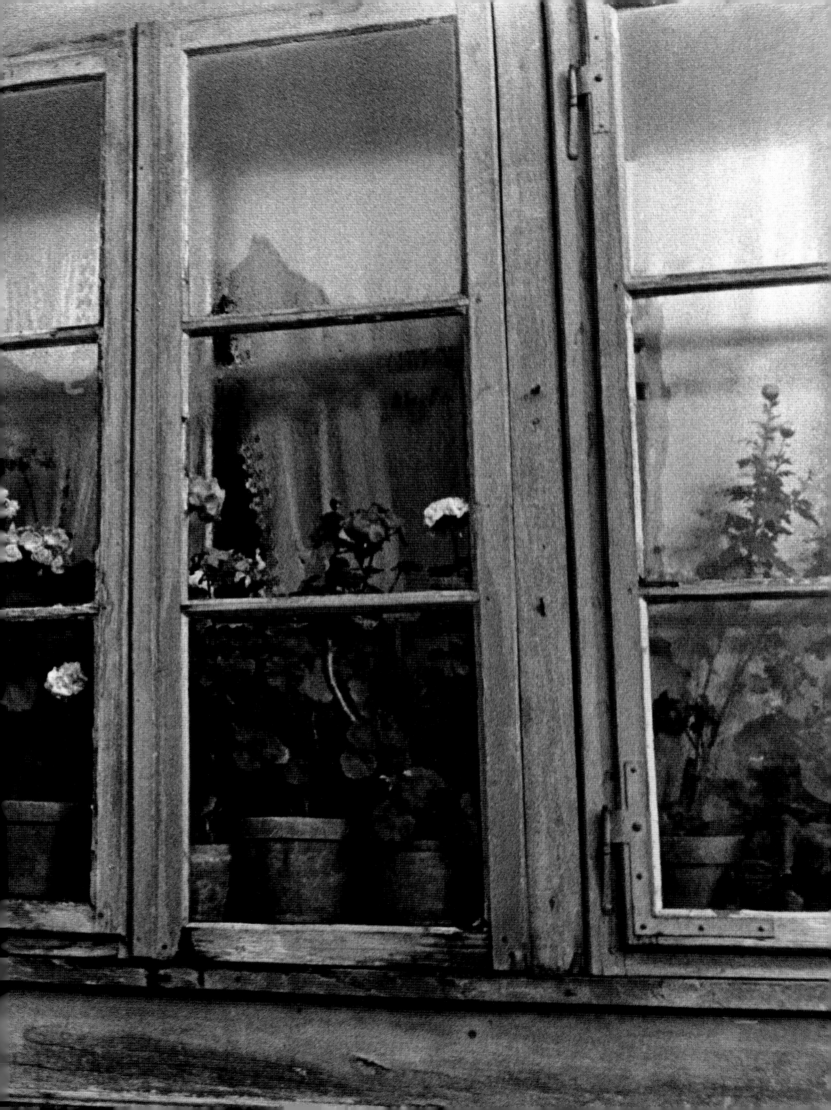

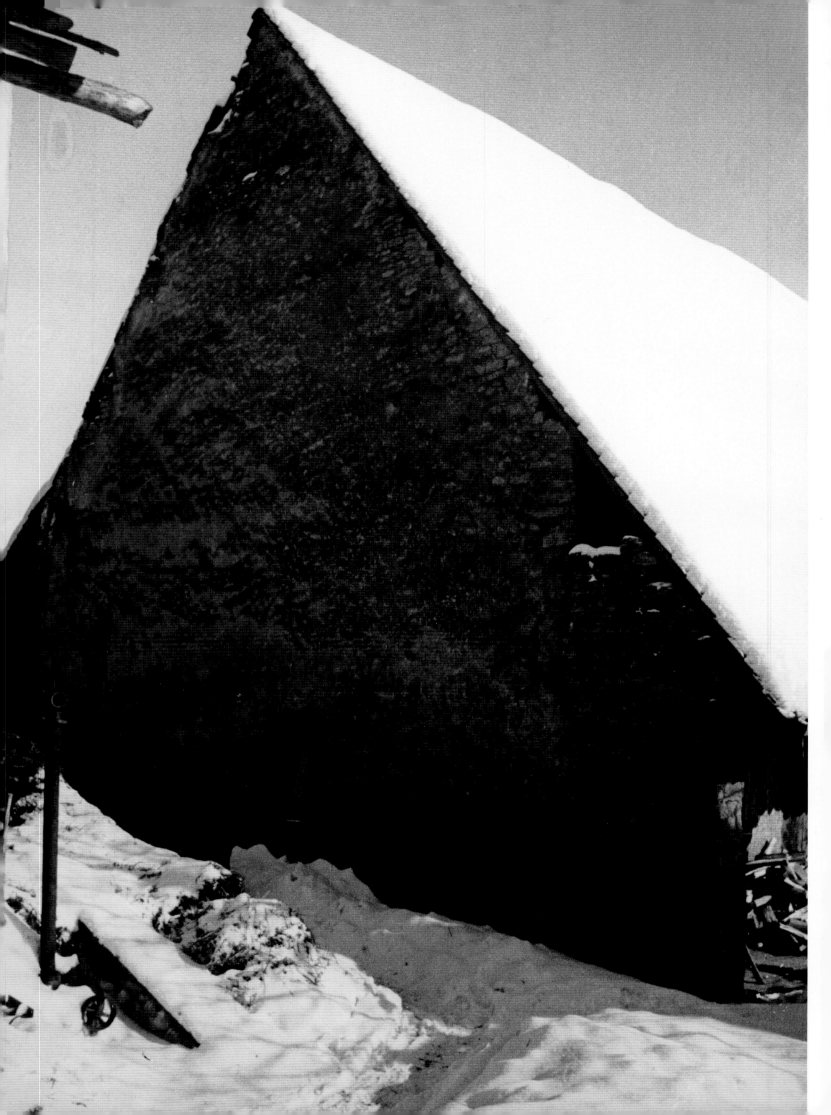

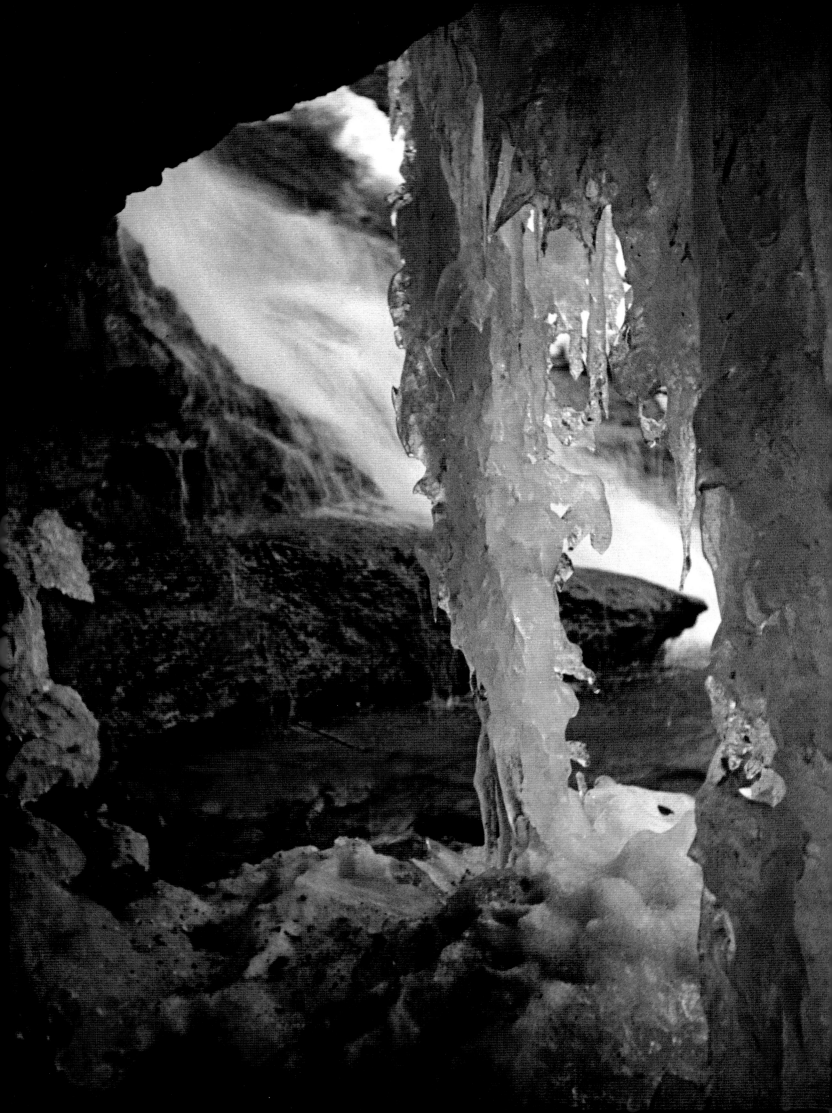

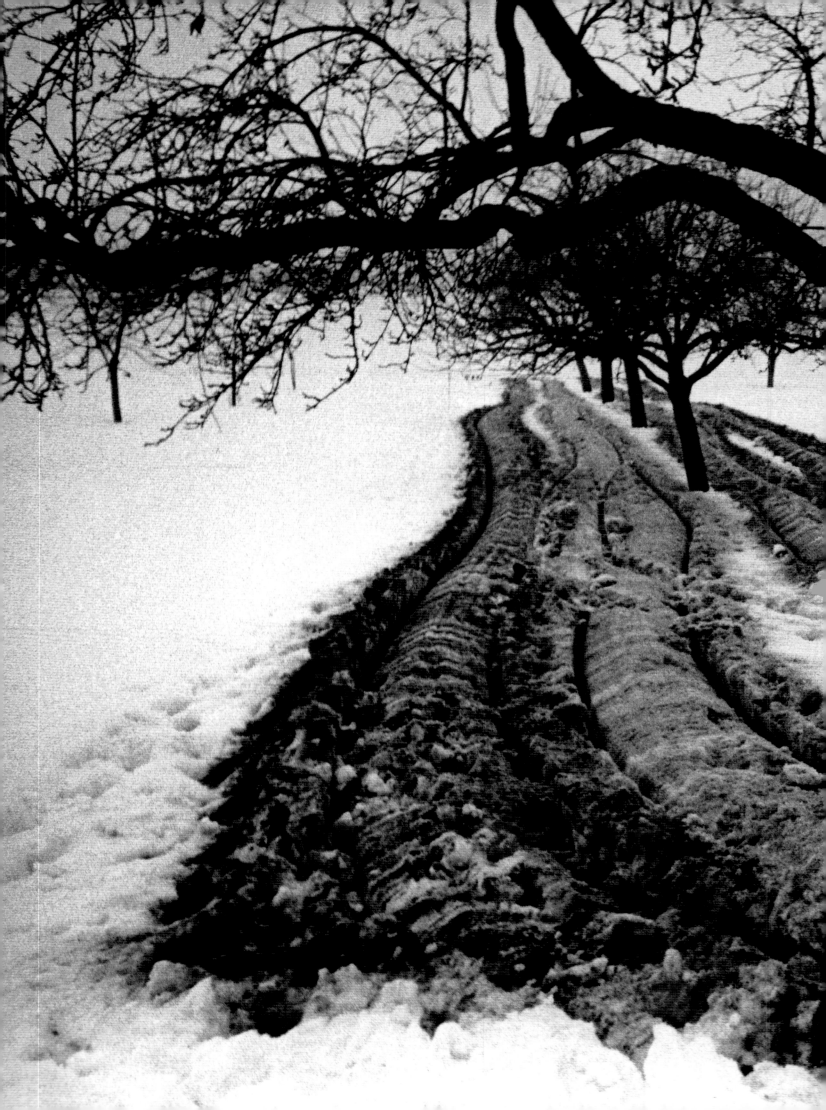

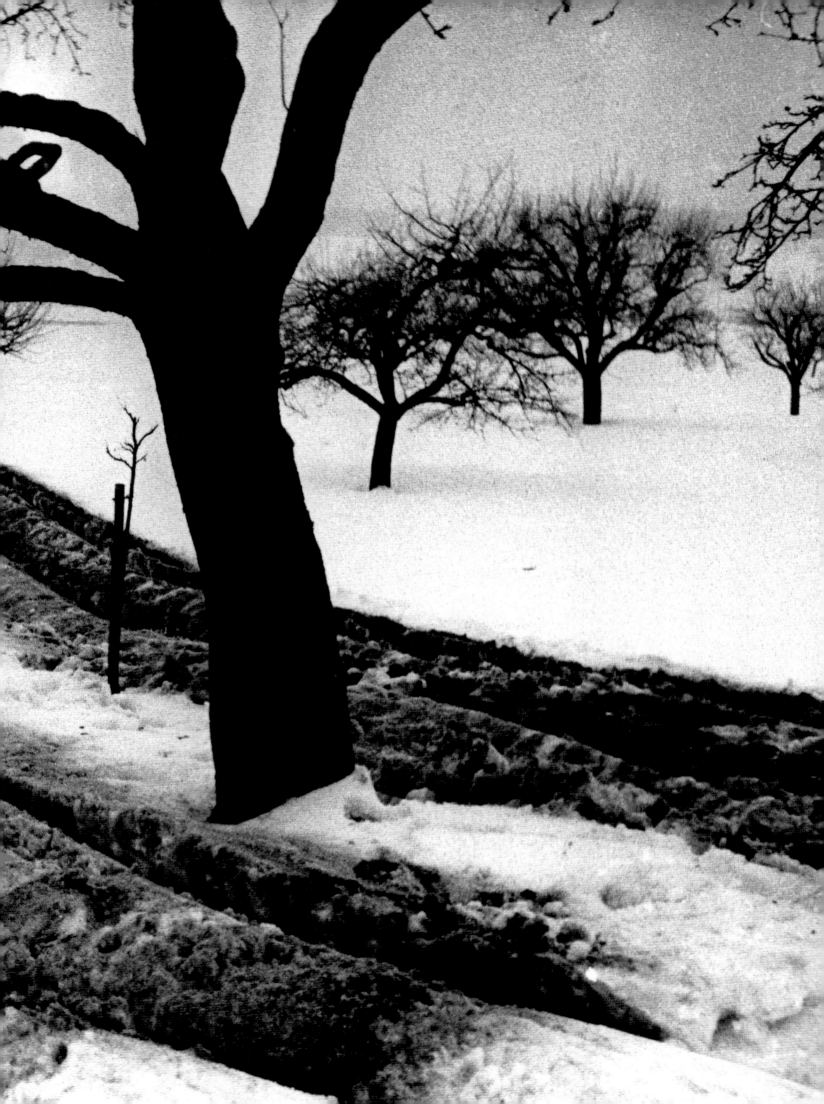

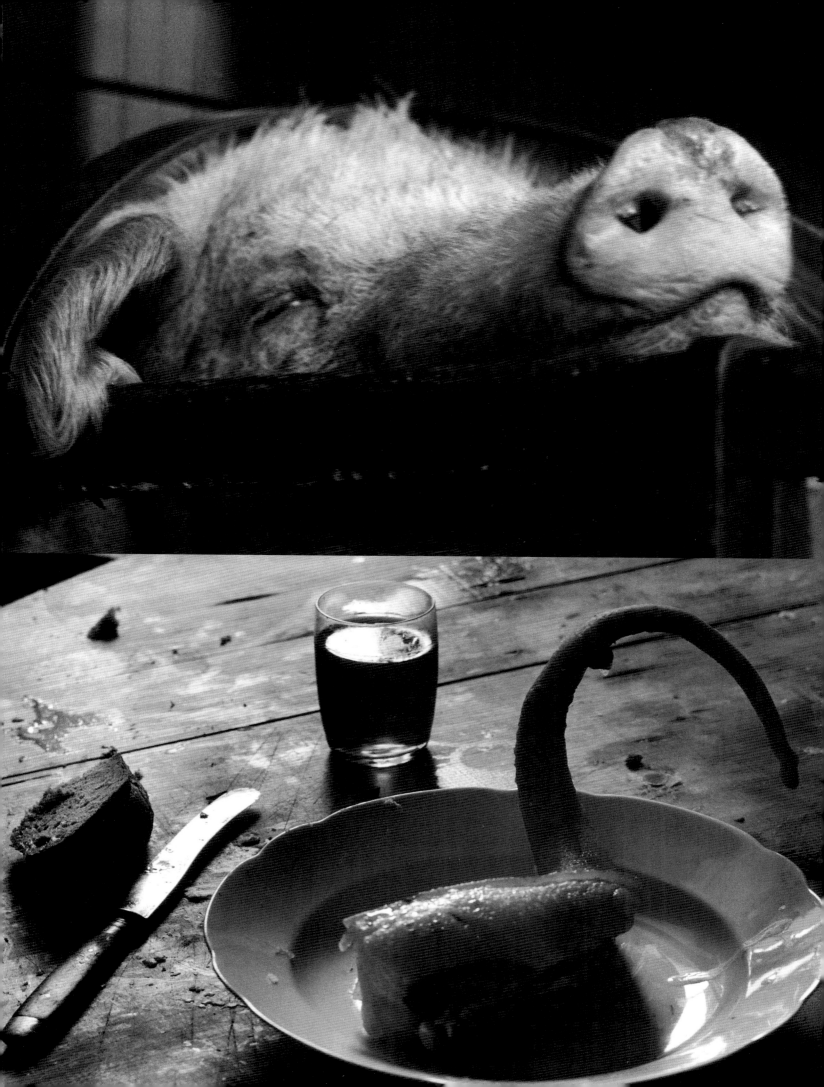

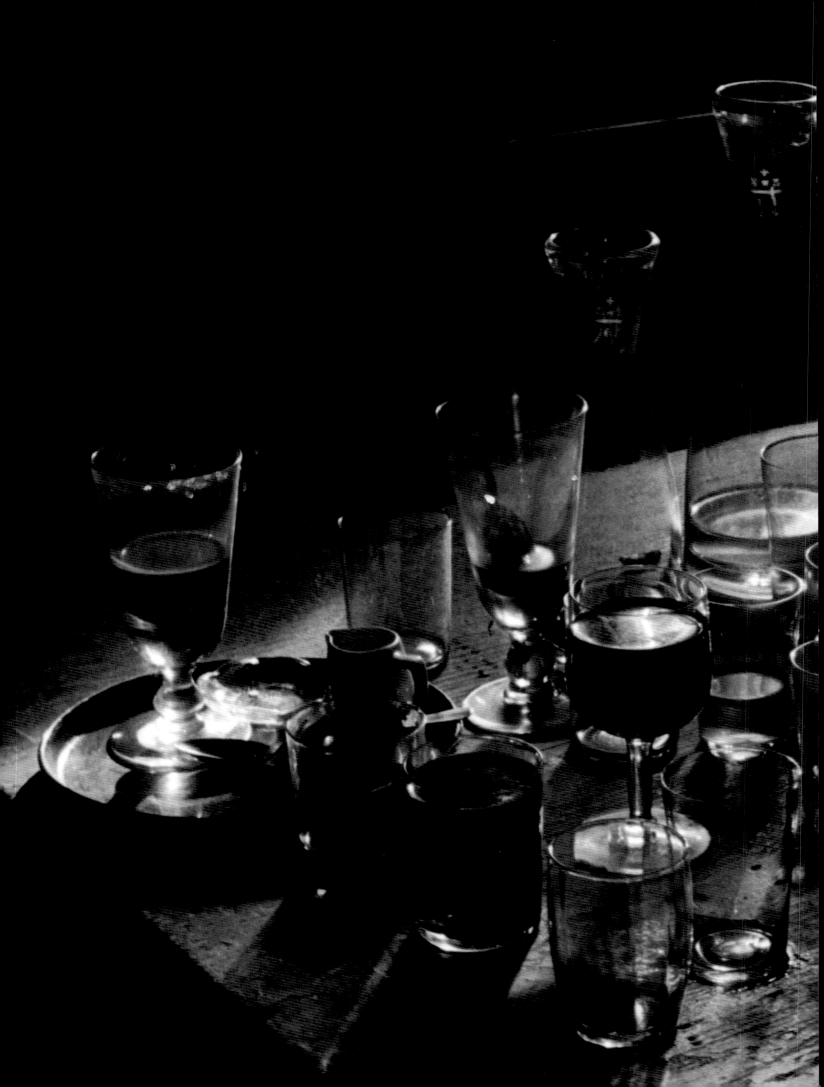

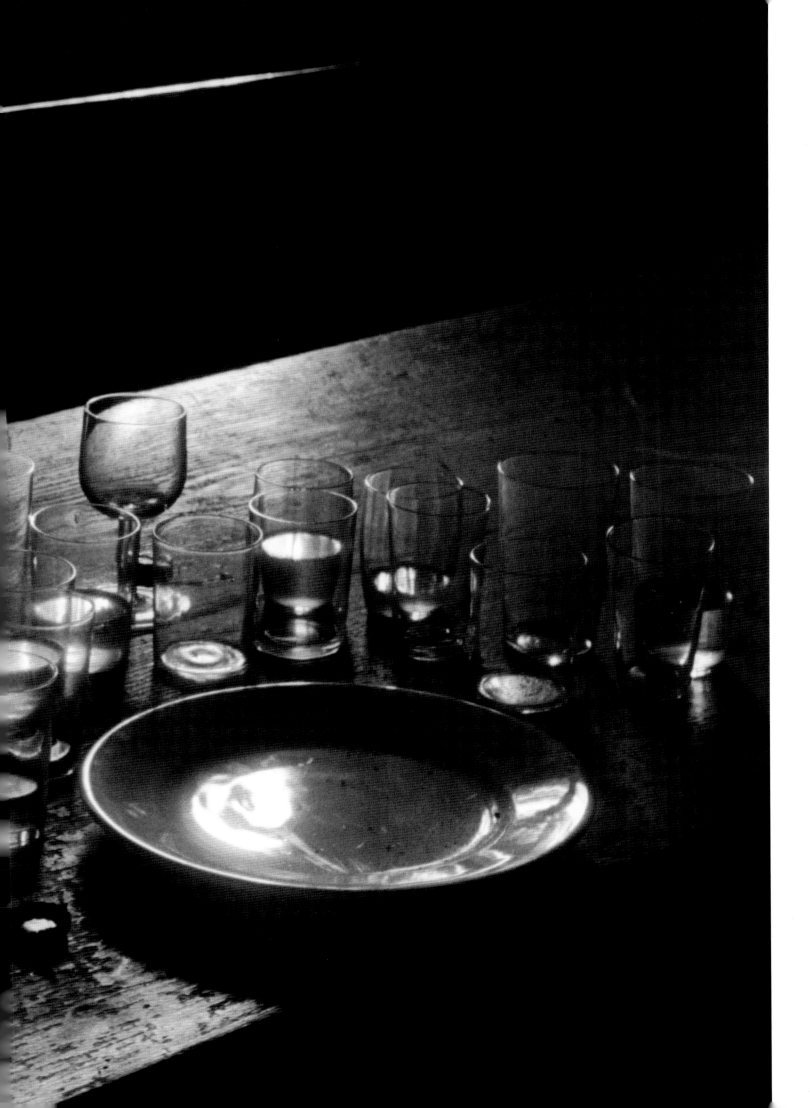

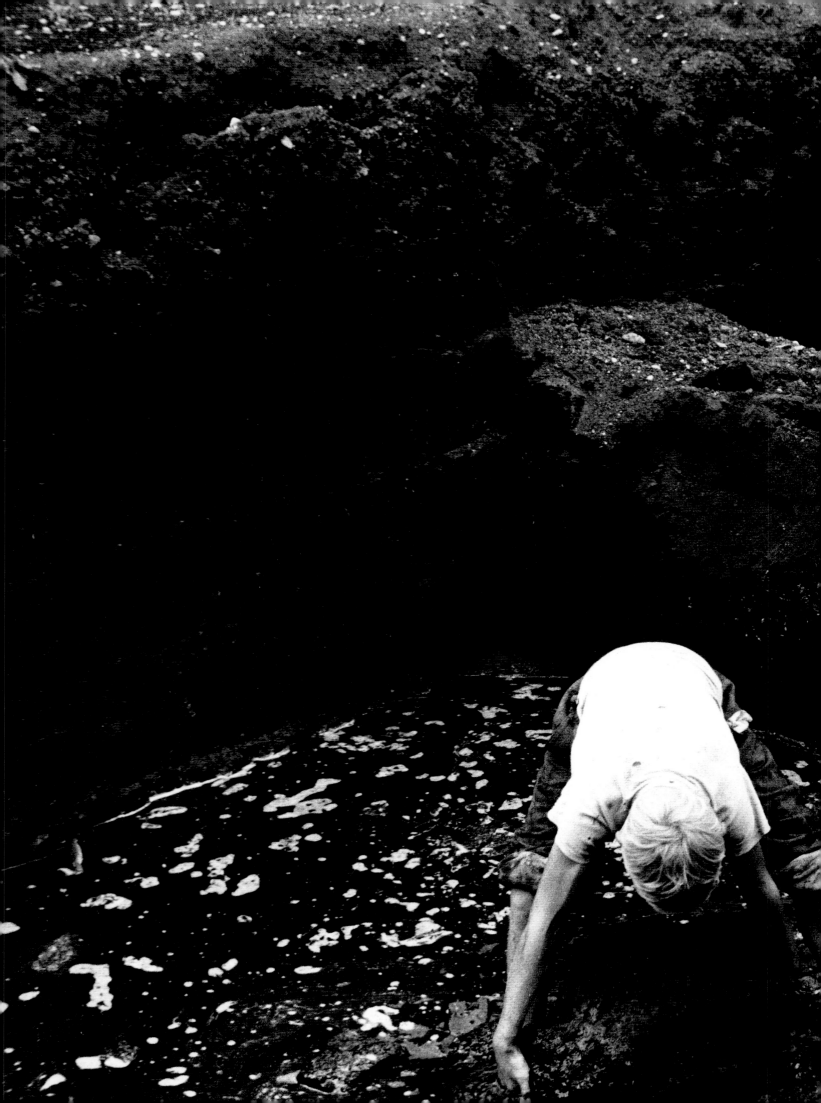

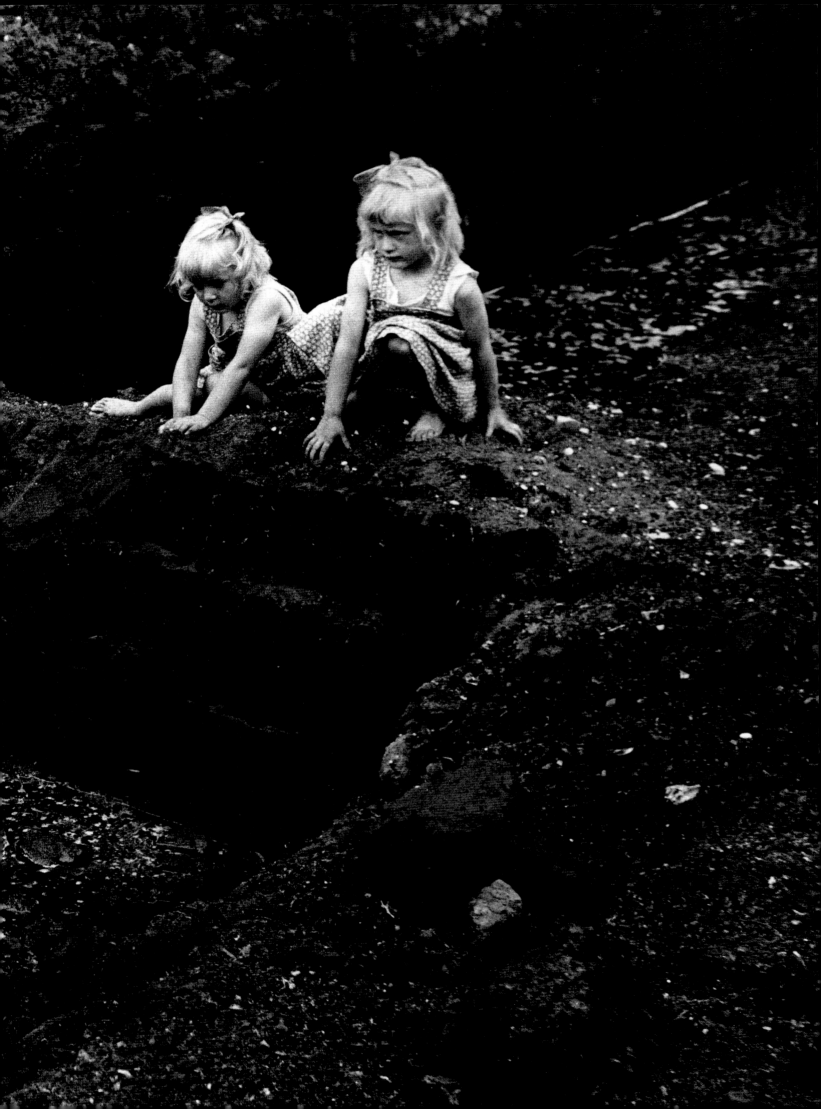

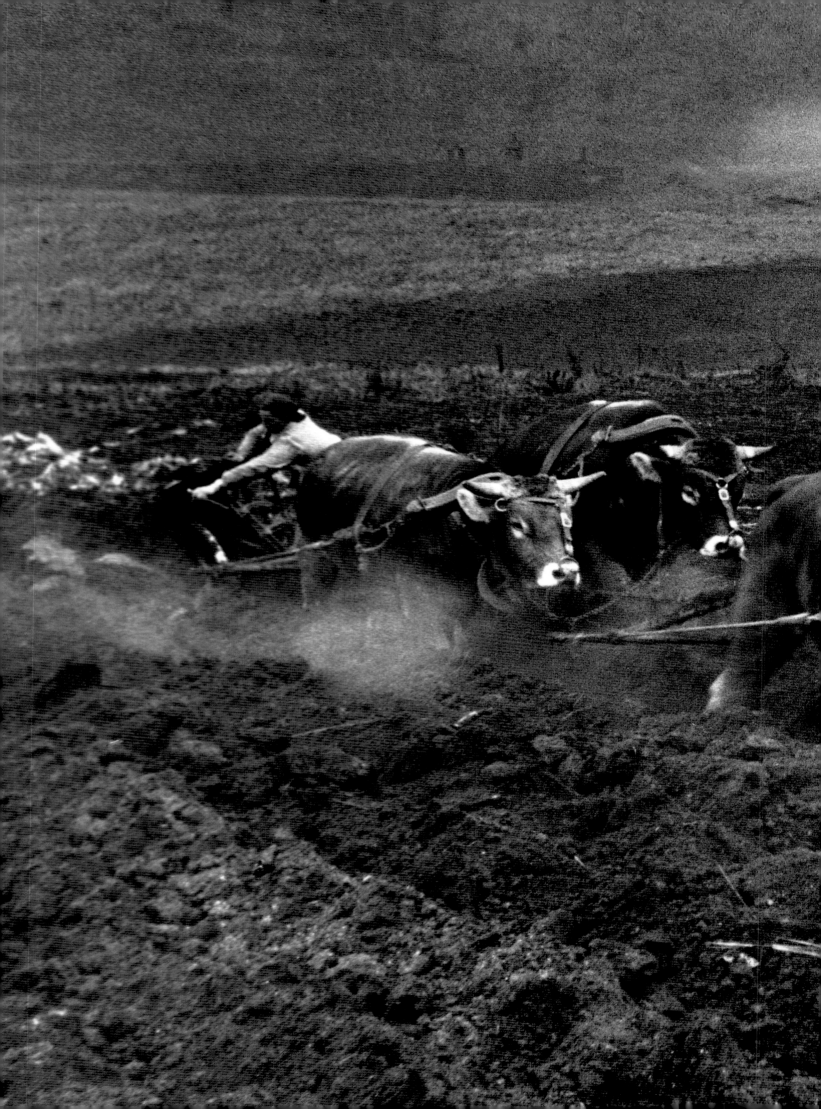

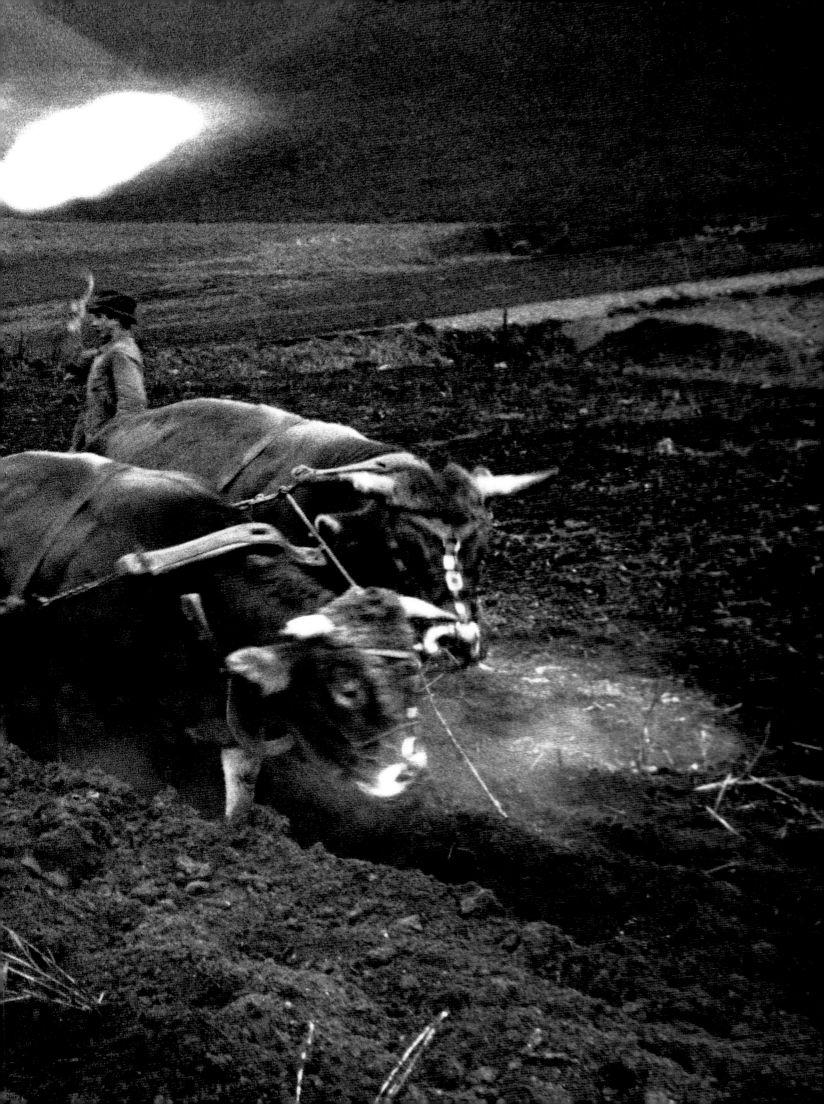

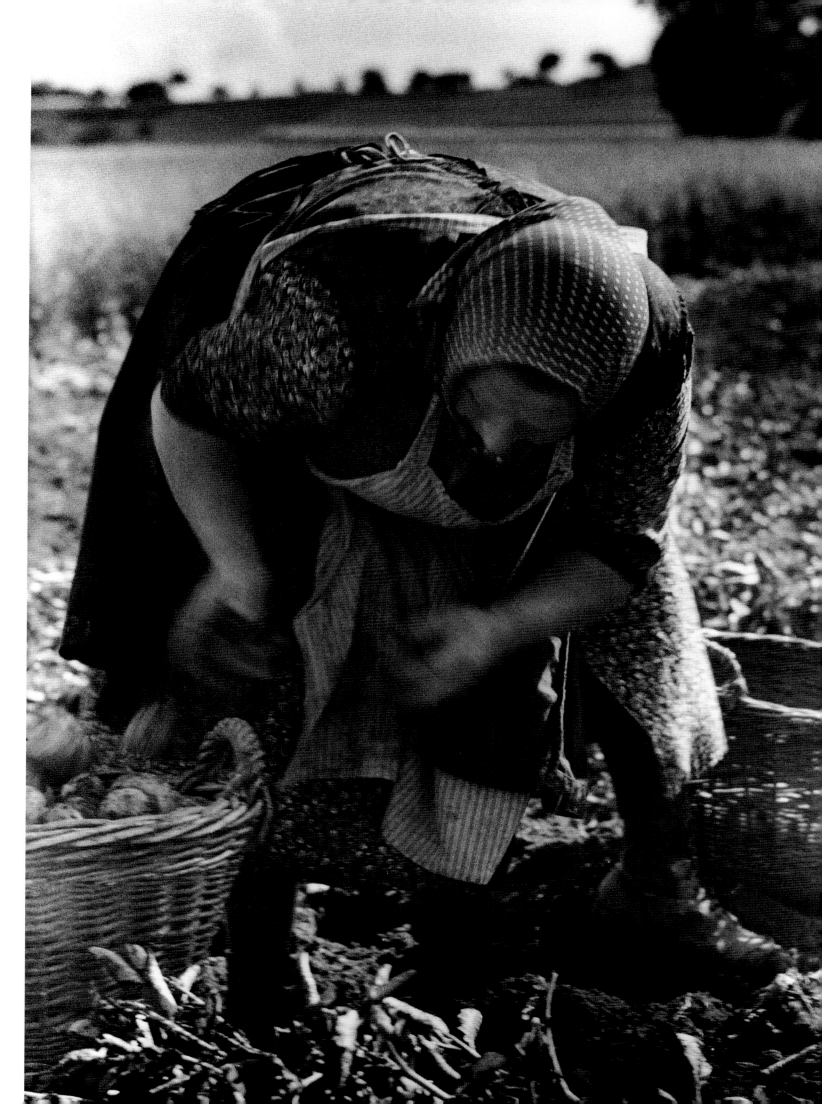

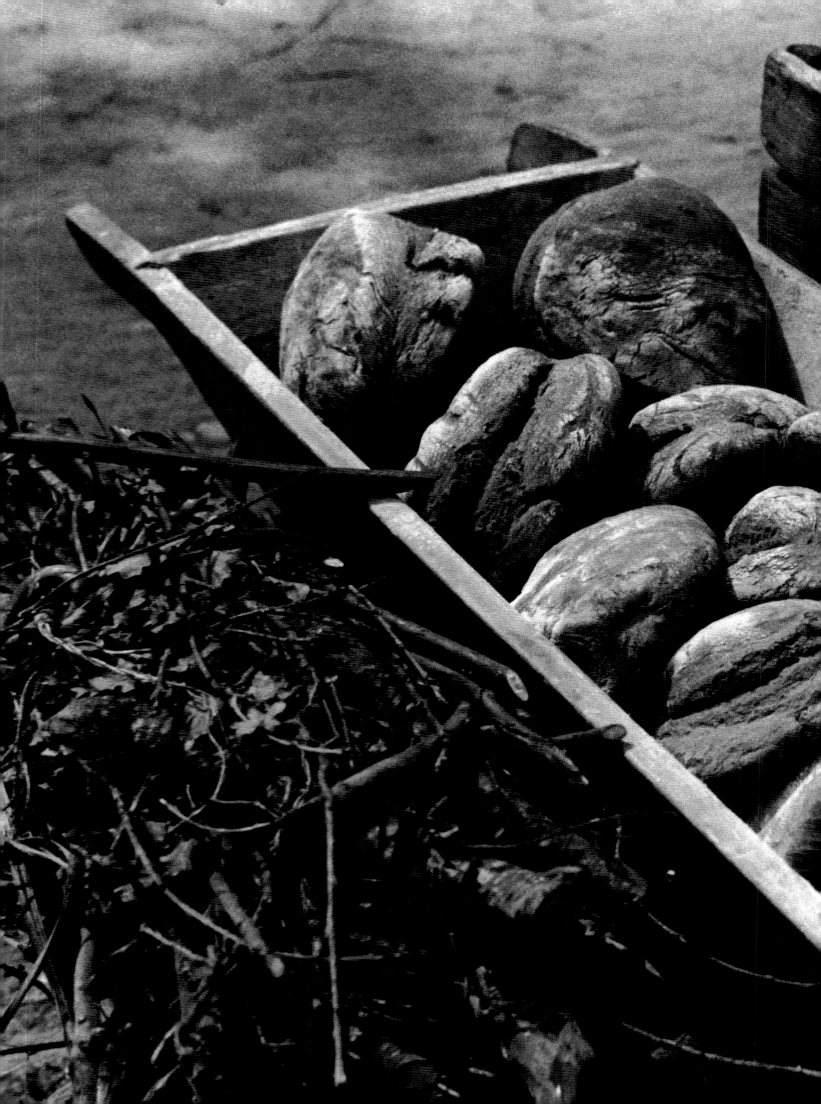

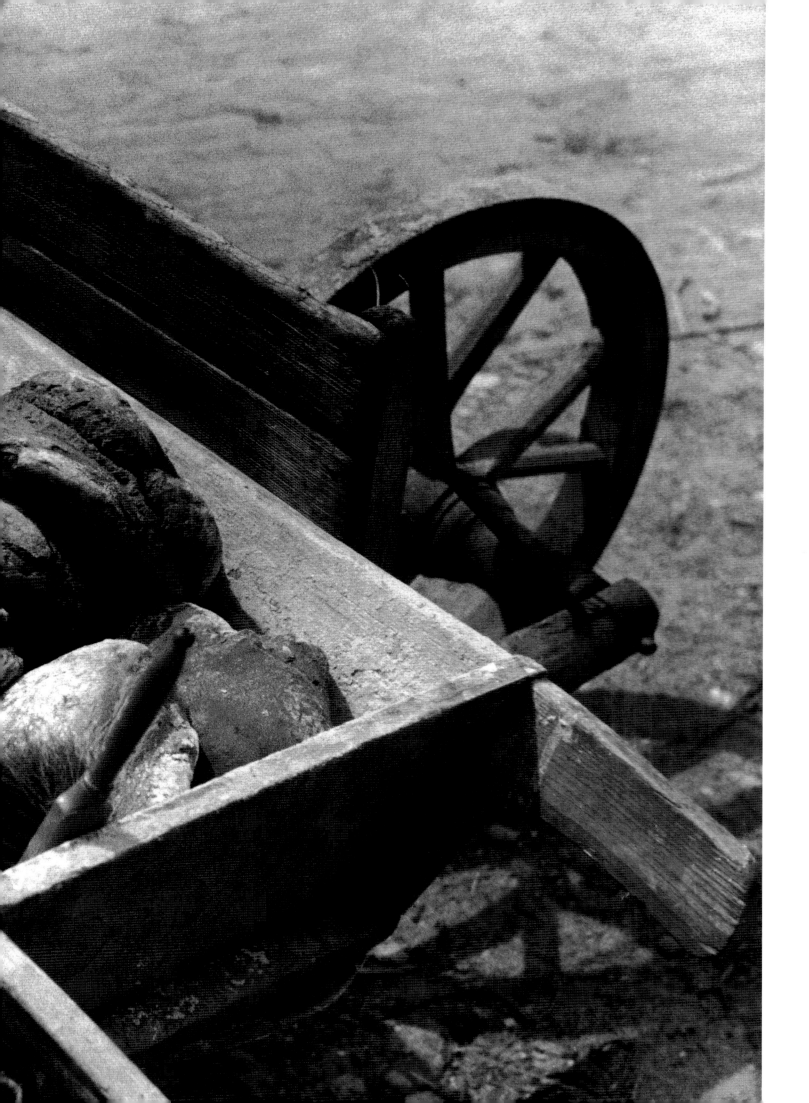

Handlung
von
Fam. H. Schrämli-Rüegg.

Hero Conserven Lenzburg

Dieses Paket verlangen!

Kochfett Nussgold

SUNLIGHT SEIFE

CHOCOLAT SPRÜNGLI CACAO

Franck Aroma

Cichorie

Usego
Gute Ware billig
Mitglied

VIM

RADION OMO

Rabatt-Verein

Sträuli Seifen
Winterthur

MAGGI'S PRODUKTE
Erbs
FABRIK VON MAGGIS NAHRUNGSMITTELN KEMPTTAL

PALMIN
PALMINA

ENKA hilft der Hausfrau

Hafermehl & Reismehl
Knorr
Suppen & Bouillon

CHOCOLAT
Grison

Bergmann's Lilienmilch-Seife

ENKA hilft der Hausfrau

Persil
für alle Wäsche

Steinfels Seifen

ECCE HOMO

Plates pp. 205–240

Photographs from Frühling, Sommer, Herbst, and Winter (Spring, Summer, Fall, and Winter), 1942/43 and Uf em Land (In the Countryside), 1953

p. 205 Untitled, Mandach, 1939

pp. 206/207 Untitled, Mettmenstetten, 1938

p. 208 Binkert Bertis Haus (Berti Binkert's House), Oeschgen, 1942

p. 209 Im Erlenbachertobel (In the Ravine of Erlenbach), 1935

pp. 210/211 Untitled, Oeschgen, 1942

p. 213 Znüni (Morning Snack), 1942

pp. 214/215 Tanzssal am Morgen (Dance Hall in the Morning), Oeschgen, 1943

p. 216 Wirtschaft im November (Restaurant in November), near Lenzburg, 1939

pp. 218/219 Winterwald (Winter Forest), c. 1942

p. 220 Fasnacht (Carnival), Sennhof, 1935

p. 221 Schlafkammer (Bedroom), Oeschgen, 1942

p. 223 Bauernfrau (Farmer's Wife), Brüttelen, 1944

pp. 224/225 Im Moor (In the Moor), near Treiten, 1944

pp. 226/227 Untitled, Küssnacht am Rigi, 1943

p. 229 Kartoffelernte (Potato Harvest), Müntschemier, 1944

pp. 230/231 Bauernbrot (Farmer's Bread), Brüttelen, 1944

p. 233 Handlung (Shop), Nieder-Uster, c. 1940

p. 234 Untitled, Müntschemier, 1944

p. 235 Linde (Lime), near Wetzwil, 1934

p. 237 Friedhof (Cemetery), Busskirch, 1934

p. 238 Gebet (Prayer), Arth am See, 1943

p. 239 Untitled, verre églomisé picture, 1940s

p. 240 Allerseelen (All Souls' Day), Busskirch, 1934

LIGHTS OF THE NIGHT

The sight of the city by night is like the photographic negative of the day. The sky is black, the houses are bright, everything is reversed, even the people. The thoughts that reach the surface of things during the day return to the inside at night. Enclosed by darkness, we feel like lights and wish to be ourselves. The life of the night is radiant; everything is its own center. This may well be the magic of everything becoming its own self and alive through its inner light.

Jakob Tuggener, c. 1935/36

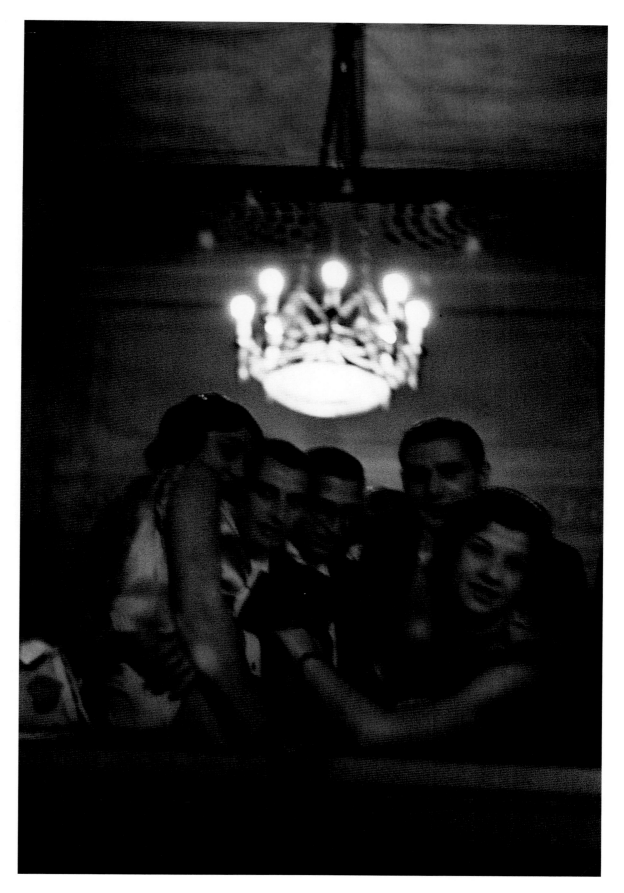

Untitled, Grand Hotel Dolder, Zurich, 1930s

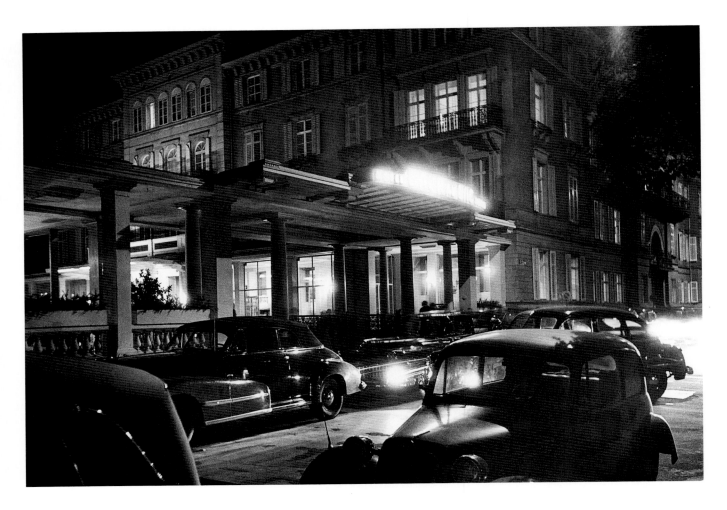

Untitled, Hotel Baur au Lac, Zurich, c. 1935

Nights at the Balls

Around 1960 Tuggener became involved in a new book project: a collection of the photographs he had been taking at society events such as artists' masked balls in Zurich and New Year's Eve balls of the high society in the Palace Hotel in St. Moritz. After *Fabrik* of 1943 and *Zürcher Oberland* of 1956, this book was to introduce Tuggener's third main theme, the "Ballnächte" (Nights at the Balls). In May 1961 he wrote to his new lover Edith Wildhagen: "My ball photographs for the publisher in Munich are now spread out on the floor. I selected them this morning, again twenty-two images. Yes, this moment gives me great pride; this is something, something brilliant. I have no reason to stick my head into the sand..."[1] However, for reasons unknown, the project was abandoned and no book with Tuggener's ball photographs was ever published. Only towards the end of the year, *Leica-Fotografie* published nine ball pictures and presented Tuggener as a "Master of the Leica," and Tuggener commented: "The 'Ballnächte' have become my favorite theme, my life's work. I have worked on it for twenty-six years trying to grasp it in all its depths and widths."[2] Tuggener's fascination with glamorous society events had begun in Berlin at the 1931 ball of the Reimann Schule where he had documented the preparations by the Reimann students but had not taken photographs during the night of the ball. However, back in Zurich and shortly after he acquired the small-format Leica camera, he photographed the "Grand Bal Russe" on 10 November 1934. As indicated on the backs of two photographs in the maquette *Baur au Lac* (1963) this was his first ball in Zurich, to which he was taken by Dolly Massow, an attractive young woman from Silesia. The Leica camera opened totally new possibilities allowing

Tuggener to take pictures at night and under poor lighting conditions. Since the 1920s, he had frequented the night clubs of the Zurich Niederdorf and had gone to folkloristic events such as the National Costume Festival and was therefore well aware of the two worlds—one associated with folk music and dance in the country, the other with jazz and night-life in the city. Just as local folklorist festivals became increasingly popular, social life in Zurich was trying to recover after the economic shock of 1929 and Tuggener was eager to be part of it and perhaps experience again the atmosphere he had enjoyed at the Reimannball in Berlin.

Possibly inspired by Brassaï's book *Paris de nuit* that had just been published, he wrote to his girlfriend Marie in November 1934: "I shall now start taking photographs at night. The 'Grand Bal Russe' (in the Hotel Baur au Lac) will be held on Saturday. I will be there and will try to take photographs of social life in winter, of elegant cars, dance, and the bar."[3] Tuggener was immediately very successful and raved about the atmosphere at the Baur au Lac, one of Zurich's luxury hotels: "What one saw of the beauty of women and the flowing silky sheen was like a fairy tale."[4] Totally enthused about this new discovery he wrote: "I am actually completely wrapped up in this world of splendor and luxury. I have attended the most sumptuous balls and brought pictures home accordingly."[5] However, success did not always come easy. At the first "Presseball" (press ball) in December he encountered problems with the flash bulbs that he had begun to use. He wrote to Marie: "But at the last ball, the 'Presseball' in the Corso theater, you did not pray for me anymore, did you? I had bad luck, my flash bulbs went on strike and two royal images were denied me."[6] Similar technical problems haunted him at the Italian Ball at the Baur au Lac, but thanks to the help of the hotel electrician he did not have to "capitulate before even taking one photograph" and was able to take "brilliant pictures" and make up for what he had missed at the "Presseball."[7] All through the winter of 1934–35 Tuggener seems to have rushed from one ball to the next and he complained that he was "overworked" and "rarely finding enough sleep" with the result that a lot of his photographs turned out unsatisfactory.[8]

Tuggener's first published ball photograph appeared in *Föhn* in 1935. It shows two young women in evening dresses choosing delicacies from a buffet loaded with fine foods and attended to by a white-capped cook. Almost no other such photographs can be found in the illustrated press of that period. One reason for this certainly was that celebrating the abundance of exquisite food enjoyed by the rich in the face of economic hardship and unemployment would have been offensive to

at least part of the readership. It is therefore not surprising that it was *Föhn,* a publication that usually did not hesitate taking up controversial subjects, that published Tuggener's photograph. Not even pictures taken at masked balls can be found readily because carnival, too, was in decline—after booming in the 1920s—due to economic reasons, and no public parades were held after 1932. Only after the war did the carnival slowly regain its popularity.

Another reason must have been that, apparently, no other Swiss photographer of stature bothered to deal with the subject, with the exception of Gotthard Schuh. He took photographs of the 1932 "Kunsthaus Maskenball" but later lost interest and included no ball photographs in his own retrospective monographs *50 Photographien* (50 Photographs) (1942) and *Begegnungen* (Encounters) (1956). The other major Swiss photographers, Hans Staub and Paul Senn, probably never even considered taking photographs at social events of the high society because their political sympathies lay with working-class people, the poor, and the unemployed. One last reason was probably the fact that balls were the territories of professional photographers specializing in the subject. These photographers, often commissioned or "licensed" by the organizers or the hotel management, usually did not like outsiders muscling in on their designated area. Thus the grand hotel was a rather closed society not unlike the factory with its own in-house photographers. Among Tuggener's first ball photographs taken in 1934 and 1935 are a great number of pictures of elegant cars parked in front of hotels, of people dancing in the dance halls and enjoying themselves at the hotel buffets and bars. But above all, there are photographs of women, beautiful and very elegant, whose bosoms, bare backs and revealing silk dresses fascinated Tuggener tremendously. He never made a secret of the fact that he often went beyond mere observation of women's radiant eroticism from a distance to engage in a personal experience of this facet of life at close range; from the "inside," to use Tuggener's terminology. Being an attractive young man himself he had no difficulties and felt no moral scruples falling in love over and over again—even during his married life.

Just a few months after they first met in 1934, he wrote to his girlfriend and later wife Marie: "I wish all people were like children, like I am. I do not live in conflict with myself: when I find love, I take it as a gift. It is a great disappointment to wait one's whole life to then realize that one has grown old, don't you think?" Typically, he constructed a religious basis for his view: "Spiritual love leads to conflict, earthly love opens the way to the freedom of the spirit." According to him it was "against

nature, which in itself is absolute and expressive of God's will," to suppress sexual desires. A woman who only practiced "spiritual" love was for Tuggener "like a rusty machine without oil that could not run anymore."[9] Even though Tuggener admitted himself that this comparison was somewhat crude, it not only sheds light on his thoughts about women but also on his fascination for machines, in which Tuggener must have perceived an erotic element as well.

Men play only a minor role in these early photographs, though the complacent dentist "Dr. Gubser" at the Hungarian Ball is an exception. Usually, men are only there to provide a light for a cigarette, or act as contrasting figures, against which the women appear even more beautiful. In other pictures men are shown in unusual, if not to say compromising, positions. For instance, there are observations of a man's advances toward a reclining woman, or of another man who, while resting his head on a young woman's lap, is pouring champagne from a bottle into his open mouth. In all of the ball photographs, also in the less indiscreet ones, Tuggener managed to capture the intimate atmosphere of refined eroticism in the dance halls bathed in the soft light of luxurious chandeliers.

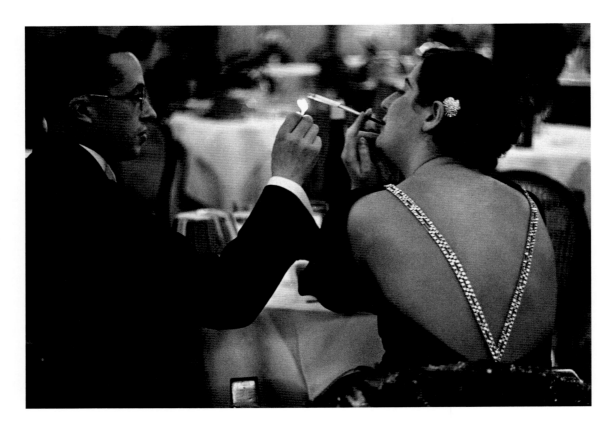

Untitled, Hungarian ball, Grand Hotel Dolder, 1935

The first major selection from Tuggener's ball photographs entitled "Jeder schönen Frau unsere Huldigung" (Every Beautiful Woman Deserves Our Homage) was again published in *Föhn* at the beginning of the ball season in November 1937. The nine photographs were accompanied by a text by an anonymous author who stated that a true ball always included "a flood of sounds, a sea of lights, and the grand toilette. A ball is not mere entertainment but a feast." The author then went on to talk about the different fashionable dances and their development, but argued that they were not as essential to the balls as everything else which was festive like "the decoration, the buffet, the [wine] cellar, the entertainment including confetti and streamers." He concluded that balls "only have one meaning: the social homage to the beauty of women. Female beauty is the male experience at the ball; homage the triumph of every woman."[10] These lines exactly echo Tuggener's feelings: he was not particularly interested in the details of dance beyond the impression of movement, but he paid close attention to all the festive details, the facial expressions and gestures of the women interacting with men.

The article also explained that the "cult of female beauty" had always been the expression of "refined culture" and that therefore balls had always been feasts of the "upper ten thousand." But now, in the second half of the 1930s, looking beautiful no longer depended on money alone since industry and technology had provided the possibilities of wearing inexpensive imitation jewelry as well as artificial silk and fur. Consequently, every woman was allowed access to public balls as long as she wore "evening toilette." Absolutely essential, however, was a new awareness of the "natural, healthy appeal of the trained female body based on the influence of sun, water, and air" resulting in a totally "new kind of eroticism." Thus female beauty was not expressive of social status anymore, but of a new way women perceived themselves. The writer ended his article by stating: "Everybody has the privilege to be beautiful. That's how our sporty time wants it."[11] Tuggener, probably like most young men of his time, was certainly attracted to this type of "new" woman that began to dominate social life.

Apart from Tuggener's attraction to the "fairy-tale" beauty of modern, sporty women there is also another, inner quality to be discovered in his ball pictures. It has to do with Tuggener's fascination with the dark, with night and the lights shining brightly, reversing the values of dark and bright, of inside and outside. Paul Morand wrote in the introduction to Brassaï's *Paris de nuit:* "The night is not the negative of day; black surfaces and white are not merely transposed, as on a

photographic plate, but another picture altogether emerges at nightfall." He thought Paris by night a dangerous place, "its darkness teems with unseen presences, the restless souls of the Parisians escaping through sleep-bound lips," and he quoted the writer Julian Green saying, "But, when the nightmists rise, such places wake to life that is a parody of death; the smiling banks turn livid, dark surfaces grow pale and flicker with funeral gleams, coming with evil glee into their own again. It is the street-lamp that works this transformation."[12] Though rooted in the same fascination, it was, of course, not death or menacing shadows that Tuggener was searching, but life, a revealing inner light.

In the second half of the 1930s he wrote a text entitled "Lichter der Nacht" (Lights of the Night) that can be seen as an answer to Morand: "The sight of the city by night is like the photographic negative of the day. The sky is black, the houses are bright, everything is reversed, even the people. ... Enclosed by darkness we feel like lights and wish to be ourselves."[13] Much later, in 1971, Hans Finsler wrote: "Night is the reverse, the negative of the day. The negative picture is also a picture of our world."[14] For Tuggener, unlike Finsler's concerns for surface, form, and function, the negative of the day is not just another possible picture of the world, but it is the picture of the world as such, of the inner world that, essentially, is he himself. Another text Tuggener wrote at about the same time is entitled "Alabasterlicht" (Alabaster Light) and is full of expressionist images and invented words that are almost impossible to translate. In it he made a poetic, dream-like connection between this inner world of night and balls at the beginning of the season: "When it gets to be November and the lights start burning early in the evening; when we sit in the brightly illuminated streetcar and colorful neon signs flicker around us; then, it is as if all those lights carry off our souls into a world that is inside, radiant and warm. ... Velvety shoulders shimmer in alabaster light, the walls phosphoresce, and sometimes the mirrors flash. The ballroom guards dark blood encircled and cocooned by distant sounds. Lamps awaken, the couples return to their seats."[15] This text evokes Tuggener's state of mind at the time of his first encounters with this other world of the ballroom. The darkness of night allows him to cut out glaring reality, both in terms of the world of "appearances," as he said philosophically, and in terms of the socio-economic conditions, the commotion and agitation of the "outside" world by which he did not want to be bothered.

The outbreak of World War II brought social life to a halt and all light entertainment such as masked balls were canceled giving way to patriotic manifestations such as

the yearly celebrations of the National Day on 1 August, or the monumental 650th anniversary of the Swiss Confederation in 1941. Despite the war or perhaps because of the blackouts resulting from it Tuggener's fascination with nocturnal atmosphere persisted. While on guard near the Rhine, he painted at night several "Mondbilder" (moon pictures) that "looked more and more like silk." One of them he sent to Marie and wrote: "Always look at this picture. It is the way toward me. In its soft outlines is the beginning of overcoming, it represents the transition from the outside to the inside."[16]

The same softness alluding to this transitory state can also be seen in many of Tuggener's ball as well as factory photographs and in some instances reaches the point of outright blurriness or graininess that some critics saw as technical flaw. In the 1947 *Camera* competition, "Struggle with Darkness," however, the jury considered Tuggener's "technical deficiencies" as appropriate means in the search for truth, the impartial capturing of life, and the expression of atmosphere and awarded him a fourth prize.[17]

Palace Hotel

The most important location for Tuggener's ball photographs was one of the most famous and expensive hotels in the world, the Palace Hotel in St. Moritz. Unlike the Waldorf Astoria in New York or the Ritz in Paris, the Palace is not in a metropolis but situated in a Swiss health resort in a wide valley surrounded by high snow-covered mountains. Built before the turn of the century and owned and run by the Badrutt family, the Palace Hotel truly resembles a massive palace with many towers, turrets, alcoves, and balconies. In its heyday, before World War I, the rich, the famous, and the powerful from all over the world came and stayed at the Palace, among them many Russian princes, the German crown prince, the Aga Khan, the tenor Enrico Caruso, the actress Eleonora Duse, and the writer George Bernard Shaw.

After World War I new guests arrived, some of them war-profiteers who showed off their wealth and tried to buy the hotel staff with enormous tips, while others, like Charlie Chaplin, used assumed names to enjoy the proverbial privacy and discretion of the hotel. The 1928 Olympic Games brought a welcome influx of sports enthusiasts but the stock crash a year later and the persistent negative economic situation in the following years had disastrous effects on business. At the beginning of World War II, the hotel was closed immediately when almost all male employees—and large numbers of the guests—were drafted. After some time

however, it was reopened and run by Badrutt's wife and the female members of the staff. After the war, the hotel's clientele changed again. Many of the former guests had died or had gone into exile, and only slowly did the hotel revive. Instead of the blue-blooded royalty, more and more self-made men, eccentric fashion and jewelry kings and oil magnates appeared and blew their newly earned money on showy and sometimes outrageous parties. The barkeeper Gustav Doebeli remembered in 1954, after serving innumerable guests for twenty-five years: "I laugh at whoever wants to make me believe that these people are bad. And I laugh even more at whoever claims they are good. They are neither good nor bad—they are the way they are. Peculiar…" As a reason for these peculiarities he suspected the combination of "women, alcohol, and eighteen hundred meters above sea level."[18]

Although Tuggener at times considered the dance hall a "a den of iniquity" and associated it with the decadent life in the city he felt an urge to deal with that topic as an artist. He felt that he had to experience it as fully and intensively as possible and chose the Palace Hotel. There he became an unbiased regular observer of the lavish New Year's Eve balls of the wealthy—as he had observed the workers in the factory and the farmers in the country. He explained to Arnold Kübler that he wanted to really "see" and "understand" life in the Palace Hotel and wrote: "For this ideal I blindly make sacrifices each year and do not shy away from the costs 'to get *even closer* to nature' as a photographer. I say to *nature,* to life, to its visual appearance. I do not care what it is, but the people should be deeply stirred and exclaim: truly, this is how it is."[19]

Tuggener used *Fabrik,* which had just been published, to gain access to the Palace Hotel in December 1943. Replying to his inquiry and referring to the books that he had sent, Hans Badrutt wrote: "I find it a brilliant idea to present the splendor of the festive balls in a photographic work similar to the impressive *Fabrik.*" He invited Tuggener to stay at the hotel for a reduced charge and take photographs of all the events taking place at the end of the year.[20]

Of course, Tuggener had taken photographs in other grand hotels during the 1930s, the Baur au Lac and the Dolder in Zurich, but the Palace in St. Moritz was different, especially around New Year's Eve. Situated in its glittery, snow-white environment it must have been for Tuggener the embodiment of the fairy-tale castle filled with beautiful princesses, even though at that time its really splendid days had passed and it was probably going through its most restrained period ever. Still, Tuggener must have felt like a prince and immersed himself totally in the "royal" world of splendor and luxury.

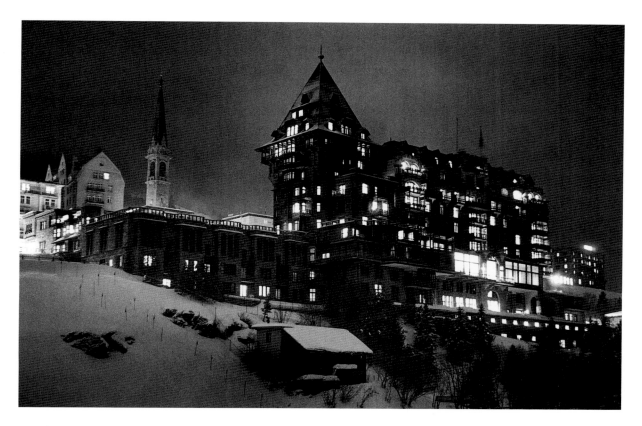

Untitled, Palace Hotel, St. Moritz, 1952

As indicated in Badrutt's letter it was clear from the very beginning that Tuggener eventually wanted to publish a book of his ball photographs. As early as 1945, right after the war, perhaps even the year before, a finished *Ballbuch* (ball book) was ready to be printed. But when Tuggener asked people for permission to include their pictures in the book, he met with considerable opposition. Someone threatening legal action wrote: "I am informing you that under no circumstances shall I give permission for the publication of the photograph made by you. Likewise, I reserve all my rights in case you should publish your *Ballbuch*."[21] Another person replied: "I am sorry but I am unable to follow your train of thoughts. As I already had the opportunity to explain to you in the ballroom of the hotel, I have absolutely no interest in such photographic subjects. I do not want to waste another word on those two things and, as a compensation for your work, I will pay for them. I will do so, however, only under the explicit condition that you send me the plate of the picture taken in the ballroom to be left in my possession."[22] Although it seems that Tuggener refused to comply with this request he had to accept another rejection by the manager of a manufacturing company in Zurich who, as a member of the board of directors of the Palace Hotel, expressed no interest whatsoever in "such things."[23]

So it seems that influential people prevented Tuggener from actually publishing his *Ballbuch* because they considered his photographs too indiscreet and too compromising. As Walter Läubli, the editor of *Camera* magazine from 1947 to 1951, later confirmed, Tuggener went around showing his ball books, but was given trouble by some "personalities in high positions." He remembered that pictures like the close-up of a key to a hotel room being offered in a lady's gloved hand, juxtaposed to the extremely grainy picture of a woman glancing at her partner in a meaningful way, were too dangerous, too suggestive of indecency for any member of the "better" society to want to be associated or identified with. At the same time, Tuggener insisted on his artistic integrity and refused to remove certain pictures from the maquettes or exchange them with less controversial ones.[24]

Despite the opposition and the apparent—but, as Tuggener insisted, unintended—critical content of his *Ballbuch,* Tuggener kept trying to find a publisher and several times almost succeeded. But in the end, there always remained an obstacle that could not be overcome. For instance, in 1957 he unsuccessfully offered it to the Bertelsmann Publishers in Germany, and in 1977 a deal with an art gallery in Zurich fell through because Tuggener wanted to be paid like other well-known artists represented by the gallery and demanded an exorbitant sum of money for his photographs. Two years later Max Wagner, a photographer and friend of Tuggener's living in St. Moritz, tried to console him and wrote: "In about 150 to 200 years universities will be interested in your work *Palace Hotel.* The book will not be in print before that. The great-great-grandchildren [of the people in the pictures] will have to be dead, otherwise you would still end up with frustrations and troubles."[25] It did not take quite that long for academic interest to be aroused, but even so to this day none of Tuggener's *Ballbücher* has been published.

Most of Tuggener's ball photographs were not even published in magazines, at least not until after the war. The only major publication in the 1940s was a portfolio of eight pictures in the first issue of *Camera* magazine edited by Hans Kasser after the late-pictorialist editor Adolf Herz had finally resigned at the end of 1946. As the short introduction stated, the photographs were dedicated to the revival of the pre-war balls that had enriched life in the 1930s and to the opening of a new season. The portfolio opens with a smiling young lady in a dark ruffled dress and is followed by pictures of a couple involved in a conversation, of hands playing the piano, the lights at the Cinema Rex in Zurich, a man watching the dancers from a balcony, a woman at the bar opposite the dentist "Dr. Gubser," and a man checking

his watch at a late hour. There is nothing critical or malicious about the photographs taken by the "masterly portrayer of our world of strong contrasts," as Kasser describes Tuggener.[26] The only exception is perhaps the one page-spread with the plump dentist seemingly gazing at the lady's generous décolleté behind half-filled glasses and bottles in the foreground.

Ballnächte

Tuggener's first maquette of a *Ballbuch* from about 1944–46 is either lost or was subsequently taken apart and revised. The earliest surviving maquette is *Ball-nächte 1934–1950,* completed in 1950 and containing one hundred and twenty-seven photographs taken at a variety of hotels, almost half of them at the Palace Hotel in St. Moritz. There are only two white pages dividing the maquette into three parts of fifty-four, twenty-three, and fifty pictures. All the photographs are either one-page verticals or double-page horizontals with the exception of four half-page horizontals and sixteen narrow verticals arranged in groups of four on page-spreads. As in *Schwarzes Eisen,* completed shortly after *Ballnächte,* there are almost no margins so verticals join in a perfectly seamless way. The photographs are not titled except for notations indicating date and place where the pictures were taken, and only very rarely are people in the photographs identified.

The layout is so dense that the rather dark interiors of the photographs blend into an almost uniform background from which the main "actors" stand out, evoking the atmosphere of one long night in which the viewer moves from the ballroom to the dining area to intimate corners and back, always in the company of one or more of the illustrious guests. It is a continuous and dynamic flow of figures, mostly women, interrupted by the sudden appearance of details, alluding to moods shifting between gaiety and boredom, boisterousness and exhaustion, between madness and dream. Tuggener wrote that the book maquette of the Palace Hotel was "like a silent film, a vision of an evening."[27] In fact, it is an almost breathless cinematic sequence produced by a moving camera, pulsating between close-ups and medium shots reminiscent of Walter Ruttmann's *Berlin. Symphonie einer Gross-stadt.* The four spreads with four narrow picture strips in each intensify the fast-moving cinematic, almost stroboscopic, effect.

In *Ballnächte,* Tuggener's camera arrives with the guests—and the viewers of his book maquette—and never really leaves, it just falls asleep among some turned-over chairs dreaming of the scent of roses. What the art historian Erwin Panofsky

wrote in 1937 about the "dynamization of space" in film seems to be equally true for Tuggener's book maquette: "At the movies ... the viewer is fixed to a seat, but only physically. ... Aesthetically, he is in constant motion, just as his eye identifies with the camera lens, which constantly changes its positions regarding distance and direction. And the space presented to the viewer moves just as the viewer does. Not only solid objects move in space, but space itself moves, changes, turns, dissolves, and recrystallizes."[28]

The structure of the maquette is very musical. A first movement with the introduction is followed by a short dynamic movement leading to the third that includes the climax and the fading out at the end. This form alludes to both the harmonious swaying flow of the waltz and the more hectic, but regular beat of jazz. The opening section of the movement includes photographs taken in 1938 at the Hotel Imperial in Vienna, pictures of the façade of the Carlton by night, the front of the Baur au Lac, and of the arriving guests. The next photographs show women dancing or flirting in the splendor of their dresses and jewelry, the musicians and details of their instruments, the preparation of the buffet, and Tuggener's empty plate decorated with one single pickle. The second and shortest movement includes, among images of different bands playing and people at the bar, a close-up of a waiter's hand balancing a small tray with money facing a picture of opened liquor bottles. The third movement picks up the theme of drinking and money again with pictures of champagne bottles in the ice-filled coolers and a close-up of a guest's hotel bill. But then first signs of tiredness and boredom appear and glass breaks before the sequence reaches the climactic midnight boisterousness with more champagne, streamers, Chinese lanterns and—since it is New Year—with a chimney-sweep bringing in a couple of piglets. An intimate coffee break and a midnight snack of sausages follow, leading to the first people getting ready to leave and a last song among empty bottles left on the floor and in the coolers on the tables surrounded by fallen chairs. A lady's head finds rest on the back of a chair while scores of bottles, half-empty glasses, and a tray with wilted roses is cleared away. What remains, in the last picture of the maquette, is a woman's name, Evelyne, written on a frosted window-pane slowly melting away in the morning sun.

As in other maquettes, there are pairs of images that construct a unity of space, for instance a lady sitting in a comfortable chair watching somewhat critically a couple dancing intimately, or two laughing ladies applauding the cooks' efforts at the elaborate buffet. These hardly noticeable moves from one space (and time)

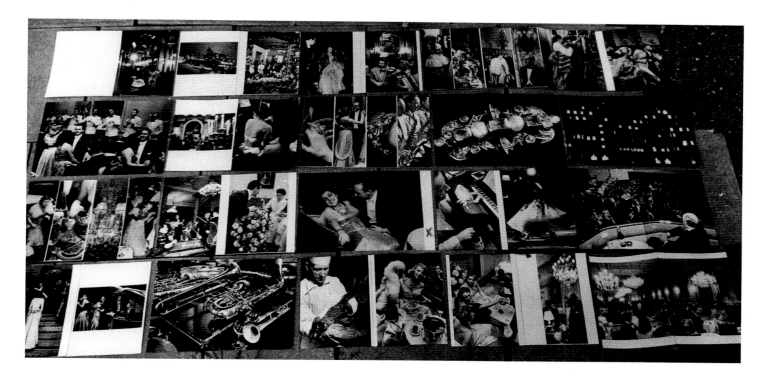

Laid-out maquette of a ball book, 1950s

into another—the photographs were actually taken years apart—support both the impression of the movement of a film camera and the feeling of a certain timelessness. Other single double-page images and juxtapositions interrupt and structure the cinematic rendering. They are close-up views of what most participants of the balls and the viewers of the maquette would consider insignificant. By singling out these close-ups and holding onto them for a moment in the flow of events, Tuggener fills them with special meaning which adds up to feelings beyond the mere surface of people and things depicted. He uses them in the same revealing way that the American art historian Horace M. Kallen ascribed to close-ups in film: "Casual actions, such as the chance play of the fingers, the opening or closing of a hand, the dropping of a handkerchief, searching or not finding, and the like, became visible hieroglyphs of the hitherto unnoticed dynamics of human relationships..."[29]

Ballnächte is a dynamic and an expressive evocation of a splendid ball night with all its bright and dark aspects. As a whole, it is a work of art that celebrates female glamour, the sensuousness of fur and silk and the luxury of jewels on bare skin which Tuggener had described in "Lichter der Nacht" and "Alabasterlicht" in the mid-1930s: "Velvety shoulders shimmer in alabaster light. ... Behind them wafts

perfume intoxicatingly distant." However, at the same time, Tuggener alludes to feelings that are beyond the gay and shiny surface: feelings of greed, boasting, jealousy, boredom, exhaustion, but also eroticism and melancholy. He knew about the dog wearing a diamond necklace worth a thousand francs and eating from a golden bowl, he knew that the Aga Khan, while wearing torn sweaters around the hotel, only ate the innermost part of a piece of meat and ran up enormous bills every night, he knew of the jealous waiter who trampled on the expensive bracelet of his fine lady lover and swallowed the diamonds, but he kept all this to himself and his photographs do not explicitly show it. These hidden feelings and stories are present in the pictures as natural aspects of human interaction, but Tuggener did not intend to expose or exploit them for ideological reasons.

Even more so than in *Uf em Land,* in *Ballnächte* the light emanates from within. There is neither daylight nor empty space around the pictures substituting for it. Three photographs show the brightly illuminated windows of the ballroom from the outside and several others show the elaborate chandeliers that are actually its source. Thus, throughout the maquette, the idea of the ballroom as a protected, interior space is emphasized. It is not a cold space as the countryside in *Frühling, Sommer, Herbst,* and *Winter* but an inviting and warm one. Moreover, the radiant light sources are often portrayed alongside people, as for instance in the picture of the waiter and the candles in the Hotel Imperial, or in the chandelier and the mirror juxtaposed to the couple drinking coffee where the shape of the lady's décolleté is the same as that of the glass drops hanging underneath the lamps. These pictures again refer directly to Tuggener's feelings expressed in his texts of the 1930s: "Those lights carry off our souls into a world that is inside, radiant and warm, ... enclosed by darkness, we feel like lights and need to be ourselves."

Exhibiting *Ballnächte*

Werner Schmalenbach, searching for material for his 1949 exhibition entitled "Photographie in der Schweiz—heute" (Photography in Switzerland—Today) realized that Tuggener's work embodied exactly the qualities he felt were missing in most contemporary photographs, namely the expressive and subjective use of the medium's technical repertoire (grain and cropping for instance) and, above all, a feeling for "life as it is." He was very impressed and included several of Tuggener's ball photographs in the exhibition that was shown in Basel and later in Copenhagen, Denmark.

In the first exhibition of the Kollegium Schweizerischer Photographen in early 1951 Tuggener showed a series of ball photographs that could be seen as a condensed version of the *Ballnächte* maquette. The critic Edwin Arnet discussed them in *Camera* magazine and stated: "In these photographs lies what is essentially Swiss, that this photographer does not seek in the importunate manner of the 'asphalt' photographers to reveal the bourgeois society in these pleasures of the dance. In such photographs he also occasionally shows the boredom, weariness and disenchanted charm of such synthetic mass pleasures, but he does not show them without affection or in a cheap accusing manner, but with real delight."[30] And in a review in the *Neue Zürcher Zeitung,* he added that Tuggener wanted to prove "that the mundane-social [world] had its human and moving noises on the side, too."[31] The critic of *Die Tat,* Max Eichenberger, who had already been impressed by *Fabrik,* wrote that Tuggener was the "most poetic" of the Kollegium photographers, "so much in fact that he not only changes the everyday into a festive day but also the reverse, the festive day into an everyday of a special kind, namely into the day of all days, for that the Day of Judgment may begin after the fall of the last illusion and the very last mask."[32] Eichenberger thus saw an element of social critique in the ball photographs. The *Genossenschaft,* on the other hand, simply noted that "the warm breath of life emanating from his pictures" was typical for Tuggener as a "consequent realist and lover of strong contrasts."[33]

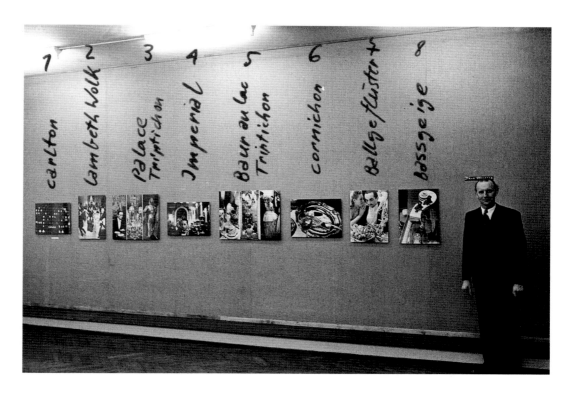

Untitled, Kollegium exhibition in Biel, self-portrait, 1952

In the 1955 exhibition of the Kollegium at the Helmhaus in Zurich entitled "Photographie als Ausdruck" (Photography as Expression) Tuggener showed a series of photographs from masked balls that proved him to be "one of the best ball photographers," as Edwin Arnet noted, because "he lets the human trickle through the carnival masks and costumes, this pleasure-lover who is already tired of the feast and surrounded by melancholy of the end."[34] This exhibition did not mark the end of Tuggener's efforts to capture the atmosphere at society dances and masked balls, but it referred back to the Reimannball in Berlin where Tuggener's involvement with this glamorous world began. He had come full circle: starting by documenting the decorations at the Reimannball with almost abstract still-lives, he had become the paradigmatic "life"-photographer who soon would be named "Master of the Leica" as a result of his extraordinary ball photographs.

In November 1969 Die Neue Sammlung of the Staatliches Museum für angewandte Kunst in Munich showed an exhibition of one hundred and ten large-format ball photographs acquired from Tuggener entitled "Feine Feste" (Fine Feasts). As Klaus-Jürgen Sembach, who organized the exhibition, remembered, it happened at a time when Tuggener was totally forgotten.[35] The exhibition was dedicated to both the quality of Tuggener's "optical-communicative creativity" and to the "decay of a social form" and was combined with a small show of French left-wing political posters made during the May 1968 student riots in Paris. Even though Tuggener's intention to "record visible facts without interpretation, without judging and accusing" was mentioned, it was also noted that the curators felt that the photographs expressed the "hardness, greed, simple-minded banality, contemptuous arrogance, harmless complacency, boredom, and surfeit of fine society."[36] These comments, and the combination of the photographs with political posters that were an integral part of the struggle against the "degenerate" social and political establishment immediately led to the perception of Tuggener's work as blatant social criticism and a call for political action. In a review entitled "Fine Feasts—And Appeals To Their Disturbance," a critic wrote that Tuggener was "something like the George Grosz of photography, a man of hard and bitter social criticism" portraying "broken pieces of people that should be swept into the gutter like the smashed crystal goblets and champagne bottles."[37]

This was not the first time that Tuggener's ball photographs had appeared in a context that directly influenced their perception as social criticism. Thirteen pictures from *Ballnächte*—most of them taken at the Palace Hotel in St. Moritz—were used

to illustrate an essay entitled "Parfumierter Schnee" (Perfumed Snow) by the German cultural and social critic Friedrich Sieburg that was published in the *Schweizer Journal* magazine in early 1952.[38] Sieburg's text described in an extremely scathing way the newly-rich postwar society frequenting the Palace Hotel without, however, directly mentioning the hotel's name. He made perfectly clear the connection between luxury at the Palace and war profiteering, between the sparkling champagne on the surface and the "cool murmuring of the river Styx" underneath. Quite naïvely it was stated in the introduction that, since only very few people belonged to the class of the "too rich," the reader should feel free to enjoy in a lighthearted way the pleasure of looking at the "pretty, elegant pictures radiating with the atmosphere of a luxury hotel." This was of course a futile attempt to separate Tuggener's pictures from the harsh criticism expressed in the text. Sieburg's mocking comments about the people at the Palace influenced the reading of Tuggener's photographs as much as the slogans on the May 1968 posters next to his exhibition "Feine Feste" in Munich. He thus could not escape being perceived as a kind of George Grosz of photography, whether he intended it or not.

After travelling to Munich to see his exhibition, Tuggener realized that his unbiased intentions had been totally misinterpreted and put into an ideological context that he could not accept. He demanded the title be changed to the original "Ballnächte" and the pink poster to be redesigned to look more like a poster for an exhibition of an artist. He wrote to Wend Fischer, the director of Die Neue Sammlung, saying "I would not dare display the poster in Switzerland because it showed people that could feel betrayed," and that, if he would not comply with his wishes, he would rather buy back all the photographs and give up the idea of showing them in other places.[39] Even though Tuggener was aware of the fact that his ball photographs represented "explosive" material, he was unable to accept that viewers perceived the latent critical content of his photographs. He does not seem to have learned from the experiences with people depicted in his photographs who had vehemently refused to be included in any kind of publication. They, apparently, knew better about the critical potential of the photographs—which could be turned against them—than the photographer himself. Tuggener did not realize that the pictures showing "life as it is" would upset those whose real lives were not at all like the ones being celebrated in the pictures.

For Tuggener differences of class and political ideology simply did not exist, or he ignored them. "Don't we all like to go to a feast?" he asked Wend Fischer, and

explained: "I photographed the 'Ballnächte' because I enjoy the shine, the atmospheric light, the silk, the beautiful women, the perfume, the music,"[40] and at another time, he exclaimed: "I photographed the workers because they are photogenic, because there is atmosphere, because there is patina, soot and dirt."[41] But it was class difference and politics that polarized people and it was the black and white model, the stereotypical opposite at work in the perception of Tuggener's photographs taken in the factories and in the ballrooms that he could never quite escape.

Still it remains intriguing that Tuggener, like the barkeeper Doebeli, saw the "peculiar" people at the Palace Hotel as neither bad nor good. Why is it that he who was familiar with dirty, hard work in the factory and the continuing struggle for survival in the country, who himself was living a very simple life in a one-room basement apartment did not want to expose at least some of the questionable aspects of high society? The question may never be answered fully but one aspect lies in the notion that Tuggener saw himself as a privileged person lucky enough to experience the lower as well as the higher areas of life to the fullest. Since the mid-1930s he perceived himself as a fairy-tale prince. And later in life, probably resulting from his interests in esoteric ideas like astrology or phrenology and in Eastern religion, he even thought he was a reincarnation of one of his ancestors, the sixteenth-century knight Wilhelm Tugginer who had served under the kings of France. He wrote in the early 1960s: "One can imagine that a family is like a blood-stream and it is a miracle how certain characteristics get carried on by the genes. The knight was one of the closest friends of the king and participated in all the feasts at the Louvre in Paris. That is why my photographs of the ball nights are an expression of this love for splendor."[42]

Therefore, when Tuggener went to the balls, he considered himself part of the "royal" class and looked at the participants with their eyes—as he had looked at his fellow soldiers with the eyes of a soldier and at the workers with the eyes of one of them. He was "his own self," nothing but an observer with the conscious mind and the open heart of a prince and not the moral bias of a petty bourgeois.

Notes

1 Tuggener in letter to Edith Wildhagen, 17 May 1961.

2 Tuggener quoted in "Jakob Tuggener," in *Leica-Fotografie,* November/December 1961, p. 235.

3 Tuggener in letter to Marie Gassler, 8 November 1934.

4 Tuggener in letter to Marie Gassler, 17 November 1934.

5 Tuggener in letter to Marie Gassler, 4 December 1934.

6 Ibid.

7 Tuggener in letter to Marie Gassler, 13 December 1934.

8 Tuggener in letters to Marie Gassler, 13 December 1934 and 2 February 1935.

9 Tuggener in letter to Marie Gassler, 8 November 1934.

10 *Föhn,* November 1937, pp. 50–52.

11 Ibid., p. 54.

12 Paul Morand in introduction to Brassaï, *Paris de nuit* (Paris, 1933), translated in *Paris After Dark* (London: Thames and Hudson, 1987), unpaginated.

13 Tuggener, "Lichter der Nacht," undated manuscript, (ca. 1935/36).

14 Hans Finsler, *Mein Weg zur Fotografie* (Zurich: Pendo, 1971), unpaginated.

15 Tuggener, "Alabasterlicht," undated manuscript, (ca. 1934/35).

16 Tuggener in undated letter to Marie Gassler, (1939–40).

17 See "Kampf mit der Dunkelheit. Betrachtungen zum Wettbewerb der *'Camera,'*" in *Camera,* September/October 1947, pp. 244, 252.

18 Gustav Doebeli, *Palace-Bar. Memoiren eines Barkeepers* (Zurich: Thomas, 1954), pp. 19–20.

19 Tuggener in undated letter to Arnold Kübler, (ca. 1944–46).

20 Letter from Hans Badrutt, 20 December 1943.

21 Letter from W. Wachtl, 19 June 1945.

22 Letter from J. Schmid, 10 January 1946.

23 Letter from J. Schmid, 12 January 1946.

24 Interview with Walter Läubli, 6 June 1990.

25 Letter from Max Wagner, 9 March 1979.

26 Hans Kasser, "Ball," in *Camera,* January/February 1947, p. 17.

27 Tuggener in letter to Wend Fischer, 3 December 1969.

28 Erwin Panofsky in *Style and Medium in the Moving Pictures* (1937), quoted in Kracauer, *op. cit.,* p. 12.

29 Horace M. Kallen in *Art and Freedom* (1942), quoted in Kracauer, *op. cit.,* p. 13.

30 Edwin Arnet, "Jakob Tuggener," in *Camera,* March 1951, p. 107.

31 Edwin Arnet, "Zur Photoausstellung im Helmhaus," in *Neue Zürcher Zeitung,* 3 March 1951.

32 Max Eichenberger, "Photo-Ausstellung im Helmhaus," in *Die Tat,* 2 March 1951.

33 Anon., "Fünf Schweizer Photographen stellen aus," in *Genossenschaft,* (ca. March 1951).

34 Edwin Arnet, "Photographie als Ausdruck," in *Neue Zürcher Zeitung,* 8 March 1955.

35 Klaus-Jürgen Sembach in a letter to the author, 2 November 1990.

36 "Feine Feste," introduction to the exhibition, Munich, November 1969.

37 "Feine Feste—und Aufrufe zu ihrer Störung," in *Süddeutsche Zeitung,* 25 November 1969.

38 Friedrich Sieburg, "Parfumierter Schnee," in *Schweizer Journal,* January/February 1952, pp. 19–27. The essay was originally published in Friedrich Sieburg, *Was nie verstummt* (Tübingen and Stuttgart: Rainer Wunderlich/Hermann Leins, 1951), pp. 79–94.

39 Tuggener in letter to Wend Fischer, 26 November 1969.

40 Tuggener in letter to Wend Fischer, 3 December 1969.

41 Tuggener in interview with Inge Bondi, April 1980.

42 Tuggener in undated note, (early 1960s).

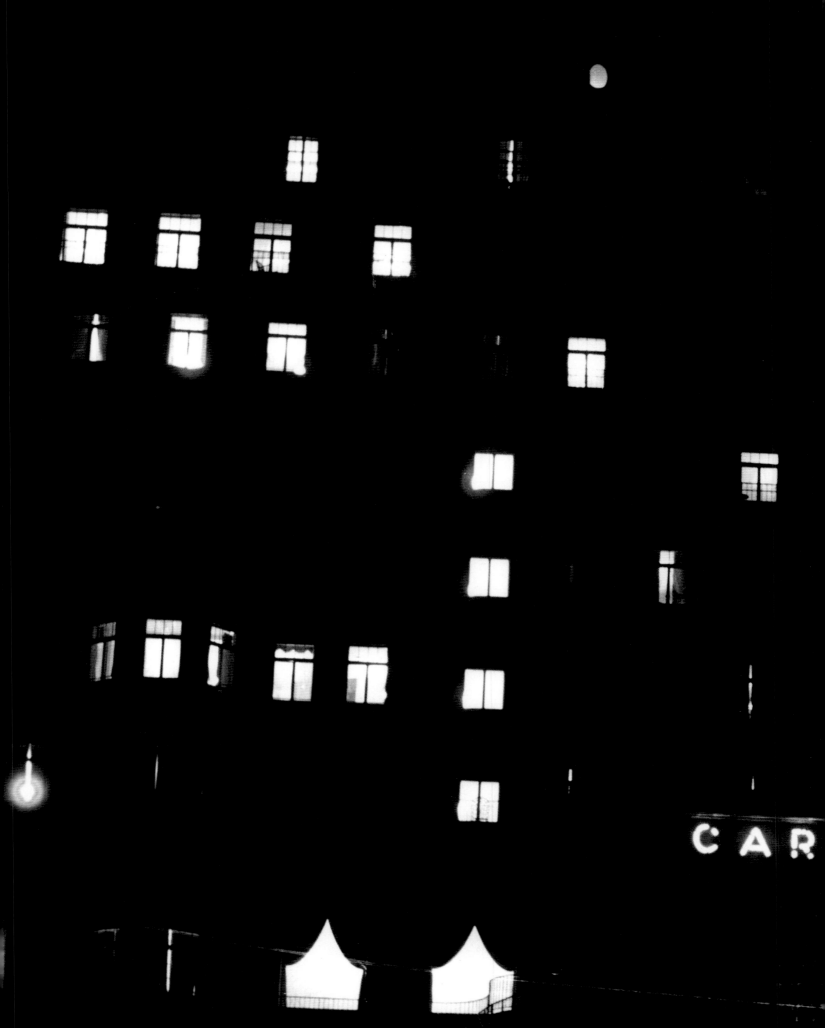

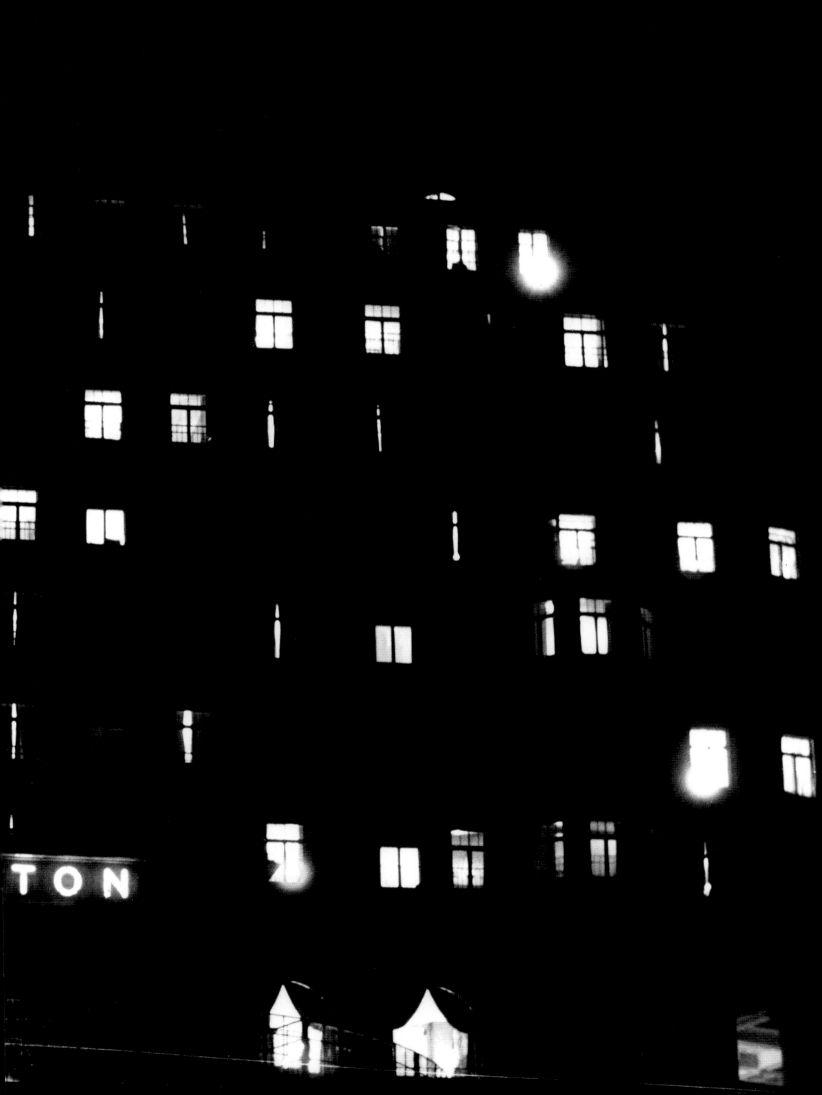

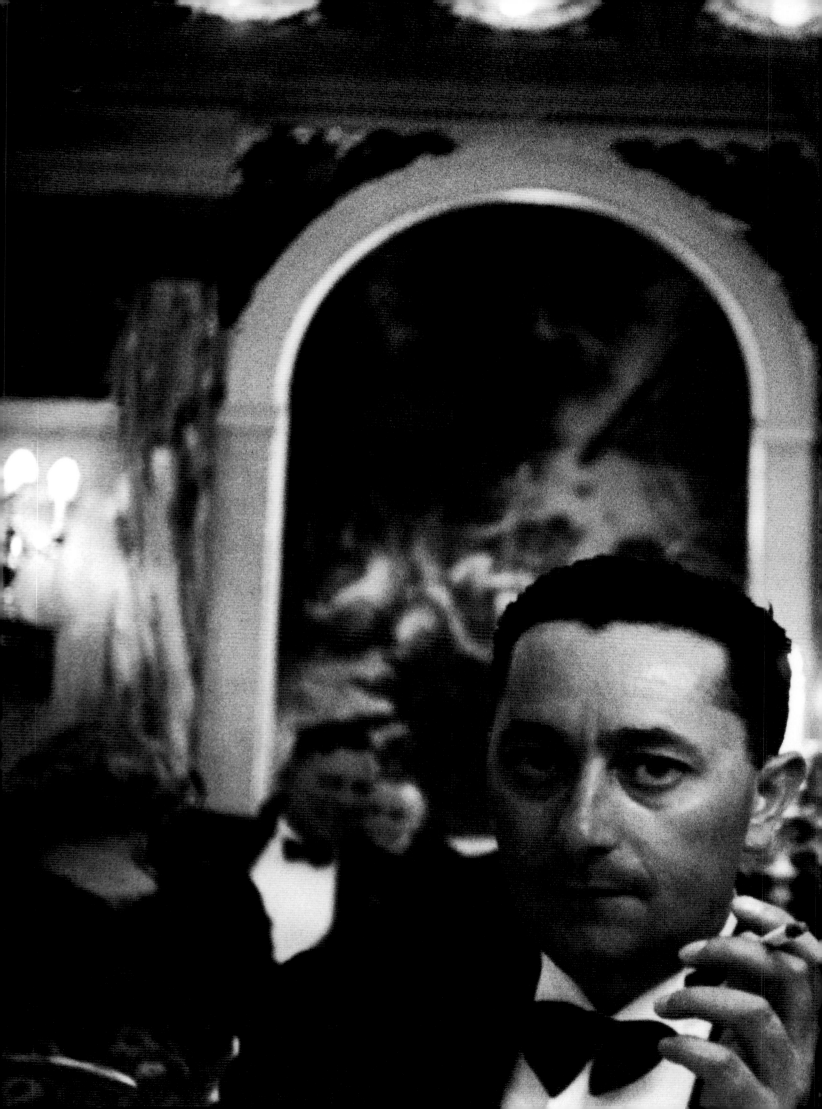

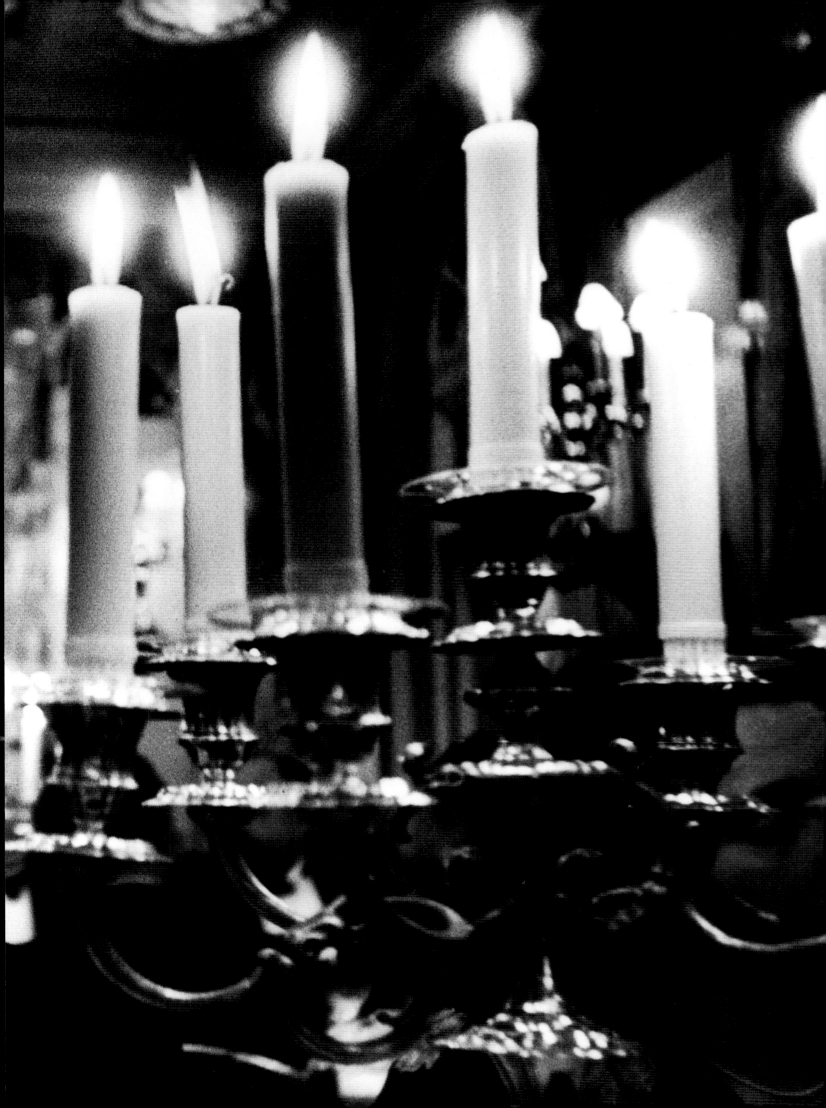

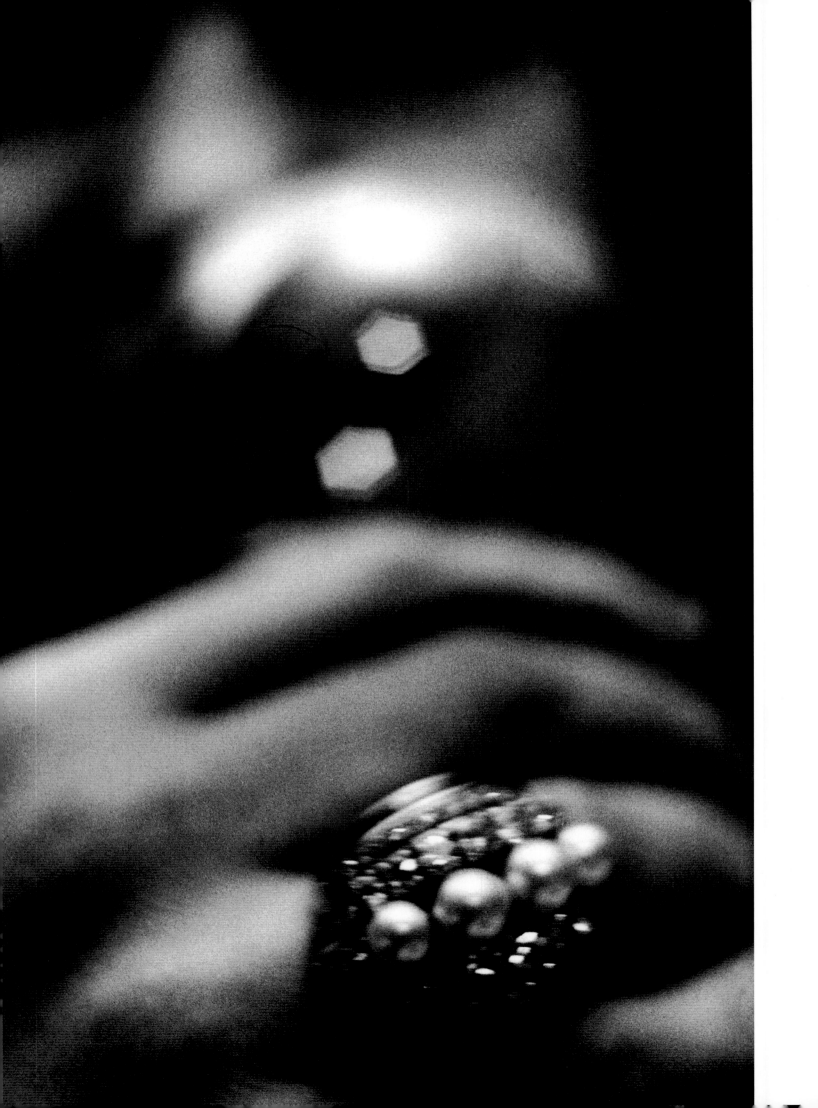

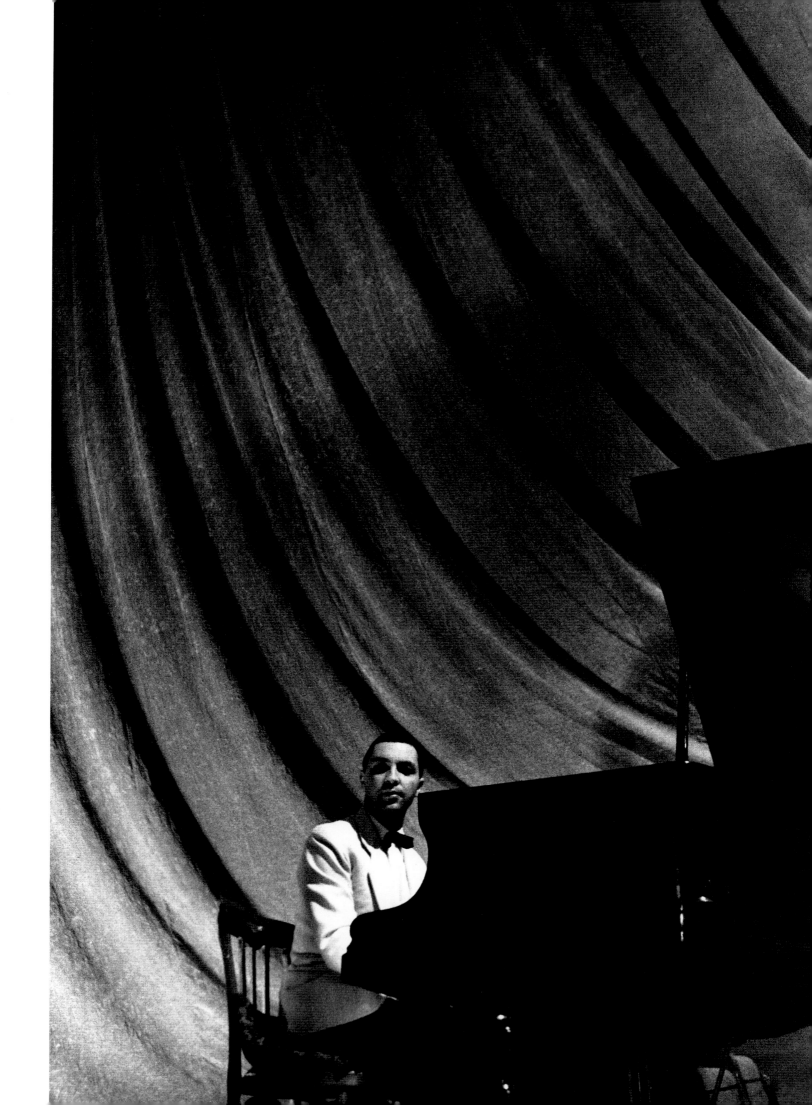

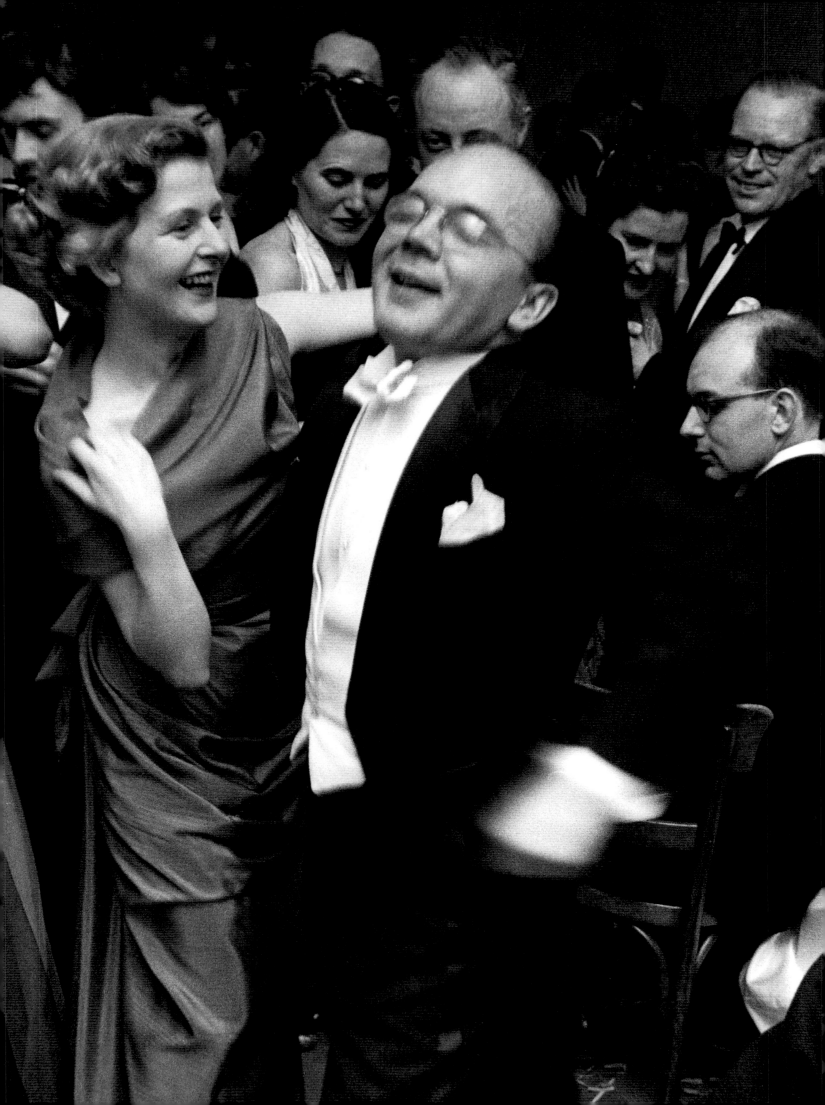

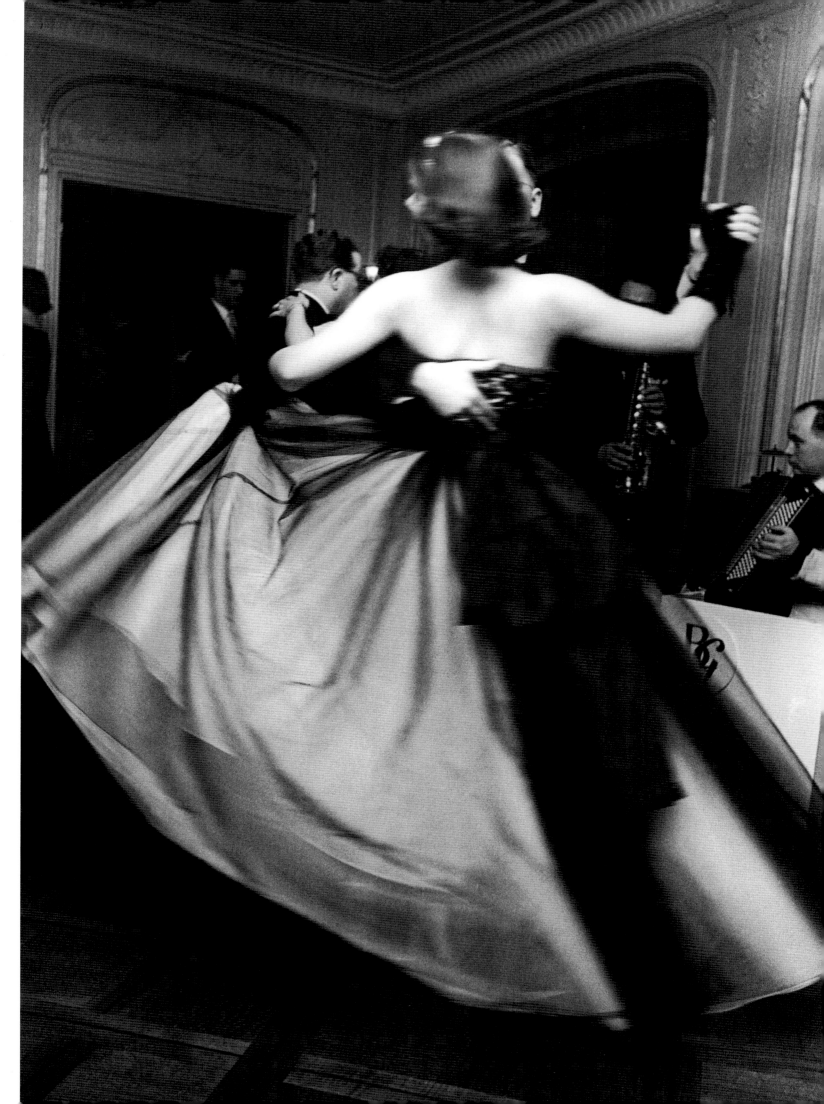

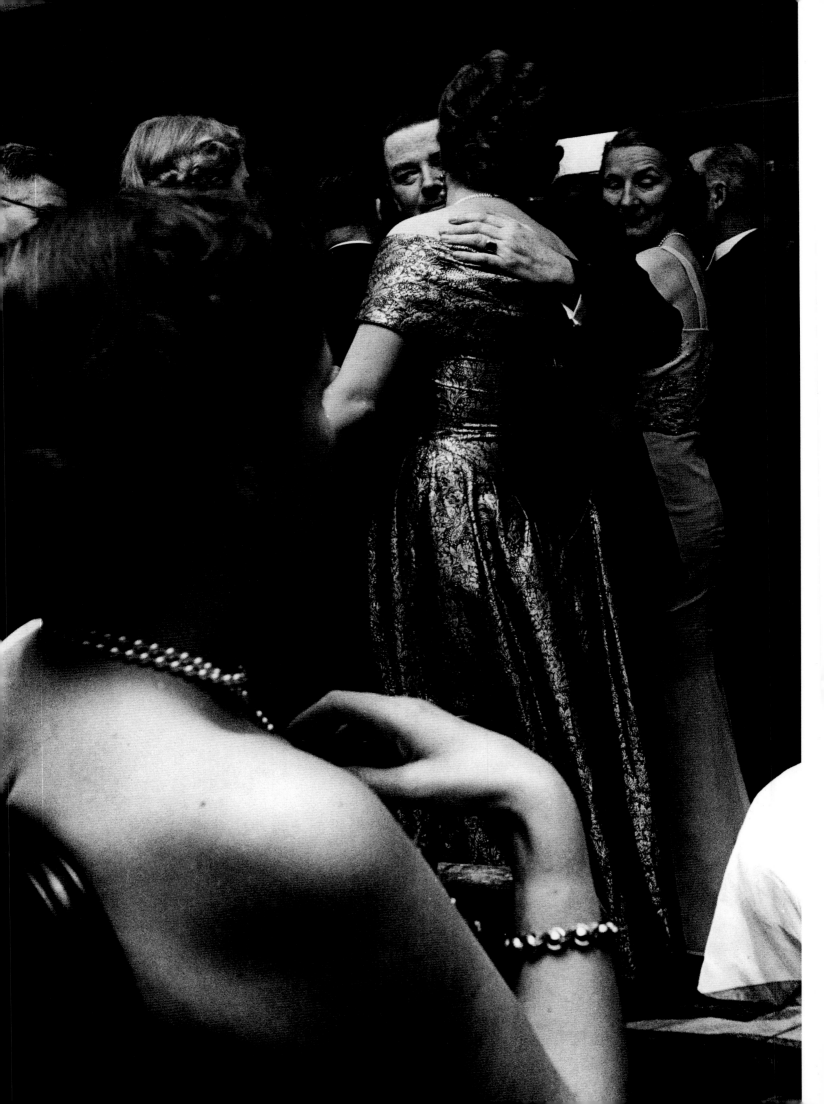

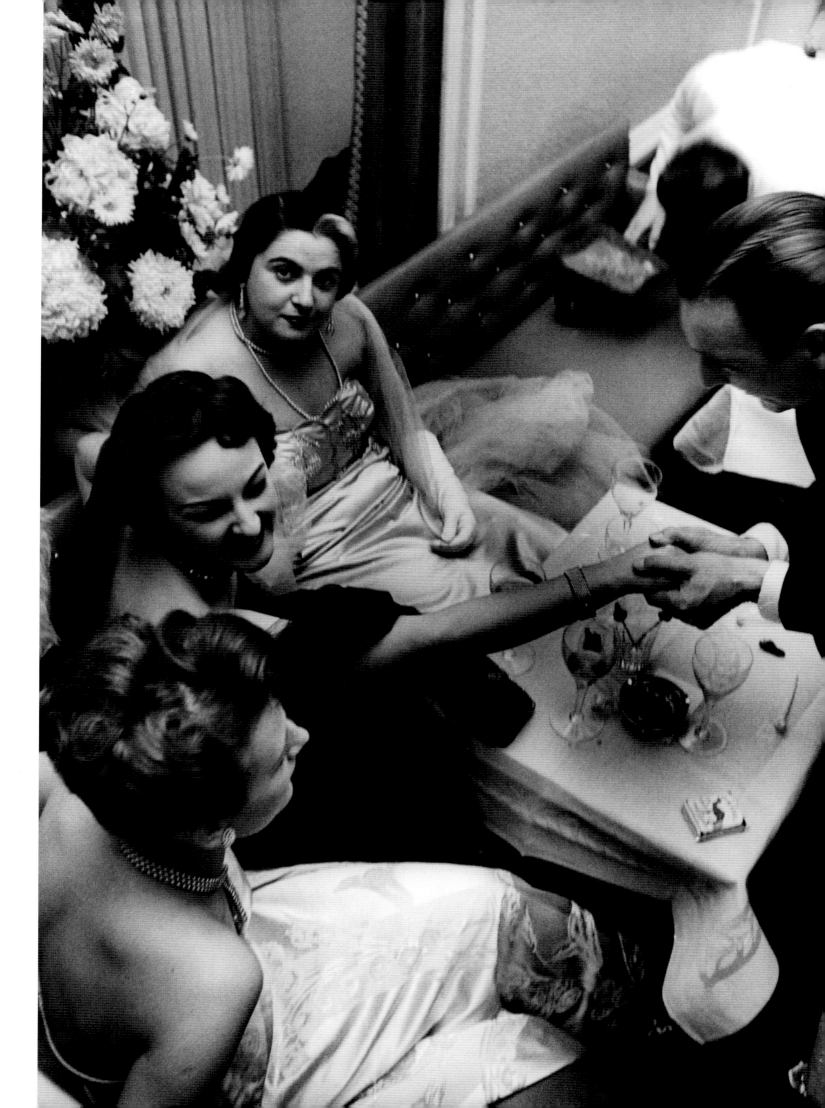

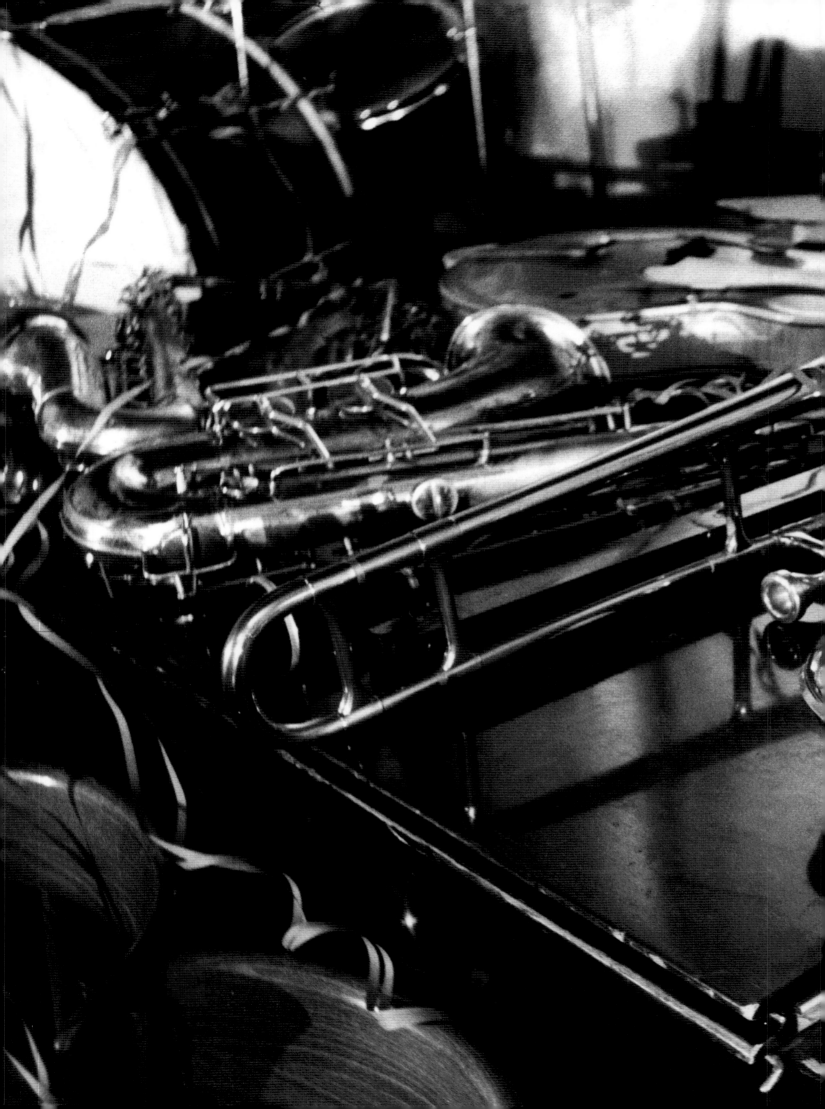

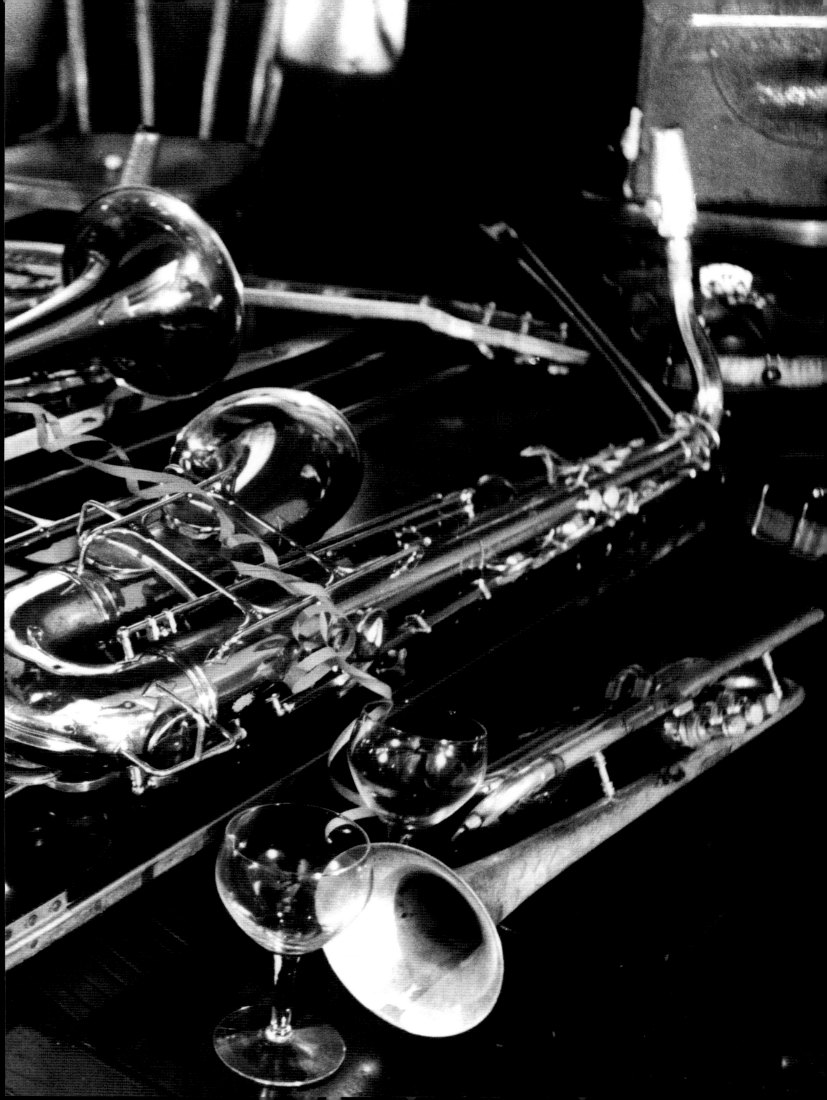

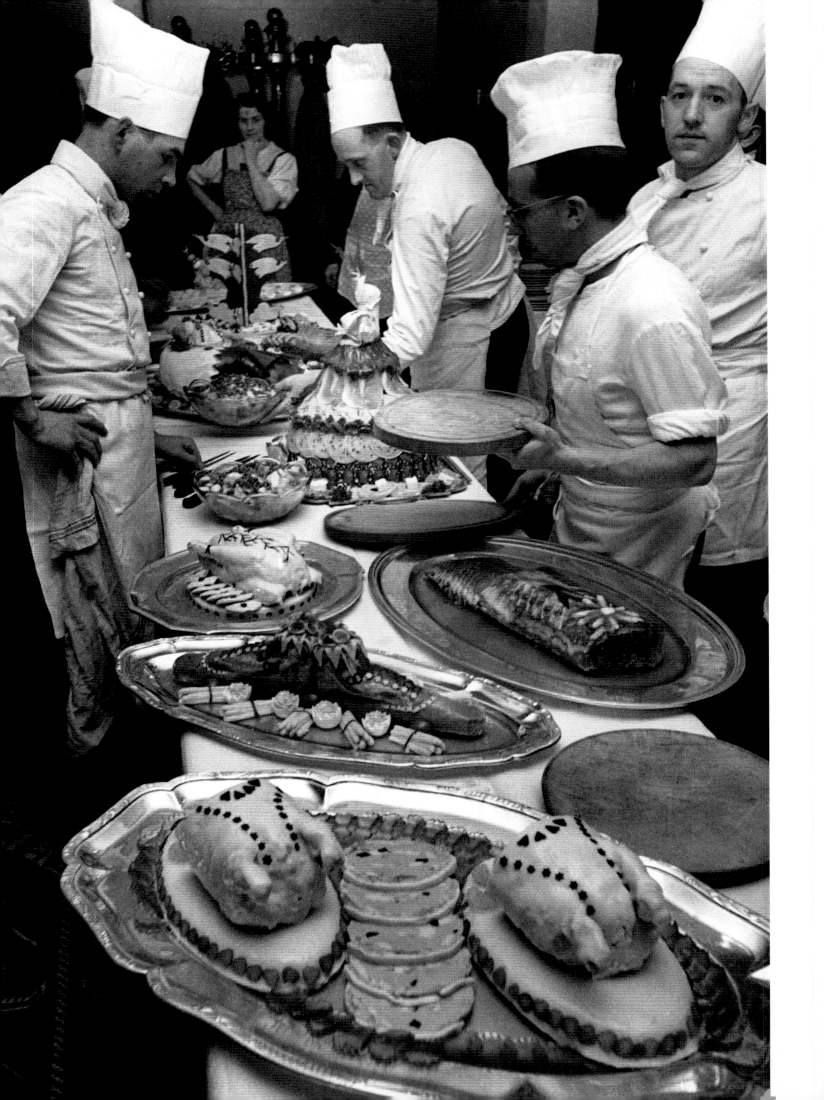

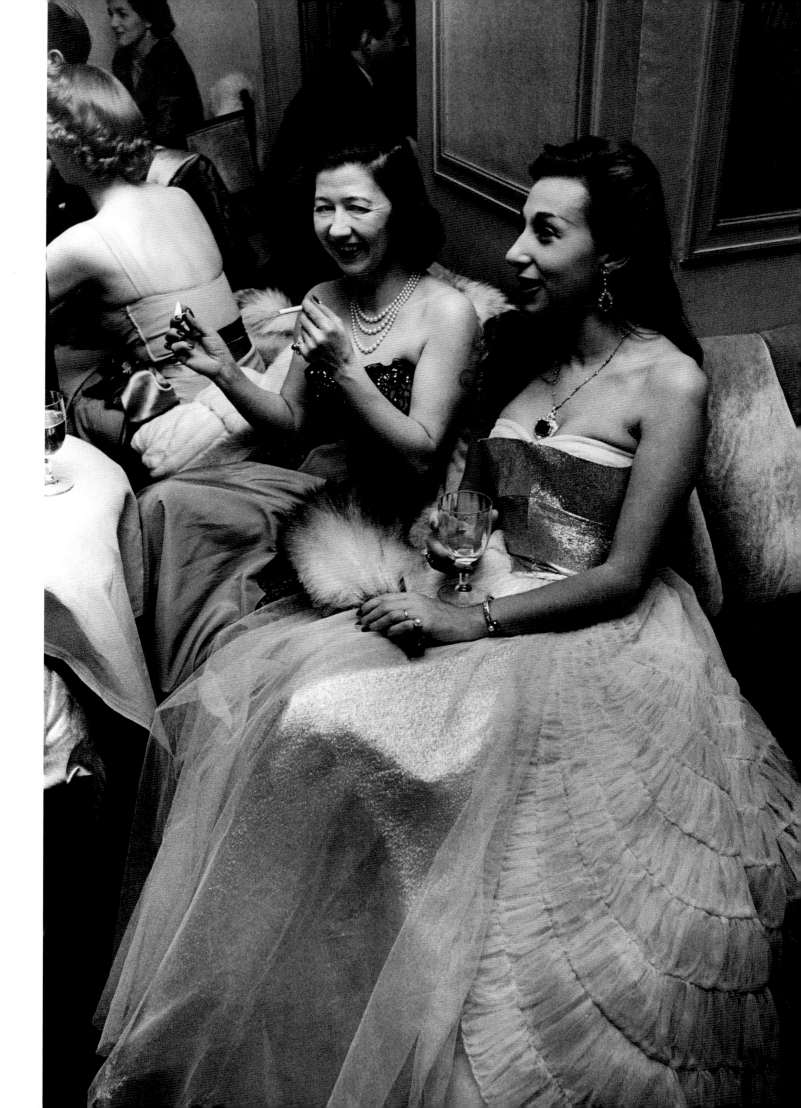

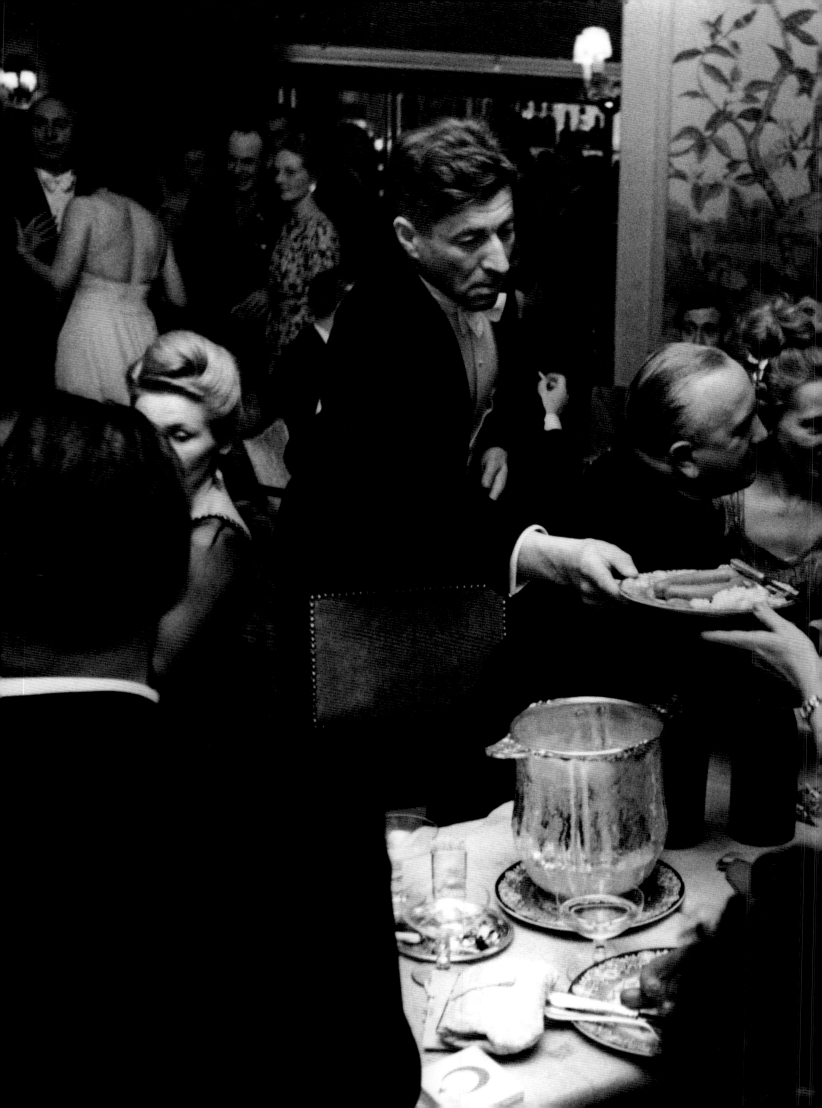

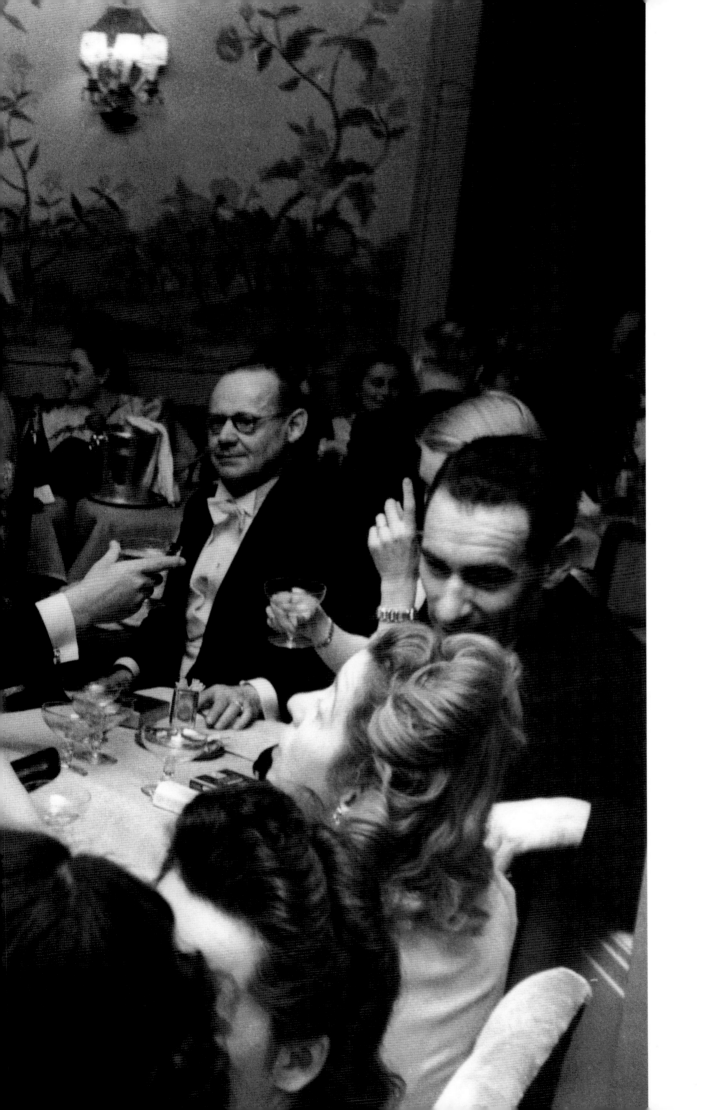

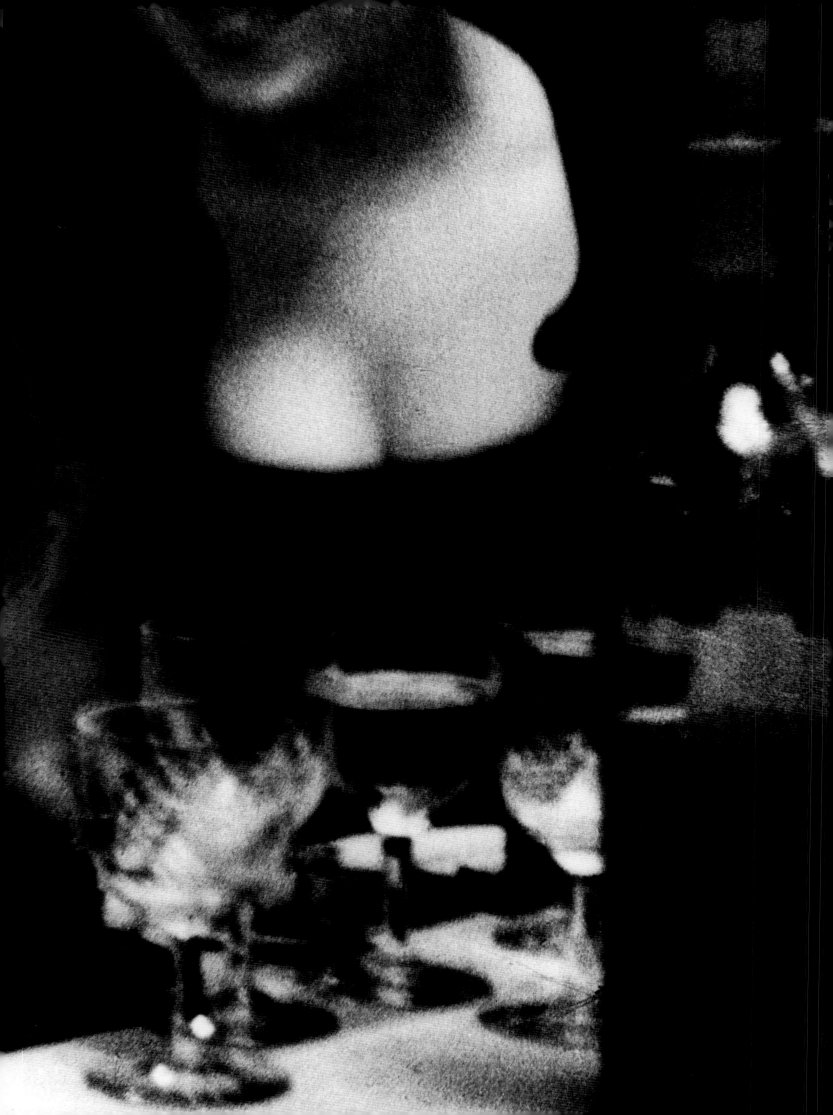

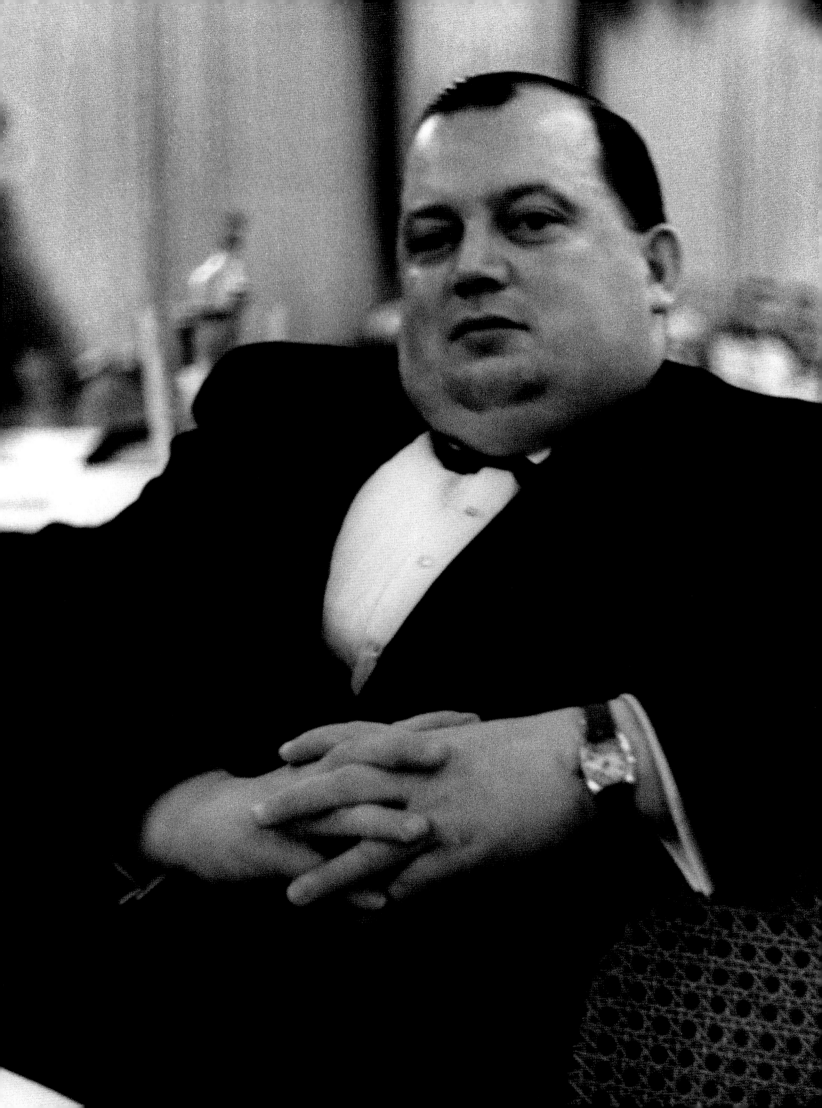

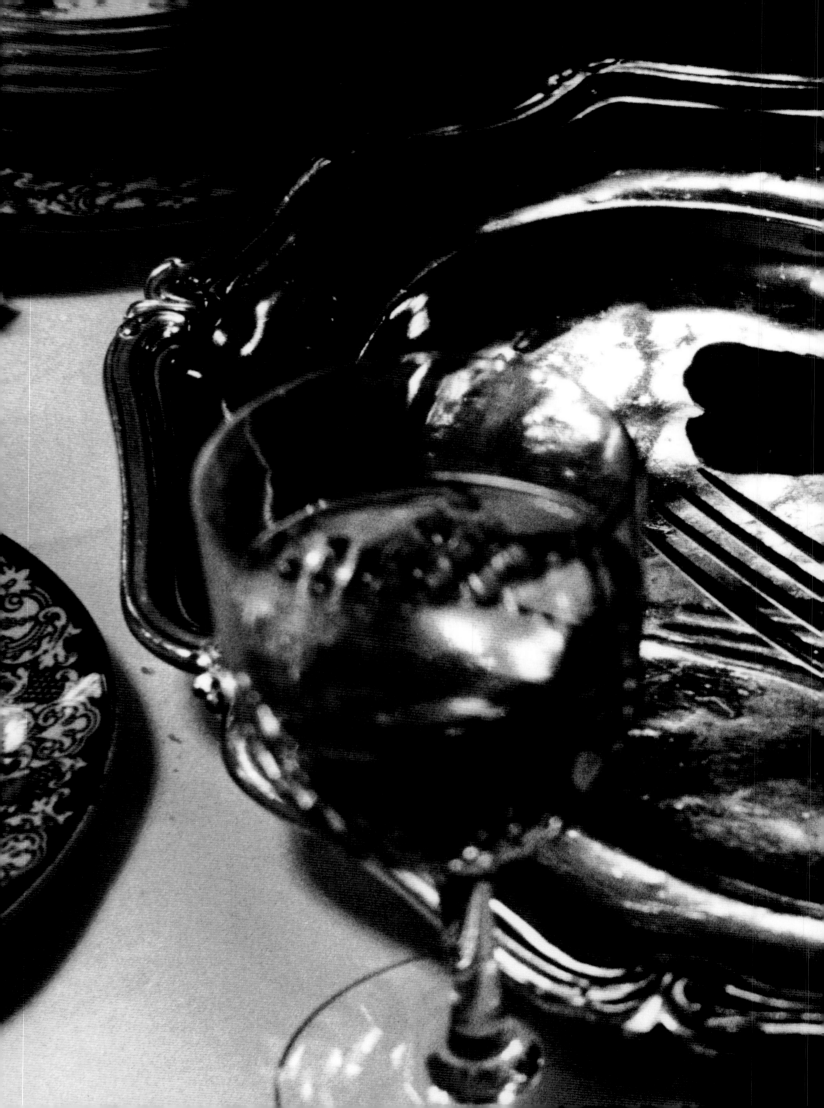

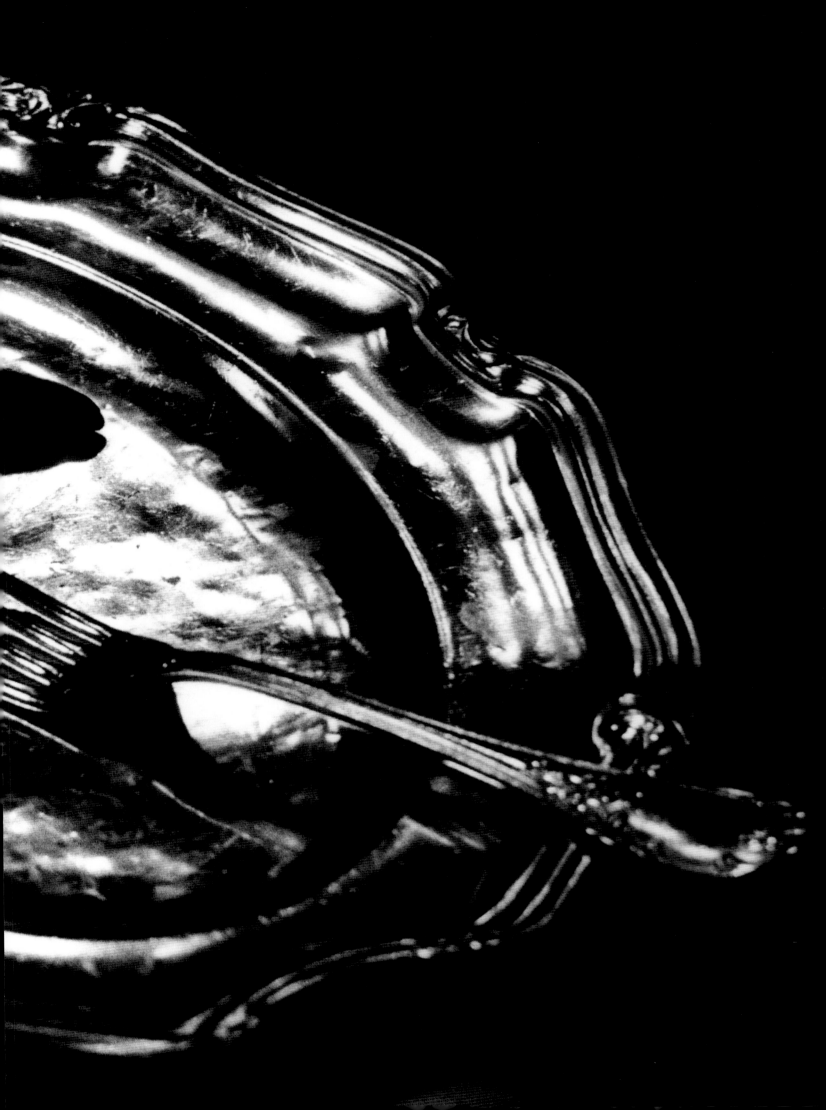

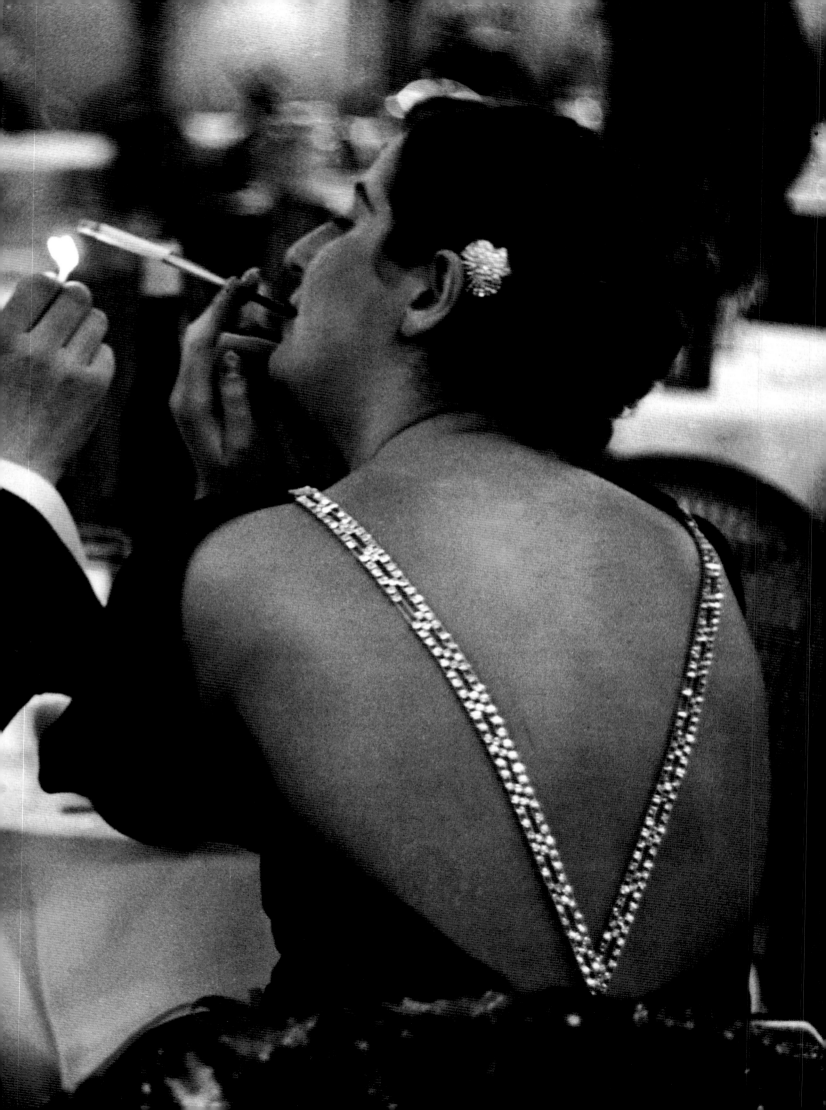

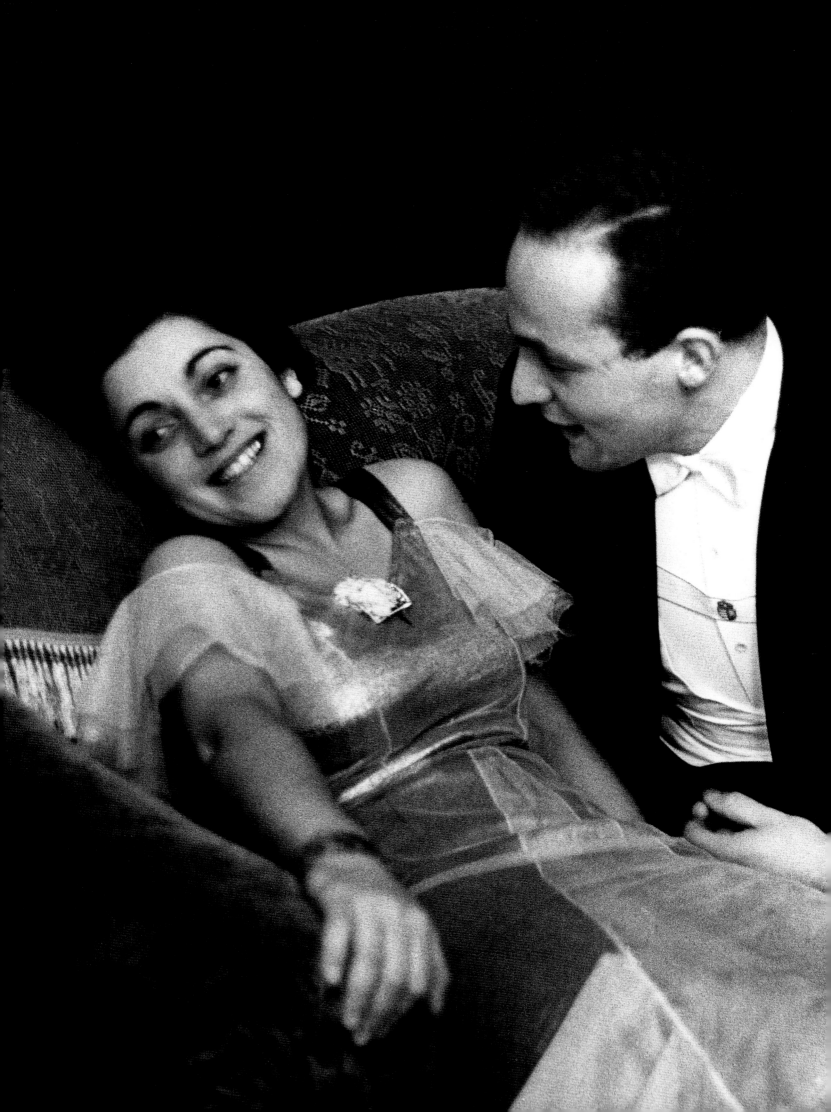

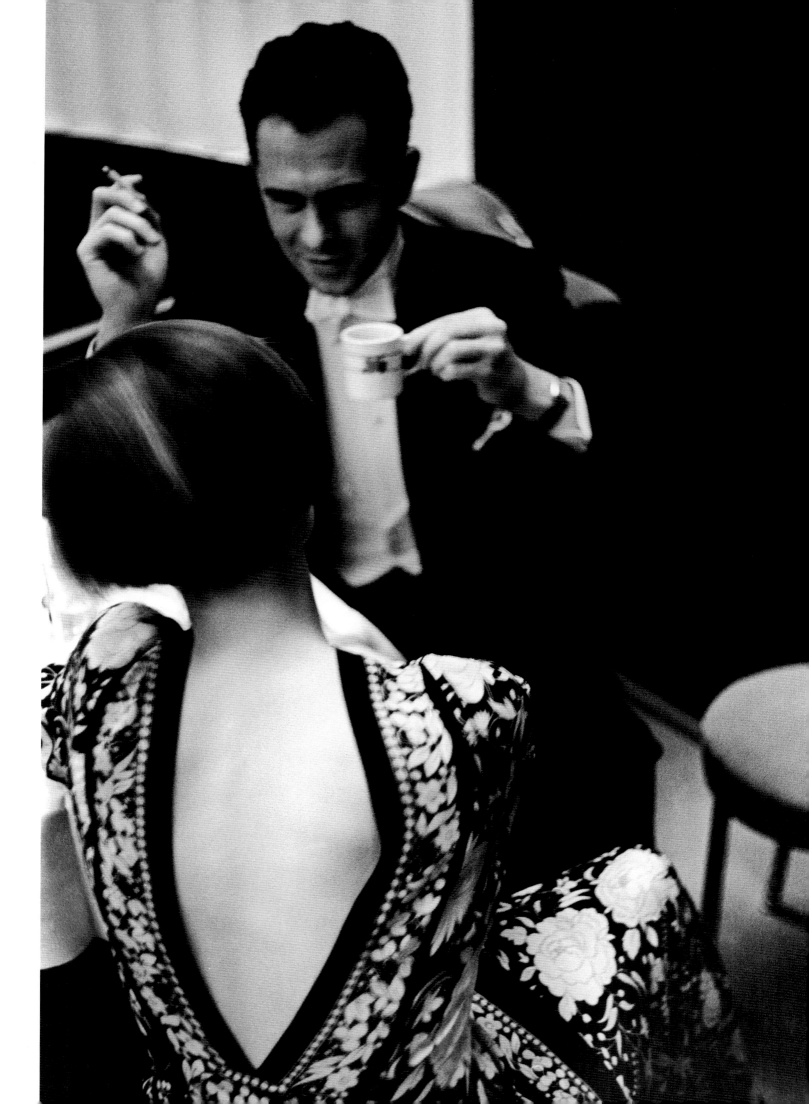

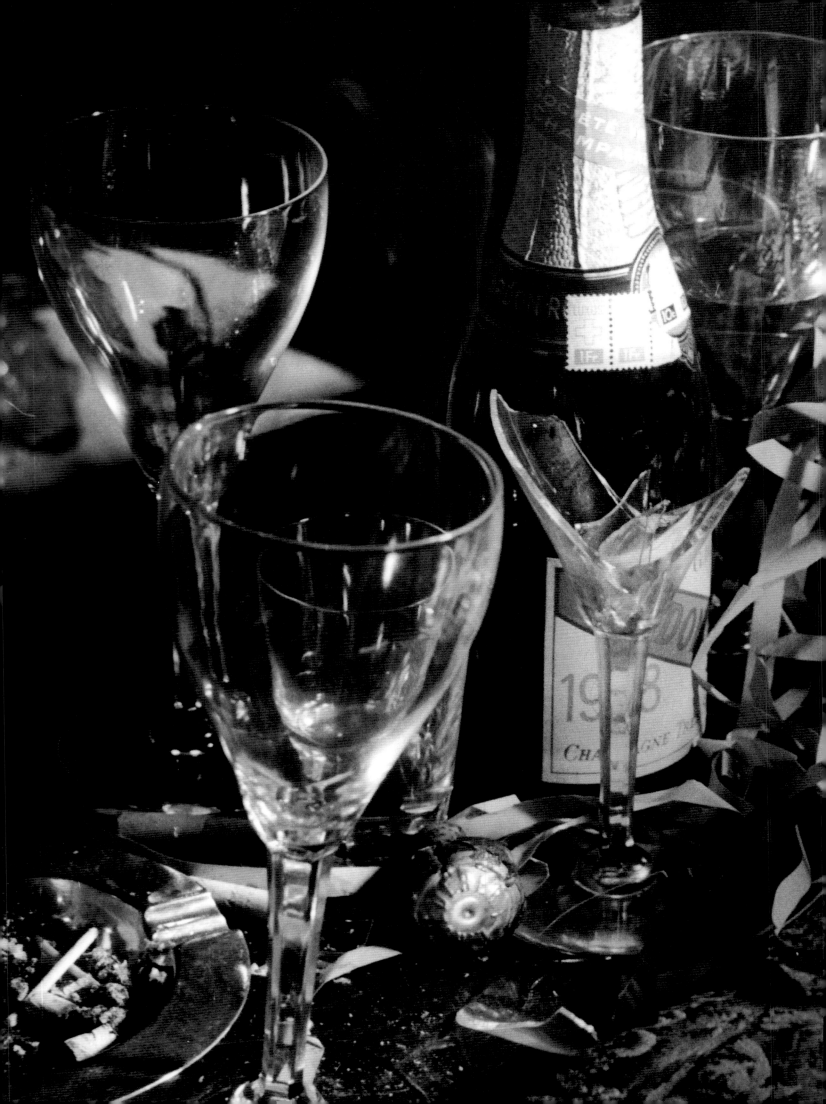

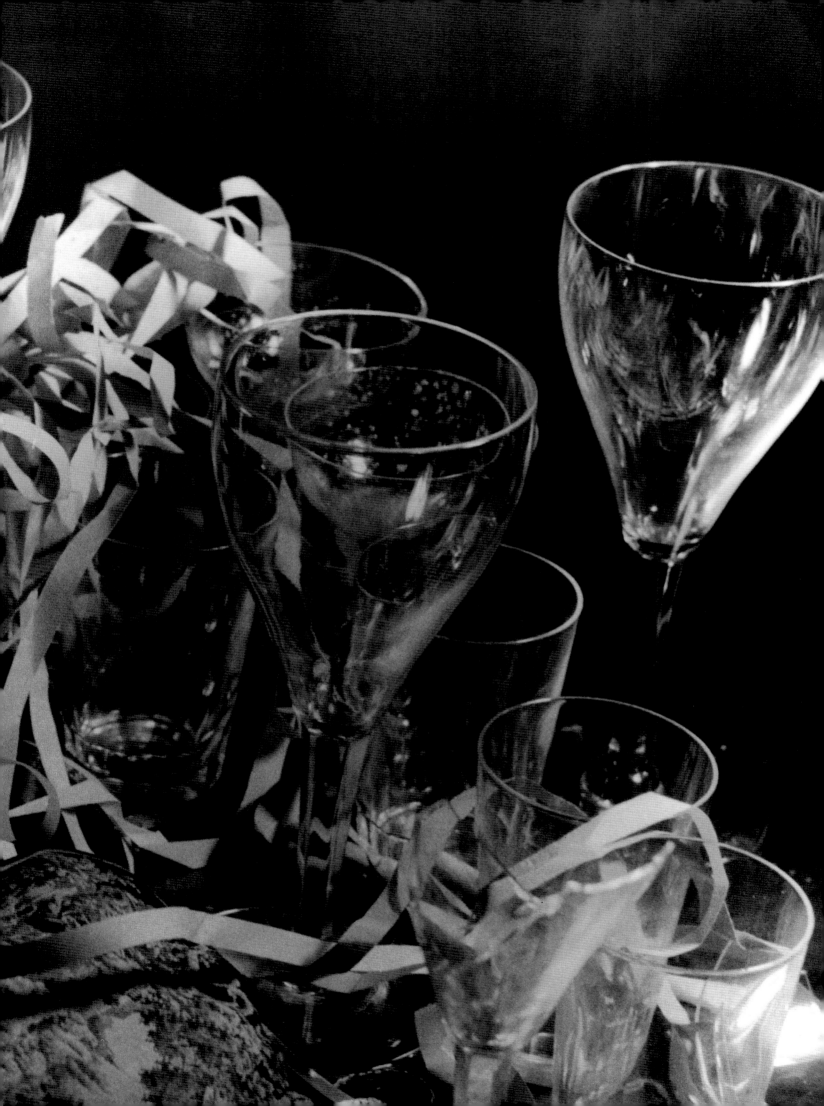

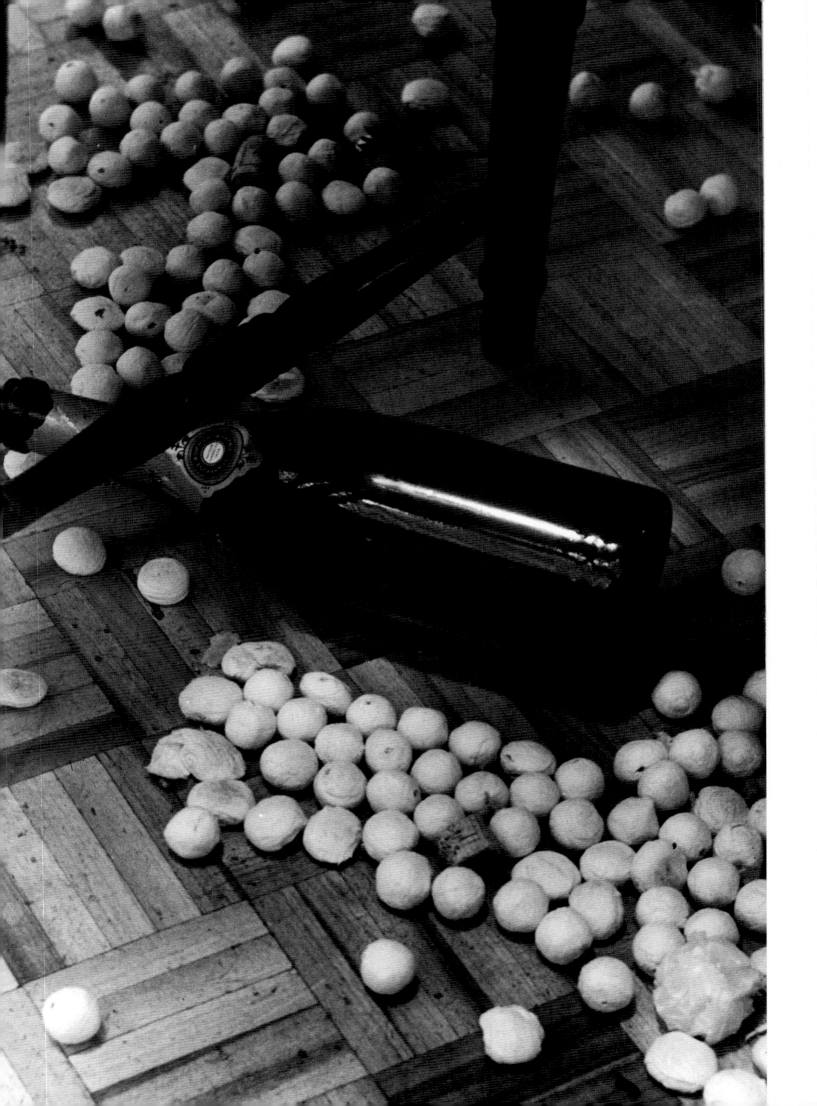

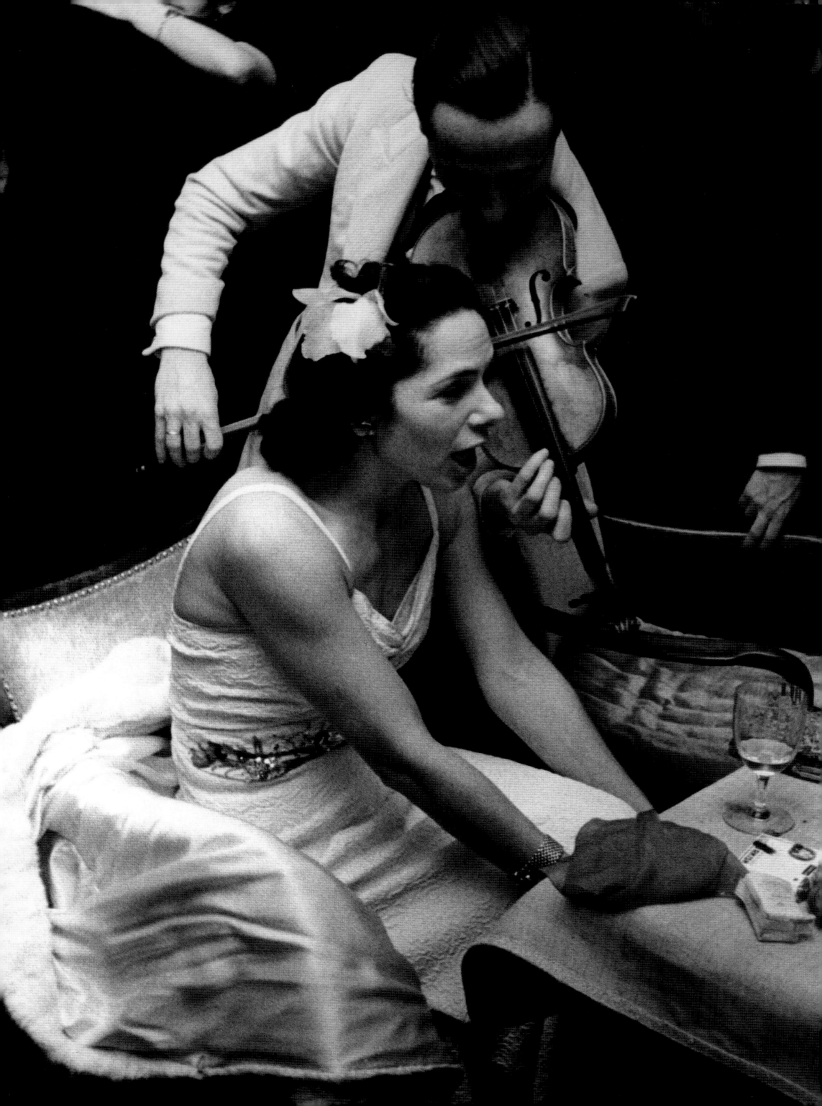

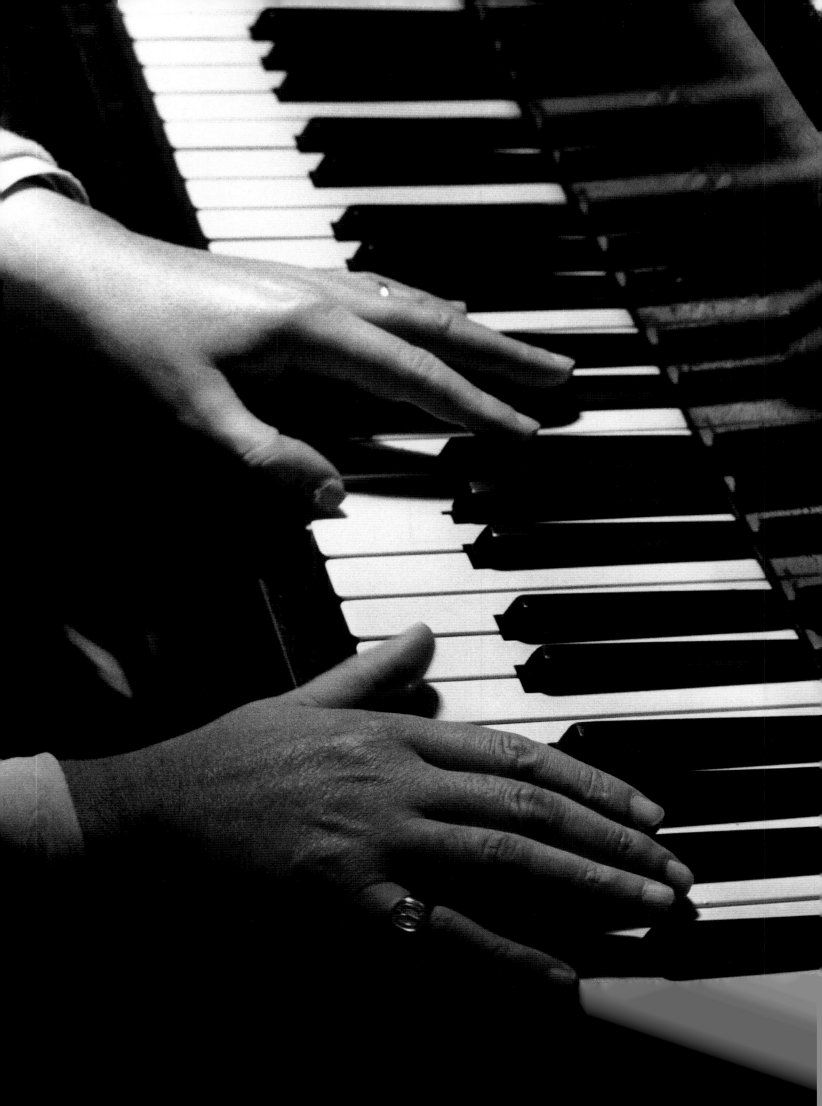

Diner
Diner

39.60

-178 39.60
70
7.- 4

395.30

220.80
174.50

395.30
+81.50

426.80

×49.50
244.46
262
107
MnerBahn

30

41.80
148.30

96

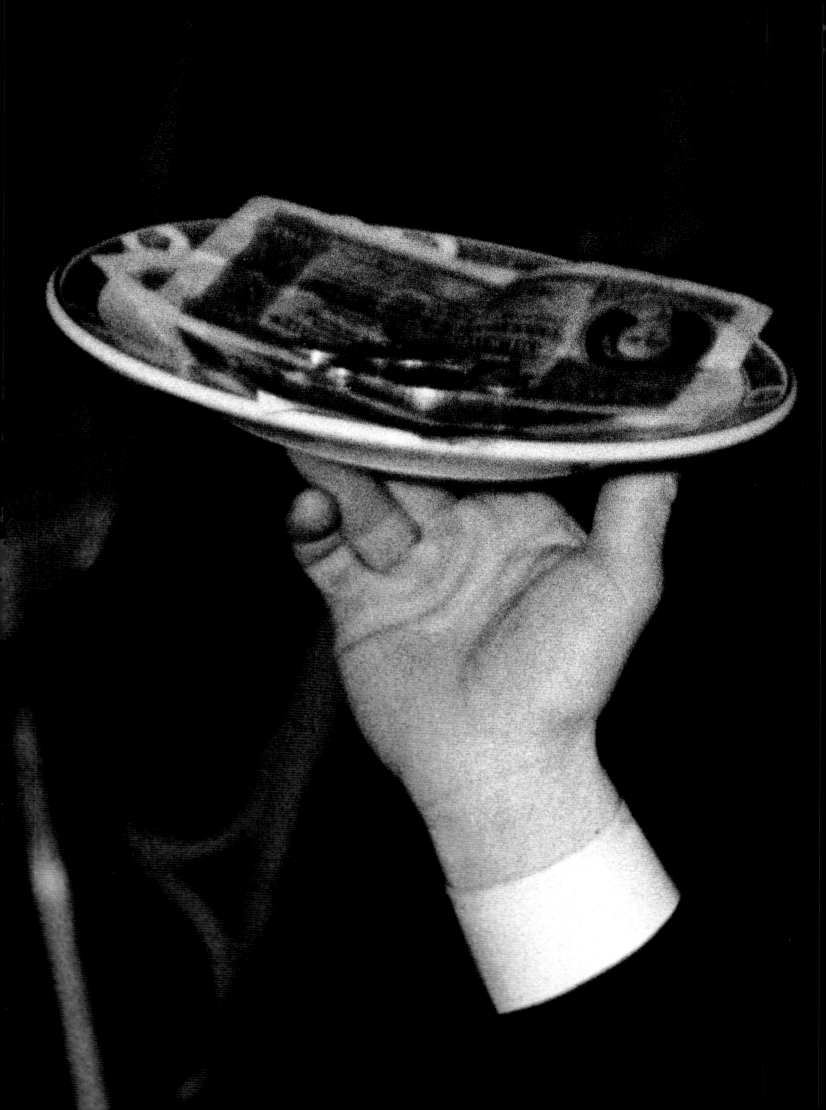

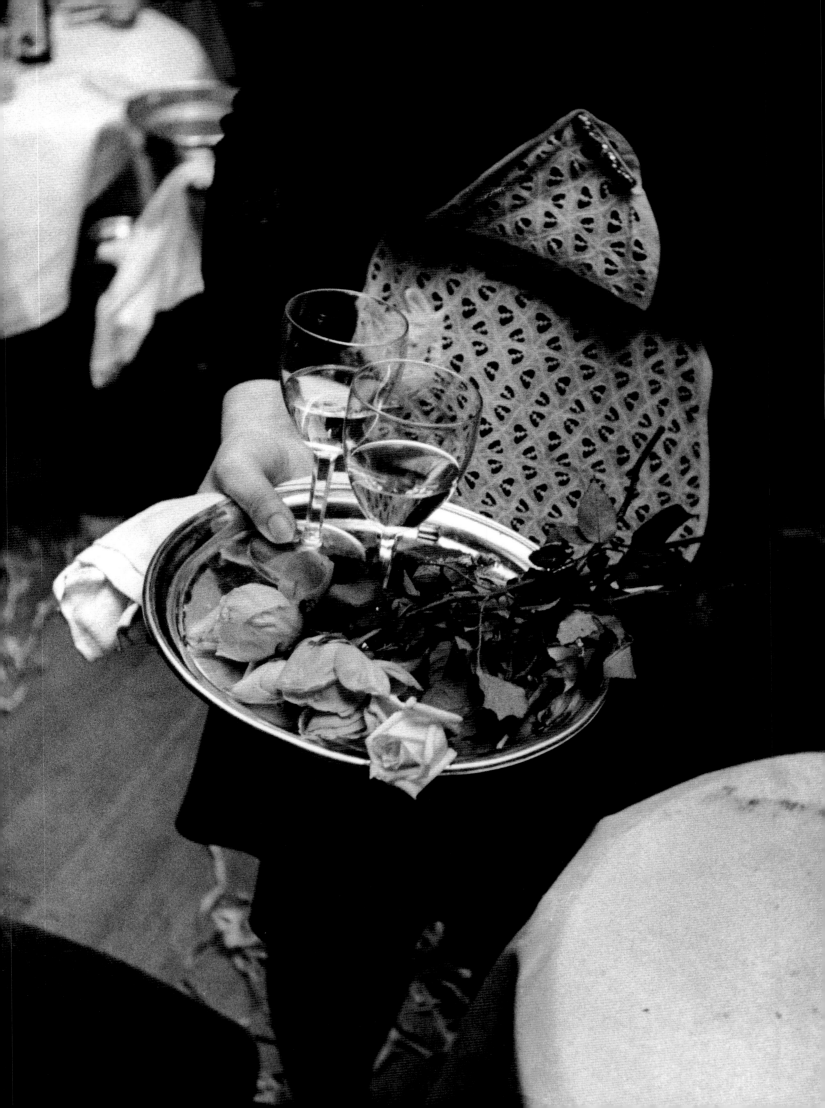

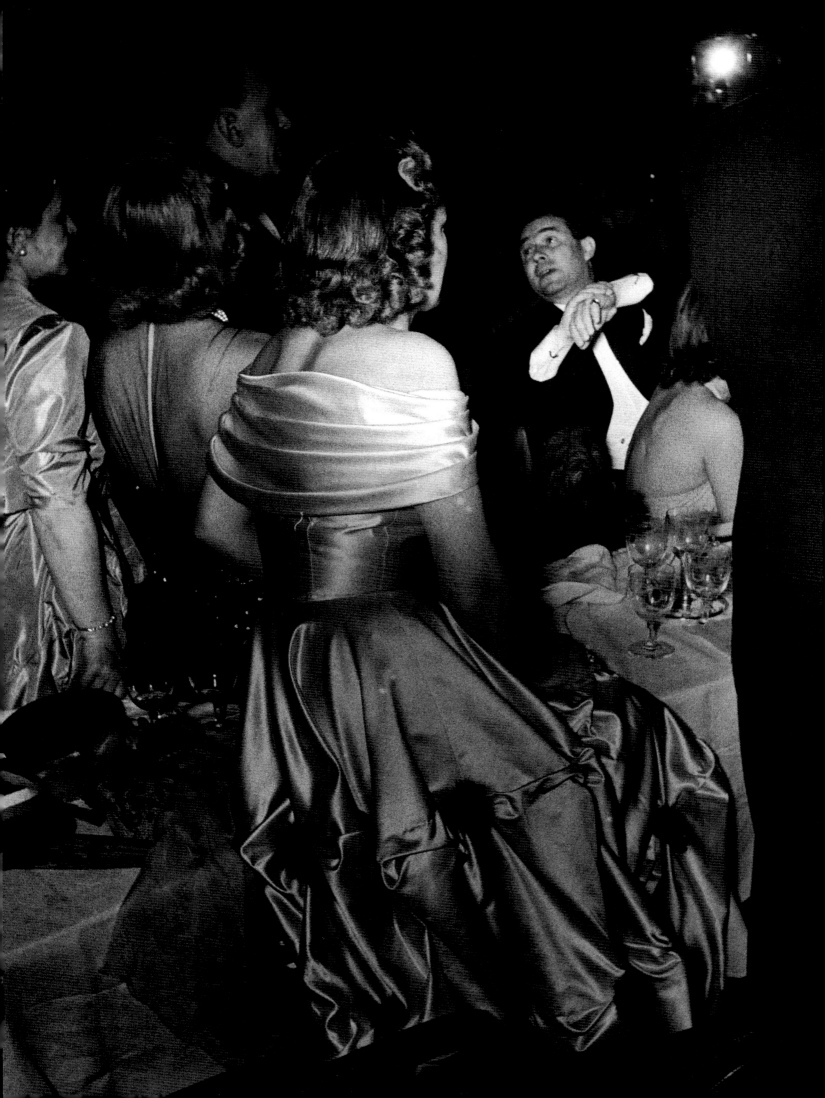

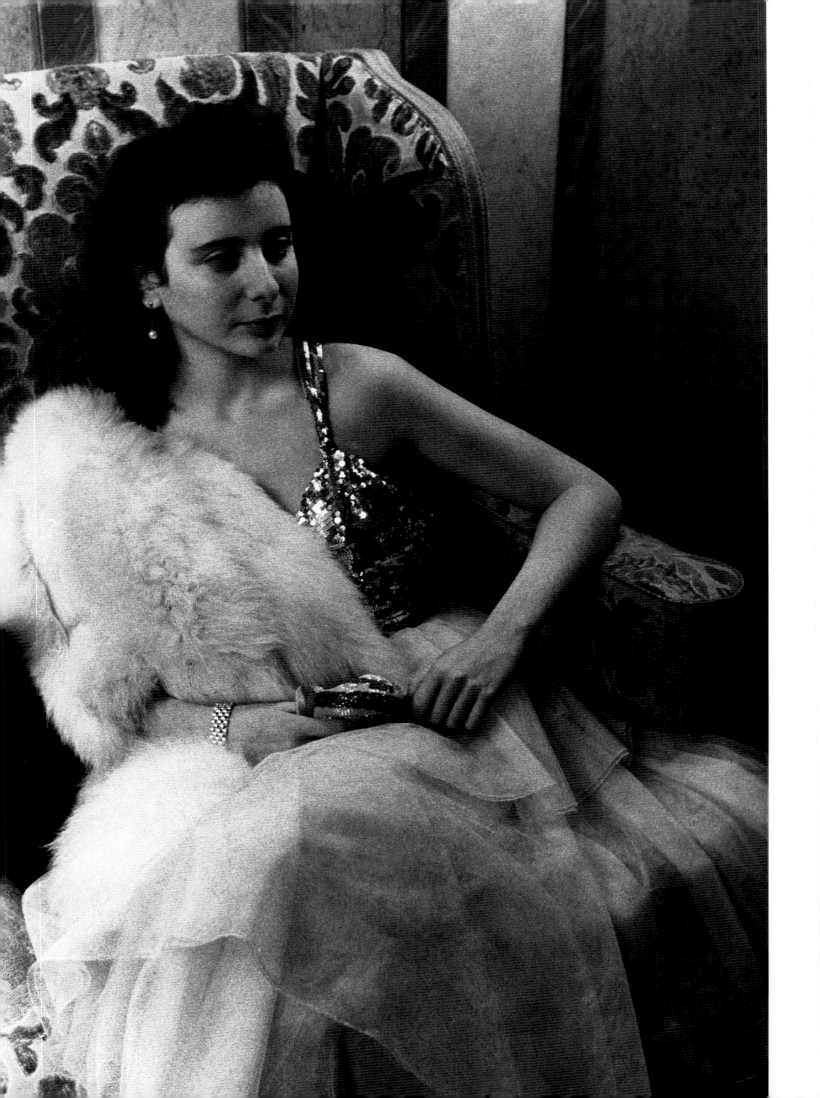

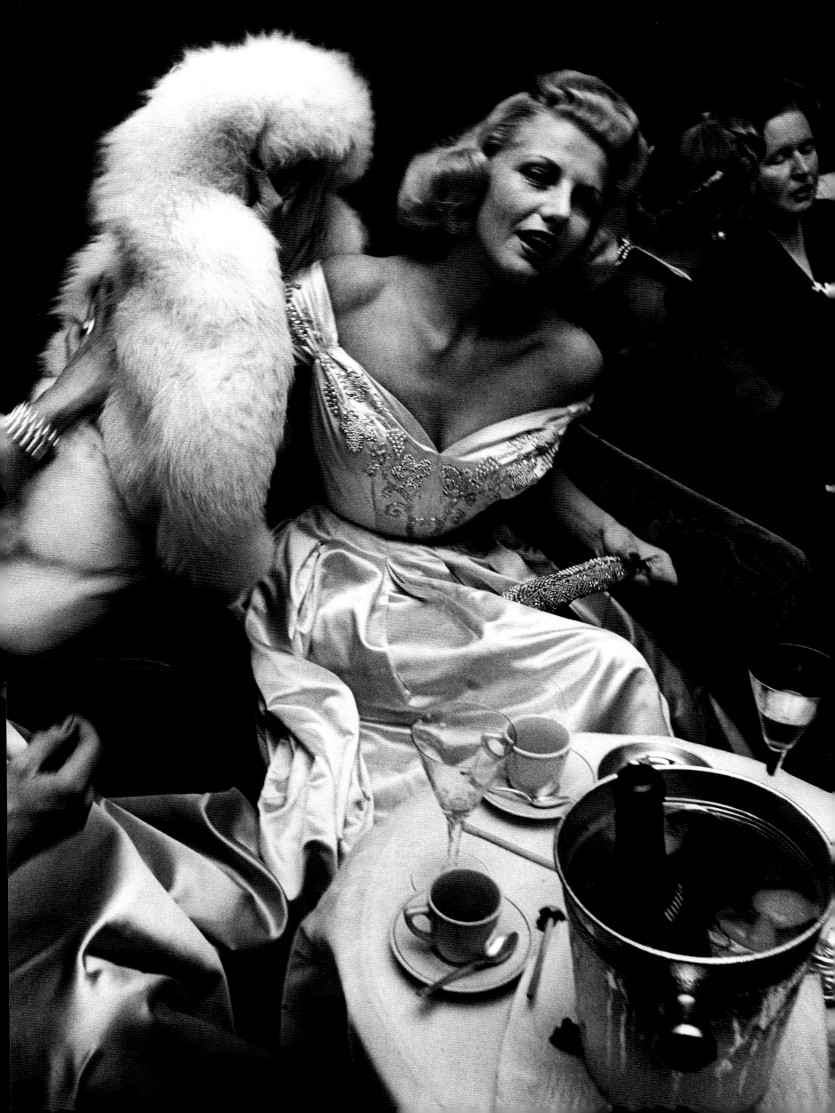

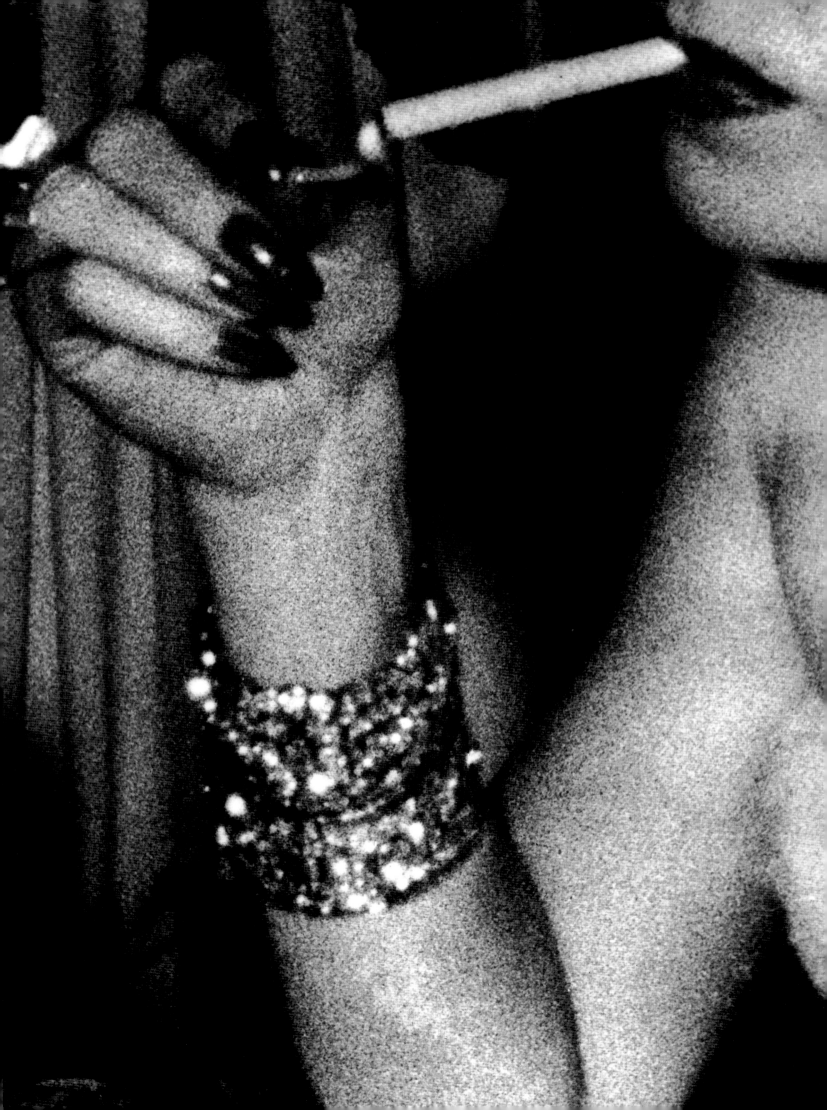

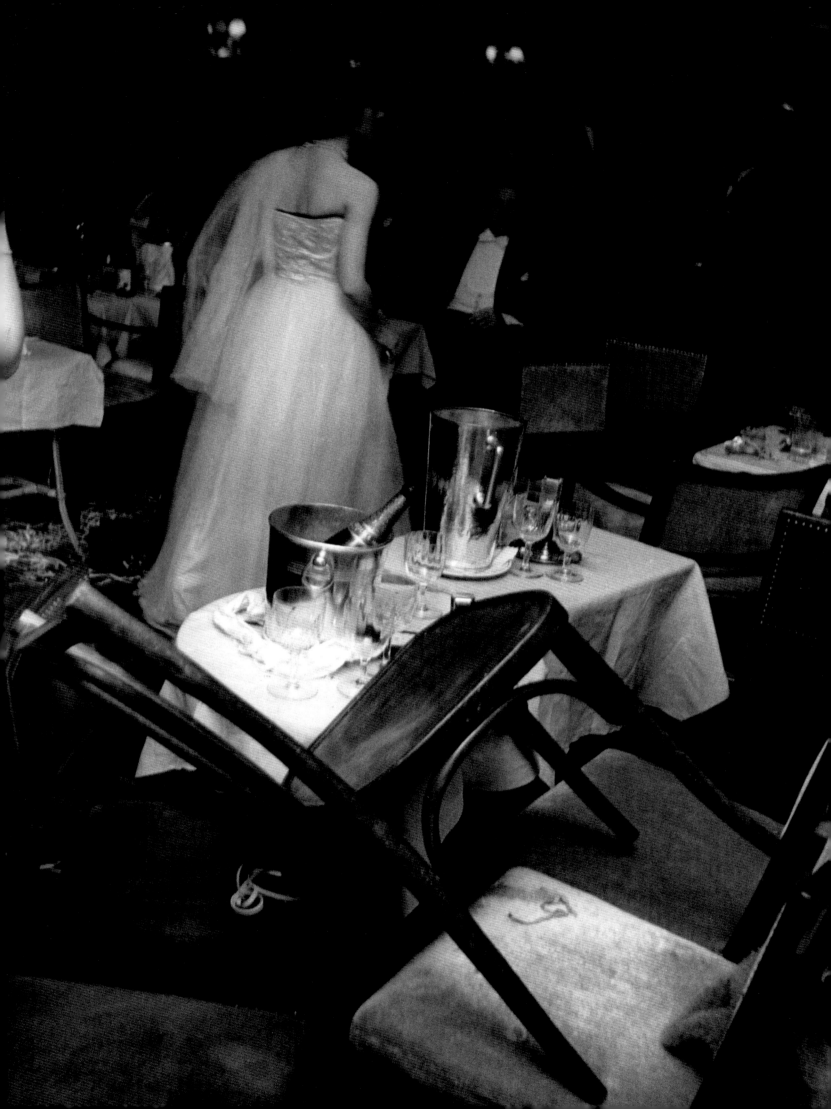

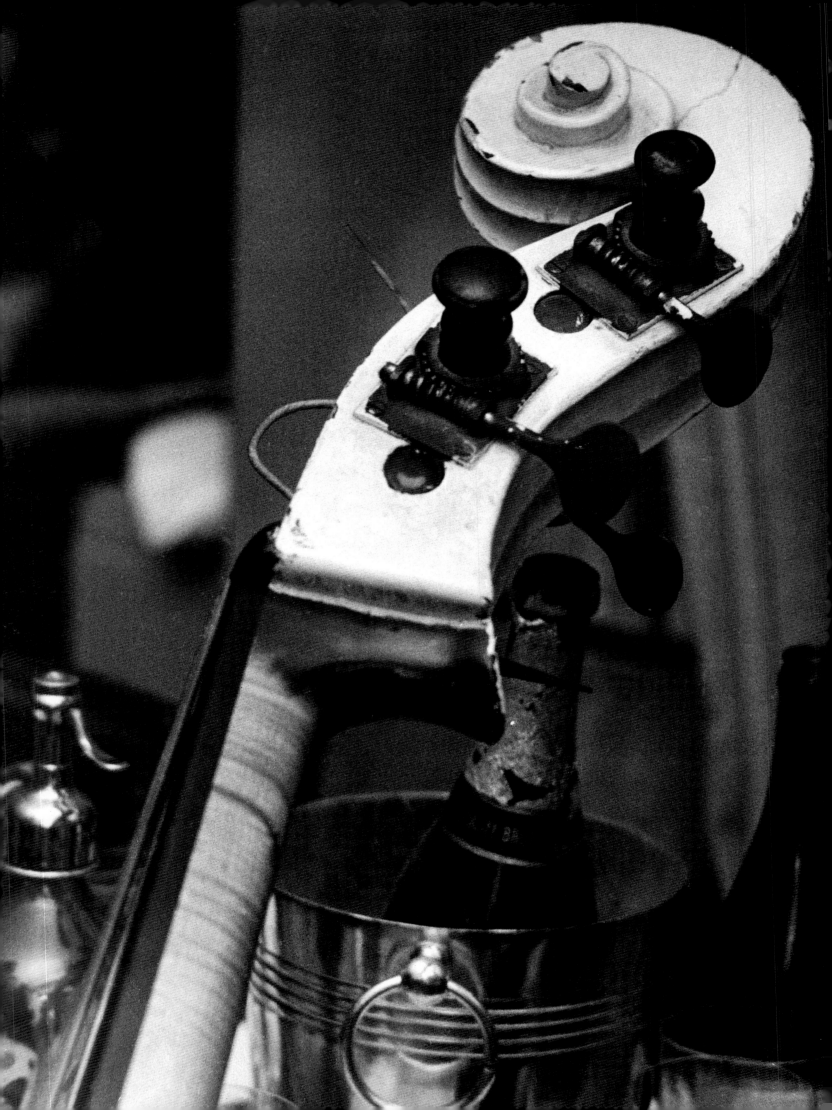

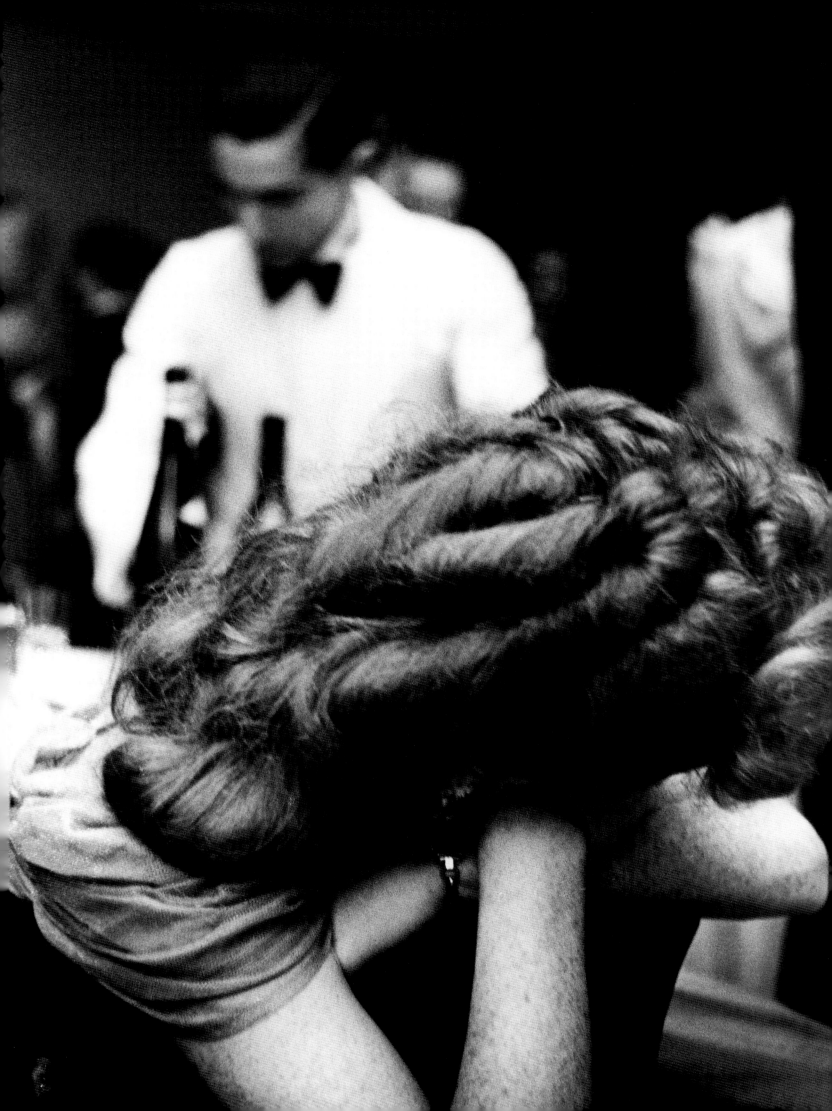

Plates pp. 264–310

Photographs from Ballnächte (Nights at the Balls), 1950

pp. 264/265 Untitled, Carlton Hotel, St. Moritz, c. 1950

pp. 266/267 Untitled, Hotel Imperial, Vienna, 1938

p. 268 Untitled, Suvretta House, St. Moritz, New Year's Eve 1950/51

p. 269 Untitled, university ball, Kongresshaus, Zurich, 1944

p. 270 Untitled, Grand Hotel Dolder, Zurich, 1950s

p. 271 Untitled, press ball, Hotel Baur au Lac, Zurich, 1949

p. 272 Untitled, ACS ball, Grand Hotel Dolder, Zurich, 1950

p. 273 Untitled, press ball, Hotel Baur au Lac, Zurich, 1940s

pp. 274/275 Untitled, Ticinesi ball, Grand Hotel Dolder, Zurich, 1943

p. 276 Untitled, guild house "zur Zimmerleuten," Zurich, 1940s

p. 277 Untitled, Palace Hotel, St. Moritz, New Year's Eve 1948/49

pp. 278/279 Untitled, Palace Bar, St. Moritz, New Year's Eve 1945/46

pp. 280/281 Untitled, Palace Hotel, St. Moritz, 1940s

p. 282 Untitled, Russian ball, Hotel Baur au Lac, Zurich, 1934

p. 283 Dr. Gubser, Zahnarzt (Dr. Gubser, Dentist), Hungarian ball,
Grand Hotel Dolder, Zurich, 1935

pp. 284/285 Mein Souper (My Dinner),
Palace Hotel, St. Moritz, New Year's Eve 1943/44

p. 286 Untitled, Hungarian ball, Grand Hotel Dolder, Zurich, 1935

p. 287 Untitled, Hungarian ball, Grand Hotel Dolder, Zurich, 1935

p. 288 Untitled, Palace Hotel, St. Moritz, 1943

p. 289 Untitled, press ball, Corso, Zurich, 1935

pp. 290/291 Untitled, Suvretta House, St. Moritz, 1946

p. 292 Untitled, Palace Hotel, St. Moritz, 1945/46

p. 293 Untitled, Palace Hotel, St. Moritz, New Year's Eve 1945/46

p. 294 Untitled, Palace Bar, St. Moritz, New Year's Eve 1943/44

p. 295 Untitled, Palace Hotel, St. Moritz, New Year's Eve 1943/44

p. 296 Untitled, Hotel Belvédère, Davos, 1944

p. 297 Untitled, Palace Hotel, St. Moritz, New Year's Eve 1943/44

p. 298 Untitled, Ticinesi ball, Grand Hotel Dolder, Zurich, 1946

p. 299 Untitled, Palace Hotel, St. Moritz, New Year's Eve 1943/44

p. 300 Untitled, Palace Hotel, St. Moritz, New Year's Eve 1943/44

p. 301 Blonde Frau (Blonde Woman), Grand Hotel Dolder, Zurich, 1948

p. 302 Untitled, Hotel Belvédère, Davos, New Year's Eve 1944/45

p. 303 Untitled, Hotel Belvédère, Davos, New Year's Eve 1944/45

p. 304 Untitled, ACS ball, Grand Hotel Dolder, Zurich, 1950

p. 305 Untitled, Kursaal, Zurich, 1938

p. 307 Untitled, Palace Bar, St. Moritz, New Year's Eve 1950/51

p. 308 Untitled, Palace Hotel, St. Moritz, 1948

p. 309 Untitled, Ticinesi ball, Grand Hotel Dolder, Zurich, 1946

p. 310 Atelier Tuggeners, Besuch hat auf Fenster signiert
(Tuggener's Atelier, Visitor Has Signed on the Window), 1935

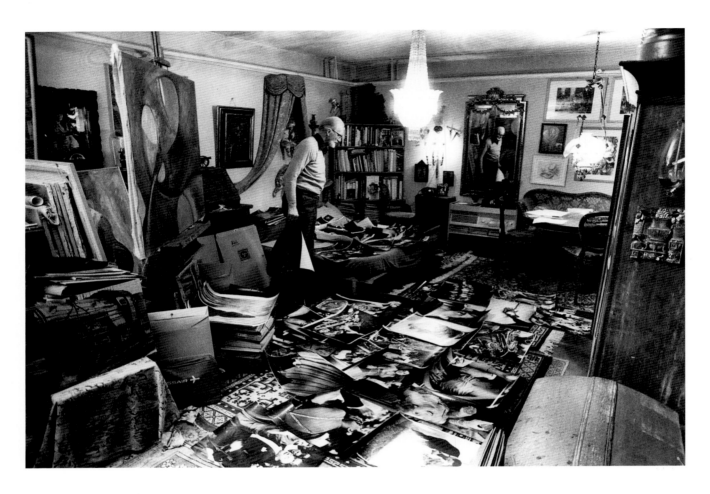

Untitled, Jakob Tuggener in his basement apartment, Zurich, 1974

The Late Years

An artist does not talk about nature, because we cannot understand a tree, none of the things "outside of us." That is why I do not want to be a chatterer and tell the world about things to which I cannot testify.

Experience is the only thing we can really and truly understand, it is our essence and it belongs to us. This is the only thing we can talk about. The only thing which for us represents "reality." Everything outside of it—nature—does not belong to us and is an appearance.

Jakob Tuggener, 14 January 1942

"I am nothing but a modern monk in his hermitage," Tuggener wrote to Edith Wildhagen in 1961.[1] He had retreated to his small basement apartment to finally and really "turn towards the inside." As he wrote to another friend: "I have lived for eight times seven years; during the ninth time I have to find perfection."[2] But the slow steps towards finding the "true essence of his soul," the "shrine within himself," at the same time led to loneliness, especially when Edith—who had become his lover after playing the main character in his film *Dornröschen* (Sleeping Beauty) of 1961—moved to the United States.[3]

Tuggener did not do too well financially during the 1960s. He worked on a more or less regular basis for the weekly *Genossenschaft* from which he earned just enough to survive. Thanks to several privately commissioned book maquettes for Hans Schindler and Max Wydler, a commission for three films for the "Feld und Wald" (Field and Forest) pavilion at the 1964 Swiss National Exhibition in Lausanne, and a series of photographs that were later published in *Forum alpinum,* he was able to continue working on his personal book maquettes, and even to make films and travel on a modest scale. He went to see several important cultural monuments all over Europe such as the great gothic cathedrals of Strasbourg, Reims, Laon, Amiens, Rouen, and Paris. He wanted to photograph them because he felt they did not represent what he believed true spirituality to be. He saw them, as he explained in 1968: "As a confirmation that all this is not Jesus Christ. After all he is not a church. He is the inner eye of the world's soul. The conscious being, the dove."[4]

Tuggener slowly began revising some of his earlier book maquettes and adding new pictures where he thought he had found better ones. He completed maquettes dealing with themes that he had been fascinated with for a long time, for instance the old textile industries in the valley of the river Aa in the upper regions of the canton of Zurich (1964), the railroad (1961/67), and Vienna and its carnival (1962/63). Laying out the hundreds of photographs needed for a book all over his bed and the living-room floor he arranged and rearranged the pictures until he was satisfied. Some maquettes remained incomplete and unbound such as one dealing with the Zurich "Künstlermaskenball" (artists' masked ball) or the car races of the 1930s and 1940s. Even though Tuggener's work was recognized in the early 1960s as an important and unique contribution to the history of photography—the curator L. Fritz Gruber presented him as one of the "Great Photographers of the Twentieth Century" at the 1963 *photokina* exhibition in Cologne—Tuggener felt increasingly frustrated that he could not find a publisher for his book maquettes. Gruber did not even include him in the book following the exhibition in Cologne, presumably for "purely technical reasons," as he told Tuggener[5] and the miniature obelisk Tuggener received as an award from the *photokina* meant nothing but a "tomb stone" to him. He began pondering questions of death and the ultimate meaning of his book maquettes in relation to his life: "I once thought about an epitaph for me: 'Take me, oh Lord, from this world where I have never lived.' When I look at the fifty books I made, I can hardly believe that 'my life is in them.' But I have always been beside it; I have only looked at it—have I lived my life at all?"[6]

Towards the end of the 1960s, when Tuggener was in danger of becoming embittered over the fact that commercial publishers and the public at large were not taking any notice of his work, artists and curators began to knock on his door. In 1967 the artist Richard P. Lohse had a chance to see some of Tuggener's early photographs and was impressed that their relevance to the present had remained unchanged. He wrote a letter to Erika Billeter, the director of the Kunstgewerbe-museum in Zurich, suggesting an exhibition to honor Tuggener as "a pioneer of photography and film in Switzerland."[7] This exhibition never came about but shortly thereafter his photographs were discovered by Klaus-Jürgen Sembach who organized the "Feine Feste" exhibition in Munich. At the same time, Swiss television produced a film portrait directed by Dieter Bachmann which was aired in November 1969. Tuggener was overwhelmed and wrote to Edith: "I have seen the film and it really made me cry, I was so moved by this honor."[8]

Tuggener's personal life took another turn when he met Maria Euphemia Baumgartner. He was fascinated by this woman of great independence and self-confidence thirty years younger than him, who taught children with learning disabilities, and they married in 1971. They kept their separate apartments, continued working independently and only lived together over the weekends and during the holidays, an arrangement which proved to be ideal. Tuggener described this situation in a short autobiographical text in the early 1970s: "He lives as a recluse in his artist's hermitage and no telephone call or visitor disturbs his peace. There he contemplates his photo-books, there he condenses the ideas for his silent films and the expressive paintings of his soul. He is happy with just two things: his work and the love of his young wife."[9]

Literally rejuvenated by this relationship, Tuggener developed new energy and turned to the theme of Zurich, his home town, on which he completed four book maquettes in a short period of time. With regained self-confidence as an artist he offered the city council an exhibition of photographs exclusively dealing with Zurich and demanded either SFr. 20,000 or the city's *Kunstpreis* (Award for Cultural Merit) for it.[10] Both ideas were rejected but Tuggener agreed to show a cross-section of his entire photographic oeuvre.[11] In this first retrospective exhibition held at the Helmhaus in 1974, he arranged his photographs as "the natural course of his life: nature of Switzerland / his hometown Zurich / work in industries / his pleasure in the world's splendor, the luxurious balls, the artists' masked balls / humor / trips throughout Europe. And at the end, again the quietness and the soil of farm life."[12] No catalogue was produced and he had to wait another seven years until Zurich honored him with the *Kunstpreis* in 1982. He was the first photographer ever to receive this award.

In the same year, Tuggener broke an agreement to cooperate on a wall-size assemblage of his photographs of the old Maschinenfabrik Oerlikon that had been taken over by the Brown Bovery Company. He also refused an offer from the Swiss Foundation of Photography acting on behalf of the Swiss government to buy one hundred of his prints for the respectable sum of SFr. 40,000 and replied: "Here it is five minutes to twelve before my second eye operation. That is why I have much more important things to do now than to think of commercial success."[13]

Despite several operations Tuggener's eyesight worsened during the following years. But he did not lose his "hungry eyes" and was most happy just looking at his pictures: "When I make my bed in the morning my eyes soon crave to see

something. Then I rush to one of my photo-boxes and enjoy my pictures and marvel at them. Only after quenching this thirst and satisfying my eyes I continue with my profane morning work."[14] Tuggener gradually stopped doing his own housework and stayed for increasingly long periods at his wife's apartment until he did not feel it necessary to return to his hermitage, for he could continue anywhere looking at his book maquettes that did—and still do—contain his life. He died in Zurich after a stroke at the age of eighty-four on 29 April 1988.

The Photographer as an Expressionist

In the history of photography Tuggener is a unique figure, not only in Switzerland, and both his work and his life stand out in an odd way and make it difficult to insert him into the larger canon of twentieth-century photography. Throughout his life, Tuggener called himself an expressionist, and he held on to the concepts of "Erlebnis" (emphatic experience) and "Kunstwollen" (artistic purpose), that were at the center of expressionist artistic practice, for a long time after the movement was outdated. Tuggener wrote in the only published summary of a series of slide lectures he held in the early 1950s: "The photographer as expressionist does not exist in the register of companies. He is the most free and independent. Unbound from any purpose, he only takes pictures of the pleasure of his experience. He is the artist and tries to express himself with his tool, in this case with a camera. ... The prerequisite, however, is not the mere recording [of reality], but the artistic purpose."[15] Of course, this is not a description of "The Photographer as an Expressionist" as such, but of Tuggener himself, the photographer and artist Jakob Tuggener. Tuggener's insistence since the 1930s on photography as an art and his notion of himself as an expressive artist is unique in Swiss photography. In this he was ahead of his time, even more so because he did not distinguish between the creative potentials of painting, film, and photography. In fact, over long periods of time he worked in all three media at the same time exploring their intrinsic qualities. For him they represented equal tools for personal expression, it only mattered whether they were used honestly and true to the artist's self. He publicly fought for the acceptance of photography and film as an art long before there was an awareness in Switzerland—and elsewhere—that photography was a creative medium with a long history related to art that had to be taken seriously. So he was not a "commercial" photographer, not because he would not have liked to sell his photographs but because there existed no market for them.

The only market for photographs in the 1930s was the illustrated press. Tuggener, unlike several other Swiss photographers, was in the comfortable position that he did not have to rely exclusively on the sale of journalistic pictures to picture magazines as he found his niche at the Maschinenfabrik Oerlikon photographing industry, an area that he was closely familiar with ever since he had been an apprentice at the industrial company Maag Zahnräder in Zurich. He was accepted as an outside photographer who enjoyed all artistic liberties—often to the annoyance of the factory photographer employed by the company. This freelance work not only provided Tuggener with a more or less regular income for many years but it also allowed him to explore a subject matter that was inaccessible to most other photographers. Over a long period of time he created a unique body of work which is both a document of technological development from the early textile industry to the modern electric locomotive and a reflection of Tuggener's personal experience and analysis of the age of the machine.

Like no other photographer in Switzerland Tuggener took advantage of the long time he had to spend in the army before and especially during the war. It was neither dead time for him, a blank spot in his career, nor did he turn into an army photographer in the service of military propaganda controlled by censorship. Quite the contrary, he began to explore for himself the landscape and the land that he was supposed to protect from the enemy and in due course and with great insistence he slowly discovered and caught in impressive pictures the inner climate—one of "inner winter"— that was dominating life during the war years in Switzerland. Thus it is not the hundreds of pictures of the daily lives of his fellow soldiers—which Tuggener also took—but his book maquettes dedicated to the four seasons and a maquette portraying the camp of interned Polish soldiers and officers that help elucidate a pivotal time in Swiss twentieth-century history.

In the middle of World War II, and in the midst of his work on technology and the countryside, Tuggener became interested in a totally different topic, the society balls in Zurich and especially those at the Palace Hotel in St. Moritz. He returned there year after year and with his camera created insights into society and human nature that were unprecedented in photography, praised by critics and feared by the people who felt exposed. But Tuggener was not a social critic with a left-wing political agenda—although he was often made into one based on the perceived opposition of the world of work and the leisure of high society. He always and vehemently resisted this notion. Neither was he a "Heimat"-photographer, even

though he always considered himself a patriot. In an interview in 1980 he exclaimed: "I am an archetypal Swiss (Urschweizer), and in terms of politics totally on the right, not the left" and stated that he had been a member of a nationalist right-wing party, the "Nationale Aktion," for a short time in the 1960s.[16] Yet essentially Tuggener was not political, perhaps he was even a-political—his friend Max Wydler thought Tuggener was totally naïve in this sphere[17]—for him politics were too much part of the agitations of an "outer" world that did not really interest him. But how could Tuggener be a modernist photographer and a conservative Swiss at the same time? How could he embrace modernism in the form of technology and express nationalist feelings at the same time? How could he be fascinated by the dangerous speed of racing cars as an expression of modernity and at the same time as an expressionist insist on spirituality, religion, and the experience of the soul? This only appears to be a paradox. In fact, it is related to and expressive of an important current in twentieth-century culture: reactionary modernism, a fusion of irrationalist and nationalist ideas with the belief in technological progress that not only influenced early right-wing ideologies in Germany and Italy but also played an important role in Switzerland since the turn of the century.[18] Tuggener can be put firmly in this context and, if one looks closely at others of his contemporaries, he was certainly not the only one.

However, like no other photographer in Switzerland, Tuggener dealt in depth with extremely diverse topics—work in the factory, life in the countryside, and pleasure in the ballroom—which, put together, become subjective explorations of human life in general, as well as the life of a free and totally independent, albeit often lonely, creative artist.

Always living very modestly Tuggener's life was a constant search for himself, and his art was an incessant struggle to express, as he wrote in his credo as an expressionist, "what moved and excited his soul." After the publication of *Fabrik,* his Pictorial Epic of Technology, Tuggener was called a *Bilderdichter,* a poet with a camera, a term that was applied to only one other Swiss photographer, Robert Frank. The critic Max Eichenberger wrote in 1951 that Tuggener's photographs not only revealed "the painter but also the poet, a rare magician and strange alchemist who, at least in small quantities, changes lead into gold."[19]

As a result of Tuggener's limited financial resources, his strong interest in film and his exploration of the reportage he developed the book format into his personal artistic language—not a descriptive language, but a poetic one with a creative

potential beyond words and reason. He deeply distrusted explanatory words because for him they distorted the meaning of pictures to the extent of preventing truthful experience altogether. As he explained in an interview in 1980: "Every book is a poem, a self-contained work. [My books] are poems, nothing else, they are silent films."[20]

Even though Tuggener was at times frustrated that publishers did not want to publish his books because they thought no audience was capable of understanding his purely visual language, he continued until old age to compose one book maquette after the other, each with a hundred photographs or more. In the area of technology he ventured into chemical industry and explored the ports of Rotterdam and Antwerp. He dedicated two maquettes to the railroad and especially the steam engine which had fascinated him throughout his life. He created numerous variants of his *Ballnächte* culminating in the final *Kolosseum* (Colosseum) in which he included artists' balls in Zurich and carnivals and the Opera Ball in Vienna. Life in the country again came to the fore in the context of the Swiss National Exhibition of 1964, and a large number of maquettes portray various Alpine regions in Switzerland including a final set called *Die vier Jahreszeiten* (The Four Seasons). The city of Zurich, the Rhine and the Danube, and the impressions of many trips abroad became topics for new book maquettes that all stand as poetic and self-contained works.

Unwavering in all his endeavors as an artist, Tuggener over the course of his life created an oeuvre which is unique in the history of photography—and whose largest part is still unpublished and awaits discovery. Only *Fabrik* stands out as a singular milestone in the history of the photographic book, so far the only public monument to Jakob Tuggener's creative power placing him in a line with other great photographers like Brassaï, Bill Brandt, and Robert Frank.

Notes

1 Tuggener in letter to Edith Wildhagen, 20 November 1961.
2 Tuggener in undated letter to Nelly Rudin (1960).
3 Tuggener in letters to Edith Wildhagen, 12 April 1961 and 7 July 1968.
4 Tuggener in a manuscript, 7 May 1968.
5 Letters from L. Fritz Gruber, 24 April 1963 and 27 October 1964.
6 Tuggener in letter to Edith Wildhagen, 27 August 1965.
7 Richard Paul Lohse in letter to Erika Billeter, 30 June 1967, Richard Paul Lohse-Stiftung, Zurich.
8 Tuggener in letter to Edith Wildhagen, 27 August 1969.
9 Tuggener in "Notizen über Tuggener," undated manuscript, (early 1970s).
10 Tuggener in letter to Christoph Vitali, 7 November 1972.
11 Tuggener in letter to Christoph Vitali, 27 June 1973.
12 Tuggener in introduction to the exhibition, November 1974.
13 Tuggener in letter to the Schweizerische Stiftung für die Photographie, 29 November 1982.
14 Tuggener in undated manuscript, (c. 1978).
15 Tuggener, "Der Fotograf als Expressionist," in *Schweizerische Photo-Rundschau,* 8 December 1950, p. 402.
16 Tuggener in interview with Inge Bondi, April 1980.
17 Interview with Max Wydler, 28 May 1990.
18 See Herf, *op. cit.* and Hans Ulrich Jost, *Die reaktionäre Avantgarde. Die Geburt der neuen Rechten in der Schweiz um 1900* (Zurich: Chronos Verlag, 1992).
19 Max Eichenberger, "Photo-Ausstellung im Helmhaus," in *Die Tat,* 2 March 1951.
20 Tuggener in interview with Inge Bondi, April 1980.

Plates pp. 321–327

p. 321 **Ferien am Bach** (Holiday at the Stream), 1950s

p. 322 **Abwasser** (Sewage), Dürsteler Wetzikon, 1942

p. 323 **Untitled,** Quaibrücke, Zurich, c. 1935

p. 324 **Wasserfall** (Waterfall), Bodio, 1940s

p. 325 **Untitled,** water surface, c. 1935

pp. 326/327 **Zwischen Antwerpen und dem Meer** (Between Antwerp and the Sea), 1957

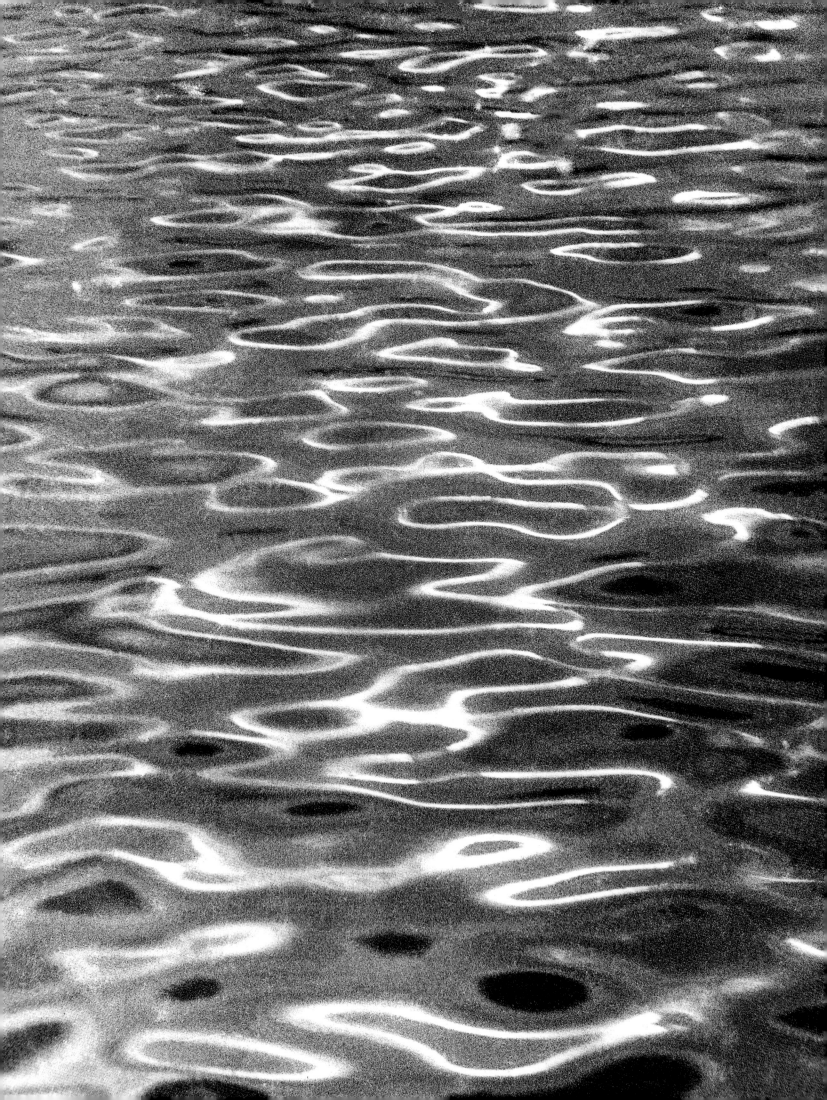

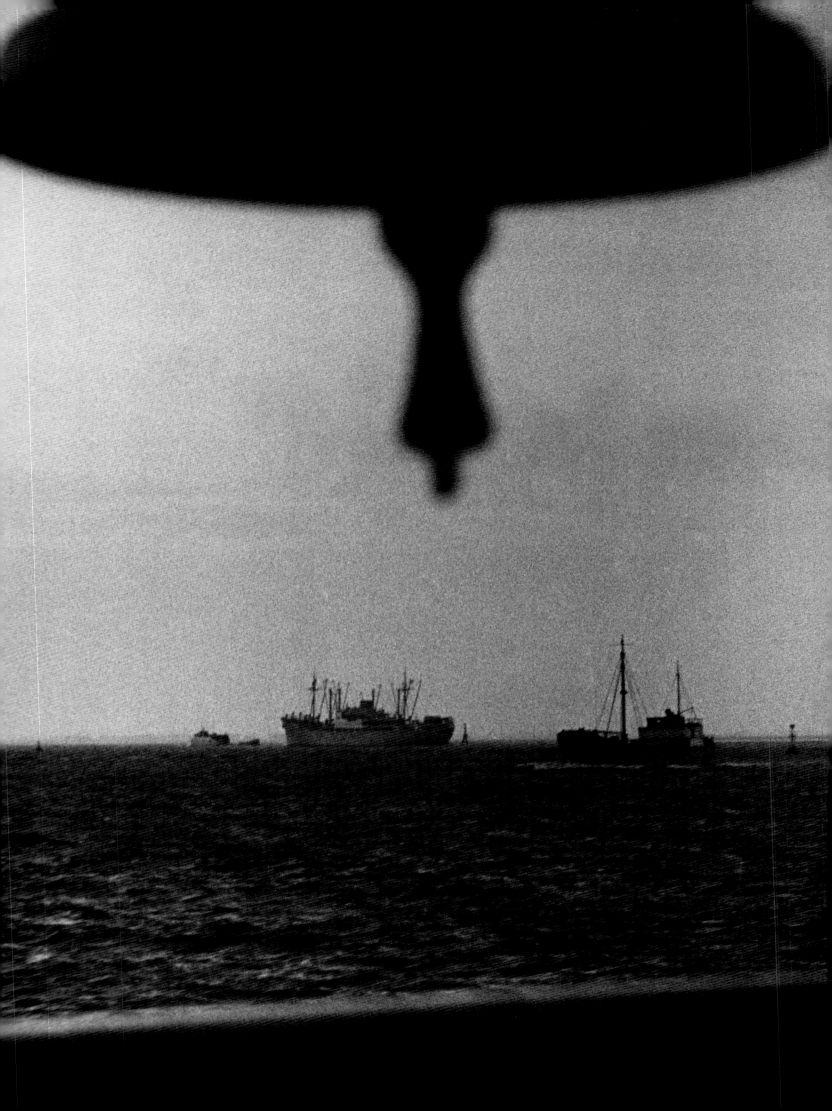

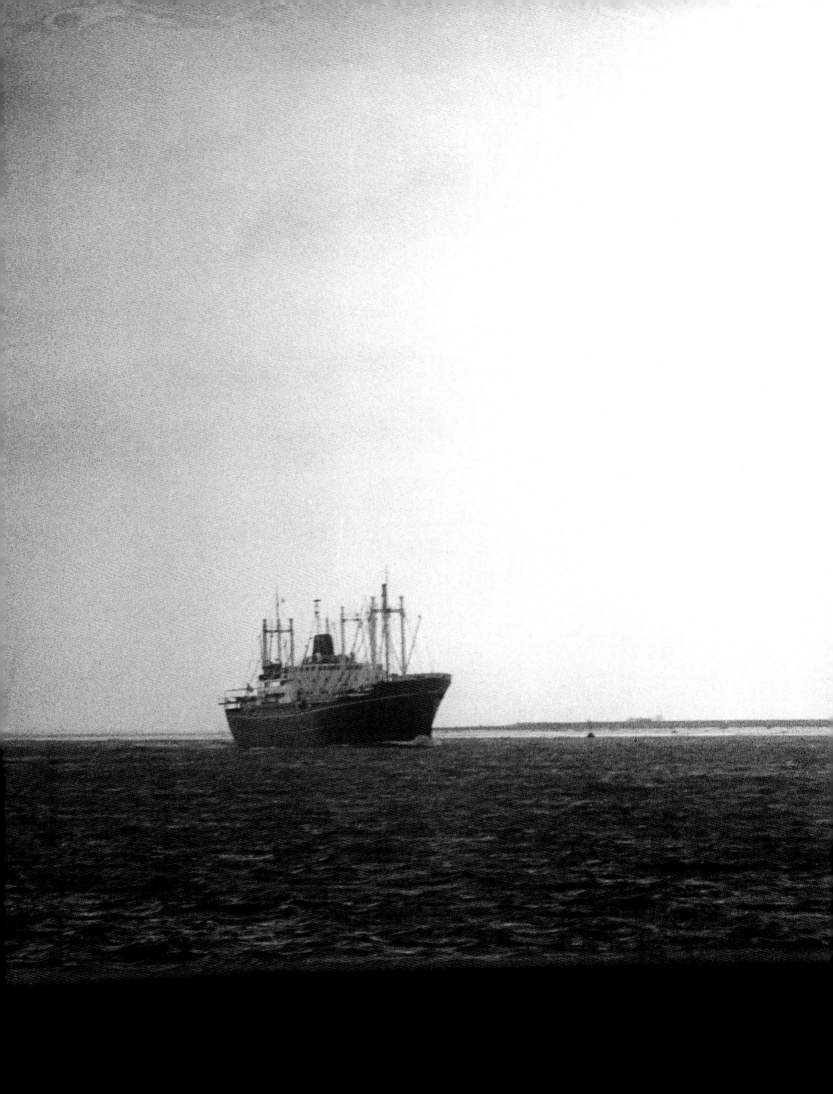

Chronology

1904
7 February. Born in Zurich, the only son of Jakob Arnold Tuggener and Anna Barbara Sennhauser, fifteen minutes before his twin sister Anita.

1910–1919
Attends primary and secondary school in Zurich.

1919–1930
Until 1923, apprenticeship as technical draftsman at Maag Zahnräder A.G., Zurich, thereafter employed in the company's construction department.

1925
23 September–28 November. Basic military training as infantry fusilier.

1926
5–17 April. First military repetition course in Egg, canton of Zurich. Meets Max Wydler who becomes a close friend.
Takes his first photographs and travels to Venice.

1928
August. Crosses the Alps on a solitary ten-day hike. Documents this and following hikes with photographs that he collects in a series of small albums.

1929
Expulsion from home after a quarrel with his sister. Moves in with his lover Senta Heisch, a hat and lampshade maker.

1930
May. Loses his job with Maag Zahnräder.
Takes a course in drawing at the Kunstgewerbeschule in Zurich.

August 1930–May 1932
Studies typography, graphic design, drawing, and film at the Reimann Schule in Berlin.

1931
24 January. Attends the Reimannball at the Kroll Opera in Berlin.
February. First photographs published in *Farbe und Form,* the magazine of the Reimann Schule.
Early May. Travels to the island of Helgoland and then returns to Zurich. Lives at his parents' house again.

1932
18–30 April. Military repetition course in Siblingen, canton of Schaffhausen, with Captain Hans Schindler. Is hired on a freelance basis by Schindler to work for *Der Gleichrichter,* the in-house magazine of the Maschinenfabrik Oerlikon (Oerlikon Machine Factory).
5 November. His first reportage published in *In freien Stunden.*

1933
4 February. Becomes a member of the Künstler-Vereinigung Zürich (Zurich Artists Association) and begins participating in their group exhibitions.

1934
Meets his future wife, Marie Gassler, while taking photographs in the canton of Appenzell.
Produces his first commissioned book entitled *MFO,* a portrait of the Maschinenfabrik Oerlikon, and afterwards buys a Leica camera.
Photographs the first Swiss Grand Prix car races on the Bremgarten-ring near Bern, the international "Flugmeeting" (aerial show) at Dübendorf and the "Trachtenfest" (festival of national costumes) in Montreux.
10 November. Attends his first ball in Zurich, the "Grand Bal Russe."

1935
Moves into an attic room at Mühlegasse 5 in Zurich.

1936
Joins the Vereinigung Zürcher Film-Amateure (Association of Zurich Amateur Filmmakers).
August. Spends two weeks in Brittany with Max Wydler.
First double-page reportage without text is published in *Der Gleichrichter.*
November. Joins the Zürcher Photographen-Verein (Zurich Photographers Association).

1937
Max Wydler buys a 16 mm film camera to shoot industrial films.
Together with Wydler produces first independent documentary film of the 4th international "Flugmeeting" at Dübendorf.
Becomes a member of the Schweizerische Photographenverband (Association of Swiss Photographers). Visits the World Fair in Paris.

1938
Produces the first of a series of commemorative books for various Swiss companies.
11–19 June. Travels to Vienna to represent Switzerland at the 4th International Amateur Film Congress.
Receives several commissions for industrial films.

1939
6 May–29 October. Several industrial films by Tuggener and Wydler are shown at the Swiss National Exhibition, "Landi," in Zurich.
September. Outbreak of World War II. Drafted for active military service; serves a total of 526 days as an infantryman in various places in Switzerland until December 1944. Takes his Leica along on patrols and takes pictures of his fellow soldiers as well as of farm life in the surrounding countryside.

1940
6 April. Marries Marie Gassler and moves to Gemeindestrasse 12.
August. Birth of first son, Jakob Silver Amadäus.

1942
January. Birth of second son, Rainer Severin.
Tuggener and Wydler win the Wanderpreis des Bundesrates (Challenge Trophy of the Swiss Government) at the 8th National Amateur Film Competition with *Rosmarie* (1942).

1943
Produces a second portrait of the Maschinenfabrik Oerlikon.
November. Publication of *Fabrik.*
December. Photographs for the first time at the New Year's Eve ball at the Palace Hotel in St. Moritz.

1944
Tuggener and Wydler win 1st prize in the Vereinigung Zürcher Film-Amateure competition with *Puls der neuen Zeit* (1938).

1945
June. Is threatened with legal action if a book with ball photographs is published.
Tuggener and Wydler win 1st prize in Vereinigung Zürcher Film-Amateure competition with *Die Seemühle* (1944).

1946
February. *Du* magazine publishes a series of seven photographs taken in the Swiss countryside.

1948
Leaves the Schweizerische Photographenverband.

1949
25 February. Gives a first slide lecture to the Zürcher Photographen-Verein (Zurich Photographers Association) entitled "Der Fotograf als Expressionist" (The Photographer as an Expressionist).
Summer. Travels to Holland and Belgium.
September. Divorces Marie Tuggener.
October issue of *Camera* magazine is devoted to Tuggener as a photographer and filmmaker.
Begins working regularly for the weekly *Genossenschaft*.
December. Leaves the Vereinigung Zürcher Film-Amateure.

1950
19 January. Marries Margrit Aschwanden and moves to Gutstrasse 85.

1951
Spring. Founding member of the Kollegium Schweizerischer Photographen (Academy of Swiss Photographers) together with Werner Bischof, Walter Läubli, Gotthard Schuh, and Paul Senn.
February–April. First exhibition of the Kollegium at the Helmhaus Zürich.
July. Participates in the first "subjektive fotografie" exhibition in Saarbrücken, Germany.

1952
27 March. Gives slide lecture "Die Photographie als Sprache" (Photography as Language) in Biel and later in Basel.
2 October. Is introduced by Robert Frank to Edward Steichen of The Museum of Modern Art, New York.

1953
16 January. Gives lecture "Film und Foto, die siebente Kunst" (Film and Photography, the Seventh Art) to the members of the Künstler-Vereinigung Zürich.
May–August. Participates in "Postwar European Photography" at The Museum of Modern Art, New York.

1954
April. Exhibits watercolors and drawings at the Städtische Kunstkammer "Zum Strau'Hoff" in Zurich.
May. Begins to photograph for a book on the Zürcher Oberland, the upper regions of the canton of Zurich.
September. Travels with his wife to Venice and Yugoslavia.

1955
January–May. Participates in "The Family of Man" at The Museum of Modern Art, New York.
March–April. Exhibition "Photographie als Ausdruck" (Photography as Expression) of the Kollegium at the Helmhaus Zürich.
Rejoins the Vereinigung Zürcher Film-Amateure.

1956
October. Publication of *Zürcher Oberland*.
25 November. Leaves the Kollegium leading to its disbanding.

1957
January issue of *Du* magazine is devoted exclusively to Tuggener and the painter Walter Linsenmaier.
April. Wins a gold medal at the 1st International Biennial of Photography in Venice.
May. Travels by car to Holland and returns by boat on the Rhine.

1958
13 February. Attends the Opernball in Vienna.
October. Divorces Margrit Tuggener.

1959
4 March. Shows ten of his silent films at the Théatre d'Hiver in Zurich.
September. Travels to London and southern England.

1960
March. Moves to a basement apartment on Titlisstrasse 52, lives and works there until the end of his life.

1964
January. Receives honorary membership of the Vereinigung Zürcher Film-Amateure.
April–October. Shows photographs and films in the Field and Forest section of the Swiss National Exhibition in Lausanne.
September. Death of first son Jakob Silver.

1965
May. Travels to Bologna and Ravenna, Italy.
Publication of *Forum alpinum*.

1966
March–April. Commissioned by Hans Schindler, Tuggener travels to Tunisia to document a development project of SwissContact.

1967
A portfolio of five photographs entitled *Schweizer Landleben* (Swiss Country Life) is published by the short-lived Phot-Ami-Club.

1968
April. Photographs the cathedrals of Strasbourg, Reims, Laon, Amiens, Rouen, and Paris.

1969
November–January 1970. Die Neue Sammlung of the Staatliche Museum für angewandte Kunst in Munich acquires one hundred and ten ball photographs and shows them in an exhibition entitled "Feine Feste."

1971
22 February. Marries Maria Euphemia Baumgartner.

1972
August. Travels on the Danube in Germany.

1974
October–January 1975. Included in "Photographie in der Schweiz: 1840 bis heute" (Photography in Switzerland: 1840 to today), the first survey of the history of photography in Switzerland at the Kunsthaus Zürich.
November–December. First retrospective exhibition "Jakob Tuggener. Fotografien 1930 bis heute" (Jakob Tuggener. Photographs from 1930 until Today) at the Helmhaus Zürich, shown again in the Museum der Stadt Solothurn in 1978.

1982
29 March. Receives "Auszeichnung für kulturelle Verdienste" (Award for Cultural Merit) of the city of Zurich.

1983
30 May. Receives honorary membership of the Schweizerische Photographenverband.
His eyesight begins to worsen and he has to have several operations for green and gray cataract.

1988
29 April. Dies after a stroke in Zurich.

Solo Exhibitions

Atelier exhibition at Gemeindestrasse 12, Zurich,
February 1945

"Jakob Tuggener," Galerie am Platz, Eglisau,
20 March–9 April 1969

"Feine Feste," Die Neue Sammlung, Staatliches Museum für
angewandte Kunst, Munich, Germany,
5 November 1969–11 January 1970

"Jakob Tuggener. Fotografien 1930 bis heute," Helmhaus Zürich,
9 November–8 December 1974;
Museum der Stadt Solothurn,
27 January–6 March 1978 (catalogue)

"Jakob Tuggener. Photographien," Stadthaus Uster,
22 September–20 October 1978

"Tuggeners Bücher," Kunsthaus Zürich,
31 October 1981–3 January 1982

"Jakob Tuggener," Kunsthaus Zürich,
4 February–9 April 2000

Group Exhibitions

"Mensch in Tätigkeit," Kunsthaus Luzern, May 1943

"Der Berufsfotograf," Helmhaus Zürich,
13 May–11 June 1944 (catalogue)

"Photographie in der Schweiz—heute," Gewerbemuseum, Basel,
19 March–30 April 1949 (catalogue)

"Vak Fotografie 1950," Stedelijk van Abbe-Museum, Eindhoven,
Holland, March 1950 (catalogue)

"Kollegium Schweizerischer Photographen," Helmhaus Zürich,
24 February–8 April 1951

"subjektive fotografie," Staatliche Schule für Kunst und Handwerk,
Saarbrücken, Germany,
12–29 July 1951 (book 1952)

"Kollegium Schweizerischer Photographen," Galerie Dufour, Biel,
Switzerland,
8 March–6 April 1952

"Weltausstellung der Photographie," Kunsthaus Luzern,
15 May–31 July 1952 (catalogue)

"Post-War European Photography," The Museum of Modern Art,
New York,
26 May–23 August 1953

"subjektive fotografie," Dreyden Gallery, George Eastman House,
Rochester, N.Y., USA,
December 1953–January 1954

"Kollegium Schweizerischer Photographen," Gewerbemuseum, Aarau,
January–March 1954

"Great Photographs," Limelight Gallery, New York,
1–30 December 1954

"subjektive fotografie 2," Staatliche Schule für Kunst und Handwerk,
Saarbrücken, Germany,
27 November 1954–27 January 1955 (book)

"The Family of Man," The Museum of Modern Art, New York,
26 January–8 May 1955 (catalogue)

"Photographie als Ausdruck," Helmhaus Zürich,
5 March–17 April 1955

"Prima Mostra Internazionale Biennale di Fotografia," Sala
Napoleonica e Ca' Giustinian, Venice, Italy,
20 April–19 May 1957 (catalogue)

"Fotografie als uitdrukkingsmiddel," Stedelijk van Abbe-Museum,
Eindhoven, Holland,
28 September–27 October 1957 (catalogue)

"Photographs from the Museum Collection," The Museum of Modern
Art, New York,
26 November 1957–18 January 1958

"The Family of Man," Kunstgewerbemuseum, Zurich,
25 January–2 March 1958

"subjektive fotografie 3: Das fotografische Selbstportrait,"
photokina, Cologne, Germany,
27 September–5 October 1958 (catalogue)

"Grosse Photographen dieses Jahrhunderts," *photokina,* Cologne,
Germany,
16–24 March 1963 (catalogue)

"EXPO 64," Pavillon "Feld und Wald", Lausanne,
30 April–25 October 1964 (book *Forum alpinum* 1965)

"Photographie in der Schweiz 1840 bis heute," Kunsthaus Zürich,
20. October 1974–5 January 1975 (catalogue)

"Neue Sachlichkeit und Surrealismus in der Schweiz 1915–1940,"
Kunstmuseum Winterthur,
15 September–11 November 1979 (book)

"Jakob Tuggener/August Sander," Work Gallery, Zurich,
26 April–10 June 1980

"Dreissiger Jahre Schweiz. Ein Jahrzehnt im Widerspruch,"
Kunsthaus Zürich,
30 October 1981–10 January 1982 (catalogue)

"La Suisse avant le miracle," Centre Culturel Suisse, Paris,
17 November 1990–20 January 1991

"Industriebild," Fotomuseum Winterthur,
9 April–5 June 1994 (book)

"Der geduldige Planet," Zementfabrik, Holderbank,
2 September–31 October 1995 (book)

"Seitenblicke," Forum der Schweizer Geschichte, Schwyz,
21 May–13 September, 1998 (catalogue)

"Ferit Kuyas und Jakob Tuggener," Villa am Aabach, Uster,
13 June–9 July 1998

Primary Sources

Unpublished Albums

1926, 23 photographs

Engelberg 1927, 27 photographs

Landschaften 1926–29, 43 photographs, nos. 1–43

Lukmanier 1928, 25 photographs, nos. 44–68

Tessin 1928, 14 photographs, nos. 69–81

Kistenpass 1928, 16 photographs, nos. 82–89

Bürs, Lünersee 1929, 14 photographs, nos. 90–103

Bludenz, Bürs, Lünersee, Schweizertor 1929, 27 photographs, nos. 104–11

Bürs bei Bludenz 1929, 12 photographs, nos. 117–124

Lurei, 1926–29, 23 photographs, nos. 126–133

Lurei, 1926–29, 15 photographs

1929, 18 photographs, nos. 135–153

Via Mala, Splügen, Misox, Ascona, Brissago 1927, 25 photographs, nos. 154–165

Tessin, Bavonatal, Cristallina 1928, 17 photographs, nos. 166–182

Erstfeld, Kröntenhütte 1927, 13 photographs, nos. 183–185

Erste Landschaften 1926, 14 photographs, nos. 168–188

MZAG. Roman v. J. Tuggener, 1929, 24 photographs, nos. 189–204

Berlin Reimannschule 1930/31, 21 photographs, nos. 205–219

Hamburg, Cuxhaven, Helgoland 1931, 26 photographs, nos. 221–247

Untitled (scrap album, Berlin 1930/31), 143 photographs

Tuggener Fotos 1929–32, 28 photographs, nos. 248–269

WK 32. 18.–30. April in Siblingen, 1932, 53 photographs, nos. 1–51

Maschinenfabrik Oerlikon MFO 1932–34, 39 photographs

Maschinenfabrik Oerlikon MFO 1932–34, 40 photographs

Untitled (Paul Klee exhibition, Kunsthaus Luzern, 1936), 35 photographs

Unpublished Book Maquettes

1935–1950

Der Zürichsee 1935, 47 pp.

Die Insel der verlorenen Schiffe, 1936, 72 pp.

Tyrol, Donau, Wien 1938, 62 pp. (not bound)

Polenwache 1942, 63 pp.

Frühling, 1942/43, 41 pp.

Sommer, 1942/43, 28 pp.

Herbst, 1942/43, 31 pp.

Winter, 1942/43, 32 pp.

Untitled (Sullana, Maag, Tornos, Escher Wyss, Bührle), c. 1943, 39 pp.

Im Tessin 1945–1948, 101 pp.

Schwarzes Eisen 1935–1950, 128 pp.

Ballnächte 1934–1950, 137 pp.

1951–1960

Genua, Neapel, Rom, 3.–8. Juli 1951, 130 pp.

Côte d'Azur, Mai 1951, 68 pp.

Provence, Mai 1951, 106 pp.

Die Maschinenzeit 1942–1951, 136 pp.

Carneval 1936–1953. Die Künstler Maskenbälle Zürichs, 107 pp.

Chemische Industrie 1944–1953, 91 pp.

Im Hafen von Antwerpen und Rotterdam, 28. August–8. September 1953, 126 pp.

Uf em Land 1935–1945, 1953, 132 pp.

Venedig, 1.–6. September 1954, 67 pp.

Yugoslavien, 6.–20. September 1954, 133 pp.

Der Rhein, 1957, 179 pp.

Ballnächte 1934–1959 (das Kolosseum), 141 pp.

London, 3.–9. September 1959, 95 pp.

England, 10.–23. September 1959, 124 pp.

Rom, 21. Oktober–2. November 1959, 112 pp.

1961–1970

Die Eisen-Bahn I, 1961, 124 pp.

Italienische Reise, 4.–19. September 1961, 132 pp.

1001 Nacht—die grossen Bälle 1935–62, 96 pp.

Palace Hotel St. Moritz—Sylvester Bälle 1943–62, 106/118 pp. (two versions)

Wiener Fasching/Wiener Gschnas 1958–1962, 100 pp.

Baur au Lac Zürich 1934–1960, 1963, 46 pp.

Die Bälle im Grand Hotel Dolder Zürich 1935–1961, 1963, 88 pp.

Wien 1938, 1958–1962, 1963, 126 pp.

Das Aathal, der "Millionenbach" 1942–1964, 112 pp.

Berlin, 4. August 1930–30. April 1931, 1964, 118 pp.

Castello Val Solda, Bologna, Ravenna, 14.–22. Mai 1965, 91 pp.

Tunesien, 24. März–8. April 1966, 72 pp.

Tunis, 25. März und 4.–8. April 1966, 61 pp.

Gabès, Süd-Tunesien, 27.–30. März 1966, 106 pp.

Eisenbahn II, 1967, 145 pp.

Lombardei, 24.–30. September 1968, 114 pp.

Der Üetliberg 1967–68, 116 pp.

Gothische Kathedralen in Nord-Frankreich I, 17.–20. April 1968, 77 pp.

Gothische Kathedralen II, 21.–26. April 1968, 77 pp.

Burgund, 16.–22. Juli 1970, 113 pp.

Der Zürichsee 1932–70, 151 pp. (three versions)

1971–1982

Die deutsche Donau 1958, 1960, 1972, 114 pp.

Zürich I, Die Altstadt 1929–1959, 1972, 107 pp.

Zürich II, Die Bahnhofstrasse, 1934–72, 107 pp.

Zürich III, Zürichs Freuden, 1931–67, 1972, 93 pp.

Zürich IV, Das Volk, 1972, 131 pp.

Die 4 Jahreszeiten. Der Frühling, 1973, 110 pp.

Die 4 Jahreszeiten. Der Sommer, 1973, 131 pp.

Die 4 Jahreszeiten. Der Winter, 1973, 119 pp.

Die 4 Jahreszeiten. Der Herbst, 1974, 129 pp.

Der Waadtländer Jura, 10.–16. Oktober 1975, 75 pp.

Deutschland-Reise 1976, 89 pp.

Untitled (Tessin), 1976, 131 pp. (not bound)

Untitled (Österreich), 1978, 108 pp.

Grand Prix Bern für Automobile und Motorräder 1936–50, 1982, 86 pp. (not bound)

Untitled (Paris, 1936–59), 1982, 125 pp. (not bound)

Unfinished and Undated Book Maquettes

Carneval 2

Eisenbahn III Ausland

Eisenbahn Schweiz

Engadin

untitled (canton of Glarus)

Graubünden West und Calancatal

Innerschweiz

Ostschweiz

Prättigau/Davos/Domleschg

Sernftal

Tuggener Buch

Uri

Wallis

Silent Films

Flugmeeting, 1937, 6 min., co-produced with Max Wydler

Puls der neuen Zeit (later changed to *Abbruch der Tonhalle),* 1938, 12 min., co-produced with Max Wydler

Grimentz, 1938, 3 min. (unfinished)

Zürich Stadt und Land, 1937–40, 24 min., co-produced with Max Wydler

Rosmarie, 1942, 16 min., with Rosmarie Beglinger and Max Wydler, co-produced with Max Wydler

Die Schiffsmaschine, 1943, 4 min., co-produced with Max Wydler

Wir fordern, 1943, 3 min., with Karl Schmid, co-produced with Max Wydler

Die Seemühle, 1944, 5 min., with Karl Weber, co-produced with Max Wydler

Der Weg aus Eden, 1946, 4 min., with Isa Kleinhäny, co-produced with Max Wydler

Dazio Grande, 1947, 6 min., with Rosetta Lumini

Uerikon-Bauma Bahn, 1948, 7 min.

Die Strassenbahnen im Kanton Zug, 1952, 11 min.

Hieronymus, 1952, 12 min., with the Wydler family

Illusion, 1954, 10 min.

Die Muse, 1957, 9 min., with Gertrud Schwabe and Walter Grab

Das Grab des Kelten, 1959, 12 min. (unfinished)

Palace Hotel, St. Moritz, 1960, 4 min.

Dornröschen, 1961, 12 min., with Edith Wildhagen

Wien, nur Du allein, 1960–62, 22 min.

Mortimer, 1962, 20 min., with Gisela Brückel and Hugo Suter

Die Versuchung des heiligen Antonius, 1963, 11 min., with Hugo Suter and Jacqueline Rosina

Die Holzfäller, 1963, 12 min.

Ciel naïf, 1967, 22 min., with Aldo Galli, Roberto Niederer and other Zurich artists

Roberto Niederer, der Glasbläser, 1970, 16 min.

Die Maschinenzeit, 1938–70, 30 min.

Published Books by Tuggener

Jakob Tuggener, *Fabrik. Ein Bildepos der Technik,* Introduction by Arnold Burgauer (Erlenbach-Zurich: Rotapfel-Verlag, 1943)

Jakob Tuggener, *Zürcher Oberland,* Text by Emil Egli (Wetzikon: Verlag AG Buchdruckerei Wetzikon und Rüti, 1956)

Schweizerische Buchgemeinschaft (ed.), *Forum alpinum* (Zurich: Arbeitsgemeinschaft Forum alpinum, 1965)

Commemorative Books for Companies

MFO. Maschinenfabrik Oerlikon (Zurich-Oerlikon, n.d. [1934])

Steckborn Kunstseide AG (Steckborn, 1938)

100 Jahre Honegger-Webstühle. 1842–1942 (Rüti: Maschinenfabrik Rüti, 1942)

MFO. Maschinenfabrik Oerlikon (Zurich-Oerlikon, 1943)

Kehricht-Verwertungs-Anstalt Basel Stadt (Basel, 1944)

Joh. Jacob Rieter & Cie. Lehrlings-Ausbildung (Winterthur: Joh. Jacob Rieter & Cie., 1944)

Von Olten-Aarburg zu Aare-Tessin. Fünfzig Jahre Elektrizität (Olten, n.d. [1945]), French edition: *Olten-Aarbourg–Aar et Tessin*

Die Webereien der Familie Näf von Kappel und Zürich 1846–1946 (Zurich, 1946)

150 Jahre Joh. Jacob Rieter & Cie. Winterthur-Töss 1795–1945 (Winterthur, 1947)

Fünfzig Jahre Schweizerische Wagons- und Aufzügefabrik A.G. Schlieren Zürich. 1899–1949 (Zurich, 1950)

50 Jahre Sprecher und Schuh Aarau. 1900–1950 (Aarau, n.d. [1950])

Bühler. Gebrüder Bühler, Maschinenfabriken und Giessereien, Uzwil (Uzwil, 1951)

Die Arbeit im chemischen Werk. Bilder aus den Fabrikations-betrieben der J. R. Geigy A.G., Basel (Basel, n.d. [1953])

Estoppey-Reber S.A. Bienne. Galvanotechnique horlogère 1885–1960 (Bienne, n.d. [1960])

Books with Major Contributions by Tuggener

Auslandschweizerwerk (ed.), *Meine Heimat* (Rorschach: Löpfe-Benz, 1942)

Martin Beheim-Schwarzbach, *Schiffe und Häfen* (Gütersloh: Sigbert Mohn, 1961)

Werner Bischof, Gottlieb Duttweiler, Arnold Kübler (eds.), *Our Leave in Switzerland* (Zurich: "Zur Limmat," 1945)

Daniel Bodmer et al. (eds.), *Zürich—Aspekte eines Kantons* (Zurich: Regierungsrat des Kantons Zürich, 1972)

Fabag (ed.), *Schweizer Künstler. Fotografie* (Zurich: Fachschriften-Verlag & Buchdruckerei, 1964)

René Gardi, *Hans, der junge Rheinschiffer* (Zurich: Büchergilde Gutenberg, 1962)

Hall, Norman (ed.). *Photography Year Book 1963* (London: Photography Magazine, 1962)

Arnold Kübler, *Mitenand—gägenand—durenand* (Zurich: Ex Libris, 1959)

Franz A. Roedelberger (ed.), *Zürich in 500 Bildern* (Zurich: Verlagsgenossenschaft, 1944)

idem, *Das Buch der Schaffensfreude* (Zurich: Interverlag, 1947)

idem, *Das Schweizerbuch vom Wandern, Reisen, Fliegen* (Bern: Verlag Verbandsdruckerei, 1956)

Edouard Seiler, *Das Schweizervolk und seine Wirtschaft* (Zurich: Arbeitsgemeinschaft Nationaler Wiederaufbau, 1944)

Jürg Stockar, *Zürich. Mode durch die Jahrhunderte* (Zurich: Orell Füssli, 1974)

VSK Basel (ed.), *Viel erreicht—noch viel zu tun. 25 Jahre Patenschaft Co-op* (Basel: Verband Schweizerischer Konsumvereine, 1967)

Maurice Zermatten, *Kleines Weinbrevier* (Zurich: Propagandazentrale für Erzeugnisse der schweizerischen Landwirtschaft, 1954)

Tuggener's Main Reportages and Portfolios Published in Magazines

1932–40

"Vom Sand und Ledischiffen," in *In freien Stunden,* 5 November 1932, pp. 16–17

"Was Arbeiter über ihre Arbeit sagen," in *Der Gleichrichter,* 12 December 1932–15 May 1934

"Köpfe aus Bureau und Werkstatt," in *Der Gleichrichter,* 1 September 1934–6 June 1936

"Bilder vom Schweizerischen Trachtenfest in Montreux," in *In freien Stunden,* 6 October 1934, pp. 14–15

"Ein Geschäft wird getätigt," in *In freien Stunden,* 17 November 1934, pp. 4–5

"Ein Mensch der immer gibt," in *Föhn,* July 1935, pp. 56–57

"Ein Segelsonntag auf dem Zürichsee," in *In freien Stunden,* 13 July 1935, pp. 8–9

"E paar Bildli vom Tuggener sim Fotobsuech i der Lochmüli Zanggalle," in *Der Gleichrichter,* 10 August 1935, pp. 3–4

"II. Grosser Preis der Schweiz," in *In freien Stunden,* 31 August 1935, cover and pp. 16–17

"Je-Ka-Mi," in *Föhn,* September 1935, pp. 26–30

"Speisewagengesellschaft," in *In freien Stunden,* 11 July 1936, pp. 16–17

"'s Berti isch z'schbaat cho…," in *Der Gleichrichter,* 15 August 1936, pp. 4–5

"Am Meer," in *In freien Stunden,* 17 October 1936, pp. 16–17

"Klausjagen," in *In freien Stunden,* 5 December 1936, pp. 8–9

"Der Scharfrichter," in *Der Gleichrichter,* 8 December 1936, pp. 4–5

"Versailles," in *In freien Stunden,* 16 January 1937, pp. 16–17

"5 Minute näch zwölfi…," in *Der Gleichrichter,* 5 July 1937, pp. 4–5

"Jeder schönen Frau unsere Huldigung," in *Föhn,* November 1937, pp. 50–54

"Pariser Weltausstellung 1937," in *Der Gleichrichter,* 20 December 1937, pp. 6–7

"Lasset den Lobgesang hören," in *In freien Stunden,* 11 June 1938, pp. 12–13

"Wien von heute," in *In freien Stunden,* 6 August 1938, pp. 16–17

"Füsilier Wipf betrachtet sich einen modernen Wiederholiger," in *Föhn,* October 1938, pp. 34–37

"Vom M.F.O.-Landitag," in *Der Gleichrichter,* 25 September 1939, pp. 2–5

"Die Nachtwächter," in *Der Gleichrichter,* 25 April 1940, pp. 4–5

1941–50

"Man muss sich zu helfen wissen," in *In freien Stunden,* 30 August 1941, pp. 8–9

"Vom Wasser," in *Du,* July 1942, pp. 37–40

"Uf em Land," in *Schweizer Spiegel,* 11 August 1945, pp. 8–12

"Uf em Land," in *Du,* February 1946, pp. 4, 33–40

"Ballnächte," in *Schweizer Spiegel,* February 1946, pp. 17–20

"Laufmädchenphilosophie," in *Der Gleichrichter,* 15 September 1946, p. 85

"Ball," in *Camera,* January/February 1947, cover and pp. 6–17

"Das Wirtshaus," in *Du,* August 1948, pp. 15, 37–41, 47

"Bürger und Bürokrat," in *Du,* January 1949, pp. 6–12, 25

"Auch Mutter sein muss gelernt sein," in *Genossenschaft,* 8 July 1950

"Der Fotograf als Expressionist," in *Schweizerische Photo-Rundschau,* 8 December 1950, pp. 402–406

1951–60
"Das Rad bestimmt das Weltgeschehen," in *Genossenschaft,* 26 May 1951

"75 Jahre MFO," in *Der Gleichrichter,* 30 November 1951, whole issue

"Parfümierter Schnee," in *Schweizer Journal,* January/February 1952, pp. 22–27

"Immer noch lebt das Märchen," in *Genossenschaft,* 31 January 1953

"Die Maschine und der Mensch," in *Genossenschaft,* 20 February 1954

"Das Leben eines Künstlers," in *Genossenschaft,* 6 October 1954

"La photographie et la réalité," in *Photorama* (Belgium), November/December 1955, pp. 760–763

"Feierabend im Dorf," in *Genossenschaft,* 31 December 1955

"Mahle, Mühle, mahle!" in *Genossenschaft,* 17 May 1958

1961–70
"Menschen in Rom," in *Atlantis,* March 1961, pp. 135–142

"Ein Bergdorf blüht auf," in *Genossenschaft,* 18 May 1963

"Unser Boden—teure Heimaterde," in *Genossenschaft,* 21 November 1964

"Hamn," in *Longitude* (Sweden), January 1966, pp. 10–13

"Die Zürcher und die Frauen," in *Genossenschaft,* 19 November 1966

"Nach 25 Jahren—noch viel zu tun," in *Genossenschaft,* 18 February–5 August 1967

"Möchten Sie gerne Bergbäuerin sein?" in *Die Genossenschafterin,* March/April 1967, pp. 3–12

"Palace Hotel," in *Du,* February 1968, pp. 124–132

"Ballgeflüster," in *Elle,* 15 December 1969, pp. 40–45

"Restaurants fotografiert von Jakob Tuggener," in *Elle,* 15 September 1970, pp. 74–78

Secondary Sources

Monographs and Surveys

Martin Gasser, *Jakob Tuggener: Photographs 1926–1956* (Ph.D. Dissertation, Princeton University, Ann Arbor: UMI Company, 1996)

Simone Kappeler, *Jakob Tuggener—Die Wirklichkeit in Bildern erleben* (Thesis submitted for a diploma, Kunstgewerbeschule Zürich, Spring 1979)

Stiftung für die Photographie (ed.), *Photographie in der Schweiz 1840 bis heute* (Teufen: Niggli, 1974)

Schweizerische Stiftung für die Photographie (ed.), *Photographie in der Schweiz von 1840 bis heute* (Bern: Benteli, 1992)

Articles

Anon., "Besuch in Zürcher Künstlerateliers: Jakob Tuggener," in *Zürcher Woche,* 25 May 1956

Erika Billeter, "Kleiner Abriss der Fotografie in Zürich," in *Zürcher Almanach,* (Zurich: Benziger, 1968), pp. 119–131

Inge Bondi, "Der kürzeste Weg zum Herzen," in *Puls (Weltwoche),* 10 September 1980, pp. 12–17

Idem, "Jakob Tuggener," in *Contemporary Photographers* (London: Macmillan, 1982), pp. 765–766

Martin Gasser, "From National Defence to Human Expression: Swiss Photography 1939–49," in *History of Photography* (England), Fall 1998, pp. 229–236

Norman Hall, "Jakob Tuggener," in *Photography,* September 1962, pp. 32–41

Alfred A. Häsler, "Das Innere sichtbar machen," in *Ex Libris,* June 1966, pp. 5–13

Hans Kasser, "Jakob Tuggener," in *Camera,* October 1949, pp. 294–307

Arnold Kübler, "Jakob Tuggener/Walter Linsenmaier," in *Du,* January 1957, pp. 2–21

Guido Magnaguagno, "Laudatio," held at the Kunsthaus Zürich, 29 March 1982 (typescript)

Idem, "Jakob Tuggener," in *Du,* July 1988, pp. 90–97

Paul Münch, "Besuch bei einem Bilderdichter," in *Die Linth (Rapperswiler Nachrichten),* 15 November 1968

Oswald Ruppen, "Jakob Tuggener," in *Schweizerische Photo-Rundschau,* 25 December 1974, pp. 8–18

Idem, "Jakob Tuggener. Fotograf," in *Schweizerische Photo-Rundschau,* 25 June 1978, pp. 26–39

Idem, "Jakob Tuggener: Zwischen Ballnacht, Mythos und Maschine," in *Passagen,* spring 1988, unpag.

D. Seylan, "Three Swiss Photographers," in *Creative Camera,* December 1977, pp. 402–413

Heinrich Stöckler, "Jakob Tuggener," in *Leica-Fotografie,* November/December 1961, pp. 230–239

Kurt Ulrich, "Der Fotograf Jakob Tuggener: Berühmt, doch ohne Erfolg," in *Brückenbauer,* 6 January 1978

Idem, "Jakob Tuggener: Poésieréaliste—typisch schweizerisch," in *Du,* March 1981, pp. 62–65

Films

Bachmann, Dieter, *Zum Beispiel: Jakob Tuggener,* Fernsehen DRS 1969

May B. Broda, *Jakob Tuggner,* in *Spuren der Zeit,* Fernsehen DRS 2000

Unpublished Interviews

Inge Bondi, interview with Jakob Tuggener, April 1980 (audio tape)

Simone Kappeler, interviews with Jakob Tuggener, September 1978 (audio tapes)

The publishers wish to thank the following persons and institutions for their support in producing this book:

Volkart Foundation; PRO HELVETIA Arts Council of Switzerland; Cultural Foundation of Spinnerei Streiff AG, Aathal; Dr. Carlo Fleischmann Foundation; Thomas Koerfer; Präsidialdepartement of the City of Zurich; MIGROS Culture Percentage.

This book is published on the occasion of the exhibition "Jakob Tuggener," organized by the Kunsthaus Zürich in co-operation with the Jakob Tuggener-Foundation and the Swiss Foundation of Photography, 4 February to 9 April 2000, Kunsthaus Zürich.

Martin Gasser (Ed.)—Jakob Tuggener

Translation Magnaguagno:	Catherine Schelbert
Editing:	Alexis Schwarzenbach
Book concept:	Martin Gasser, Jean Robert
Design:	Robert & Durrer, Zurich
Typesetting & Lithography:	Egli.Kunz & Partner AG, Glattbrugg ZH
Printing:	Waser Druck AG, Buchs ZH
Binding:	Buchbinderei Burkhardt AG, Mönchaltorf ZH

First Scalo Edition 2000
ISBN 3-908247-24-1
Printed in Switzerland

DATE DUE
